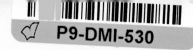

NORMAN ROCKWELL'S

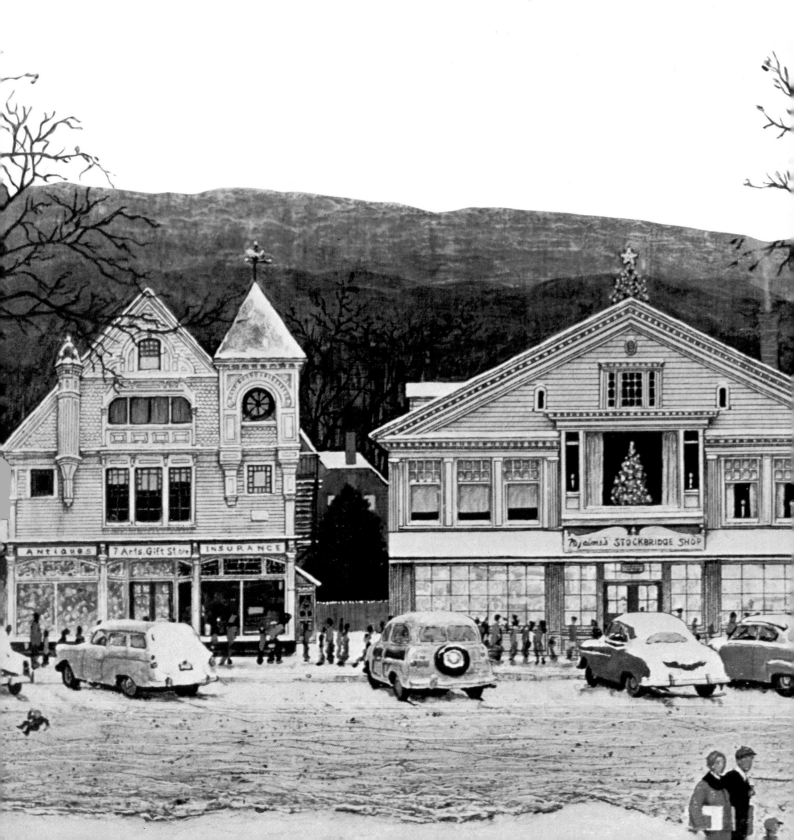

MOLLY ROCKWELL *Consulting Editor*

CHRISTMAS BOOK

Guideposts

CARMEL · NEW YORK 10512

Illustrations are of paintings or portions of paintings which appeared in publications by Brown & Bigelow, Inc., Country Gentleman Magazine, Cowles Communications' Look Magazine, Hallmark Cards, Inc., Ladies Home Journal, The Literary Digest, Massachusetts Mutual Life Insurance Company, McCall's Magazine, Parker Pen Co., Inc., The Saturday Evening Post, and The Woman's Home Companion. Illustration on page 174 is from The George Macy Companies, Inc., New York.

Special thanks are due to David Wood, Curator, and Margaret Batty, Assistant of The Old Corner House, Stockbridge, Massachusetts, for their cooperation, and to Hallmark Cards, Inc., for theirs.

Project editor, Lena Tabori Fried

Editor, Ruth Eisenstein

Designer, Julie Bergen

Director Rights and Reproductions, Barbara Lyons

Library of Congress Cataloging in Publication Data

Main entry under title:
Norman Rockwell's Christmas Book.

SUMMARY: Stories, poems, carols, and recollections of Christmas by world-famous authors, with 120 illustrations by Norman Rockwell.
1. Christmas—Literary collection. [1. Christmas—Literary collections] 1. Rockwell, Norman, 1894-
II. Rockwell, Molly.
PZ5.N59 [Fic] 77-7087
This special Guideposts edition is published by arrangement with Harry N. Abrams.

ACKNOWLEDGEMENTS

"Why the Chimes Rang" by Raymond Macdonald Alden (Indianapolis: Bobbs-Merrill, 1906).

"My Christmas Miracle" by Taylor Caldwell. Reprinted by permission of *Family Weekly*, copyright © 1968, 641 Lexington Avenue, New York, New York 10022.

"Christmas in Maine" by Robert P. Tristram Coffin. Copyright 1941 by R. P. T. Coffin. Renewed 1968 by R. T. Coffin, Jr.

"Christmas on a Farm in New York" by Theodore Ledyard Cuyler. Reprinted from *The Twelve Days of Christmas* by Miles and John Hadfield. Copyright 1961 by Little, Brown and Company, Boston.

"Mistletoe" by Walter de la Mare. Reprinted by permission of The Literary Trustees of Walter de la Mare, and The Society of Authors, London.

"In Search of Christmas" by James E. Fogartie, from *Stories For Christmas* edited by Mary Virginia Robinson, copyright by M. E. Bratcher 1967. Used by permission of John Knox Press and the author.

"Christmas Trees" by Robert Frost. From *The Poetry of Robert Frost* edited by Edward Connery Lathem. Copyright 1916, © 1969 by Holt, Rinehart and Winston. Copyright 1944 by Robert Frost. Reprinted by permission of Holt, Rinehart and Winston, Publishers.

"The Miraculous Staircase" by Arthur Gordon. Reprinted by permission from *Guideposts Magazine*, copyright December 1966 by Guideposts Associates, Inc., Carmel, New York 10512.

"The Gift of the Magi" by O. Henry. Reprinted from *The Four Million*, published by Doubleday and Company, Inc.

"Waiting . . . Waiting for Christmas" by Elizabeth English. Reprinted with permission from *Guideposts Magazine*. Copyright © 1983 by Guideposts Associates, Inc., Carmel, NY 10512.

"Legend of the Christmas Rose" by Selma Lagerlöf. From *The Girl from Marsh Croft* by S. Lagerlöf. Copyright 1910 by S. Lagerlöf. Reprinted by permission of Doubleday and Company, Inc.

"A Surprise for the Teacher" by Sam Levenson. From *Christmas with Ed Sullivan* by Ed Sullivan. Copyright © 1959 by Ed Sullivan. Used with permission of McGraw-Hill Book Company.

"Christmas Eve at Sea" by John Masefield. From *Salt-Water Poems and Ballads* by John Masefield. Copyright 1916 by John Masefield, renewed 1944 by John Masefield. Reprinted by permission of Macmillan.

"Christmas Eve in Our Village" by Phyllis McGinley. From *Times Three* by Phyllis McGinley. Copyright 1951 by Phyllis McGinley. First published in *The New Yorker*. Reprinted by permission of The Viking Press.

"A Carol for Children" by Ogden Nash. Copyright 1934 by Ogden Nash.

"The Boy Who Laughed at Santa Claus" by Ogden Nash. Copyright 1937 by Ogden Nash.

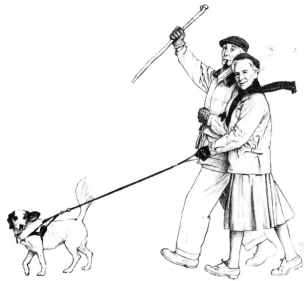

"A Gift of the Heart" by Norman Vincent Peale. Reprinted with permission from the January 1968 *Reader's Digest*. Copyright 1968 by The Reader's Digest Association, Inc.

"Down Pens" by Saki. From *The Short Stories of Saki* (H.H. Munro). All rights reserved. Reprinted by permission of The Viking Press.

"A Miserable, Merry Christmas" by Lincoln Steffens. From *The Autobiography of Lincoln Steffens*, copyright 1931 by Harcourt Brace Jovanovich, Inc.; renewed 1959 by Peter Steffens. Reprinted by permission of the publishers.

"Christmas This Year" by Booth Tarkington. Privately printed by Booth Tarkington, 1945.

"Once on Christmas" by Dorothy Thompson. Copyright 1938 by Oxford University Press. Renewed 1966 by Michael Lewis.

"Letter from Santa Claus" by Mark Twain. Pages 36–39 in *My Father Mark Twain* by Clara Clemens. Copyright 1931 by Clara Clemens Gabrilowitsch; renewed 1931 by Clara Clemens Samossoud. Reprinted by permission of Harper and Row, Publishers, Inc.

"Mr. Edwards Meets Santa Claus" by Laura Ingalls Wilder. From *Little House on the Prairie*, by Laura Ingalls Wilder. Text copyright by Laura Ingalls Wilder. © renewed 1963 by Roger L. MacBride. Reprinted by permission of Harper and Row, Publishers, Inc.

Fifteen songs and carols from *A Treasury of Christmas Songs and Carols* edited and annotated by Henry W. Simon. By permission of Barthold Fles, Literary Agent, New York.

"The First Christmas Tree" by Lucy Wheelock. Reprinted with permission from Mrs. Ada Dickinson.

"The Light From the Cave" by Sidney Fields. Reprinted from *The Guideposts Family Christmas Book*, reprinted by permission of Guideposts Associates, Inc. Copyright © 1980 by Guideposts Associates, Inc., Carmel, NY 10512.

"Grandma Holman's Mincemeat Pie" reprinted from *The Guideposts Family Christmas Book* by permission of Guideposts Associates, Inc. Copyright © 1980 by Guideposts Associates, Inc.

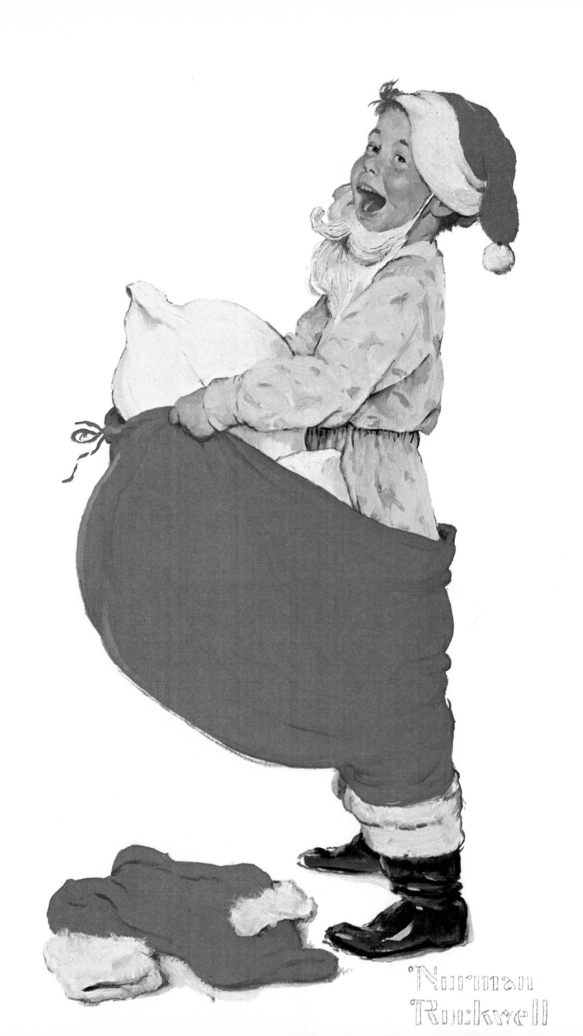

CONTENTS

THE FIRST CHRISTMAS

STORIES

CAROLS

POEMS

CHRISTMAS REMEMBERED

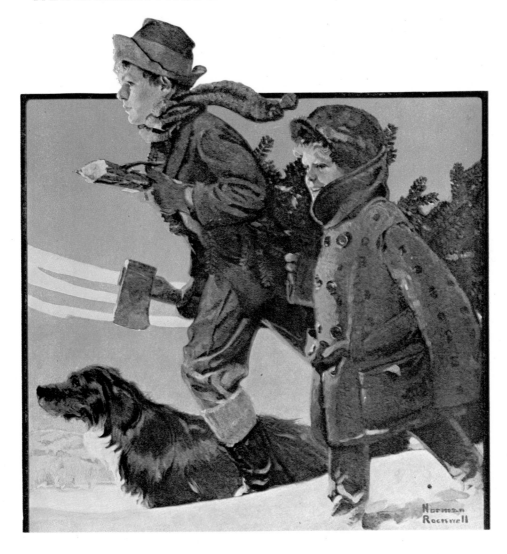

A
LIST OF
AUTHORS

LOUISA MAY AL-
COTT (1832–1888) •HANS
CHRISTIAN ANDERSEN
(1805–1875) • W.H. AUDEN (1907–
1973) • TAYLOR CALDWELL (b. 1900) •
LEWIS CARROLL
(CHARLES LUTWIDGE
DODGSON; 1832–1898) •
FRANCIS P. CHURCH (1839–
1906) • JOHN CLARE (1793–1864) •
ROBERT P. TRISTRAM COFFIN (1892–
1955) •RICHARD CRASHAW (1613–1649) •
THEODORE LEDYARD CUYLER (1822–1909) •
WALTER DE LA MARE (1873–1956) •CHARLES DICK-
ENS (1812–1870) •FANNIE MERRITT FARMER (1857–1915)
• ANATOLE FRANCE (1844–1924) • ROBERT FROST (1874–
1963) • ARTHUR GORDON (b. 1912) • O. HENRY (WILLIAM
SIDNEY PORTER; 1862–1910) • ROBERT HERRICK (1591–1674) •
WILLIAM DEAN HOWELLS (1837–
1920) • LANGSTON HUGHES (1902–
1967) • SELMA LAGERLÖF (1858–1940) •
SAM LEVENSON (b. 1911) • GEORGE MAC-
DONALD (1824–1905) • PHYLLIS McGINLEY
(b. 1905) • JOHN MASEFIELD (1878–1967) • JOHN
MILTON (1608–1674) • CLEMENT CLARKE MOORE
(1779–1863) •CHRISTOPHER MORLEY (1890–1957) •ELIZ-
ABETH MORROW (1873–1955) •OGDEN NASH (1902–1971) •
NORMAN VINCENT PEALE (b. 1898) • SAKI (H.H. MUNRO;
1870–1916) • WILLIAM SHAKESPEARE (1564–1616) • CHRISTO-
PHER SMART (1722–1771) • LINCOLN STEFFENS (1866–1936) •BOOTH
TARKINGTON (1869–1946) • WILLIAM MAKEPEACE THACKERAY (1811–
1863) • DOROTHY THOMPSON (1894–1961) • MARK TWAIN (SAMUEL
LANGHORNE CLEMENS; 1835–1910) •LAURA INGALLS WILDER (1867–1957)

THE FIRST CHRISTMAS

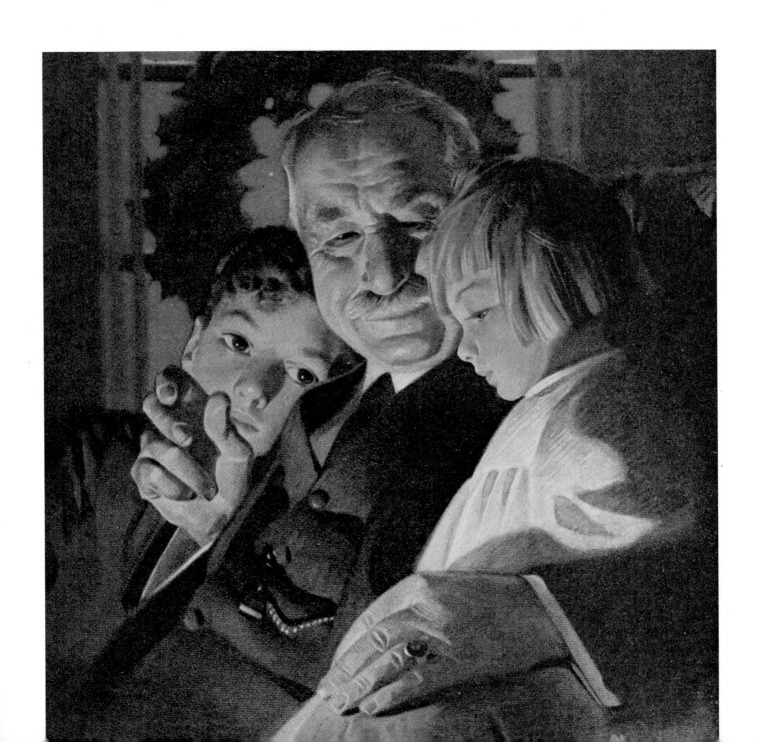

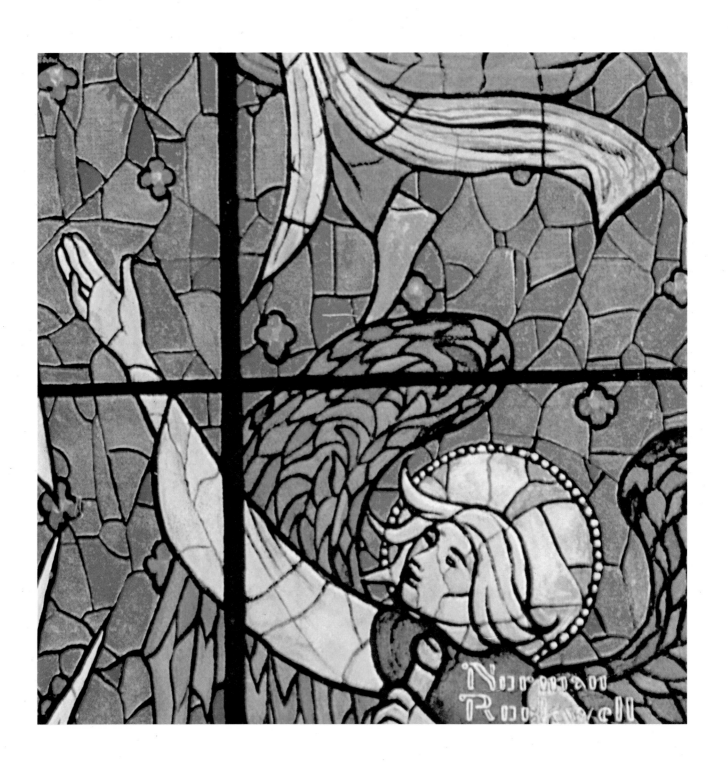

Born in Bethlehem

(ST. LUKE 2:1–16)

And it came to pass in those days, that there went out a decree from Caesar Augustus, that all the world should be taxed.

(*And* this taxing was first made when Cyrenius was governor of Syria.)

And all went to be taxed, every one into his own city.

And Joseph also went up from Galilee, out of the city of Nazareth, into Judæa, unto the city of David, which is called Bethlehem; (because he was of the house and lineage of David:)

To be taxed with Mary his espoused wife, being great with child.

And so it was, that, while they were there, the days were accomplished that she should be delivered.

And she brought forth her firstborn son, and wrapped him in swaddling clothes, and laid him in a manger; because there was no room for them in the inn.

And there were in the same country shepherds abiding in the field, keeping watch over their flock by night.

And, lo, the angel of the Lord came upon them, and the glory of the Lord shone round about them: and they were sore afraid.

And the angel said unto them, Fear not: for, behold, I bring you good tidings of great joy, which shall be to all people.

For unto you is born this day in the city of David a Saviour, which is Christ the Lord.

And this *shall be* a sign unto you; Ye shall find the babe wrapped in swaddling clothes, lying in a manger.

And suddenly there was with the angel a multitude of the heavenly host praising God, and saying,

Glory to God in the highest, and on earth peace, good will toward men.

And it came to pass, as the angels were gone away from them into heaven, the shepherds said one to another, Let us now go even unto Bethlehem, and see this thing which is come to pass, which the Lord hath made known unto us.

And they came with haste, and found Mary, and Joseph, and the babe lying in a manger.

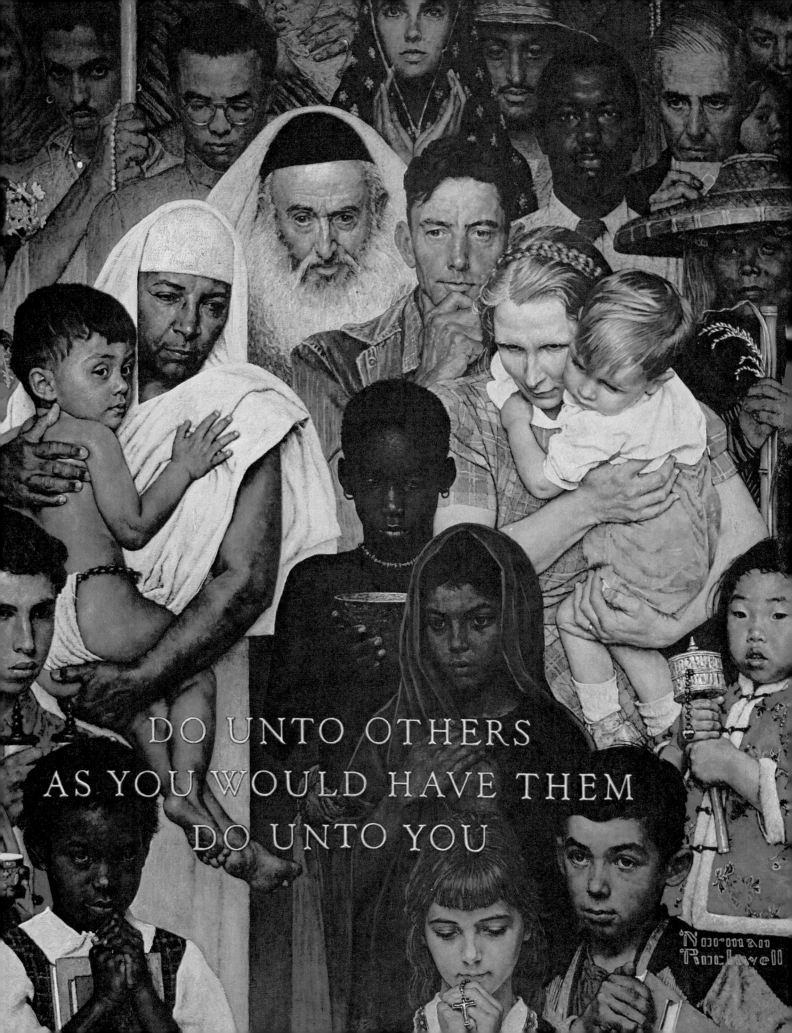

The Three Wise Men

(ST. MATTHEW 2:1–14)

Now when Jesus was born in Bethlehem of Judæa in the days of Herod the king, behold, there came wise men from the east to Jerusalem.

Saying, Where is he that is born King of the Jews? for we have seen his star in the east, and are come to worship him.

When Herod the king had heard *these things*, he was troubled, and all Jerusalem with him.

And when he had gathered all the chief priests and scribes of the people together, he demanded of them where Christ should be born.

And they said unto him, In Bethlehem of Judæa: for thus it is written by the prophet,

And thou Bethlehem, *in* the land of Juda, art not the least among the princes of Juda: for out of thee shall come a Governor, that shall rule my people Israel.

Then Herod, when he had privily called the wise men, enquired of them diligently what time the star appeared.

And he sent them to Bethlehem, and said, Go and search diligently for the young child; and when ye have found *him*, bring me word again, that I may come and worship him also.

When they had heard the king, they departed; and, lo, the star, which they saw in the east, went before them, till it came and stood over where the young child was.

When they saw the star, they rejoiced with exceeding great joy.

And when they were come into the house, they saw the young child with Mary his mother, and fell down, and worshipped him: and when they had opened their treasures, they presented unto him gifts; gold, and frankincense, and myrrh.

And being warned of God in a dream that they should not return to Herod, they departed into their own country another way.

And when they were departed, behold, the angel of the Lord appeareth to Joseph in a dream, saying, Arise, and take the young child and his mother, and flee into Egypt, and be thou there until I bring thee word: for Herod will seek the young child to destroy him.

When he arose, he took the young child and his mother by night, and departed into Egypt.

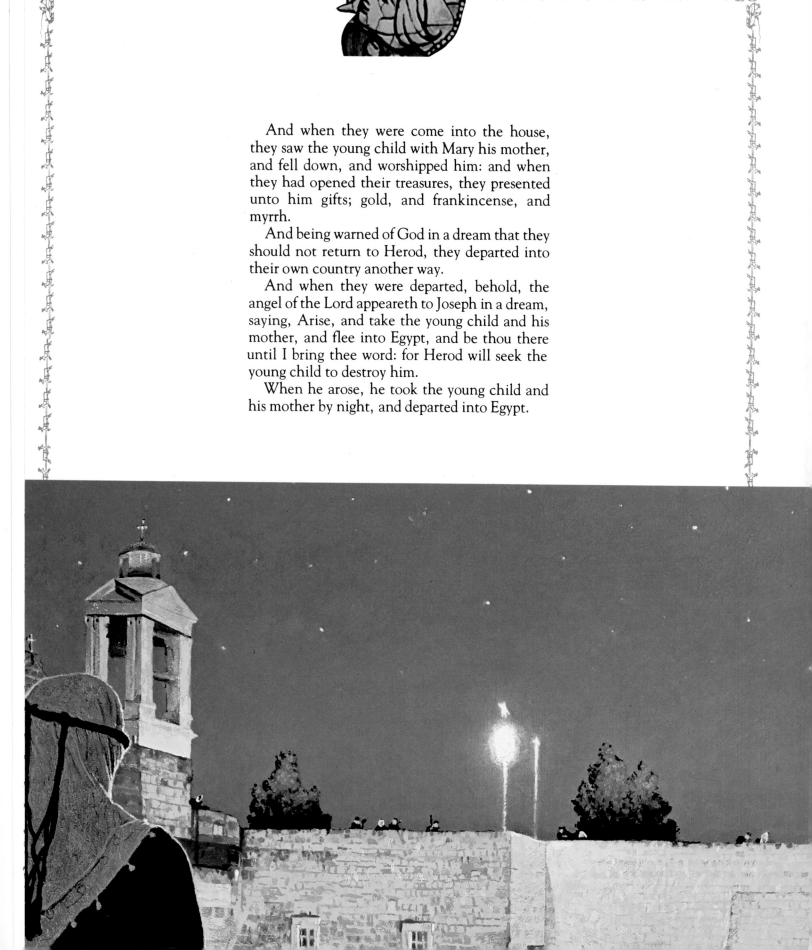

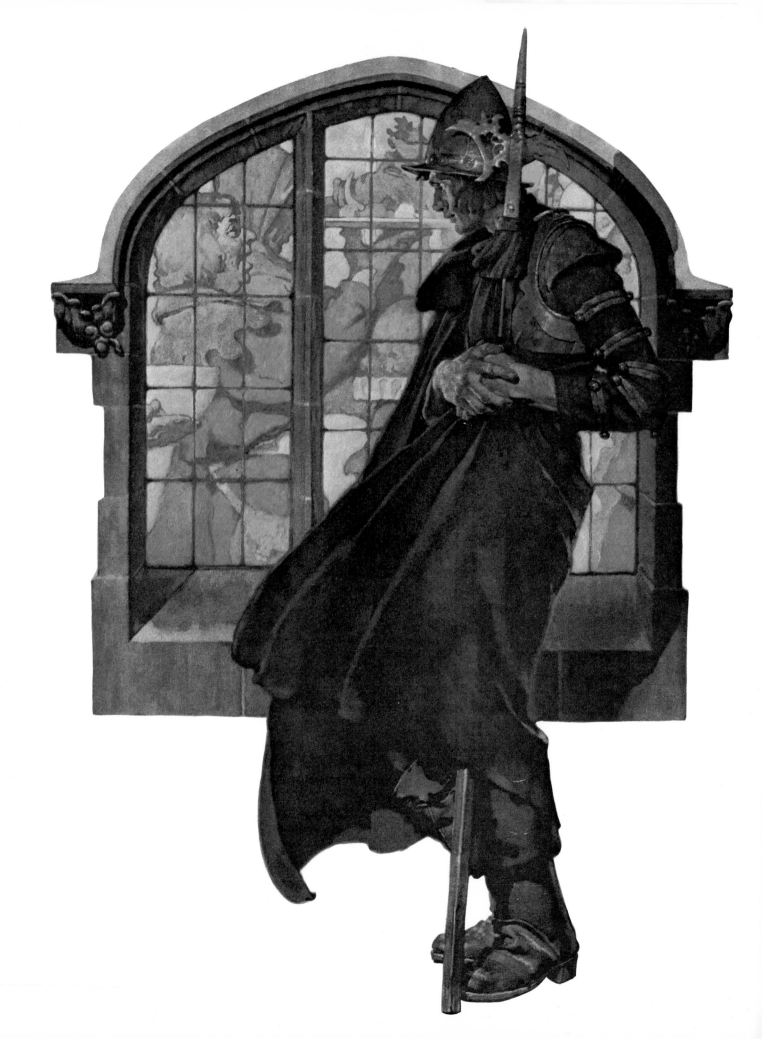

A Hymn Sung as by
the Shepherds

RICHARD CRASHAW

Welcome, all wonders in one sight!
Eternity shut in a span!
 Summer in winter, day in night!
Heaven in earth, and God in man!
 Great little One! whose all-embracing birth
Lifts earth to heaven, stoops heaven to earth. . . .
 . . .
 To Thee, meek Majesty! soft King
Of simple graces and sweet loves:
 Each of us his lamb will bring,
Each his pair of silver doves;
 Till burnt at last in fire of Thy fair eyes,
Ourselves become our own best sacrifice.

That Holy Thing

GEORGE MacDONALD

They all were looking for a king
 To slay their foes and lift them high:
Thou cam'st, a little baby thing
 That made a woman cry.

O Son of Man, to right my lot
 Naught but Thy presence can avail;
Yet on the road Thy wheels are not,
 Nor on the sea Thy sail!

My how or when Thou wilt not heed,
 But come down Thine own secret stair,
That Thou mayst answer all my need—
 Yea, every bygone prayer.

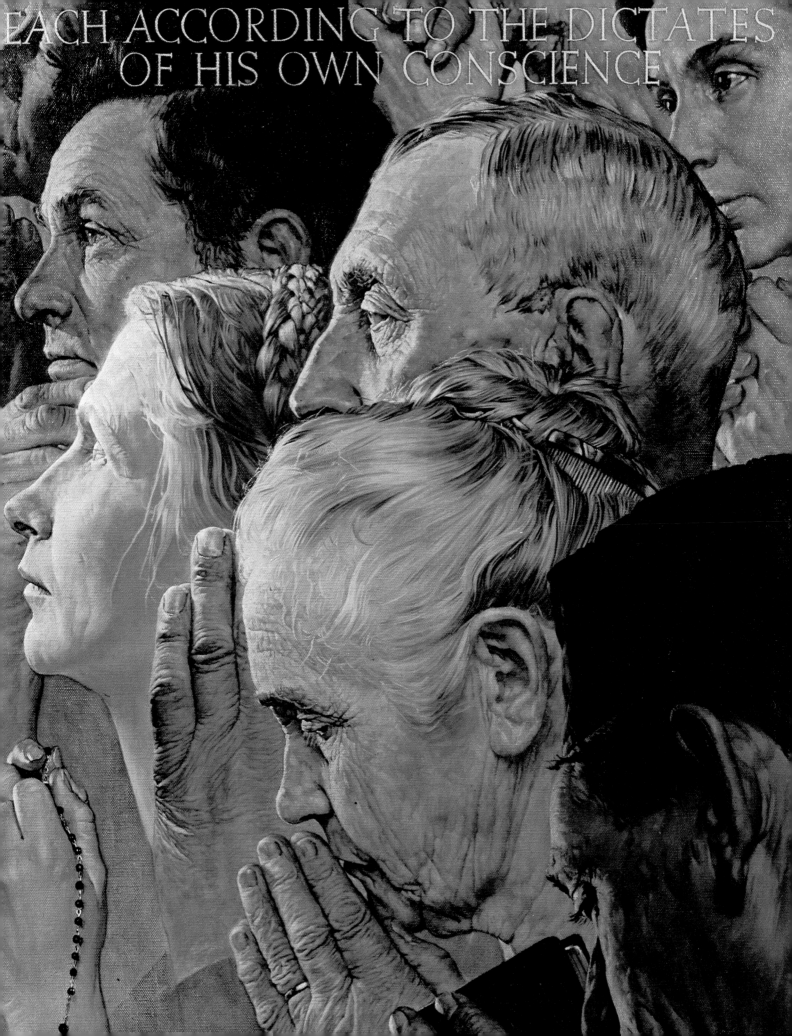

On the Morning of Christ's Nativity

JOHN MILTON

Say, Heavenly Muse, shall not thy sacred vein
Afford a present to the Infant God?
Hast thou no verse, no hymn, or solemn strain,
To welcome him to this his new abode,
Now while the heaven, by the sun's team untrod,
 Hath took no print of the approaching light,
And all the spangled host keep watch in squadrons bright?

See how from far upon the eastern road
The star-led wizards haste with odours sweet!
O run; prevent them with thy humble ode,
And lay it lowly at his blessed feet;
Have thou the honour first thy Lord to greet
 And join thy voice unto the angel quire,
From out his secret altar touched with hallowed fire.

The Hymn

It was the winter wild,
While the Heaven-born Child
 All meanly wrapt in the rude manger lies;
Nature in awe to him
Had doffed her gaudy trim,
 With her great Master so to sympathize:
It was no season then for her
To wanton with the sun, her lusty paramour.
 . . .
But he, her fears to cease,
Sent down the meek-eyed Peace;
 She crowned with olive green came softly sliding
Down through the turning sphere,
His ready harbinger,
 With turtle wing the amorous clouds dividing,
And waving wide her myrtle wand,
She strikes a universal peace through sea and land.
 . . .

The stars, with deep amaze,
Stand fixed in steadfast gaze,
 Bending one way their precious influence,
And will not take their flight,
For all the morning light,
 Or Lucifer that often warned them thence;
But in their glimmering orbs did glow,
Until their Lord himself bespake, and bid them go.
. . .

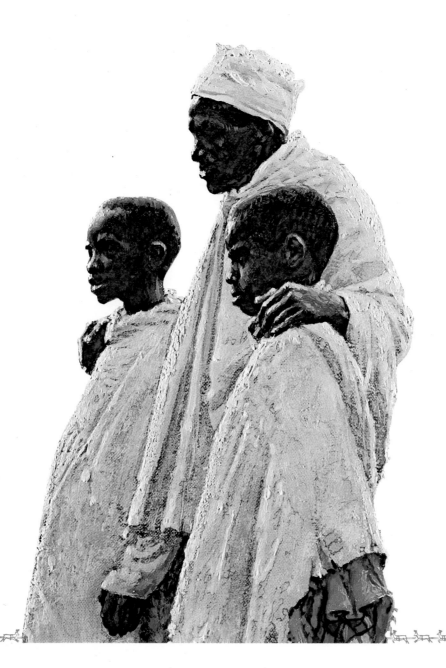

The shepherds on the lawn,
Or ere the point of dawn,
 Sat simply chatting in a rustic row;
Full little thought they then
That the mighty Pan
 Was kindly come to live with them below;
Perhaps their loves or else their sheep,
Was all that did their silly thoughts so busy keep.

· · ·

When such music sweet
Their hearts and ears did greet,
 As never was by mortal finger strook,
Divinely warbled voice
Answering the stringèd noise
 As all their souls in blissful rapture took:
The air such pleasure loth to lose,
With thousand echoes still prolongs each heavenly close.

· · ·

But see! the Virgin blest
Hath laid her Babe to rest.
 Time is our tedious song should here have ending:
Heaven's youngest-teemèd star
Hath fixed her polished car,
 Her sleeping Lord with handmaid lamp attending;
And all about the courtly stable
Bright-harnessed angels sit in order serviceable.

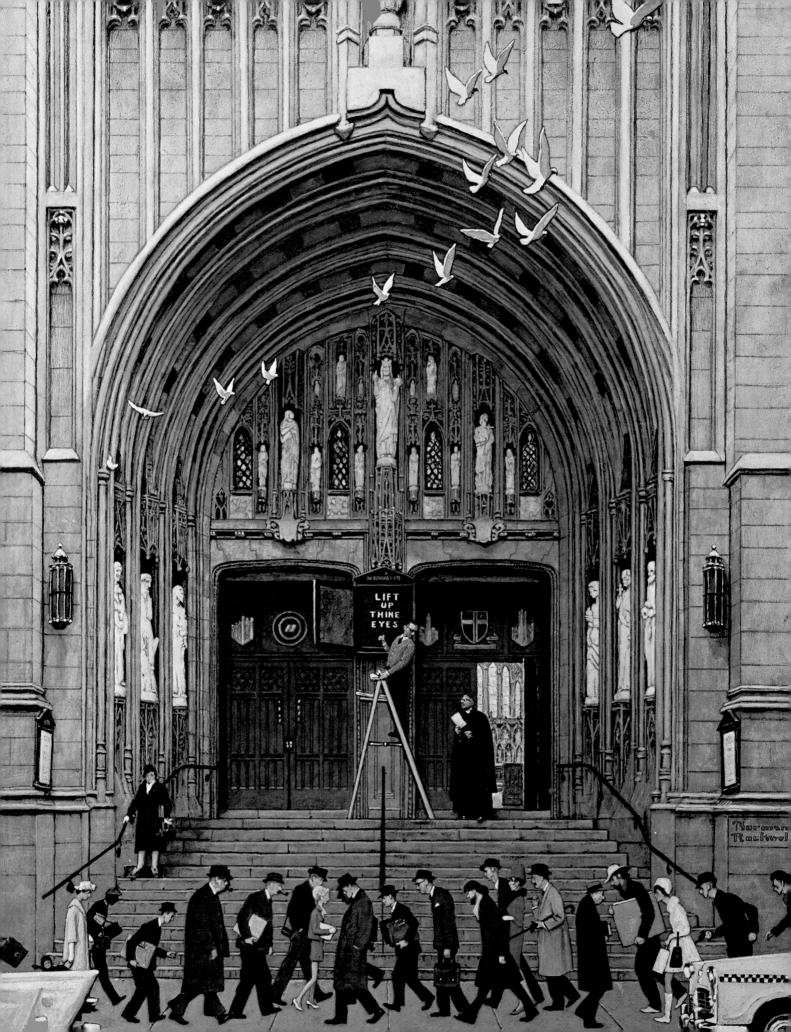

A Carol for Children

OGDEN NASH

God rest you merry, Innocents,
Let nothing you dismay,
Let nothing wound an eager heart
Upon this Christmas day.

Yours be the genial holly wreaths,
The stockings and the tree;
An aged world to you bequeaths
Its own forgotten glee.

Soon, soon enough come crueler gifts,
The anger and the tears;
Between you now there sparsely drifts
A handful yet of years.

Oh, dimly, dimly glows the star
Through the electric throng;
The bidding in temple and bazaar
Drowns out the silver song.

The ancient altars smoke afresh,
The ancient idols stir;
Faint in the reek of burning flesh
Sink frankincense and myrrh.

Gaspar, Balthazar, Melchior!
Where are your offerings now?
What greetings to the Prince of War,
His darkly branded brow?

Two ultimate laws alone we know,
The ledger and the sword—
So far away, so long ago,
We lost the infant Lord.

Only the children clasp His hand;
His voice speaks low to them,
And still for them the shining band
Wings over Bethlehem.

God rest you merry, Innocents,
While Innocence endures.
A sweeter Christmas than we to ours
May you bequeath to yours.

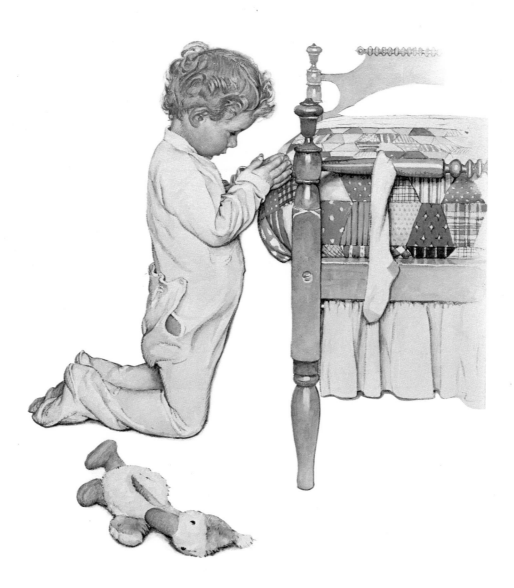

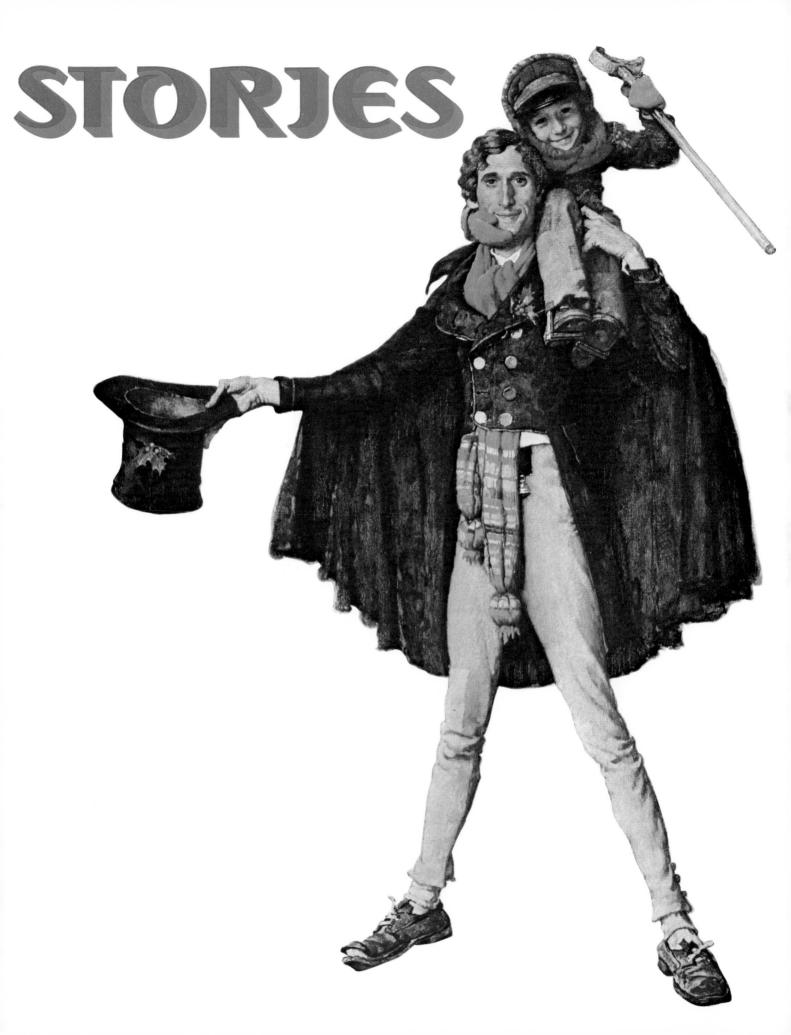

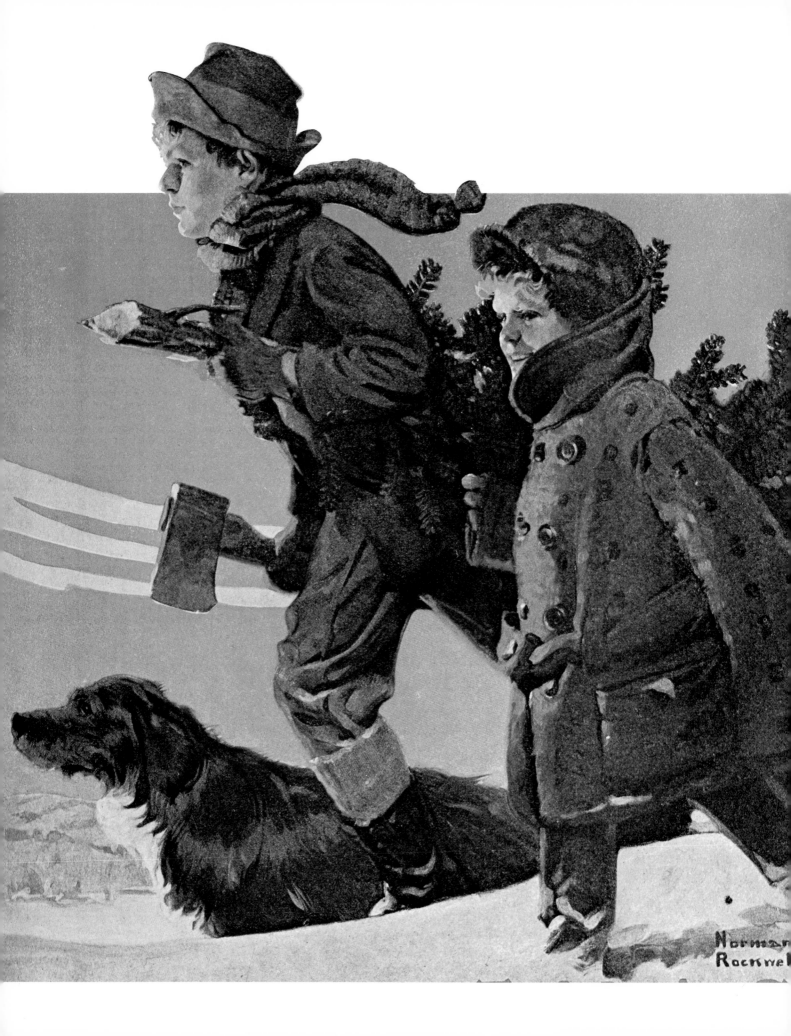

The Fir Tree

HANS CHRISTIAN ANDERSEN

Out in the forest stood a pretty little Fir Tree. It had a good place; it could have sunlight, air there was in plenty, and all around grew many larger comrades—pines as well as firs. But the little Fir Tree wished ardently to become greater. It did not care for the warm sun and the fresh air; it took no notice of the peasant children, who went about talking together, when they had come out to look for strawberries and raspberries. Often they came with a whole potful, or had strung berries on a straw; then they would sit down by the little Fir Tree and say, "How pretty and small that one is!" and the Fir Tree did not like to hear that at all.

Next year he had grown a great joint, and the following year he was longer still, for in fir trees one can always tell by the number of rings they have how many years they have been growing.

"Oh, if I were only as great a tree as the others!" sighed the little Fir, "then I would spread my branches far around and look out from my crown into the wide world. The birds would then build nests in my boughs, and when the wind blew I could nod just as grandly as the others yonder."

He took no pleasure in the sunshine, in the birds, and in the red clouds that went sailing over him morning and evening.

When it was winter, the snow lay all around, white and sparkling, a hare would often come jumping along, and spring right over the little Fir Tree. Oh! this made him so angry. But two winters went by, and when the third came the little Tree had grown so tall that the hare was obliged to run around it.

"Oh! to grow, to grow, and become old; that's the only fine thing in the world," thought the Tree.

In the autumn woodcutters always came and felled a few of the largest trees; that was done this year too, and the little Fir Tree, that was now quite well grown, shuddered with fear, for the great stately trees fell to the ground with a crash, and their branches were cut off, so that the trees looked quite naked, long, and slender—they could hardly be recognized. But then they were laid upon wagons, and horses dragged them away out of the wood. Where were they going? What destiny awaited them?

In the spring when the Swallows and the Stork came, the Tree asked them, "Do you know where they were taken? Did you not meet them?"

The Swallows knew nothing about it, but the Stork looked thoughtful, nodded his head, and said:

"Yes, I think so. I met many new ships when I flew out of Egypt; on the ships were stately masts; I fancy these were the trees. They smelled like fir. I can assure you they're stately—very stately."

"Oh that I were only big enough to go over the sea! What kind of thing is this sea, and how does it look?"

"It would take too long to explain all that," said the Stork, and he went away.

"Rejoice in thy youth," said the Sunbeams; "rejoice in thy fresh growth, and in the young life that is within thee."

And the wind kissed the Tree, and the dew wept tears upon it; but the Fir Tree did not understand about that.

When Christmas time approached, quite young trees were felled, sometimes trees which were neither so old nor so large as this Fir Tree, that never rested, but always wanted to go away. These young trees, which were always the most beautiful, kept all their branches; they were put upon wagons, and the horses dragged them away out of the wood.

"Where are they all going?" asked the Fir Tree. "They are not greater than I—indeed, one of them was much smaller. Why do they keep all their branches? Whither are they taken?"

"We know that! We know that!" chirped the Sparrows. "Yonder in the town we looked in at the windows. We know where they go. Oh! they are dressed up in the greatest pomp and splendor that can be imagined. We have looked in at the windows, and have perceived that they are planted in the middle of a warm room, and adorned with the most beautiful things—gilt apples, honey cakes, playthings, and many hundreds of candles."

"And then?" asked the Fir Tree, and trembled through all its branches. "And then? What happens then?"

"Why, we have not seen anything more. But it is incomparable."

"Perhaps I may be destined to tread this glorious path one day!" cried the Fir Tree, rejoicingly. "That is even better than traveling across the sea. How painfully I long for it! If it were only Christmas now! Now I am great and grown up, like the rest who were led away last year. Oh, if I were only on the carriage! If I were only in the warm room, among all the pomp and splendor! And then? Yes, then something even better will come, something far more charming, or else why should they adorn me so? There must be something grander, something greater still to come; but what? Oh! I'm suffering. I'm longing! I don't know myself what is the matter with me!"

"Rejoice in us," said the Air and Sunshine. "Rejoice in thy fresh youth here in the woodland."

But the Fir Tree did not rejoice at all, but it grew and grew; winter and summer it stood there, green, dark green. The people who saw it said, "That's a handsome tree!" and at Christmas time it was felled before any of the others. The ax cut deep into its marrow, and the tree fell to the ground with a sigh; it felt a pain, a sensation of faintness, and could not think at all of happiness, for it was sad at parting from its home, from the place where it had grown up; it knew that it should never again see the dear old companions, the little bushes and flowers all around—perhaps not even the birds. The parting was not at all agreeable.

The Tree only came to itself when it was unloaded in a yard, with other trees, and heard a man say:

"This one is famous; we want only this one!"

Now two servants came in gay liveries, and carried the Fir Tree into a large, beautiful salon. All around the walls hung pictures, and by the great stove stood large Chinese vases with lions on the covers; there were rocking-chairs, silken sofas, great tables covered with picture-books, and toys worth a hundred times a hundred dollars, at least the children said so. And the Fir Tree was put into a great tub filled with sand; but no one could see that it was a tub, for it was hung round with green cloth, and stood on a large, many-colored carpet. Oh, how the Tree trembled! What was to happen now? The servants, and the young ladies also, decked it out. On one branch they hung little nets, cut out of colored paper; every net was filled with sweetmeats; golden apples and walnuts hung down, as if they grew there, and more than a hundred little candles, red, white, and blue, were fastened to the different boughs. Dolls that looked exactly like real people—the tree had never seen such before—swung among the foliage, and high on the summit of the Tree was fixed a tinsel star. It was splendid, particularly splendid.

"This evening," said all, "this evening it will shine."

"Oh," thought the Tree, "that it were evening already! Oh, that the lights may soon be lit up!

When may that be done? Will the sparrows fly against the panes? Shall I grow fast here, and stand adorned in summer and winter?"

Yes, he did not guess badly. But he had a complete backache from mere longing, and backache is just as bad for a tree as a headache for a person.

At last the candles were lighted. What a brilliance, what a splendor! The Tree trembled so in all its branches that one of the candles set fire to a green twig, and it was scorched.

"Heaven preserve us!" cried the young ladies; and they hastily put the fire out.

Now the Tree might not even tremble. Oh, that was terrible! It was so afraid of setting fire to some of its ornaments, and it was quite bewildered with all the brilliance. And now the folding doors were thrown wide open, and a number of children rushed in as if they would have overturned the whole Tree; the older people followed more deliberately. The little ones stood quite silent, but only for a minute; then they shouted till the room rang; they danced gleefully round the Tree, and one present after another was plucked from it.

"What are they about?" thought the Tree. "What's going to be done?"

And the candles burned down to the twigs, and as they burned down they were extinguished, and then the children received permission to plunder the Tree. Oh! they rushed in upon it, so that every branch cracked again: if it had not been fastened by the top and by the golden star to the ceiling, it would have fallen down.

The children danced about with their pretty toys. No one looked at the Tree except one old man, who came up and peeped among the branches, but only to see if a fig or an apple had not been forgotten.

"A story! A story!" shouted the children; and they drew a little fat man toward the tree; and he sat down just beneath it—"for then we shall be in the green wood," said he, "and the tree may have the advantage of listening to my tale. But I can only tell one. Will you hear the story of Ivede-Avede, or of Klumpey-Dumpey, who fell downstairs, and still was raised up to honor and married the Princess?"

"Ivede-Avede!" cried some, "Klumpey-Dumpey!" cried others, and there was a great crying and shouting. Only the Fir Tree was quite silent, and thought, "Shall I not be in it? Shall I have nothing to do in it?" But he had been in the evening's amusement, and had done what was required of him.

And the fat man told about Klumpey-Dumpey who fell downstairs and yet was raised to honor and married a Princess. And the children clapped their hands and cried, "Tell another! tell another!" and they wanted to hear about Ivede-Avede; but they only got the story of Klumpey-Dumpey. The Fir Tree stood quite silent and thoughtful; never had the birds in the wood told such a story as that. Klumpey-Dumpey fell downstairs, and yet came to honor and married a Princess!

"Yes, so it happens in the world!" thought the Fir Tree, and believed it must be true, because that was such a nice man who told it.

"Well, who can know? Perhaps I shall fall downstairs, too, and marry a Princess!" And it looked forward with pleasure to being adorned again, the next evening, with candles and toys, gold and fruit. "Tomorrow I shall not tremble," it thought.

"I shall rejoice in all my splendor. Tomorrow I shall hear the story of Klumpey-Dumpey again, and perhaps that of Ivede-Avede, too."

And the Tree stood all night quiet and thoughtful.

In the morning the servants and the chambermaid came in.

"Now my splendor will begin afresh," thought the Tree. But they dragged him out of the room, and upstairs to the garret, and here they put him in a dark corner where no daylight shone.

"What's the meaning of this?" thought the Tree. "What am I to do here? What is to happen?"

And he leaned against the wall, and thought,

and thought. And he had time enough, for days and nights went by, and nobody came up; and when at length some one came, it was only to put some great boxes in a corner. Now the Tree stood quite hidden away, and the supposition is that it was quite forgotten.

"Now it's winter outside," thought the Tree. "The earth is hard and covered with snow, and people cannot plant me; therefore I suppose I'm to be sheltered here until Spring comes. How considerate that is! How good people are! If it were only not so dark here, and so terribly solitary!—not even a little hare? That was pretty out there in the wood, when the snow lay thick and the hare sprang past; yes, even when he jumped over me; but then I did not like it. It is terribly lonely up here!"

"Piep! piep!" said a little Mouse, and crept forward, and then came another little one. They smelled at the Fir Tree, and then slipped among the branches.

"It's horribly cold," said the two little Mice, "or else it would be comfortable here. Don't you think so, old Fir Tree?"

"I'm not old at all," said the Fir Tree. "There are many much older than I."

"Where do you come from?" asked the Mice. "And what do you know?" They were dreadfully inquisitive. "Tell us about the most beautiful spot on earth. Have you been there? Have you been in the storeroom, where cheeses lie on the shelves, and hams hang from the ceiling, where one dances on tallow candles, and goes in thin and comes out fat?"

"I don't know that," replied the Tree; "but I know the wood, where the sun shines and the birds sing."

And then it told all about its youth.

And the little Mice had never heard anything of the kind; and they listened and said:

"What a number of things you have seen! How happy you must have been!"

"I?" replied the Fir Tree; and it thought about what it had told. "Yes, those were really quite happy times." But then he told of the Christmas Eve, when he had been hung with sweetmeats and candles.

"Oh!" said the little Mice, "how happy you have been, you old Fir Tree!"

"I'm not old at all," said the Tree. "I only came out of the wood this winter. I'm only rather backward in my growth."

"What splendid stories you can tell!" said the little Mice.

And the next night they came with four other little Mice, to hear what the Tree had to relate; and the more it said, the more clearly did it remember everything, and thought. "Those were quite merry days! But they may come again. Klumpey-Dumpey fell downstairs, and yet he married a Princess. Perhaps I shall marry a Princess, too!" And the Fir Tree thought of a pretty little Birch Tree that grew out in the forest; for the Fir Tree, that Birch was a real Princess.

"Who's Klumpey-Dumpey?" asked the little Mice.

And then the Fir Tree told the whole story. It could remember every single word; and the little Mice were ready to leap to the very top of the Tree with pleasure. Next night a great many more Mice came, and on Sunday two Rats even appeared; but these thought the story was not pretty, and the little Mice were sorry for that, for now they also did not like it so much as before.

"Do you know only one story?" asked the Rats.

"Only that one," replied the Tree. "I heard that on the happiest evening of my life; I did not think then how happy I was."

"That's a very miserable story. Don't you know any about bacon and tallow candles—a storeroom story?"

"No," said the Tree.

"Then we'd rather not hear you," said the Rats.

And they went back to their own people. The little Mice at last stayed away also; and then the Tree sighed and said:

"It was very nice when they sat round me, the merry little Mice, and listened when I spoke to them. Now that's past too. But I shall remember to be pleased when they take me out."

But when did that happen? Why, it was one morning that people came and rummaged in the garret; the boxes were put away, and the tree brought out; they certainly threw him rather roughly on the floor, but a servant dragged him away at once to the stairs, where the daylight shone.

"Now life is beginning again!" thought the Tree.

It felt the fresh air and the first sunbeam, and now it was out in the courtyard. Everything passed so quickly that the Tree quite forgot to look at itself, there was so much to look at all round. The courtyard was close to a garden, and here everything was blooming; the roses hung fresh over the paling, the linden trees were in blossom, and the swallows cried, "Quinze-wit! quinze-wit! my husband's come!" But it was not the Fir Tree they meant.

"Now I shall live!" said the Tree, rejoicingly, and spread its branches far out; but, alas! they were all withered and yellow; and it lay in the corner among nettles and weeds. The tinsel star was still upon it, and shone in the bright sunshine.

In the courtyard a couple of the merry children were playing who had danced round the tree at Christmas time, and had rejoiced over it. One of the youngest ran up and tore off the golden star.

"Look what is sticking to the ugly old fir tree!" said the child, and he trod upon the branches till they cracked again under his boots.

And the Tree looked at all the blooming flowers and the splendor of the garden, and then looked at itself, and wished it had remained in the dark corner of the garret; it thought of its fresh youth in the wood, of the merry Christmas Eve, and of the little Mice which had listened so pleasantly to the story of Klumpey-Dumpey.

"Past! past!" said the old Tree. "Had I but rejoiced when I could have done so! Past! past!"

And the servant came and chopped the Tree into little pieces; a whole bundle lay there; it blazed brightly under the great brewing copper, and it sighed deeply, and each sigh was like a little shot; and the children who were at play there ran up and seated themselves at the fire, looked into it, and cried "Puff! puff!" But at each explosion, which was a deep sigh, the Tree thought of a summer day in the woods, or of a winter night there, when the stars beamed; he thought of Christmas Eve and of Klumpey-Dumpey, the only story he had ever heard or knew how to tell; and then the Tree was burned.

The boys played in the garden, and the youngest had on his breast a golden star, which the Tree had worn on its happiest evening. Now that was past, and the Tree's life was past, and the story is past too: past! past!—and that's the way with all stories.

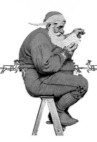

A Pint of Judgment

ELIZABETH MORROW

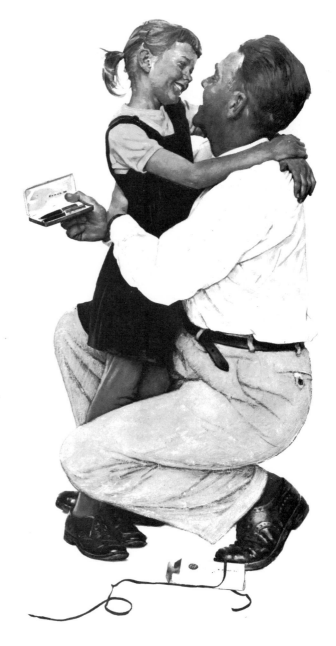

The Tucker family made out lists of what they wanted for Christmas. They did not trust to Santa Claus' taste or the wisdom of aunts and uncles in such an important matter. By the first week in December everybody had written out what he or she hoped to receive.

Sally, who was seven, when she could only print had sent little slips of paper up the chimney with her desires plainly set forth. She had wondered sometimes if neatly written requests like Ellen's were not more effective than the printed ones. Ellen was eight. She had asked last year for a muff and Santa had sent it.

Mother always explained that one should not expect to get all the things on the list; "Only what you want most, dear, and sometimes you have to wait till you are older for those."

For several years Sally had asked for a lamb and she had almost given up hope of finding one tied to her stocking on Christmas morning. She had also asked for a white cat and a dove and they had not come either. Instead a bowl of goldfish had been received. Now she wrote so plainly that there was no excuse for misunderstandings like this.

Derek still printed his list—he was only six and yet he had received an Indian suit the very first time he asked for it. It was puzzling.

Caroline, called "Lovey" for short, just stood on the hearth rug and shouted "Dolly! Bow wow!" but anybody with Santa Claus' experience would know that rag dolls and woolly dogs were the proper presents for a four-year-old.

The lists were useful too in helping one to decide what to make for Father and Mother and

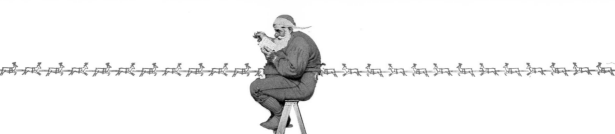

the others for Christmas. The little Tuckers had been brought up by their grandmother in the belief that a present you made yourself was far superior to one bought in a store. Mother always asked for a great many things the children could make. She was always wanting knitted washcloths, pincushion covers, blotters, and penwipers. Father needed pipe cleaners, calendars and decorated match boxes.

This year Sally longed to do something quite different for her mother. She was very envious of Ellen, who had started a small towel as her present, and was pulling threads for a fringed end.

"Oh! Ellen! How lovely that is!" she sighed. "It is a real grown-up present, just as if Aunt Elsie had made it."

"And it isn't half done yet," Ellen answered proudly. "Grandma is helping me with cross-stitch letters in blue and red for one end."

"If I could only make something nice like that! Can't you think of something for me?"

"A hemmed handkerchief?" suggested Ellen.

"Oh, no! Mother has lots of handkerchiefs."

"Yes, but when I gave her one for her birthday she said she had never had enough handkerchiefs. They were like asparagus."

"They don't look like asparagus," Sally replied, loath to criticize her mother but evidently confused. "Anyway, I don't want to give her a handkerchief."

"A penwiper?"

"No, I'm giving Father that."

"A new pincushion cover?"

"Oh! no, Ellen. I'm sick of those presents. I want it to be a big—lovely—Something—a great surprise."

Ellen thought a minute. She was usually resourceful and she did not like to fail her little sister. They had both been earning money all through November and perhaps this was a time to *buy* a present for Mother—even if Grandma disapproved.

"I know that Mother has made out a new list," she said. "She and Father were laughing about it

last night in the library. Let's go and see if it is there."

They found two papers on the desk, unmistakably lists. They were typewritten. Father's was very short: "Anything wrapped up in tissue paper with a red ribbon around it."

"Isn't Father funny?" giggled Ellen. "I'd like to fool him and do up a dead mouse for his stocking."

Mother had filled a full page with her wants. Ellen read out slowly:

Pair of Old English silver peppers
Fur coat
 ("Father will give her that.")
Umbrella
Robert Frost's Poems
Silk stockings
Muffin tins
Small watering pot for house plants
Handkerchiefs
Guest towels
 ("Aren't you glad she asked for that?" Sally
 broke in.)
Knitted wash cloths
A red pencil
A blue pencil
Ink eraser
Pen holders
Rubber bands
Hot water bag cover
 A quart of judgment

This last item was scribbled in pencil at the bottom of the sheet.

As Ellen finished reading, she said with what Sally called her "little-mother air," "You needn't worry at all about Mother's present. There are lots of things here you could make for her. Couldn't you do a hot water bag cover if Grandma cut it out for you? I'm sure you could. You take a nice soft piece of old flannel. . . ."

"No! No! Nothing made out of old flannel!" cried Sally. "That's such a baby thing. I want it to be different—and a great surprise. I wish I could

give her the silver peppers.... That's the first thing on her list; but I've only got two dollars and three cents in my bank and I'm afraid that's not enough."

"Oh! It isn't the peppers she wants most!" cried Ellen. "It's the *last* thing she wrote down—that 'quart of judgment.' I know for I heard her tell Father, 'I need that more than anything else...even a pint would help.' And then they both laughed."

"What is judgment?" asked Sally

"It's what the judge gives—a judgment," her sister answered. "It must be something to do with the law."

"Then I know it would cost more than two dollars and three cents," said Sally. "Father said the other day that nothing was so expensive as the law."

"But she only asked for a pint," Ellen objected. "A pint of anything couldn't be very expensive, unless it was diamonds and rubies."

"She wanted a *quart*," Sally corrected. "And she just said that afterwards about a pint helping because she knew a whole quart would be too much for us to buy."

"A hot water bag cover would be lots easier," cautioned Ellen.

"I don't want it to be easy!" cried Sally. "I want it to be what she wants!"

"Well, perhaps you could get it cheap from Uncle John," Ellen suggested. "He's a lawyer—and he's coming to dinner tonight, so you could ask him."

Sally was not afraid to ask Uncle John anything. He never laughed at her or teased her as Uncle Tom sometimes did and he always talked to her as if she were grown up. On any vexed question he always sided with her and Ellen. He had even been known to say before Mother that coconut cake was good for children and that seven-thirty for big girls of seven and eight was a disgracefully early bedtime. He thought arctics unnecessary in winter and when a picnic was planned, he always knew it would be a fine day.

Sally drew him into the little library that evening and shut the door carefully.

"Is it something very important?" he asked as they seated themselves on the sofa.

"Yes," she answered. "Awfully important. It's a secret. You won't tell, will you?"

"No, cross my heart and swear. What is it?"

"It's—it's...Oh—Uncle John—what *is* judgment? I must get some."

"Judgment? That *is* an important question, my dear." Uncle John seemed puzzled for a moment. "And it is hard to answer. Why do you bother about that now? You have your whole life to get it....Come to me again when you're eighteen."

"But I can't wait so long. I must get it right away. Mother wants it for a Christmas present. She put on her list, 'A quart of judgment.' She said even a pint would help."

Uncle John laughed. He threw back his head and shouted. Sally had never seen him laugh so hard. He shook the sofa with his mirth and tears rolled down his cheeks. He didn't stop until he saw that Sally was hurt—and even then a whirlwind of chuckles seized him occasionally.

"I'm not laughing at you, Sally darling," he explained at last, patting her shoulder affectionately, "but at your mother. She doesn't need judgment. She has it. She always has had it. She's a mighty fine woman—your mother. She must have put that on her list as a joke."

"Oh no! Excuse me, Uncle John," Sally protested. "She told Father she wanted it more than anything else. Wouldn't it be a good Christmas present?"

"Perfectly swell," her uncle answered. "The most useful. If you have any left over, give me some."

"Why, I was going to ask you to sell me some," Sally explained. "Ellen said you would surely have it."

Just then Mother called "Ellen! Sally! Bedtime. Hurry, dears. It's twenty minutes to eight already."

"Bother!" exclaimed Sally. "I'm always having

to go to bed. But please tell me where I can get it. At Macy's? Delia is taking us to town tomorrow."

"No, my dear," he answered. "Macy sells almost everything but not that. It doesn't come by the yard."

"Girls!" Mother's voice again.

"Oh! Quick, Uncle John," whispered Sally. "Mother's coming. I'll have to go. Just tell me. What *is* judgment?"

"It is *sense*, Sally," he answered, quite solemn and serious now. "Common sense. But it takes a lot...." He could not finish the sentence for at this point Mother opened the door and carried Sally off to bed.

The little girl snuggled down under the sheets very happily. Uncle John had cleared her mind of all doubt. She had only time for an ecstatic whisper to Ellen before Delia put out the light: "It's all right about Mother's present. Uncle John said it would be 'swell.'" Then she began to calculate: "If it is just cents, common cents, I have ever so many in my bank and I can earn some more. Perhaps I have enough already."

With this delicious hope she fell asleep.

T he first thing after breakfast the next morning she opened her bank. It was in the shape of a fat man sitting in a chair. When you put a penny in his hand he nodded his head in gratitude as the money slipped into his safetybox. Sally unscrewed the bottom of this and two dollars and three cents rolled out. It was not all in pennies. There were several nickels, three dimes, two quarters and a fifty-cent piece. It made a rich-looking pile. Sally ran to the kitchen for a pint cup and then up to the nursery to pour her wealth into it. No one was there in the room to hear her cry of disappointment. The coins did not reach to the "Half" marked on the measure.

But there was still hope. The half dollar and quarters when they were changed would lift the

level of course. She put all the silver into her pocket and consulted Ellen.

Her sister had passed the penny-bank stage and kept her money in a blue leather purse which was a proud possession. Aunt Elsie had given it to her last Christmas. It had two compartments and a small looking-glass—but there was very little money in it now. Ellen had already bought a good many presents. She was only able to change one quarter and one dime.

"Let's ask Derek," she said. "He loves to open his bank because he can use the screwdriver of his tool set."

Derek was delighted to show his savings— forty-five cents—but he was reluctant to give them all up for one quarter and two dimes. It would mean only three pieces to drop into the chimney of the little red house which was his bank.

"They don't click at all," he complained, experimenting with the coins Sally held out. "You'll take all my money. I won't have hardly anything."

"You'll have *just* as much money to spend," explained Ellen.

"Yes," Derek admitted, "but not to jingle. I like the jingle. It sounds so much more."

He finally decided to change one nickel and one dime.

Then Grandma changed a dime and Sally had sixty pennies all together to put into the pint cup. They brought the pile up about an inch.

When father came home that night she asked him to change the fifty-cent piece, the quarter and the three nickels, but he did not have ninety cents in pennies and he said that he could not get them until Monday and now it was only Saturday.

"You understand, Sally," he explained looking down into his little daughter's anxious face, "you don't have any more money after this is changed. It only looks more."

"I know, but I want it that way," she answered.

On Monday night he brought her the change

and it made a full inch more of money in the cup. Still it was less than half a pint. Sally confided her discouragement to Ellen.

"Are you sure," asked her sister, "that it was this kind of present Mother wanted? She never asked for money before."

"I'm sure," Sally replied. "Uncle John said it was *cents* and that it would take a lot. Besides she prayed for it in church yesterday—so she must want it awfully."

"Prayed for it!" exclaimed Ellen in surprise.

"Yes. I heard her. It's that prayer we all say together. She asked God for 'two cents of all thy mercies.'"

"But if she wants a whole pint why did she only ask for 'two cents'?" demanded the practical Ellen.

"I don't know," Sally answered. "Perhaps she thought it would be greedy. Mother is never greedy."

For several days things were at a standstill. Ellen caught a cold and passed it on to Sally and Derek. They were all put to bed and could do very little Christmas work. While Mother read aloud to them Sally finished her penwiper for Father and decorated a blotter for Uncle John—but sewing on Grandma's pincushion cover was difficult because the pillow at Sally's back kept slipping and she couldn't keep the needle straight. There seemed no way of adding anything to the pint cup.

"Mother, how could I earn some money quickly before Christmas?" Sally asked the first day that she was up.

"You have already earned a good deal, dear," Mother said. "Do you really need more?"

"Yes, Mother, lots more."

"How about getting 100 in your number work? Father gives you a dime every time you do that."

"Yes," sighed Sally, "but it's very hard to get all the examples right. Don't you think when I get all right but one he might give me nine cents?"

"No," said Mother laughing. "Your father be-lieves that nothing is good in arithmetic but 100."

She did earn one dime that way and then school closed, leaving no hope for anything more before Christmas.

On the twentieth of December there was a windfall. Aunt Elsie, who usually spent the holidays with them, was in the South and she sent Mother four dollars—one for each child for a Christmas present. "She told me to buy something for you," Mother explained, "but I thought perhaps you might like to spend the money yourselves—later on—during vacation."

"Oh! I'd like my dollar right away!" cried Sally delightedly. "And," she added rather shamefacedly, "Lovey is so little...do you think she needs all her money? Couldn't she give me half hers?"

"Why Sally, I'm surprised at you!" her mother answered. "I can't take your little sister's share for you. It wouldn't be fair. I am buying a new *Benjamin Bunny* for Lovey."

Aunt Elsie's gift brought the pennies in the pint cup a little above the half mark.

On the twenty-first Sally earned five cents by sweeping off the back porch. This had been a regular source of revenue in the fall, but when the dead leaves gave place to snow Mother forbade the sweeping. On the twenty-first there was no snow and Sally was allowed to go out with her little broom.

On the twenty-second Ellen and Sally went to a birthday party and Sally found a shiny bright dime in her piece of birthday cake. This helped a little. She and Ellen spent all their spare moments in shaking up the pennies in the pint measure—but they could not bring the level much above "One Half." Ellen was as excited over the plan now as Sally and she generously added her last four cents to the pile.

On the twenty-third Sally made a final desperate effort. "Mother," she said, "Uncle John is coming to dinner again tonight. Do you think he

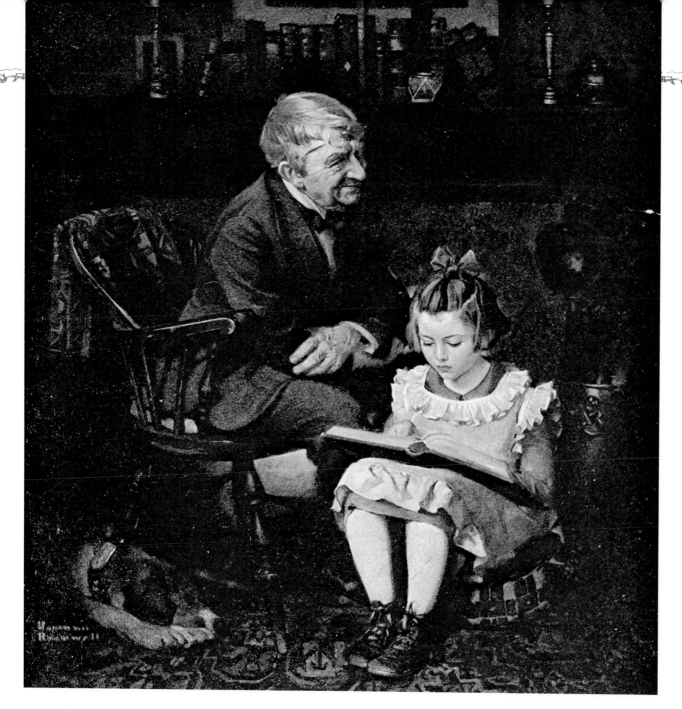

would be willing to give me my birthday dollar now?"

Mother smiled as she answered slowly—"But your birthday isn't till June. Isn't it rather strange to ask for your present so long ahead? Where is all this money going to?"

"It's a secret! My special secret!" cried the little girl, taking her mother's reply for consent.

Uncle John gave her the dollar. She hugged and kissed him with delight and he said, "Let me always be your banker, Sally. I'm sorry you are so hard up, but don't take any wooden nickels."

"'Wooden nickels,'" she repeated slowly.

"What are they? Perhaps they would fill up the bottom—"

"Of your purse?" Uncle John finished the sentence for her. "No, no, my dear. They are a very poor bottom for anything—and they are worse on top."

"It wasn't my purse," said Sally. "It was—but it's a secret."

When Father changed the birthday dollar into pennies he said, "You are getting to be a regular little miser, my dear. I don't understand it. Where is all this money going to?"

"That's just what Mother asked," Sally

answered. "It's a secret. You'll know on Christmas. Oh, Father, I think I have enough now!"

But she hadn't. The pennies seemed to melt away as they fell into the measure. She and Ellen took them all out three times and put them back again shaking them sideways and forwards, but it was no use. They looked a mountain on the nursery floor but they shrank in size the moment they were put inside that big cup. The mark stood obstinately below "Three Quarters."

"Oh! Ellen!" sobbed Sally after the third attempt. "Not even a pint! It's a horrid mean little present! All my presents are horrid. I never can give nice things like you! Oh dear, what shall I do!"

"Don't cry, Sally—please don't," said Ellen trying to comfort her little sister. "It's not a horrid present. It will look lovely when you put tissue paper around it and lots of red ribbon and a card. It *sounds* so much more than it looks," Ellen went on, giving the cup a vigorous jerk. "Why don't you print on your card 'Shake well before opening,' like our cough mixture?"

"I might," assented Sally, only partly reassured.

She had believed up to the last moment that she would be able to carry out her plan. It was vaguely associated in her mind with a miracle. Anything might happen at Christmas time but this year she had hoped for too much. It was so late now however that there was nothing to do but make the outside of her gift look as attractive as possible. She and Ellen spent most of the afternoon before Christmas wrapping up their presents. The pint cup was a little awkward in shape but they had it well covered and the red satin ribbon gathered tight at the top before Grandma made the final bow. It was a real rosette, for Sally had asked for something special.

Christmas Eve was almost more fun than Christmas. The Tuckers made a ceremony of hanging up their stockings. The whole family formed a line in the upper hall with Father at the head, the youngest child on his back, and then they marched downstairs keeping step to a Christmas chant. It was a home-made nonsense verse with a chorus of "Doodley-doodley, doodley-doo!" which everybody shouted. By the time they reached the living-room the line was in wild spirits.

The stockings were always hung in the same places. Father had the big armchair to the right of the fireplace and Mother the large mahogany chair opposite it, Lovey had a small white chair borrowed from the nursery. Derek tied his sock to the hook which usually held the fire tongs above the wood basket (it was a very inconvenient place but he liked it) and Ellen and Sally divided the sofa.

After the stockings were put up, one of the children recited the Bible verses, "And there were in the same country shepherds abiding in the field, keeping watch over their flock by night," through "Mary kept all these things and pondered them in her heart." Sally had said the verses last Christmas—Ellen the year before—and now it was Derek's turn. He only forgot once and Ellen prompted him softly.

Then they all sang Holy Night—and Father read "'Twas the Night Before Christmas." Last of all, the children distributed their gifts for the family—with a great many stern directions: "Mother, you won't look at this till tomorrow, will you? Father, you promise not to peek?" Then they went up to bed and by morning Father and Mother and Santa Claus had the stockings stuffed full of things.

It went off as usual this year but through all the singing and the shouting Sally had twinges of disappointment thinking of Mother's unfinished present. She had squeezed it into Mother's stocking with some difficulty. Then came Ellen's lovely towel and on top of that Derek's calendar which he had made in school.

There was a family rule at the Tuckers' that stockings were not opened until after breakfast.

Mother said that presents on an empty stomach were bad for temper and digestion and though it was hard to swallow your cereal Christmas morning, the children knew it was no use protesting.

The first sight of the living-room was wonderful. The place had completely changed over night. Of course the stockings were knobby with unknown delights, and there were packages everywhere, on the tables and chairs, and on the floor big express boxes that had come from distant places, marked "Do Not Open Until Christmas."

Some presents are of such unmistakable shape that they cannot be hidden. Last year Derek had jumped right onto his rocking horse shouting, "It's mine! I know it's mine!" This morning he caught sight of a drum and looked no further. Lovey fell upon a white plush bunny. A lovely pink parasol was sticking out of the top of Sally's stocking and Ellen had a blue one. They just unfurled them over their heads and then watched Father and Mother unwrapping their presents.

The girls felt Derek and Lovey were very young because they emptied their stockings without a look towards the two big armchairs. That was the most thrilling moment, when your own offering came to view and Mother said, "Just what I wanted!" or Father, "How did you know I needed a penwiper?"

Mother always opened the children's presents first. She was untying the red ribbon on Ellen's towel now and reading the card which said "Every stitch a stitch of love." As she pulled off the tissue paper she exclaimed, "What beautiful work! What exquisite little stitches! Ellen—I am proud of you. This is a charming guest towel. Thank you, dear, so much."

"Grandma marked the cross-stitch for me," explained Ellen, "but I did all the rest myself."

Sally shivered with excitement as Mother's hand went down into her stocking again and tugged at the tin cup.

"Here is something very heavy," she said. "I can't guess what it is, and the card says 'Merry Christmas to Mother from Sally. Shake well before opening.' Is it medicine or cologne?"

Nobody remembered just what happened after that. Perhaps Grandma's bow was not tied tightly enough, perhaps Mother tilted the cup as she shook it, but in a moment all the pennies were on the floor. They rolled everywhere, past the chairs, into the grate, under the sofa and on to the remotest corners of the room. There was a terrific scramble. Father and Mother and Ellen and Sally and Derek, even Grandma and Lovey got down on their hands and knees to pick them up. They bumped elbows and knocked heads together and this onrush sent the coins flying everywhere. The harder they were chased the more perversely they hid themselves. Out of the hubbub Mother cried, "Sally dear, what is this? I don't understand. All your Christmas money for me? Darling, I can't take it."

Sally flung herself into her mother's arms with a sob. "Oh! you must!" she begged. "I'm sorry it's not a whole pint. I tried so hard. You said—you said—you wanted it most of all."

"Most of all?"

"Yes, judgment, cents. Uncle John said it was cents. You said even a pint would help. Won't half a pint be some good?"

Father and Mother and Grandma all laughed then. Father laughed almost as hard as Uncle John did when he first heard of Mother's list, and he declared that he was going to take Sally into the bank as a partner. But Mother lifted the little girl into her lap and whispered, "It's the most wonderful present I ever had. There's nothing so wonderful as sense—except love."

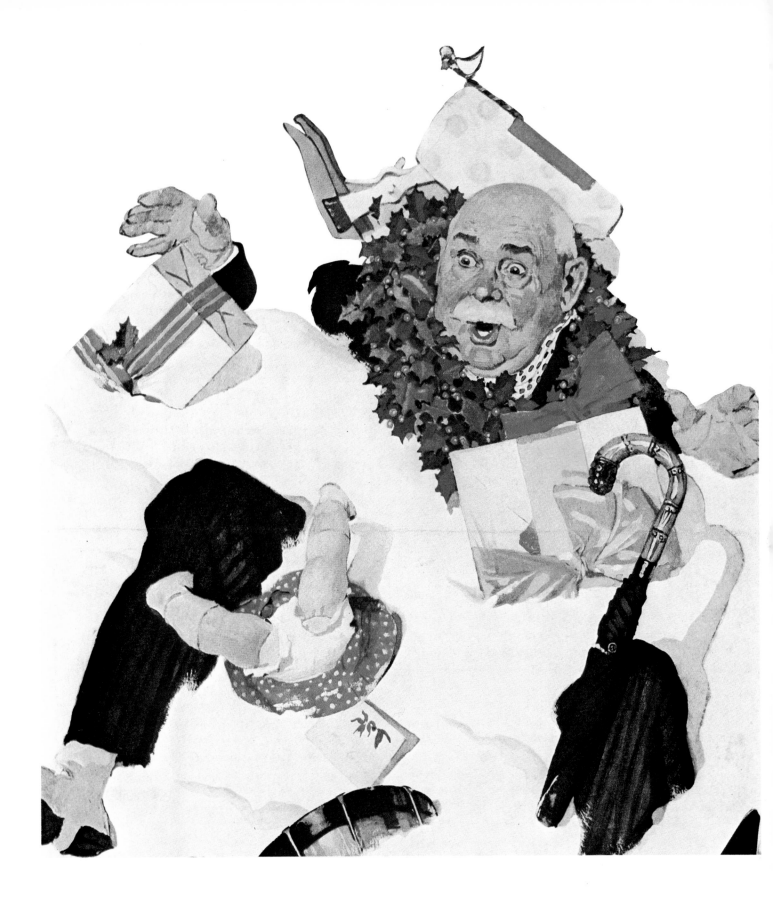

A Miserable, Merry Christmas

LINCOLN STEFFENS

My father's business seems to have been one of slow but steady growth. He and his local partner, Llewelen Tozer, had no vices. They were devoted to their families and to "the store," which grew with the town, which, in turn, grew and changed with the State from a gambling, mining, and ranching community to one of farming, fruit-raising, and building. Immigration poured in, not gold-seekers now, but farmers, businessmen and home-builders, who settled, planted, reaped, and traded in the natural riches of the State, which prospered greatly, "making" the people who will tell you that they "made the State."

As the store made money and I was getting through the primary school, my father bought a lot uptown, at Sixteenth and K Streets, and built us a "big" house. It was off the line of the city's growth, but it was near a new grammar school for me and my sisters, who were coming along fast after me. This interested the family, not me. They were always talking about school; they had not had much of it themselves, and they thought they had missed something. My father used to write speeches, my mother verses, and their theory seems to have been that they had talents which a school would have brought to flower. They agreed, therefore, that their children's gifts should have all the schooling there was. My view, then, was that I had had a good deal of it already, and I was not interested at all. It interfered with my own business, with my own education.

And indeed I remember very little of the primary school. I learned to read, write, spell, and count, and reading was all right. I had a practi-cal use for books, which I searched for ideas and parts to play with, characters to be, lives to live. The primary school was probably a good one, but I cannot remember learning anything except to read aloud "perfectly" from a teacher whom I adored and who was fond of me. She used to embrace me before the whole class and she favored me openly to the scandal of the other pupils, who called me "teacher's pet." Their scorn did not trouble me; I saw and I said that they envied me. I paid for her favor, however. When she married I had queer, unhappy feelings of resentment; I didn't want to meet her husband, and when I had to I wouldn't speak to him. He laughed, and she kissed me—happily for her, to me offensively. I never would see her again. Through with her, I fell in love immediately with Miss Kay, another grown young woman who wore glasses and had a fine, clear skin. I did not know her, I only saw her in the street, but once I followed her, found out where she lived, and used to pass her house, hoping to see her, and yet choking with embarrassment if I did. This fascination lasted for years; it was still a sort of super-romance to me when later I was "going with" another girl nearer my own age.

What interested me in our new neighborhood was not the school, nor the room I was to have in the house all to myself, but the stable which was built back of the house. My father let me direct the making of a stall, a little smaller than the other stalls, for my pony, and I prayed and hoped and my sister Lou believed that that meant that I would get the pony, perhaps for Christmas. I pointed out to her that there were three other stalls and no horses at all. This I said

in order that she should answer it. She could not. My father, sounded, said that some day we might have horses and a cow; meanwhile a stable added to the value of a house. "Some day" is a pain to a boy who lives in and knows only "now." My good little sisters, to comfort me, remarked that Christmas was coming, but Christmas was always coming and grown-ups were always talking about it, asking you what you wanted and then giving you what they wanted you to have. Though everybody knew what I wanted, I told them all again. My mother knew that I told God, too, every night. I wanted a pony, and to make sure that they understood, I declared that I wanted nothing else.

"Nothing but a pony?" my father asked.

"Nothing," I said.

"Not even a pair of high boots?"

That was hard. I did want boots, but I stuck to the pony. "No, not even boots."

"Nor candy? There ought to be something to fill your stocking with, and Santa Claus can't put a pony into a stocking."

That was true, and he couldn't lead a pony down the chimney either. But no. "All I want is a pony," I said. "If I can't have a pony, give me nothing, nothing."

Now I had been looking myself for the pony I wanted, going to sales stables, inquiring of horsemen, and I had seen several that would do. My father let me "try" them. I tried so many ponies that I was learning fast to sit a horse. I chose several, but my father always found some fault with them. I was in despair. When Christmas was at hand I had given up all hope of a pony, and on Christmas Eve I hung up my stocking along with my sisters', of whom, by the way, I now had three. I haven't mentioned them or their coming because, you understand, they were girls, and girls, young girls, counted for nothing in my manly life. They did not mind me either; they were so happy that Christmas Eve that I caught some of their merriment. I speculated on what I'd get; I hung up the biggest

stocking I had, and we all went reluctantly to bed to wait till morning. Not to sleep; not right away. We were told that we must not only sleep promptly, we must not wake up till seven-thirty the next morning—or if we did, we must not go to the fireplace for our Christmas. Impossible.

We did sleep that night, but we woke up at six A.M. We lay in our beds and debated through the open doors whether to obey till, say, half-past six. Then we bolted. I don't know who started it, but there was a rush. We all disobeyed; we raced to disobey and get first to the fireplace in the front room downstairs. And there they were, the gifts, all sorts of wonderful things, mixed-up piles of presents; only, as I disentangled the mess, I saw that my stocking was empty; it hung limp; not a thing in it; and under an around it—nothing. My sisters had knelt down, each by her pile of gifts; they were squealing with delight, till they looked up and saw me standing there in my nightgown with nothing. They left their piles to come to me and look with me at my empty place. Nothing. They felt my stocking: nothing.

I don't remember whether I cried at that moment, but my sisters did. They ran with me back to my bed, and there we all cried till I became indignant. That helped some. I got up, dressed, and driving my sisters away, I went alone out into the yard, down to the stable, and there, all by myself, I wept. My mother came out to me by and by; she found me in my pony stall, sobbing on the floor, and she tried to comfort me. But I heard my father outside; he had come part way with her, and she was having some sort of angry quarrel with him. She tried to comfort me; besought me to come to breakfast. I could not; I wanted no comfort and no breakfast. She left me and went on into the house with sharp words for my father.

I don't know what kind of a breakfast the family had. My sisters said it was "awful." They were ashamed to enjoy their own toys. They came to me, and I was rude. I ran away from

them. I went around to the front of the house, sat down on the steps, and, the crying over, I ached. I was wronged, I was hurt—I can feel now what I felt then, and I am sure that if one could see the wounds upon our hearts, there would be found still upon mine a scar from that terrible Christmas morning. And my father, the practical joker, he must have been hurt, too, a little. I saw him looking out of the window. He was watching me or something for an hour or two, drawing back the curtain ever so little lest I catch him, but I saw his face, and I think I can see now the anxiety upon it, the worried impatience.

After—I don't know how long—surely an hour or two—I was brought to the climax of my agony by the sight of a man riding a pony down the street, a pony and a brand-new saddle; the most beautiful saddle I ever saw, and it was a boy's saddle; the man's feet were not in the stirrups; his legs were too long. The outfit was perfect; it was the realization of all my dreams, the answer to all my prayers. A fine new bridle, with a light curb bit. And the pony! As he drew near,

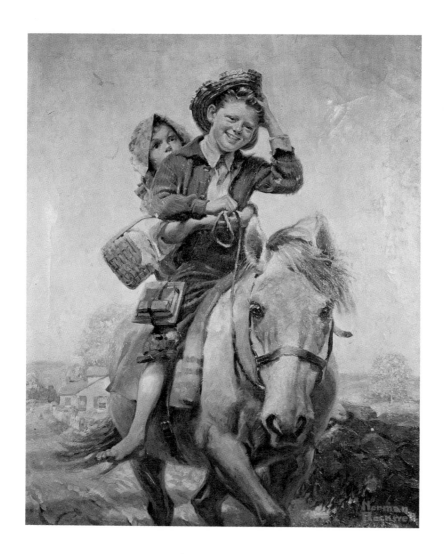

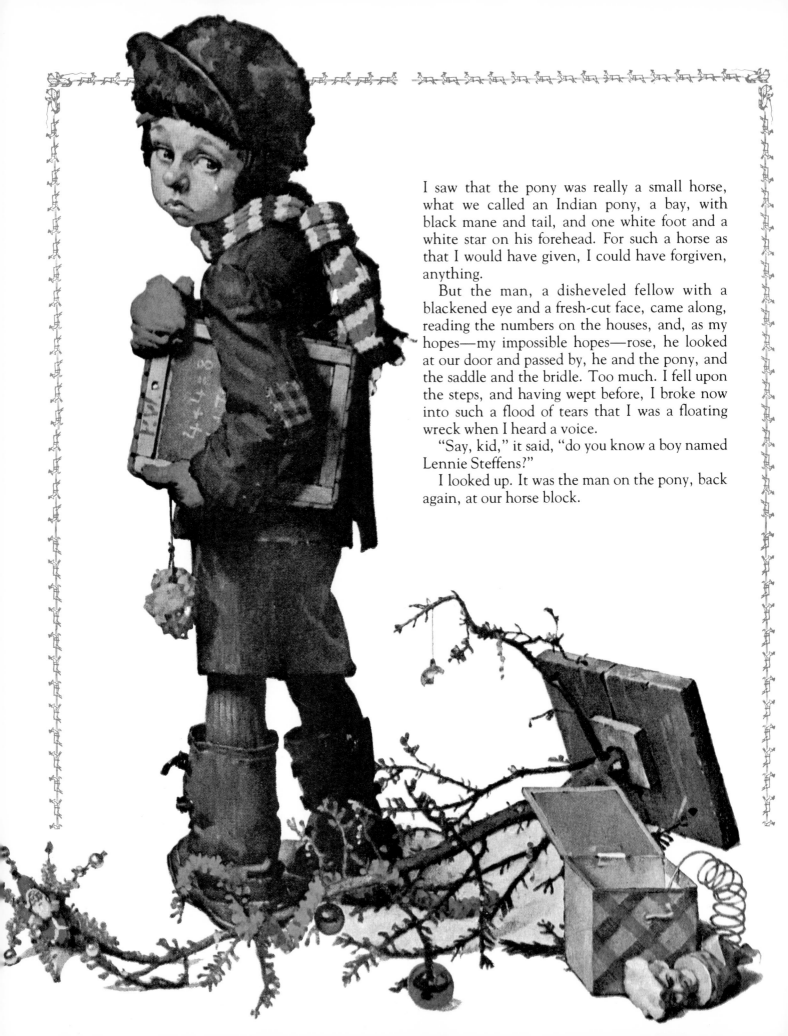

I saw that the pony was really a small horse, what we called an Indian pony, a bay, with black mane and tail, and one white foot and a white star on his forehead. For such a horse as that I would have given, I could have forgiven, anything.

But the man, a disheveled fellow with a blackened eye and a fresh-cut face, came along, reading the numbers on the houses, and, as my hopes—my impossible hopes—rose, he looked at our door and passed by, he and the pony, and the saddle and the bridle. Too much. I fell upon the steps, and having wept before, I broke now into such a flood of tears that I was a floating wreck when I heard a voice.

"Say, kid," it said, "do you know a boy named Lennie Steffens?"

I looked up. It was the man on the pony, back again, at our horse block.

"Yes," I spluttered through my tears. "That's me."

"Well," he said, "then this is your horse. I've been looking all over for you and your house. Why don't you put your number where it can be seen?"

"Get down," I said, running out to him.

He went on saying something about "ought to have got here at seven o'clock; told me to bring the nag here and tie him to your post and leave him for you. But, hell, I got into a drunk—and a fight—and a hospital, and—"

"Get down," I said.

He got down, and he boosted me up to the saddle. He offered to fit the stirrups to me, but I didn't want him to. I wanted to ride.

"What's the matter with you?" he said, angrily. "What you crying for? Don't you like the horse? He's a dandy, this horse. I know him of old. He's fine at cattle; he'll drive 'em alone."

I hardly heard, I could scarcely wait, but he persisted. He adjusted the stirrups, and then, finally, off I rode, slowly, at a walk, so happy, so thrilled, that I did not know what I was doing. I did not look back at the house or the man, I rode off up the street, taking note of everything—of the reins, of the pony's long mane, of the carved leather saddle. I had never seen anything so beautiful. And mine! I was going to ride up past Miss Kay's house. But I noticed on the horn of the saddle some stains like rain-drops, so I turned and trotted home, not to the house but to the stable. There was the family, father, mother, sisters, all working for me, all happy. They had been putting in place the tools of my new business: blankets, curry-comb, brush, pitchfork—everything, and there was hay in the loft.

"What did you come back so soon for?" somebody asked. "Why didn't you go on riding?"

I pointed to the stains. "I wasn't going to get my new saddle rained on," I said. And my father laughed. "It isn't raining," he said. "Those are not rain-drops."

"They are tears," my mother gasped, and she gave my father a look which sent him off to the house. Worse still, my mother offered to wipe away the tears still running out of my eyes. I gave her such a look as she had given him, and she went off after my father, drying her own tears. My sisters remained and we all unsaddled the pony, put on his halter, led him to his stall, tied and fed him. It began really to rain; so all the rest of that memorable day we curried and combed that pony. The girls plaited his mane, forelock, and tail, while I pitchforked hay to him and curried and brushed, curried and brushed. For a change we brought him out to drink; we led him up and down, blanketed like a race-horse; we took turns at that. But the best, the most inexhaustible fun, was to clean him. When we went reluctantly to our midday Christmas dinner, we all smelt of horse, and my sisters had to wash their faces and hands. I was asked to, but I wouldn't, till my mother bade me look in the mirror. Then I washed up—quick. My face was caked with the muddy lines of tears that had coursed over my cheeks to my mouth. Having washed away that shame, I ate my dinner, and as I ate I grew hungrier and hungrier. It was my first meal that day, and as I filled up on the turkey and the stuffing, the cranberries and the pies, the fruit and the nuts—as I swelled, I could laugh. My mother said I still choked and sobbed now and then, but I laughed, too; I saw and enjoyed my sisters' presents till—I had to go out and attend to my pony, who was there, really and truly there, the promise, the beginning, of a happy double life. And—I went and looked to make sure—there was the saddle, too, and the bridle.

But that Christmas, which my father had planned so carefully, was it the best or the worst I ever knew? He often asked me that; I never could answer as a boy. I think now that it was both. It covered the whole distance from broken-hearted misery to bursting happiness—too fast. A grown-up could hardly have stood it.

The Miraculous Staircase

ARTHUR GORDON

On that cool December morning in 1878, sunlight lay like an amber rug across the dusty streets and adobe houses of Santa Fe. It glinted on the bright tile roof of the almost completed Chapel of Our Lady of Light and on the nearby windows of the convent school run by the Sisters of Loretto. Inside the convent, the Mother Superior looked up from her packing as a tap came on her door.

"It's *another* carpenter, Reverend Mother," said Sister Francis Louise, her round face apologetic. "I told him that you're leaving right away, that you haven't time to see him, but he says...."

"I know what he says," Mother Magdalene said, going on resolutely with her packing. "That he's heard about our problem with the new chapel. That he's the best carpenter in all of New Mexico. That he can build us a staircase to the choir loft despite the fact that the brilliant architect in Paris who drew the plans failed to leave any space for one. And despite the fact that five master carpenters have already tried and failed. You're quite right, Sister; I don't have time to listen to that story again."

"But he seems such a nice man," said Sister Francis Louise wistfully, "and he's out there with his burro, and...."

"I'm sure," said Mother Magdalene with a smile, "that he's a charming man, and that his burro is a charming donkey. But there's sickness down at the Santo Domingo pueblo, and it may be cholera. Sister Mary Helen and I are the only ones here who've had cholera. So we have to go. And you have to stay and run the school. And that's that!" Then she called, "Manuela!"

A young Indian girl of 12 or 13, black-haired and smiling, came in quietly on moccasined feet. She was a mute. She could hear and understand, but the Sisters had been unable to teach her to speak. The Mother Superior spoke to her gently: "Take my things down to the wagon, child. I'll be right there." And to Sister Francis Louise: "You'd better tell your carpenter friend to come back in two or three weeks. I'll see him then."

"Two or three weeks! Surely you'll be home for Christmas?"

"If it's the Lord's will, Sister. I hope so."

In the street, beyond the waiting wagon, Mother Magdalene could see the carpenter, a bearded man, strongly built and taller than most Mexicans, with dark eyes and a smiling, wind-burned face. Beside him, laden with tools and scraps of lumber, a small gray burro stood patiently. Manuela was stroking its nose, glancing shyly at its owner. "You'd better explain," said the Mother Superior, "that the child can hear him, but she can't speak."

Goodbyes were quick—the best kind when you leave a place you love. Southwest, then, along the dusty trail, the mountains purple with shadow, the Rio Grande a ribbon of green far off to the right. The pace was slow, but Mother Magdalene and Sister Mary Helen amused themselves by singing songs and telling Christmas stories as the sun marched up and down the sky. And their leathery driver listened and nodded.

Two days of this brought them to Santo Domingo Pueblo, where the sickness was not cholera after all, but measles, almost as deadly in an Indian village. And so they stayed, helping

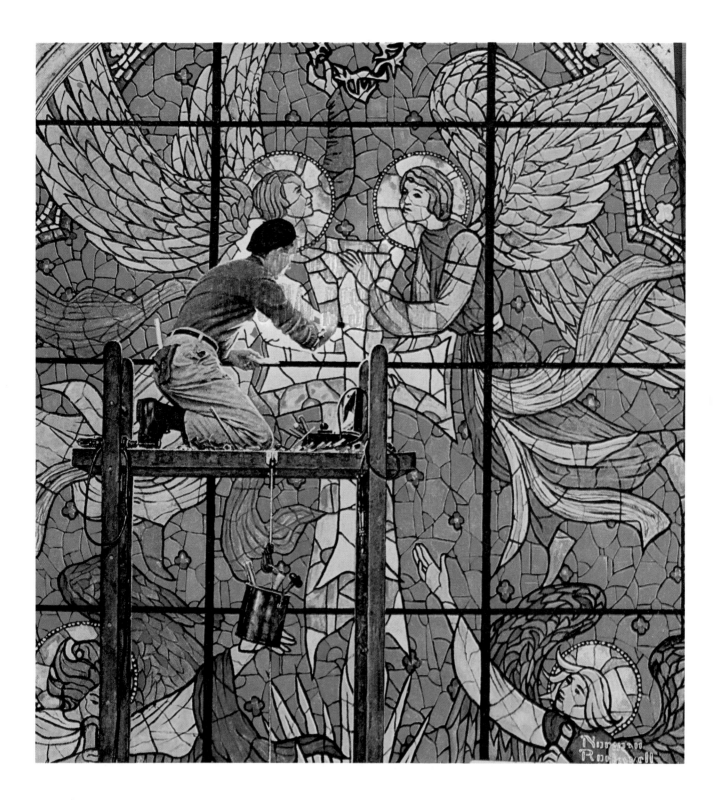

the harassed Father Sebastian, visiting the dark adobe hovels where feverish brown children tossed and fierce Indian dogs showed their teeth.

At night they were bone-weary, but sometimes Mother Magdalene found time to talk to Father Sebastian about her plans for the dedication of the new chapel. It was to be in April; the Archbishop himself would be there. And it might have been dedicated sooner, were it not for this incredible business of a choir loft with no means of access—unless it were a ladder.

"I told the Bishop," said Mother Magdalene, "that it would be a mistake to have the plans drawn in Paris. If something went wrong, what could we do? But he wanted our chapel in Santa Fe patterned after the Sainte Chapelle in Paris, and who am I to argue with Bishop Lamy? So the talented Monsieur Mouly designs a beautiful choir loft high up under the rose window, and no way to get to it."

"Perhaps," sighed Father Sebastian, "he had in mind a heavenly choir. The kind with wings."

"It's not funny," said Mother Magdalene a bit sharply. "I've prayed and prayed, but apparently there's no solution at all. There just isn't room on the chapel floor for the supports such a staircase needs."

The days passed, and with each passing day Christmas drew closer. Twice, horsemen on their way from Santa Fe to Albuquerque brought letters from Sister Francis Louise. All was well at the convent, but Mother Magdalene frowned over certain paragraphs. "The children are getting ready for Christmas," Sister Francis Louise wrote in her first letter. "Our little Manuela and the carpenter have become great friends. It's amazing how much he seems to know about us all. . . ."

And what, thought Mother Magdalene, is the carpenter still doing there?

The second letter also mentioned the carpenter. "Early every morning he comes with another load of lumber, and every night he goes away. When we ask him by what authority he does these things, he smiles and says nothing. We have tried to pay him for his work, but he will accept no pay. . . ."

Work? What work? Mother Magdalene wrinkled up her nose in exasperation. Had that softhearted Sister Francis Louise given the man permission to putter around in the new chapel? With firm and disapproving hand, the Mother Superior wrote a note ordering an end to all such unauthorized activities. She gave it to an Indian pottery-maker on his way to Santa Fe.

But that night the first snow fell, so thick and heavy that the Indian turned back. Next day at noon the sun shone again on a world glittering with diamonds. But Mother Magdalene knew that another snowfall might make it impossible for her to be home for Christmas. By now the sickness at Santo Domingo was subsiding. And so that afternoon they began the long ride back.

The snow did come again, making their slow progress even slower. It was late on Christmas Eve, close to midnight, when the tired horses plodded up to the convent door. But lamps still burned. Manuela flew down the steps, Sister Francis Louise close behind her. And chilled and weary though she was, Mother Magdalene sensed instantly an excitement, an electricity in the air that she could not understand.

Nor did she understand it when they led her, still in her heavy wraps, down the corridor, into the new, as-yet-unused chapel where a few candles burned. "Look, Reverend Mother," breathed Sister Francis Louise. "Look!"

Like a curl of smoke the staircase rose before them, as insubstantial as a dream. Its top rested against the choir loft. Nothing else supported it; it seemed to float on air. There were no banisters. Two complete spirals it made, the polished wood gleaming softly in the candlelight. "Thirty-three steps," whispered Sister Francis Louise. "One for each year in the life of Our Lord."

Mother Magdalene moved forward like a woman in a trance. She put her foot on the first step, then the second, then the third. There was not a tremor. She looked down, bewildered, at Manuela's ecstatic, upturned face. "But it's impossible! There wasn't time!"

"He finished yesterday," the Sister said. "He didn't come today. No one has seen him anywhere in Santa Fe. He's gone."

"But *who* was he? Don't you even know his *name?*"

The Sister shook her head, but now Manuela pushed forward, nodding emphatically. Her mouth opened; she took a deep, shuddering breath; she made a sound that was like a gasp in the stillness. The nuns stared at her, transfixed. She tried again. This time it was a syllable, followed by another. "Jo-sé." She clutched the Mother Superior's arm and repeated the first word she had ever spoken. "José!"

Sister Francis Louise crossed herself. Mother Magdalene felt her heart contract. José—the Spanish word for Joseph. Joseph the Carpenter. Joseph the Master Woodworker of. . . .

"José!" Manuela's dark eyes were full of tears. "José!"

Silence, then, in the shadowy chapel. No one moved. Far away across the snow-silvered town Mother Magdalene heard a bell tolling midnight. She came down the stairs and took Manuela's hand. She felt uplifted by a great surge of wonder and gratitude and compassion and love. And she knew what it was. It was the spirit of Christmas. And it was upon them all.

Author's Note. You may see the inexplicable staircase itself in Santa Fe today. It stands just as it stood when the chapel was dedicated almost a hundred years ago—except for the banister, which was added later. Tourists stare and marvel. Architects shake their heads and murmur, "Impossible." No one knows the identity of the designer-builder. All the Sisters know is that the problem existed, a stranger came, solved it and left.

The 33 steps make two complete turns without central support. There are no nails in the staircase; only wooden pegs. The curved stringers are put together with exquisite precision; the wood is spliced in seven places on the inside and nine on the outside. The wood is said to be a hard-fir variety, nonexistent in New Mexico. School records show that no payment for the staircase was ever made.

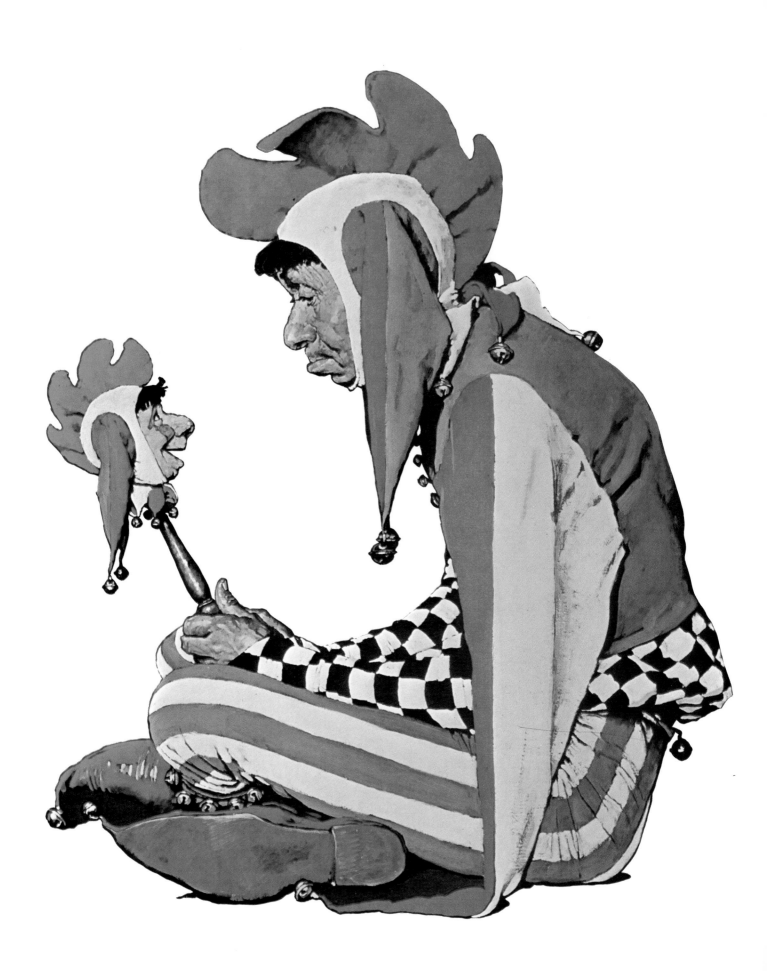

Why the Chimes Rang

RAYMOND MACDONALD ALDEN

There was once in a faraway country where few people have ever travelled, a wonderful church. It stood on a high hill in the midst of a great city; and every Sunday, as well as on sacred days like Christmas, thousands of people climbed the hill to its great archways, looking like lines of ants all moving in the same direction.

When you came to the building itself, you found stone columns and dark passages, and a grand entrance leading to the main room of the church. This room was so long that one standing at the doorway could scarcely see to the other end, where the choir stood by the marble altar. In the farthest corner was the organ; and this organ was so loud, that sometimes when it played, the people for miles around would close their shutters and prepare for a great thunderstorm. Altogether, no such church as this was ever seen before, especially when it was lighted up for some festival, and crowded with people, young and old. But the strangest thing about the whole building was the wonderful chime of bells.

At one corner of the church was a great gray tower, with ivy growing over it as far up as one could see. I say as far as one could see, because the tower was quite great enough to fit the great church, and it rose so far into the sky that it was only in very fair weather that any one claimed to be able to see the top. Even then one could not be certain that it was in sight. Up, and up, and up climbed the stones and the ivy; and as the men who built the church had been dead for hundreds of years, every one had forgotten how high the tower was supposed to be.

Now all the people knew that at the top of the tower was a chime of Christmas bells. They had hung there ever since the church had been built, and were the most beautiful bells in the world. Some thought it was because a great musician had cast them and arranged them in their place; others said it was because of the great height, which reached up where the air was clearest and purest; however that might be no one who had ever heard the chimes denied that they were the sweetest in the world. Some described them as sounding like angels far up in the sky; others as

sounding like strange winds singing through the trees.

But the fact was that no one had heard them for years and years. There was an old man living not far from the church who said that his mother had spoken of hearing them when she was a little girl, and he was the only one who was sure of as much as that. They were Christmas chimes, you see, and were not meant to be played by men or on common days. It was the custom on Christmas Eve for all the people to bring to the church their offerings to the Christ-Child; and when the greatest and best offering was laid on the altar there used to come sounding through the music of the choir the Christmas chimes far up in the tower. Some said that the wind rang them, and others, that they were so high that the angels could set them swinging. But for many long years they had never been heard. It was said that people had been growing less careful of their gifts for the Christ-Child, and that no offering was brought great enough to deserve the music of the chimes.

Every Christmas Eve the rich people still crowded to the altar, each one trying to bring some better gift than any other, without giving anything that he wanted for himself, and the church was crowded with those who thought that perhaps the wonderful bells might be heard again. But although the service was splendid, and the offerings plenty, only the roar of the wind could be heard, far up in the stone tower.

Now, a number of miles from the city, in a little country village, where nothing could be seen of the great church but glimpses of the tower when the weather was fine, lived a boy named Pedro, and his little brother. They knew very little

about the Christmas chimes, but they had heard of the service in the church on Christmas Eve, and had a secret plan which they had often talked over when by themselves, to go to see the beautiful celebration.

"Nobody can guess, Little Brother," Pedro would say; "all the fine things there are to see and hear; and I have even heard it said that the Christ-Child sometimes comes down to bless the service. What if we could see Him?"

The day before Christmas was bitterly cold, with a few lonely snowflakes flying in the air, and a hard white crust on the ground. Sure enough Pedro and Little Brother were able to slip quietly away early in the afternoon; and although the walking was hard in the frosty air, before nightfall they had trudged so far, hand in hand, that they saw the lights of the big city just ahead of them. Indeed they were about to enter one of the great gates in the wall that surrounded it, when they saw something dark on the snow near their path, and stepped aside to look at it.

It was a poor woman, who had fallen just outside the city, too sick and tired to get in where she might have found shelter. The soft snow made of a drift a sort of pillow for her, and she would soon be so sound asleep, in the wintry air, that no one could ever waken her again. All this Pedro saw in a moment and he knelt down beside her and tried to rouse her, even tugging at her arm a little, as though he would have tried to carry her away. He turned her face toward him, so that he could rub some of the snow on it, and when he had looked at her silently a moment he stood up again, and said:

"It's no use, Little Brother. You will have to go alone."

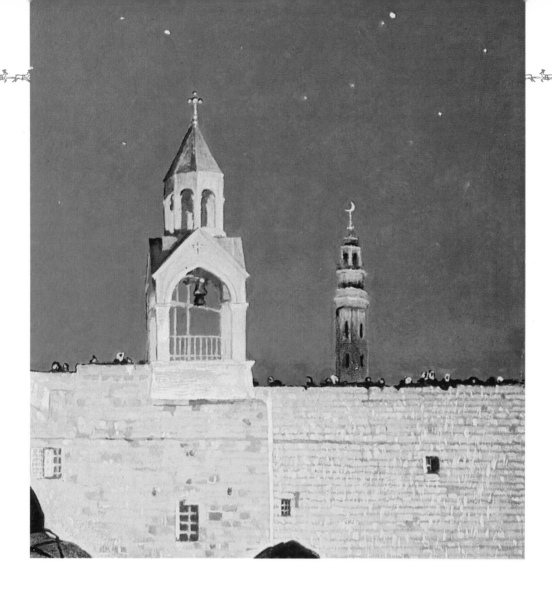

"Alone?" cried Little Brother. "And you not see the Christmas festival?"

"No," said Pedro, and he could not keep back a bit of a choking sound in his throat. "See this poor woman. Her face looks like the Madonna in the chapel window, and she will freeze to death if nobody cares for her. Every one has gone to the church now, but when you come back you can bring some one to help her. I will rub her to keep her from freezing, and perhaps get her to eat the bun that is left in my pocket."

"But I cannot bear to leave you, and go on alone," said Little Brother.

"Both of us need not miss the service," said Pedro, "and it had better be I than you. You can easily find your way to church; and you must see and hear everything twice, Little Brother—once for you and once for me. I am sure the Christ-Child must know how I should love to come with you and worship Him; and oh! if you get a chance, Little Brother, to slip up to the altar without getting in any one's way, take this little silver piece of mine, and lay it down for my offering, when no one is looking. Do not forget where you have left me, and forgive me for not going with you."

In this way he hurried Little Brother off to the city and winked hard to keep back the tears, as he heard the crunching footsteps sounding farther and farther away in the twilight. It was pretty hard to lose the music and splendour of the Christmas celebration that he had been planning for so long, and spend the time instead in that lonely place in the snow.

The great church was a wonderful place that night. Every one said that it had never looked so bright and beautiful before. When the organ played and the thousands of people sang, the walls shook with the sound, and little Pedro, away outside the city wall, felt the earth tremble around him.

At the close of the service came the procession with the offerings to be laid on the altar. Rich men and great men marched proudly up to lay down their gifts to the Christ-Child. Some brought wonderful jewels, some baskets of gold so heavy that they could scarcely carry them down the aisle. A great writer laid down a book that he had been making for years and years. And last of all walked the king of the country, hoping with all the rest to win for himself the chime of the Christmas bells. There went a great murmur through the church as the people saw the king take from his head the royal crown, all set with precious stones, and lay it gleaming on the altar, as his offering to the Holy Child. "Surely," every one said, "we shall hear the bells now, for nothing like this has ever happened before."

But still only the cold old wind was heard in the tower and the people shook their heads; and some of them said, as they had before, that they never really believed the story of the chimes, and doubted if they ever rang at all.

The procession was over, and the choir began the closing hymn. Suddenly the organist stopped playing, and every one looked at the old minister, who was standing by the altar, holding up his hand for silence. Not a sound could be heard from any one in the church, but as all the people strained their ears to listen, there came softly, but distinctly, swinging through the air, the sound of the chimes in the tower. So far away, and yet so clear the music seemed—so much sweeter were the notes than anything that had been heard before, rising and falling away up there in the sky, that the people in the church sat for a moment as still as though something held each of them by the shoulders. Then they all stood up together and stared straight at the altar, to see what great gift had awakened the long silent bells.

But all that the nearest of them saw was the childish figure of Little Brother, who had crept softly down the aisle when no one was looking, and had laid Pedro's little piece of silver on the altar.

Mr. Edwards Meets Santa Claus

LAURA INGALLS WILDER

The days were short and cold, the wind whistled sharply, but there was no snow. Cold rains were falling. Day after day the rain fell, pattering on the roof and pouring from the eaves.

Mary and Laura stayed close by the fire, sewing their nine-patch quilt blocks, or cutting paper dolls from scraps of wrapping-paper, and hearing the wet sound of the rain. Every night was so cold that they expected to see snow next morning, but in the morning they saw only sad, wet grass.

They pressed their noses against the squares of glass in the windows that Pa had made, and they were glad they could see out. But they wished they could see snow.

Laura was anxious because Christmas was near, and Santa Claus and his reindeer could not travel without snow. Mary was afraid that, even if it snowed, Santa Claus could not find them, so far away in Indian Territory. When they asked Ma about this, she said she didn't know.

"What day is it?" they asked her, anxiously. "How many more days till Christmas?" And they counted off the days on their fingers, till there was only one more day left.

Rain was still falling that morning. There was not one crack in the gray sky. They felt almost sure there would be no Christmas. Still, they kept hoping.

Just before noon the light changed. The clouds broke and drifted apart, shining white in a clear blue sky. The sun shone, birds sang, and thousands of drops of water sparkled on the grasses. But when Ma opened the door to let in the fresh, cold air, they heard the creek roaring.

They had not thought about the creek. Now they knew they would have no Christmas, because Santa Claus could not cross that roaring creek.

Pa came in, bringing a big fat turkey. If it weighed less than twenty pounds, he said, he'd eat it, feathers and all. He asked Laura, "How's that for a Christmas dinner? Think you can manage one of those drumsticks?"

She said, yes, she could. But she was sober. Then Mary asked him if the creek was going down, and he said it was still rising.

Ma said it was too bad. She hated to think of Mr. Edwards eating his bachelor cooking all alone on Christmas day. Mr. Edwards had been asked to eat Christmas dinner with them, but Pa shook his head and said a man would risk his neck, trying to cross that creek now.

"No," he said. "That current's too strong. We'll just have to make up our minds that Edwards won't be here tomorrow."

Of course that meant that Santa Claus could not come, either.

Laura and Mary tried not to mind too much. They watched Ma dress the wild turkey, and it was a very fat turkey. They were lucky little girls, to have a good house to live in, and a warm fire to sit by, and such a turkey for their Christmas dinner. Ma said so, and it was true. Ma said it was too bad that Santa Claus couldn't come this year, but they were such good girls that he hadn't forgotten them; he would surely come next year.

Still, they were not happy.

After supper that night they washed their hands and faces, buttoned their red-flannel night-gowns, tied their night-cap strings, and soberly said their prayers. They lay down in bed

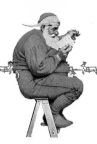

and pulled the covers up. It did not seem at all like Christmas time.

Pa and Ma sat silently by the fire. After a while Ma asked why Pa didn't play the fiddle, and he said, "I don't seem to have the heart to, Caroline."

After a longer while, Ma suddenly stood up.

"I'm going to hang up your stockings, girls," she said. "Maybe something will happen."

Laura's heart jumped. But then she thought again of the creek and she knew nothing could happen.

Ma took one of Mary's clean stockings and one of Laura's, and she hung them from the mantel-shelf, on either side of the fireplace. Laura and Mary watched her over the edge of their bedcovers.

"Now go to sleep," Ma said, kissing them goodnight. "Morning will come quicker if you're asleep."

She sat down again by the fire and Laura almost went to sleep. She woke up a little when she heard Pa say, "You've only made it worse, Caroline." And she thought she heard Ma say: "No, Charles. There's the white sugar." But perhaps she was dreaming.

Then she heard Jack growl savagely. The door-latch rattled and some one said, "Ingalls! Ingalls!" Pa was stirring up the fire, and when he opened the door Laura saw that it was morning. The outdoors was gray.

"Great fishhooks, Edwards! Come in, man! What's happened?" Pa exclaimed.

Laura saw the stockings limply dangling, and she scrooged her shut eyes into the pillow. She heard Pa piling wood on the fire, and she heard Mr. Edwards say he had carried his clothes on his head when he swam the creek. His teeth rattled and his voice shivered. He would be all right, he said, as soon as he got warm.

"It was too big a risk, Edwards," Pa said. "We're glad you're here, but that was too big a risk for a Christmas dinner."

"Your little ones had to have a Christmas," Mr. Edwards replied. "No creek could stop me, after I fetched them their gifts from Independence."

Laura sat straight up in bed. "Did you see Santa Claus?" she shouted.

"I sure did," Mr. Edwards said.

"Where? When? What did he look like? What did he say? Did he really give you something for us?" Mary and Laura cried.

"Wait, wait a minute!" Mr. Edwards laughed. And Ma said she would put the presents in the stockings, as Santa Claus intended. She said they mustn't look.

Mr. Edwards came and sat on the floor by their bed, and he answered every question they asked him. They honestly tried not to look at Ma, and they didn't quite see what she was doing.

When he saw the creek rising, Mr. Edwards said, he had known that Santa Claus could not get across it. ("But you crossed it," Laura said. "Yes," Mr. Edwards replied, "but Santa Claus is too old and fat. He couldn't make it, where a long, lean razor-back like me could do so.") And Mr. Edwards reasoned that if Santa Claus couldn't cross the creek, likely he would come no farther south than Independence. Why should he come forty miles across the prairie, only to be turned back? Of course he wouldn't do that!

So Mr. Edwards had walked to Independence. ("In the rain?" Mary asked. Mr. Edwards said he wore his rubber coat.) And there, coming down the street in Independence, he had met Santa Claus. ("In the daytime?" Laura asked. She hadn't thought that anyone could see Santa Claus in the daytime. No, Mr. Edwards said; it was night, but light shone out across the street from the saloons.)

Well, the first thing Santa Claus said was, "Hello, Edwards!" ("Did he know you?" Mary asked, and Laura asked, "How did you know he was really Santa Claus?" Mr. Edwards said that Santa Claus knew everybody. And he had recognized Santa at once by his whiskers. Santa Claus had the longest, thickest, whitest set of whiskers west of the Mississippi.)

So Santa Claus said, "Hello, Edwards! Last

time I saw you you were sleeping on a corn-shuck bed in Tennessee." And Mr. Edwards well remembered the little pair of red-yarn mittens that Santa Claus had left for him that time.

Then Santa Claus said: "I understand you're living now down along the Verdigris River. Have you ever met up, down yonder, with two little girls named Mary and Laura?"

"I surely am acquainted with them," Mr. Edwards replied.

"It rests heavy on my mind," said Santa Claus. "They are both of them sweet, pretty, good little young things, and I know they are expecting me. I surely do hate to disappoint two good little girls like them. Yet with the water up the way it is, I can't ever make it across that creek. I can figure no way whatsoever to get to their cabin this year. Edwards," Santa Claus said. "Would you do me the favor to fetch them their gifts one time?"

"I'll do that, and with pleasure," Mr. Edwards told him.

Then Santa Claus and Mr. Edwards stepped across the street to the hitching-posts where the pack-mule was tied. ("Didn't he have his reindeer?" Laura asked. "You know he couldn't," Mary said. "There isn't any snow." Exactly, said Mr. Edwards. Santa Claus traveled with a pack-mule in the southwest.)

And Santa Claus uncinched the pack and looked through it, and he took out the presents for Mary and Laura.

"Oh, what are they?" Laura cried; but Mary asked, "Then what did he do?"

Then he shook hands with Mr. Edwards, and he swung up on his fine bay horse. Santa Claus rode well, for a man of his weight and build. And he tucked his long, white whiskers under his bandana. "So long, Edwards," he said, and he rode away on the Fort Dodge trail, leading his pack-mule and whistling.

Laura and Mary were silent an instant, thinking of that.

Then Ma said, "You may look now, girls."

Something was shining bright in the top of Laura's stocking. She squealed and jumped out of bed. So did Mary, but Laura beat her to the fireplace. And the shining thing was a glittering new tin cup.

Mary had one exactly like it.

These new tin cups were their very own. Now they each had a cup to drink out of. Laura jumped up and down and shouted and laughed, but Mary stood still and looked with shining eyes at her own tin cup.

Then they plunged their hands into the stockings again. And they pulled out two long, long sticks of candy. It was peppermint candy, striped red and white. They looked and looked at that beautiful candy, and Laura licked her stick, just one lick. But Mary was not so greedy. She didn't take even one lick of her stick.

Those stockings weren't empty yet. Mary and Laura pulled out two small packages. They unwrapped them, and each found a little heart-shaped cake. Over their delicate brown tops was sprinkled white sugar. The sparkling grains lay like tiny drifts of snow.

The cakes were too pretty to eat. Mary and Laura just looked at them. But at last Laura turned hers over, and she nibbled a tiny nibble from underneath, where it wouldn't show. And the inside of that little cake was white!

It had been made of pure white flour, and sweetened with white sugar.

Laura and Mary never would have looked in their stockings again. The cups and the cakes and the candy were almost too much. They were too happy to speak. But Ma asked if they were sure the stockings were empty.

Then they put their arms down inside them, to make sure.

And in the very toe of each stocking was a shining bright, new penny!

They had never even thought of such a thing as having a penny. Think of having a whole penny for your very own. Think of having a cup and a cake and a stick of candy *and* a penny.

There never had been such a Christmas.

Now of course, right away, Laura and Mary should have thanked Mr. Edwards for bringing

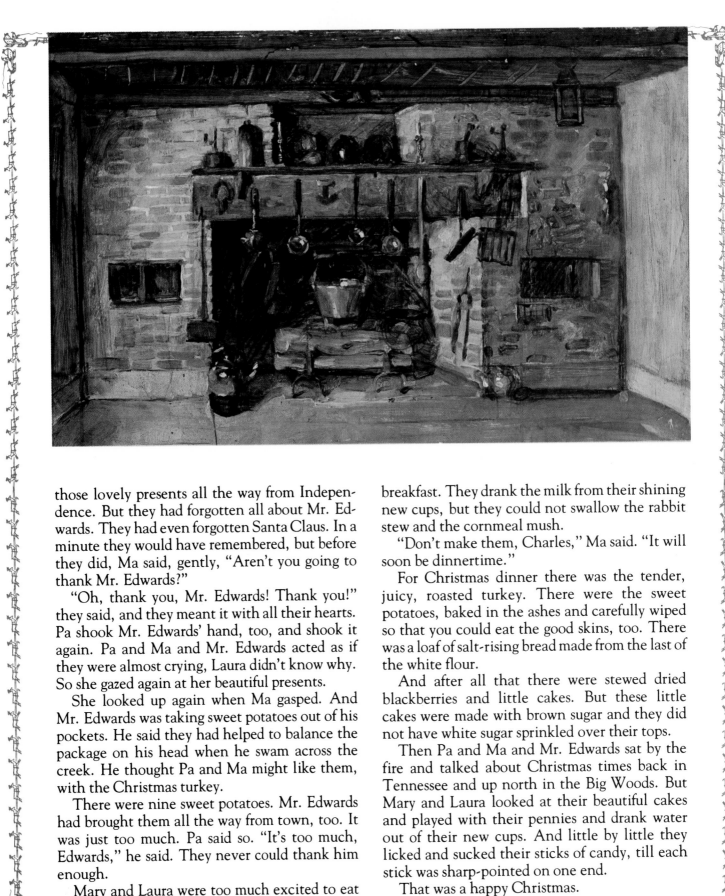

those lovely presents all the way from Independence. But they had forgotten all about Mr. Edwards. They had even forgotten Santa Claus. In a minute they would have remembered, but before they did, Ma said, gently, "Aren't you going to thank Mr. Edwards?"

"Oh, thank you, Mr. Edwards! Thank you!" they said, and they meant it with all their hearts. Pa shook Mr. Edwards' hand, too, and shook it again. Pa and Ma and Mr. Edwards acted as if they were almost crying, Laura didn't know why. So she gazed again at her beautiful presents.

She looked up again when Ma gasped. And Mr. Edwards was taking sweet potatoes out of his pockets. He said they had helped to balance the package on his head when he swam across the creek. He thought Pa and Ma might like them, with the Christmas turkey.

There were nine sweet potatoes. Mr. Edwards had brought them all the way from town, too. It was just too much. Pa said so. "It's too much, Edwards," he said. They never could thank him enough.

Mary and Laura were too much excited to eat breakfast. They drank the milk from their shining new cups, but they could not swallow the rabbit stew and the cornmeal mush.

"Don't make them, Charles," Ma said. "It will soon be dinnertime."

For Christmas dinner there was the tender, juicy, roasted turkey. There were the sweet potatoes, baked in the ashes and carefully wiped so that you could eat the good skins, too. There was a loaf of salt-rising bread made from the last of the white flour.

And after all that there were stewed dried blackberries and little cakes. But these little cakes were made with brown sugar and they did not have white sugar sprinkled over their tops.

Then Pa and Ma and Mr. Edwards sat by the fire and talked about Christmas times back in Tennessee and up north in the Big Woods. But Mary and Laura looked at their beautiful cakes and played with their pennies and drank water out of their new cups. And little by little they licked and sucked their sticks of candy, till each stick was sharp-pointed on one end.

That was a happy Christmas.

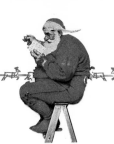

Waiting...
Waiting for Christmas

ELIZABETH ENGLISH

Herman and I finally locked our store and dragged ourselves home to South Caldwell Street. It was 11:00 p.m. Christmas Eve of 1949. We were dog tired.

Ours was one of those big old general appliance stores that sold everything from refrigerators and toasters and record players to bicycles and dollhouses and games. We'd sold almost all of our toys; and all of the layaways, except one package, had been picked up.

Usually Herman and I kept the store open until everything had been picked up. We knew we wouldn't have waked up very happy on Christmas morning knowing that some little child's gift was back on the layaway shelf. But the person who had put a dollar down on that package never appeared.

Early Christmas morning our 12-year-old son Tom and Herman and I were out under the tree opening up gifts. But, I'll tell you, there was something very humdrum about this Christmas. Tom was growing up; he hadn't wanted any toys—just clothes and games. I missed his childish exuberance of past years.

As soon as breakfast was over, Tom left to visit his friend next door. And Herman disappeared into the bedroom, mumbling, "I'm going back to sleep. There's nothing left to stay up for anyway."

So there I was alone, doing the dishes and feeling very letdown. It was nearly 9:00 a.m., and sleet mixed with snow cut the air outside. The wind rattled our windows, and I felt grateful for the warmth of the apartment. *Sure glad I don't have to go out on a day like today*, I thought to myself, picking up the wrappings and ribbons strewn around the living room.

And then it began. Something I'd never experienced before. A strange, persistent urge. "Go to the store," it seemed to say.

I looked at the icy sidewalk outside. *That's crazy*, I said to myself. I tried dismissing the thought, but it wouldn't leave me alone. *Go to the store.*

Well, I *wasn't* going to go. I'd never gone to the store on Christmas Day in all the 10 years we'd owned it. No one opened shop on that day. There wasn't any reason to go, I didn't want to, and I wasn't going to.

For an hour, I fought that strange feeling. Fin-

ally, I couldn't stand it any longer, and I got dressed.

"Herman," I said, feeling silly, "I think I'll walk down to the store."

Herman woke up with a start. "Whatever for? What are you going to do there?"

"Oh, I don't know," I replied lamely. "There's not much to do here, I just think I'll wander down."

He argued against it a little, but I told him that I'd be back soon. "Well, go on," he grumped, "but I don't see any reason for it."

I put on my gray wool coat and a gray tam on my head, then my galoshes and my red scarf and gloves. Once outside, none of those garments seemed to help. The wind cut right through me and the sleet stung my cheeks. I groped my way along the mile down to 117 East Park Avenue, slipping and sliding all the way.

I shivered, and I tucked my hands inside the pockets to keep them from freezing. I felt ridiculous. I had no business being out in that bitter chill.

There was the store just ahead. The sign announced Radio-Electronic Sales and Service, and the big glass windows jutted out onto the sidewalk. *But, what in the world?* I wondered. In front of the store stood two little boys, huddled together. One about nine, and the other six.

"Here she comes!" yelled the other one. He had his arm around the younger. "See, I told you she would come," he said jubilantly.

They were little black children, and they were half frozen. The younger one's face was wet with tears, but when he saw me, his eyes opened wide and his sobbing stopped.

"What are you two children doing out here in this freezing rain?" I scolded, hurrying them into the store and turning up the heat. "You should

be at home on a day like this!" They were poorly dressed. They had no hats or gloves, and their shoes barely held together. I rubbed their small, icy hands, and got them up close to the heater.

"We've been waiting for you," replied the older. They had been standing outside since 9:00a.m., the time I normally open the store.

"Why were you waiting for me?" I asked, astonished.

"My litle brother Jimmy didn't get any Christmas." He touched Jimmy's shoulder. "We want to buy some skates. That's what he wants. We have these three dollars. See, Miss Lady," he said, pulling the money from his pocket.

I looked at the dollars in his hand. I looked at their expectant faces. And then I looked around the store. "I'm sorry," I said, "but we've sold almost everything. We have no ska . . ." Then my eye caught sight of the layaway shelf with its one lone package. I tried to remember . . . Could it be . . . ?

"Wait a minute," I told the boys. I walked over, picked up the package, unwrapped it and, miracle of miracles, there was a pair of skates!

Jimmy reached for them. *Lord*, I said silently, *let them be his size.*

And miracle added upon miracle, they *were* his size.

When the older boy finished tying the laces on Jimmy's right foot and saw that the skate fit—perfectly—he stood up and presented the dollars to me.

"No, I'm not going to take your money," I told him. I *couldn't* take his money. "I want you to have these skates, and I want you to use your money to get some gloves for your hands."

The two boys just blinked at first. Then their eyes became like saucers, and their grins stretched wide when they understood I was giv-

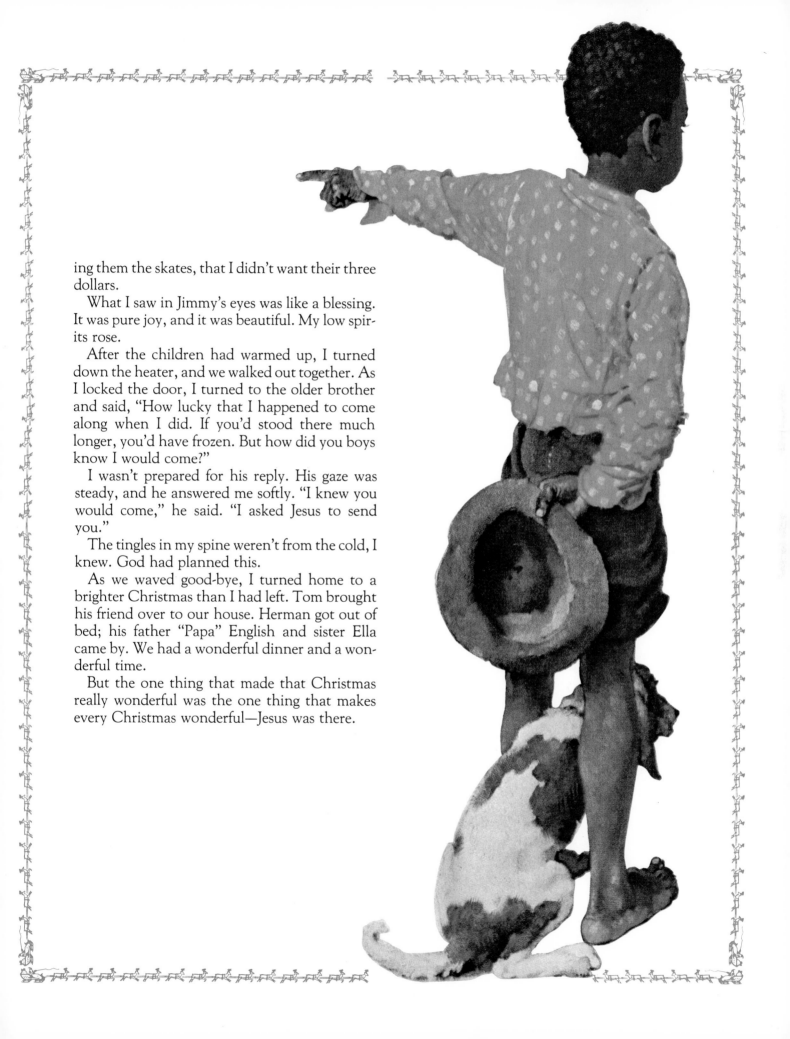

ing them the skates, that I didn't want their three dollars.

What I saw in Jimmy's eyes was like a blessing. It was pure joy, and it was beautiful. My low spirits rose.

After the children had warmed up, I turned down the heater, and we walked out together. As I locked the door, I turned to the older brother and said, "How lucky that I happened to come along when I did. If you'd stood there much longer, you'd have frozen. But how did you boys know I would come?"

I wasn't prepared for his reply. His gaze was steady, and he answered me softly. "I knew you would come," he said. "I asked Jesus to send you."

The tingles in my spine weren't from the cold, I knew. God had planned this.

As we waved good-bye, I turned home to a brighter Christmas than I had left. Tom brought his friend over to our house. Herman got out of bed; his father "Papa" English and sister Ella came by. We had a wonderful dinner and a wonderful time.

But the one thing that made that Christmas really wonderful was the one thing that makes every Christmas wonderful—Jesus was there.

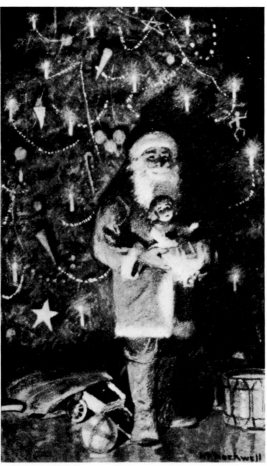

The First Christmas Tree
LUCY WHEELOCK

Two little children were sitting by the fire one cold winter's night. All at once they heard a timid knock at the door and one ran to open it.

There, outside in the cold and darkness, stood a child with no shoes upon his feet and clad in thin, ragged garments. He was shivering with cold, and he asked to come in and warm himself.

"Yes, come in," cried both the children. "You shall have our place by the fire. Come in."

They drew the little stranger to their warm seat and shared their supper with him, and gave him their bed, while they slept on a hard couch.

In the night they were awakened by strains of sweet music, and looking out, they saw a band of children in shining garments, approaching the house. They were playing on golden harps and the air was full of melody.

Suddenly the Strange Child stood before them: no longer cold and ragged, but clad in silvery light.

His soft voice said: "I was cold and you took Me in. I was hungry and you fed Me. I was tired and you gave Me your bed. I am the Christ-Child, wandering through the world to bring peace and happiness to all good children. As you have given to Me, so may this tree every year give rich fruit to you."

So saying, He broke a branch from the fir-tree that grew near the door, and He planted it in the ground and disappeared. And the branch grew into a great tree, and every year it bore beautiful fruit for the kind children.

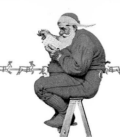

Christmas Every Day

WILLIAM DEAN HOWELLS

The little girl came into her papa's study, as she always did Saturday morning before breakfast, and asked for a story. He tried to beg off that morning, for he was very busy, but she would not let him. So he began:

"Well, once there was a little pig—"

She put her hand over his mouth and stopped him at the word. She said she had heard little pig stories till she was perfectly sick of them.

"Well, what kind of story *shall* I tell, then?"

"About Christmas. It's getting to be the season. It's past Thanksgiving already."

"It seems to me," argued her papa, "that I've told as often about Christmas as I have about little pigs."

"No difference! Christmas is more interesting."

"Well!" Her papa roused himself from his writing by a great effort. "Well, then, I'll tell you about the little girl that wanted it Christmas every day in the year. How would you like that?"

"First-rate!" said the little girl; and she nestled into comfortable shape in his lap, ready for listening.

"Very well, then, this little pig—Oh, what are you pounding me for?"

"Because you said little pig instead of little girl."

"I should like to know what's the difference between a little pig and a little girl that wanted it Christmas every day!"

"Papa," said the little girl, warningly, "if you don't go on, I'll *give* it to you!" And at this her papa darted off like lightning, and began to tell the story as fast as he could.

Well, once there was a little girl who liked Christmas so much that she wanted it to be Christmas every day in the year; and as soon as Thanksgiving was over she began to send postal cards to the old Christmas Fairy to ask if she mightn't have it. But the old Fairy never answered any of the postals; and, after a while, the little girl found out that the Fairy was pretty particular, and wouldn't even notice anything but letters, not even correspondence cards in envelopes; but real letters on sheets of paper, and sealed outside with a monogram—or your initial, any way. So, then, she began to send her letters; and in about three weeks—or just the day before Christmas, it was—she got a letter from the Fairy, saying she might have it Christmas every day for a year, and then they would see about having it longer.

The little girl was a good deal excited already, preparing for the old-fashioned, once-a-year Christmas that was coming the next day, and perhaps the Fairy's promise didn't make such an impression on her as it would have made at some other time. She just resolved to keep it to herself, and surprise everybody with it as it kept coming true; and then it slipped out of her mind altogether.

She had a splendid Christmas. She went to bed early, so as to let Santa Claus have a chance at the stockings, and in the morning she was up the first of anybody and went and felt them, and found hers all lumpy with packages of candy, and oranges and grapes, and pocket-books and rubber balls and all kinds of small presents, and her big brother's with nothing but the tongs in them, and

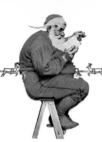

her young lady sister's with a new silk umbrella, and her papa's and mamma's with potatoes and pieces of coal wrapped up in tissue paper, just as they always had every Christmas. Then she waited around till the rest of the family were up, and she was the first to burst into the library, when the doors were opened, and look at the large presents laid out on the library-table—books, and portfolios, and boxes of stationery, and breast-pins, and dolls, and little stoves, and dozens of handkerchiefs, and ink-stands, and skates, and snow-shovels, and photograph-frames, and little easels, and boxes of water-colors, and Turkish paste, and nougat, and candied cherries, and dolls' houses, and water-proofs—and the big Christmas-tree, lighted and standing in a waste-basket in the middle.

She had a splendid Christmas all day. She ate so much candy that she did not want any breakfast; and the whole forenoon the presents kept pouring in that the expressman had not had time to deliver the night before; and she went 'round giving the presents she had got for other people, and came home and ate turkey and cranberry for dinner, and plum-pudding and nuts and raisins and oranges and more candy, and then went out and coasted and came in with a stomach-ache, crying; and her papa said he would see if his house was turned into that sort of fool's paradise another year; and they had a light supper, and pretty early everybody went to bed cross.

Here the little girl pounded her papa in the back, again.

"Well, what now? Did I say pigs?"

"You made them *act* like pigs."

"Well, didn't they?"

"No matter; you oughtn't to put it into a story."

"Very well, then, I'll take it all out."

Her father went on:

The little girl slept very heavily, and she slept very late, but she was wakened at last by the other children dancing 'round her bed with their stockings full of presents in their hands.

"What is it?" said the little girl, and she rubbed her eyes and tried to rise up in bed.

"Christmas! Christmas! Christmas!" they all shouted, and waved their stockings.

"Nonsense! It was Christmas yesterday."

Her brothers and sisters just laughed. "We don't know about that. It's Christmas to-day, any way. You come into the library and see."

Then all at once it flashed on the little girl that the Fairy was keeping her promise, and her year of Christmases was beginning. She was dreadfully sleepy, but she sprang up like a lark—a lark that had overeaten itself and gone to bed cross—and darted into the library. There it was again! Books, and portfolios, and boxes of stationery, and breast-pins—

"You needn't go over it all, Papa; I guess I can remember just what was there," said the little girl.

Well, and there was the Christmas-tree blazing away, and the family picking out their presents, but looking pretty sleepy, and her father perfectly puzzled, and her mother ready to cry. "I'm sure I don't see how I'm to dispose of all these things," said her mother, and her father said it seemed to him they had had something just like it the day before, but he supposed he must have dreamed it. This struck the little girl as the best kind of joke; and so she ate so much candy she didn't want any breakfast, and went 'round carrying presents, and had turkey and cranberry for dinner, and then went out and coasted, and came in with a—

"Papa!"

"Well, what now?"

"What did you promise, you forgetful thing?"

"Oh! oh, yes!"

Well, the next day, it was just the same thing over again, but everybody getting crosser; and at the end of a week's time so many people had lost their tempers that you could pick up lost tempers everywhere; they perfectly strewed the ground. Even when people tried to recover their tempers

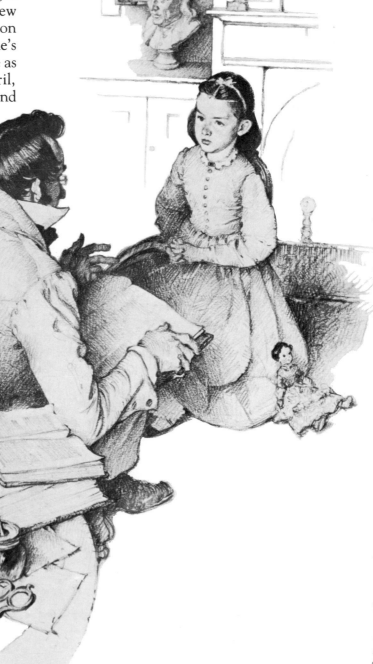

they usually got somebody else's, and it made the most dreadful mix.

The little girl began to get frightened, keeping the secret all to herself; she wanted to tell her mother, but she didn't dare to; and she was ashamed to ask the Fairy to take back her gift, it seemed ungrateful and ill-bred, and she thought she would try to stand it, but she hardly knew how she could, for a whole year. So it went on and on, and it was Christmas on St. Valentine's Day, and Washington's Birthday just the same as any day, and it didn't skip even the First of April, though everything was counterfeit that day, and that was some *little* relief.

After a while, coal and potatoes began to be awfully scarce, so many had been wrapped up in tissue paper to fool papas and mammas with. Turkeys got to be about a thousand dollars apiece—

"Papa!"

"Well, what?"

"You're beginning to fib."

"Well, *two* thousand, then."

And they got to passing off almost anything for turkeys—half-grown humming-birds, and even rocs out of the "Arabian Nights"—the real turkeys were so scarce. And cranberries—well, they asked a diamond apiece for cranberries. All the woods and orchards were cut down for Christmas-trees, and where the woods and orchards used to be, it looked just like a stubble-field, with the stumps. After a while they had to make Christmas-trees out of rags, and stuff them with bran, like old-fashioned dolls; but there were plenty of rags, because people got so poor, buying presents for one another, that they couldn't get any new clothes, and they just wore their old ones to tatters. They got so poor that everybody had to go to the poor-house, except the confectioners, and the fancy store-keepers, and the picture-booksellers, and the expressmen; and *they* all got so rich and proud that they would hardly wait upon a person when he came to buy; it was perfectly shameful!

Well, after it had gone on about three or four months, the little girl, whenever she came into the room in the morning and saw those great ugly lumpy stockings dangling at the fire-place, and the disgusting presents around everywhere, used to just sit down and burst out crying. In six months she was perfectly exhausted; she couldn't even cry any more; she just lay on the lounge and rolled her eyes and panted. About the beginning of October she took to sitting down on dolls, wherever she found them—French dolls, or any kind—she hated the sight of them so; and by Thanksgiving she was crazy, and just slammed her presents across the room.

By that time people didn't carry presents around nicely any more. They flung them over the fence, or through the window, or anything; and, instead of running their tongues out and taking great pains to write "For dear Papa," or "Mamma," or "Brother," or "Sister," or "Susie," or "Sammie," or "Billie," or "Bobby," or "Jimmie," or "Jennie," or whoever it was, and troubling to get the spelling right, and then signing their names, and "'Xmas, 188—," they used to write in the gift-books, "Take it, you horrid old thing!" and then go and bang it against the front door. Nearly everybody had built barns to hold their presents, but pretty soon the barns overflowed, and then they used to let them lie out in the rain, or anywhere. Sometimes the police used to come and tell them to shovel their presents off the sidewalk, or they would arrest them.

"I thought you said everybody had gone to the poor-house," interrupted the little girl.

"They did go, at first," said her papa; "but after a while the poor-houses got so full that they had to send the people back to their own houses. They tried to cry, when they got back, but they couldn't make the least sound."

"Why couldn't they?"

"Because they had lost their voices, saying 'Merry Christmas' so much. Did I tell you how it was on the Fourth of July?"

"No; how was it?" And the little girl nestled closer, in expectation of something uncommon.

Well, the night before, the boys stayed up to celebrate, as they always do, and fell asleep before twelve o'clock, as usual, expecting to be wakened by the bells and cannon. But it was nearly eight o'clock before the first boy in the United States woke up, and then he found out what the trouble was. As soon as he could get his clothes on, he ran out of the house and smashed a big cannon-torpedo down on the pavement; but it didn't make any more noise than a damp wad of paper, and, after he tried about twenty or thirty more, he began to pick them up and look at them. Every single torpedo was a big raisin! Then he just streaked it upstairs, and examined his fire-crackers and toy-pistol and two-dollar collection

of fireworks and found that they were nothing but sugar and candy painted up to look like fireworks! Before ten o'clock, every boy in the United States found out that his Fourth of July things had turned into Christmas things; and then they just sat down and cried—they were so mad. There are about twenty million boys in the United States, and so you can imagine what a noise they made. Some men got together before night, with a little powder that hadn't turned into purple sugar yet, and they said they would fire off *one* cannon, any way. But the cannon burst into a thousand pieces, for it was nothing but rock-candy, and some of the men nearly got killed. The Fourth of July orations all turned into Christmas carols, and when anybody tried to read the Declaration, instead of saying, "When in the course of human events it becomes necessary," he was sure to sing, "God rest you, merry gentlemen." It was perfectly awful.

The little girl drew a deep sigh of satisfaction . "And how was it at Thanksgiving?" she asked. Her papa hesitated. "Well, I'm almost afraid to tell you. I'm afraid you'll think it's wicked." "Well, tell, any way," said the little girl.

Well, before it came Thanksgiving, it had leaked out who had caused all these Christmases. The little girl had suffered so much that she had talked about it in her sleep; and after that, hardly anybody would play with her. People just perfectly despised her, because if it had not been for her greediness, it wouldn't have happened; and now, when it came Thanksgiving, and she wanted them to go to church, and have a squash-pie and turkey, and show their gratitude, they said that all the turkeys had been eaten up for her old Christmas dinners, and if she would stop the Christmases, they would see about the gratitude. Wasn't it dreadful? And the very next day the little girl began to send letters to the Christmas Fairy, and then telegrams, to stop it. But it didn't do any good; and then she got to calling at the Fairy's house, but the girl that came to the door always said "Not at home," or "Engaged," or "At

dinner," or something like that; and so it went on till it came to the old once-a-year Christmas Eve. The little girl fell asleep, and when she woke up in the morning—

"She found it was all nothing but a dream," suggested the little girl.

"No, indeed!" said her papa. "It was all every bit true!"

"Well, what *did* she find out then?"

"Why, that it wasn't Christmas at last, and wasn't ever going to be, any more. Now it's time for breakfast."

The little girl held her papa fast around the neck.

"You shan't go if you're going to leave it *so!*"

"How do you want it left?"

"Christmas once a year."

"All right," said her papa; and he went on again.

Well, there was the greatest rejoicing all over the country, and it extended clear up into Canada. The people met together everywhere, and kissed and cried for joy. The city carts went around and gathered up all the candy and raisins and nuts, and dumped them into the river; and it made the fish perfectly sick; and the whole United States, as far out as Alaska, was one blaze of bonfires, where the children were burning up their gift-books and presents of all kinds. They had the greatest *time!*

The little girl went to thank the old Fairy because she had stopped it being Christmas, and she said she hoped she would keep her promise, and see that Christmas never, never came again. Then the Fairy frowned, and asked her if she was sure she knew what she meant; and the little girl asked her, why not? and the old Fairy said that now she was behaving just as greedily as ever, and she'd better look out. This made the little girl think it all over carefully again, and she said she would be willing to have it Christmas about once in a thousand years; and then she said a hundred, and then she said ten, and at last she got down to one. Then the Fairy said that was the good old way that had pleased people ever since Christmas

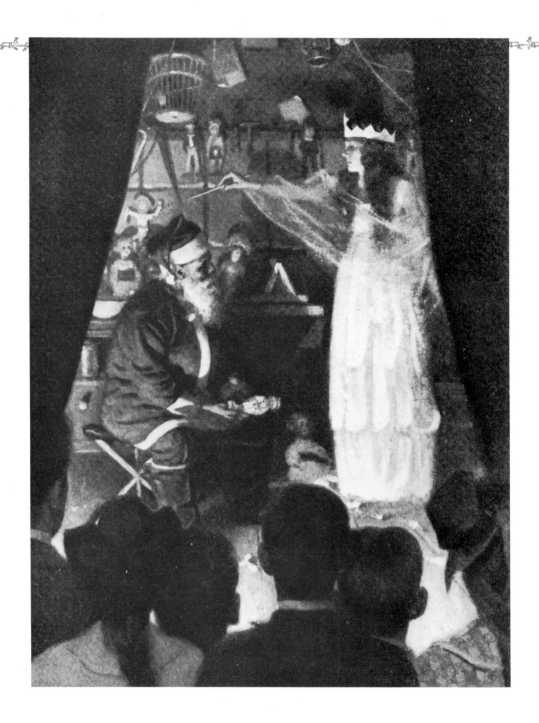

began, and she was agreed. Then the little girl said, "What're your shoes made of?" And the Fairy said, "Leather." And the little girl said, "Bargain's done forever," and skipped off, and hippity-hopped the whole way home, she was so glad.

"How will that do?" asked the papa.

"First-rate!" said the little girl; but she hated to have the story stop, and was rather sober. However, her mamma put her head in at the door, and asked her papa:

"Are you never coming to breakfast? What have you been telling that child?"

"Oh, just a moral tale."

The little girl caught him around the neck again.

"*We* know! Don't you tell *what*, Papa! Don't you tell *what!*"

The Gift of the Magi

O. HENRY

One dollar and eighty-seven cents. That was all. And sixty cents of it was in pennies. Pennies saved one and two at a time by bulldozing the grocer and the vegetable man and the butcher until one's cheeks burned with the silent imputation of parsimony that such close dealing implied. Three times Della counted it. One dollar and eighty-seven cents. And the next day would be Christmas.

There was clearly nothing to do but flop down on the shabby little couch and howl. So Della did it. Which instigates the moral reflection that life is made up of sobs, sniffles, and smiles, with sniffles predominating.

While the mistress of the home is gradually subsiding from the first stage to the second, take a look at the home. A furnished flat at $8 per week. It did not exactly beggar description, but it certainly had that word on the lookout for the mendicancy squad.

In the vestibule below was a letter-box into which no letter would go, and an electric button from which no mortal finger could coax a ring. Also appertaining thereunto was a card bearing the name "Mr. James Dillingham Young."

The "Dillingham" had been flung to the breeze during a former period of prosperity when its possessor was being paid $30 per week. Now, when the income was shrunk to $20, the letters of "Dillingham" looked blurred, as though they were thinking seriously of contracting to a modest and unassuming D. But whenever Mr. James Dillingham Young came home and reached his flat above he was called "Jim" and greatly hugged by Mrs. James Dillingham Young, already introduced to you as Della. Which is all very good.

Della finished her cry and attended to her cheeks with the powder rag. She stood by the window and looked out dully at a grey cat walking a grey fence in a grey backyard. To-morrow would be Christmas Day, and she had only $1.87 with which to buy Jim a present. She had been saving every penny she could for months, with this result. Twenty dollars a week doesn't go far. Expenses had been greater than she had calculated. They always are. Only $1.87 to buy a present for Jim. Her Jim. Many a happy hour she had spent planning for something nice for him. Something fine and rare and sterling—something just a little bit near to being worthy of the honour of being owned by Jim.

There was a pier-glass between the windows of the room. Perhaps you have seen a pier-glass in an $8 flat. A very thin and very agile person may, by observing his reflection in a rapid sequence of longitudinal strips, obtain a fairly accurate conception of his looks. Della, being slender, had mastered the art.

Suddenly she whirled from the window and stood before the glass. Her eyes were shining brilliantly, but her face had lost its colour within twenty seconds. Rapidly she pulled down her hair and let it fall to its full length.

Now, there were two possessions of the James Dillingham Youngs in which they both took a mighty pride. One was Jim's gold watch that had been his father's and grandfather's. The other was Della's hair. Had the Queen of Sheba lived in the flat across the airshaft, Della would have let her hair hang out the window some day to dry just to depreciate Her Majesty's jewels and gifts. Had King Solomon been the janitor, with all his

treasures piled up in the basement, Jim would have pulled out his watch every time he passed, just to see him pluck at his beard from envy.

So now Della's beautiful hair fell about her, rippling and shining like a cascade of brown waters. It reached below her knee and made itself almost a garment for her. And then she did it up again nervously and quickly. Once she faltered for a minute and stood still while a tear or two splashed on the worn red carpet.

On went her old brown jacket; on went her old brown hat. With a whirl of skirts and with the brilliant sparkle still in her eyes, she fluttered out the door and down the stairs to the street.

Where she stopped the sign read: "Mme. Sofronie. Hair Goods of All Kinds." One flight up Della ran, and collected herself, panting. Madame, large, too white, chilly, hardly looked the "Sofronie."

"Will you buy my hair?" asked Della.

"I buy hair," said Madame. "Take yer hat off and let's have a sight at the looks of it."

Down rippled the brown cascade.

"Twenty dollars," said Madame, lifting the mass with a practised hand.

"Give it to me quick," said Della.

Oh, and the next two hours tripped by on rosy wings. Forget the hashed metaphor. She was ransacking the stores for Jim's present.

She found it at last. It surely had been made for Jim and no one else. There was no other like it in any of the stores, and she had turned all of them inside out. It was a platinum fob chain simple and chaste in design, properly proclaiming its value by substance alone and not by meretricious ornamentation—as all good things should do. It was even worthy of The Watch. As soon as she saw it she knew that it must be Jim's. It was like him. Quietness and value—the description applied to both. Twenty-one dollars they took from her for it, and she hurried home with the 87 cents. With that chain on his watch Jim might be properly anxious about the time in any company. Grand as the watch was, he sometimes looked at it on the sly on account of the old leather strap that he used in place of a chain.

When Della reached home her intoxication gave way a little to prudence and reason. She got out her curling irons and lighted the gas and went to work repairing the ravages made by generosity added to love. Which is always a tremendous task, dear friends—a mammoth task.

Within forty minutes her head was covered with tiny close-lying curls that made her look wonderfully like a truant schoolboy. She looked at her reflection in the mirror long, carefully, and critically.

"If Jim doesn't kill me," she said to herself, "before he takes a second look at me, he'll say I look like a Coney Island chorus girl. But what could I do—oh! what could I do with a dollar and eighty-seven cents?"

At 7 o'clock the coffee was made and the frying-pan was on the back of the stove hot and ready to cook the chops.

Jim was never late. Della doubled the fob chain in her hand and sat on the corner of the table near the door that he always entered. Then she heard his step on the stair away down on the first flight, and she turned white for just a moment. She had a habit of saying little silent prayers about the simplest everyday things, and now she whispered: "Please God, make him think I am still pretty."

The door opened and Jim stepped in and closed it. He looked thin and very serious. Poor fellow, he was only twenty-two—and to be burdened with a family! He needed a new overcoat and he was without gloves.

Jim stopped inside the door, as immovable as a setter at the scent of quail. His eyes were fixed upon Della, and there was an expression in them that she could not read, and it terrified her. It was not anger, nor surprise, nor disapproval, nor horror, nor any of the sentiments that she had been prepared for. He simply stared at her fixedly with that peculiar expression on his face.

Della wriggled off the table and went for him.

"Jim, darling," she cried, "don't look at me that way. I had my hair cut off and sold it because I couldn't have lived through Christmas without giving you a present. It'll grow out again—you won't mind, will you? I just had to do it. My hair

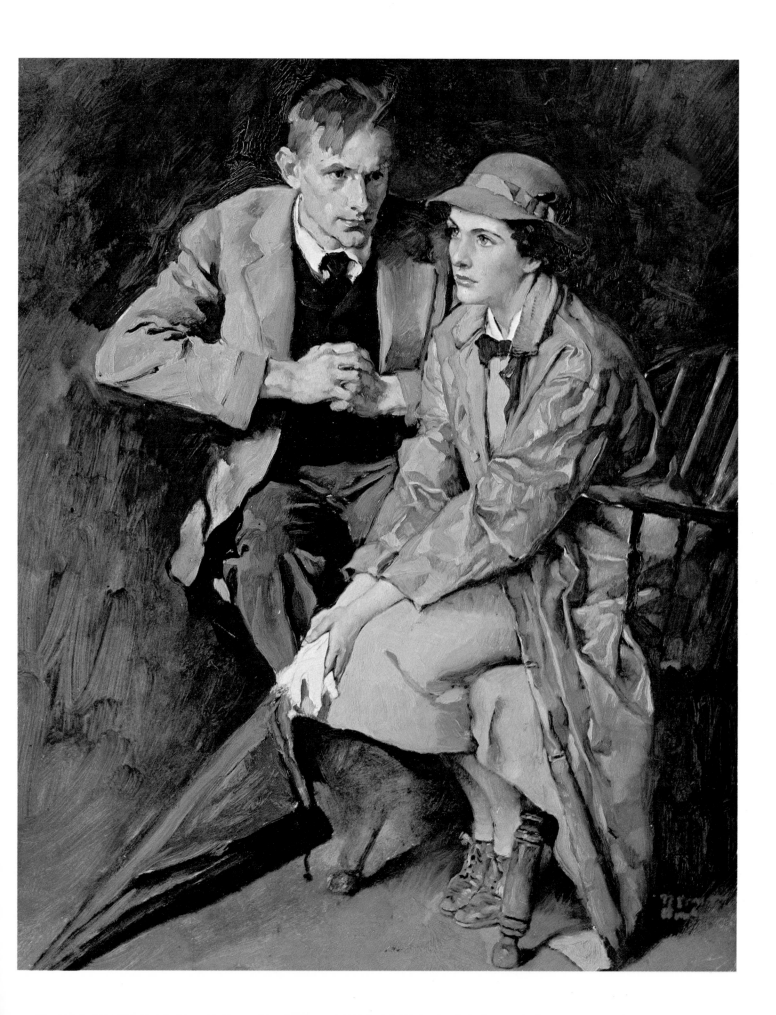

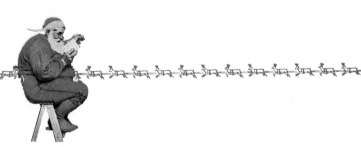

grows awfully fast. Say 'Merry Christmas!' Jim, and let's be happy. You don't know what a nice—what a beautiful, nice gift I've got for you."

"You've cut off your hair?" asked Jim, laboriously, as if he had not arrived at that patent fact yet even after the hardest mental labour.

"Cut it off and sold it," said Della. "Don't you like me just as well, anyhow? I'm me without my hair, ain't I?"

Jim looked about the room curiously.

"You say your hair is gone?" he said, with an air almost of idiocy.

"You needn't look for it," said Della. "It's sold, I tell you—sold and gone, too. It's Christmas Eve, boy. Be good to me, for it went for you. Maybe the hairs of my head were numbered," she went on with a sudden serious sweetness, "but nobody could ever count my love for you. Shall I put the chops on, Jim?"

Out of his trance Jim seemed quickly to wake. He enfolded his Della. For ten seconds let us regard with discreet scrutiny some inconsequential object in the other direction. Eight dollars a week or a million a year—what is the difference? A mathematician or a wit would give you the wrong answer. The magi brought valuable gifts, but that was not among them. This dark assertion will be illuminated later on.

Jim drew a package from his overcoat pocket and threw it upon the table.

"Don't make any mistake, Dell," he said, "about me. I don't think there's anything in the way of a haircut or a shave or a shampoo that could make me like my girl any less. But if you'll unwrap that package you may see why you had me going a while at first."

White fingers and nimble tore at the string and paper. And then an ecstatic scream of joy; and then, alas! a quick feminine change to hysterical tears and wails, necessitating the immediate employment of all the comforting powers of the lord of the flat.

For there lay The Combs—the set of combs, side and back, that Della had worshipped for long in a Broadway window. Beautiful combs, pure tortoise shell, with jeweled rims—just the shade to wear in the beautiful vanished hair. They were expensive combs, she knew, and her heart had simply craved and yearned over them without the least hope of possession. And now, they were hers, but the tresses that should have adorned the coveted adornments were gone.

But she hugged them to her bosom, and at length she was able to look up with dim eyes and a smile and say: "My hair grows so fast, Jim!"

And then Della leaped up like a little singed cat and cried, "Oh, oh!"

Jim had not yet seen his beautiful present. She held it out to him eagerly upon her open palm. The dull precious metal seemed to flash with a reflection of her bright and ardent spirit.

"Isn't it a dandy, Jim? I hunted all over town to find it. You'll have to look at the time a hundred times a day now. Give me your watch. I want to see how it looks on it."

Instead of obeying, Jim tumbled down on the couch and put his hands under the back of his head and smiled.

"Dell," said he, "let's put our Christmas presents away and keep 'em a while. They're too nice to use just at present. I sold the watch to get the money to buy your combs. And now suppose you put the chops on."

The magi, as you know, were wise men—wonderfully wise men who brought gifts to the Babe in the manger. They invented the art of giving Christmas presents. Being wise, their gifts were no doubt wise ones, possibly bearing the privilege of exchange in case of duplication. And here I have lamely related to you the uneventful chronicle of two foolish children in a flat who most unwisely sacrificed for each other the greatest treasures of their house. But in a last word to the wise of these days let it be said that of all who give gifts these two were the wisest. Of all who give and receive gifts, such as they are wisest. Everywhere they are wisest. They are the magi.

The Poor Relation's Story

CHARLES DICKENS

He was very reluctant to take precedence of so many respected members of the family by beginning the round of stories they were to relate as they sat in a goodly circle by the Christmas fire; and he modestly suggested that it would be more correct if "John our esteemed host" (whose health he begged to drink) would have the kindness to begin. For as to himself, he said, he was so little used to lead the way that really—But as they all cried out here, that he must begin, and agreed with one voice that he might, could, would, and should begin, he left off rubbing his hands, and took his legs out from under his armchair, and did begin.

I have no doubt (said the poor relation) that I shall surprise the assembled members of our family, and particularly John our esteemed host, to whom we are so much indebted for the great hospitality with which he has this day entertained us, by the confession I am going to make. But, if you do me the honour to be surprised at anything that falls from a person so unimportant in the family as I am, I can only say that I shall be scrupulously accurate in all I relate.

I am not what I am supposed to be. I am quite another thing. Perhaps before I go further, I had better glance at what I *am* supposed to be.

It is supposed, unless I mistake—the assembled members of our family will correct me if I do, which is very likely (here the poor relation looked mildly about him for contradiction); that I am nobody's enemy but my own. That I never met with any particular success in anything. That I failed in business because I was unbusi-

ness-like and credulous—in not being prepared for the interested designs of my partner. That I failed in love, because I was ridiculously trustful—in thinking it impossible that Christiana could deceive me. That I failed in my expectations from my uncle Chill, on account of not being as sharp as he could have wished in worldly matters. That, through life, I have been rather put upon and disappointed in a general way. That I am at present a bachelor of between fifty-nine and sixty years of age, living on a limited income in the form of a quarterly allowance, to which I see that John our esteemed host wishes me to make no further allusion.

The supposition as to my present pursuits and habits is to the following effect.

I live in a lodging in the Clapham Road—a very clean back room, in a very respectable house—where I am expected not to be at home in the day-time, unless poorly; and which I usually leave in the morning at nine o'clock, on pretence of going to business. I take my breakfast—my roll and butter, and my half-pint of coffee—at the old-established coffee-shop near Westminster Bridge; and then I go into the City—I don't know why—and sit in Garraway's Coffee House, and on 'Change, and walk about, and look into a few offices and countinghouses where some of my relations or acquaintance are so good as to tolerate me, and where I stand by the fire if the weather happens to be cold. I get through the day in this way until five o'clock, and then I dine: at a cost, on the average, of one and threepence. Having still a little money to spend on my evening's en-

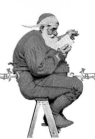

tertainment, I look into the old-established cof-fee-shop as I go home, and take my cup of tea, and perhaps my bit of toast. So, as the large hand of the clock makes its way round to the morning hour again, I make my way round to the Clap-ham Road again, and go to bed when I get to my lodging—fire being expensive, and being ob-jected to by the family on account of its giving trouble and making a dirt.

Sometimes, one of my relations or acquaint-ance is so obliging as to ask me to dinner. These are holiday occasions, and then I generally walk in the Park. I am a solitary man, and seldom walk with anybody. Not that I am avoided because I am shabby; for I am not at all shabby, having al-ways a very good suit of black on (or rather Ox-ford mixture, which has the appearance of black and wears much better); but I have got into a habit of speaking low, and being rather silent, and my spirits are not high, and I am sensible that I am not an attractive companion.

The only exception to this general rule is the child of my first cousin, Little Frank. I have a par-ticular affection for that child, and he takes very kindly to me. He is a diffident boy by nature; and in a crowd he is soon run over, as I may say, and forgotten. He and I, however, get on exceedingly well. I have a fancy that the poor child will in time succeed to my peculiar position in the fam-ily. We talk but little; still, we understand each other. We walk about, hand in hand; and with-out much speaking he knows what I mean, and I know what he means. When he was very little in-deed, I used to take him to the windows of the toy-shops, and show him the toys inside. It is sur-prising how soon he found out that I would have made him a great many presents if I had been in circumstances to do it.

Little Frank and I go and look at the outside of the Monument—he is very fond of the Monu-ment—and at the Bridges, and at all the sights that are free. On two of my birthdays, we have dined on à-la-mode beef, and gone at half-price to the play, and been deeply interested. I was once walking with him in Lombard Street, which

we often visit on account of my having men-tioned to him that there are great riches there—he is very fond of Lombard Street—when a gentleman said to me as he passed by, "Sir, your little son has dropped his glove." I assure you, if you will excuse my remarking on so trivial a cir-cumstance, this accidental mention of the child as mine, quite touched my heart and brought the foolish tears into my eyes.

When Little Frank is sent to school in the country, I shall be very much at a loss what to do with myself, but I have the intention of walking down there once a month and seeing him on a half-holiday. I am told he will then be at play upon the Heath; and if my visits should be ob-jected to, as unsettling the child, I can see him from a distance without his seeing me, and walk back again. His mother comes of a highly genteel family, and rather disapproves, I am aware, of our being too much together. I know that I am not calculated to improve his retiring disposition; but I think he would miss me beyond the feeling of the moment if we were wholly separated.

When I die in the Clapham Road, I shall not leave much more in this world than I shall take out of it; but, I happen to have a miniature of a bright-faced boy, with a curling head, and an open shirt-frill waving down his bosom (my mother had it taken for me, but I can't believe that it was ever like), which will be worth noth-ing to sell, and which I shall beg may be given to Frank. I have written my dear boy a little letter with it, in which I have told him that I felt very sorry to part from him, though bound to confess that I know no reason why I should remain here. I have given him some short advice, the best in my power, to take warning of the consequences of being nobody's enemy but his own; and I have endeavoured to comfort him for what I fear he will consider a bereavement, by pointing out to him, that I was only a superfluous something to every one but him; and that having by some means failed to find a place in this great assembly, I am better out of it.

Such (said the poor relation, clearing his throat

and beginning to speak a little louder) is the general impression about me. Now, it is a remarkable circumstance which forms the aim and purpose of my story, that this is all wrong. This is not my life, and these are not my habits. I do not even live in the Clapham Road. Comparatively speaking, I am very seldom there. I reside, mostly, in a—I am almost ashamed to say the word, it sounds so full of pretension—in a Castle. I do not mean that it is an old baronial habitation, but still it is a building always known to every one by the name of a Castle. In it, I preserve the particulars of my history; they run thus:

It was when I first took John Spatter (who had been my clerk) into partnership, and when I was still a young man of not more than five-and-twenty, residing in the house of my uncle Chill, from whom I had considerable expectations, that I ventured to propose to Christiana. I had loved Christiana a long time. She was very beautiful, and very winning in all respects. I rather mis-

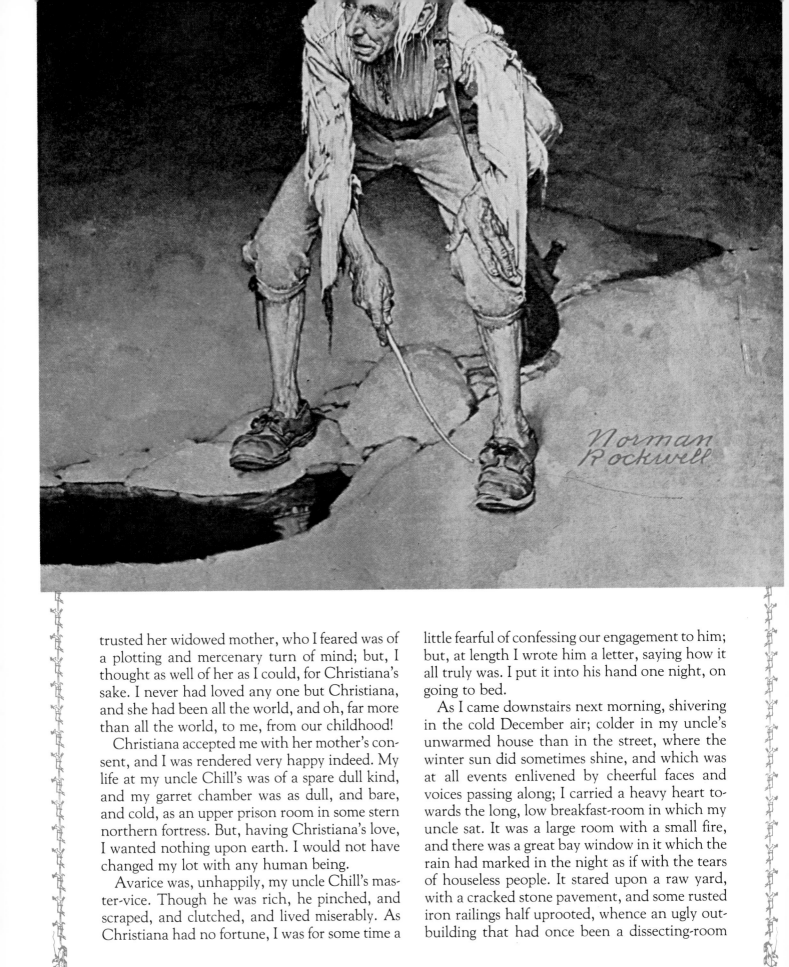

trusted her widowed mother, who I feared was of a plotting and mercenary turn of mind; but, I thought as well of her as I could, for Christiana's sake. I never had loved any one but Christiana, and she had been all the world, and oh, far more than all the world, to me, from our childhood!

Christiana accepted me with her mother's consent, and I was rendered very happy indeed. My life at my uncle Chill's was of a spare dull kind, and my garret chamber was as dull, and bare, and cold, as an upper prison room in some stern northern fortress. But, having Christiana's love, I wanted nothing upon earth. I would not have changed my lot with any human being.

Avarice was, unhappily, my uncle Chill's master-vice. Though he was rich, he pinched, and scraped, and clutched, and lived miserably. As Christiana had no fortune, I was for some time a little fearful of confessing our engagement to him; but, at length I wrote him a letter, saying how it all truly was. I put it into his hand one night, on going to bed.

As I came downstairs next morning, shivering in the cold December air; colder in my uncle's unwarmed house than in the street, where the winter sun did sometimes shine, and which was at all events enlivened by cheerful faces and voices passing along; I carried a heavy heart towards the long, low breakfast-room in which my uncle sat. It was a large room with a small fire, and there was a great bay window in it which the rain had marked in the night as if with the tears of houseless people. It stared upon a raw yard, with a cracked stone pavement, and some rusted iron railings half uprooted, whence an ugly outbuilding that had once been a dissecting-room

(in the time of the great surgeon who had mortgaged the house to my uncle), stared at it.

We rose so early always, that at that time of the year we breakfasted by candlelight. When I went into the room, my uncle was so contracted by the cold, and so huddled together in his chair behind the one dim candle, that I did not see him until I was close to the table.

As I held out my hand to him, he caught up his stick (being infirm, he always walked about the house with a stick), and made a blow at me, and said, "You fool!"

"Uncle," I returned, "I didn't expect you to be so angry as this." Nor had I expected it, though he was a hard and angry old man.

"You didn't expect!" said he; "when did you ever expect? When did you ever calculate, or look forward, you contemptible dog?"

"These are hard words, Uncle!"

"Hard words? Feathers, to pelt such an idiot as you with," said he. "Here! Betsy Snap! Look at him!"

Betsy Snap was a withered, hard-featured, yellow old woman—our only domestic—always employed, at this time of the morning, in rubbing my uncle's legs. As my uncle adjured her to look at me, he put his lean grip on the crown of her head, she kneeling beside him, and turned her face towards me. An involuntary thought connecting them both with the dissecting-room, as it must often have been in the surgeon's time, passed across my mind in the midst of my anxiety.

"Look at the snivelling milksop!" said my uncle. "Look at the baby! This is the gentleman who, people say, is nobody's enemy but his own. This is the gentleman who can't say no. This is the gentleman who was making such large profits in his business that he must needs take a partner, t'other day. This is the gentleman who is going to marry a wife without a penny, and who falls into the hands of Jezebels who are speculating on my death!"

I knew, now, how great my uncle's rage was; for nothing short of his being almost beside himself would have induced him to utter that concluding word, which he held in such repugnance that it was never spoken or hinted at before him on any account.

"On my death," he repeated, as if he were defying me for defying his own abhorrence of the word. "On my death—death—Death! But I'll spoil the speculation. Eat your last under this roof, you feeble wretch, and may it choke you!"

You may suppose that I had not much appetite for the breakfast to which I was bidden in these terms; but I took my accustomed seat. I saw that I was repudiated henceforth by my uncle; still I could bear that very well, possessing Christiana's heart.

He emptied his basin of bread-and-milk as usual, only that he took it on his knees with his chair turned away from the table where I sat. When he had done, he carefully snuffed out the candle; and the cold-slate-coloured, miserable day looked in upon us.

"Now, Mr. Michael," said he, "before we part, I should like to have a word with these ladies in your presence."

"As you will, sir," I returned; "but you deceive yourself, and wrong us, cruelly, if you suppose that there is any feeling at stake in this contract but pure, disinterested, faithful love."

To this, he only replied, "You lie!" and not one other word.

We went, through half-thawed snow and half-frozen rain, to the house where Christiana and her mother lived. My uncle knew them very well. They were sitting at their breakfast, and were surprised to see us at that hour.

"Your servant, ma'am," said my uncle to the mother. "You divine the purpose of my visit, I dare say, ma'am. I understand there is a world of pure, disinterested, faithful love cooped up here. I am happy to bring it all it wants, to make it complete. I bring you your son-in-law, ma'am—

and you, your husband, miss. The gentleman is a perfect stranger to me, but I wish him joy of his wise bargain."

He snarled at me as he went out, and I never saw him again.

It is altogether a mistake (continued the poor relation) to suppose that my dear Christiana, over-persuaded and influenced by her mother, married a rich man, the dirt from whose carriage-wheels is often, in these changed times, thrown upon me as she rides by. No, no. She married me.

The way we came to be married rather sooner than we intended was this. I took a frugal lodging and was saving and planning for her sake, when, one day, she spoke to me with great earnestness, and said:

"My dear Michael, I have given you my heart. I have said that I loved you, and I have pledged myself to be your wife. I am as much yours through all changes of good and evil as if we had been married on the day when such words passed between us. I know you well, and know that if we should be separated and our union broken off, your whole life would be shadowed, and all that might, even now, be stronger in your character for the conflict with the world would then be weakened to the shadow of what it is!"

"God help me, Christiana!" said I. "You speak the truth."

"Michael!" said she, putting her hand in mine, in all maidenly devotion, "let us keep apart no longer. It is but for me to say that I can live contented upon such means as you have, and I well know you are happy. I say so from my heart. Strive no more alone; let us strive together. My dear Michael, it is not right that I should keep secret from you what you do not suspect, but what distresses my whole life. My mother: without considering that what you have lost, you have lost for me, and on the assurance of my faith: sets her heart on riches, and urges suit upon me, to my misery. I cannot bear this, for to bear it is to be untrue to you. I would rather share your struggles than look on. I want no better

home than you can give me. I know that you will aspire and labour with a higher courage if I am wholly yours, and let it be so when you will!"

I was blest indeed, that day, and a new world opened to me. We were married in a very little while, and I took my wife to our happy home. That was the beginning of the residence I have spoken of; the Castle we have ever since inhabited together, dates from that time. All our children have been born in it. Our first child—now married—was a little girl, whom we called Christiana. Her son is so like Little Frank, that I hardly know which is which.

The current impression as to my partners' dealings with me is also quite erroneous. He did not begin to treat me coldly, as a poor simpleton, when my uncle and I so fatally quarrelled; nor did he afterwards gradually possess himself of our business and edge me out. On the contrary, he behaved to me with the utmost good faith and honour.

Matters between us took this turn: On the day of my separation from my uncle, and even before the arrival at our counting-house of my trunks (which he sent after me, *not* carriage paid), I went down to our room of business, on our little wharf, overlooking the river; and there I told John Spatter what happened. John did not say, in reply, that rich old relatives were palpable facts, and that love and sentiment were moonshine and fiction. He addressed me thus:

"Michael," said John, "we were at school together, and I generally had the knack of getting on better than you, and making a higher reputation."

"You had, John," I returned.

"Although," said John, "I borrowed your books and lost them; borrowed your pocket-money, and never repaid it; got you to buy my damaged knives at a higher price than I had given for them new; and to own to the windows that I had broken."

"All not worth mentioning, John Spatter," said I, "but certainly true."

"When you were first established in this infant business, which promises to thrive so well," pursued John, "I came to you, in my search for almost any employment, and you made me your clerk."

"Still not worth mentioning, my dear John Spatter," said I; "still, equally true."

"And finding that I had a good head for business, and that I was really useful *to* the business, you did not like to retain me in that capacity, and thought it an act of justice soon to make me your partner."

"Still less worth mentioning than any of those other little circumstances you have recalled, John Spatter," said I; "for I was, and am, sensible of your merits and my deficiencies."

"Now, my good friend," said John, drawing my arm through his, as he had had a habit of doing at school; while two vessels outside the windows of our counting-house—which were shaped like the stern windows of a ship—went lightly down the river with the tide, as John and I might then be sailing away in company, and in trust and confidence, on our voyage of life; "let there, under these friendly circumstances, be a right understanding between us. You are too easy, Michael. You are nobody's enemy but your own. If I were to give you that damaging character among our connexion, with a shrug, and a shake of the head, and a sigh; and if I were further to abuse the trust you place in me—"

"But you never will abuse it at all, John," I observed.

"Never!" said he; "but I am putting a case—I

say, and if I were further to abuse that trust by keeping this piece of our common affairs in the dark, and this other piece in the light, and again this other piece in the twilight, and so on, I should strengthen my strength, and weaken your weakness, day by day, until at last I found myself on the high road to fortune, and you left behind on some bare common, a hopeless number of miles out of the way."

"Exactly so," said I.

"To prevent this, Michael," said John Spatter, "or the remotest chance of this, there must be perfect openness between us. Nothing must be concealed, and we must have but one interest."

"My dear John Spatter," I assured him, "that is precisely what I mean."

"And when you are too easy," pursued John, his face glowing with friendship, "you must allow me to prevent that imperfection in your nature from being taken advantage of, by any one; you must not expect me to humour it—"

"My dear John Spatter," I interrupted. "I *don't* expect you to humour it. I want to correct it."

"And I, too," said John.

"Exactly so!" cried I. "We both have the same end in view; and, honourably seeking it, and fully trusting one another, and having but one interest, ours will be a prosperous and happy partnership."

"I am sure of it!" returned John Spatter. And we shook hands most affectionately.

I took John home to my Castle, and we had a very happy day. Our partnership throve very well. My friend and partner supplied what I wanted, as I had foreseen that he would; and by improving both the business and myself, amply acknowledged any little rise in life to which I had helped him.

I am not (said the poor relation, looking at the fire as he slowly rubbed his hands) very rich, for I never cared to be that; but I have enough, and am above all moderate wants and anxieties. My Castle is not a splendid place, but it is very com-

fortable, and it has a warm and cheerful air, and is quite a picture of Home.

Our eldest girl, who is very like her mother, married John Spatter's eldest son. Our two families are closely united in other areas of attachment. It is very pleasant of an evening, when we are all assembled together—which frequently happens—and when John and I talk over old times, and the one interest there has always been between us.

I really do not know, in my Castle, what loneliness is. Some of our children or grandchildren are always about it, and the young voices of my descendants are delightful—oh, how delightful!—to me to hear. My dearest and devoted wife, ever faithful, ever loving, ever helpful and sustaining and consoling, is the priceless blessing of my house; from whom all its other blessings spring. We are rather a musical family, and when Christiana sees me, at any time, a little weary or depressed, she steals to the piano and sings a gentle air she used to sing when we were first betrothed. So weak a man am I, that I cannot bear to hear it from any other source. They played it once, at the Theatre, when I was there with Little Frank; and the child said wondering, "Cousin Michael, whose hot tears are these that have fallen on my hand?"

Such is my Castle, and such are the real particulars of my life therein preserved. I often take Little Frank home there. He is very welcome to my grandchildren, and they play together. At this time of the year—the Christmas and New Year time—I am seldom out of my Castle. For, the associations of the season seem to hold me there, and the precepts of the season seem to teach me that it is well to be there.

"And the Castle is—" observed a grave, kind voice among the company.

"Yes. My Castle," said the poor relation, shaking his head as he still looked at the fire, "is in the Air. John our esteemed host suggests its situation accurately. My Castle is in the Air! I have done. Will you be so good as to pass the story!"

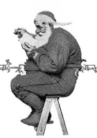

My Christmas Miracle

TAYLOR CALDWELL

For many of us, one Christmas stands out from all the others, the one when the meaning of the day shone clearest.

Although I did not guess it, my own "truest" Christmas began on a rainy spring day in the bleakest year of my life. Recently divorced, I was in my 20s, had no job, and was on my way downtown to go the rounds of the employment offices. I had no umbrella, for my old one had fallen apart, and I could not afford another one. I sat down in the streetcar, and there against the seat was a beautiful silk umbrella with a silver handle inlaid with gold and flecks of bright enamel. I had never seen anything so lovely.

I examined the handle and saw a name engraved among the golden scrolls. The usual procedure would have been to turn in the umbrella to the conductor, but on impulse I decided to take it with me and find the owner myself. I got off the streetcar in a downpour and thankfully opened the umbrella to protect myself. Then I searched a telephone book for the name on the umbrella and found it. I called, and a lady answered.

Yes, she said in surprise, that was her umbrella, which her parents, now dead, had given her for a birthday present. But, she added, it had been stolen from her locker at school (she was a teacher) more than a year before. She was so excited that I forgot I was looking for a job and went directly to her small house. She took the umbrella, and her eyes filled with tears.

The teacher wanted to give me a reward, but—though $20 was all I had in the world—her happiness at retrieving this special possession was such that to have accepted money would have spoiled something. We talked for a while, and I must have given her my address. I don't remember.

The next six months were wretched. I was able to obtain only temporary employment here and there, for a small salary, though this was what they now call the Roaring Twenties. But I put aside 25 or 50 cents when I could afford it for my little girl's Christmas presents. (It took me six months to save $8.) My last job ended the day before Christmas, my $30 rent was soon due, and I had $15 to my name—which Peggy and I would need for food. She was home from her convent boarding school and was excitedly looking forward to her gifts the next day, which I had already purchased. I had bought her a small tree, and we were going to decorate it that night.

The stormy air was full of the sound of Christmas merriment as I walked from the streetcar to my small apartment. Bells rang and children shouted in the bitter dusk of the evening, and windows were lighted and everyone was running and laughing. But there would be no Christmas for me, I knew, no gifts, no remembrance whatsoever. As I struggled through the snowdrifts, I just about reached the lowest point in my life. Unless a miracle happened I would be homeless in January, foodless, jobless. I had prayed steadily for weeks, and there had been no answer but this coldness and darkness, this harsh air, this abandonment. God and men had completely forgotten me. I felt old as death, and as lonely. What was to become of us?

I looked in my mailbox. There were only bills in it, a sheaf of them, and two white envelopes which I was sure contained more bills. I went up three dusty flights of stairs, and I cried, shivering in my thin coat. But I made myself smile so I

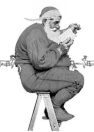

could greet my little daughter with a pretense of happiness. She opened the door for me and threw herself in my arms, screaming joyously and demanding that we decorate the tree immediately.

Peggy was not yet six years old, and had been alone all day while I worked. She had set our kitchen table for our evening meal, proudly, and put pans out and the three cans of food which would be our dinner. For some reason, when I looked at those pans and cans, I felt brokenhearted. We would have only hamburgers for our Christmas dinner tomorrow, and gelatin. I stood in the cold little kitchen, and misery overwhelmed me. For the first time in my life, I doubted the existence of God and His mercy, and the coldness in my heart was colder than ice.

The doorbell rang, and Peggy ran fleetly to answer it, calling that it must be Santa Claus. Then I heard a man talking heartily to her and went to the door. He was a delivery man, and his arms were full of big parcels, and he was laughing at my child's frenzied joy and her dancing. "This is a mistake," I said, but he read the name on the parcels, and they were for me. When he had gone I could only stare at the boxes. Peggy and I sat on the floor and opened them. A huge doll, three times the size of the one I had bought for her. Gloves. Candy. A beautiful leather purse. Incredible! I looked for the name of the sender. It was the teacher, the address simply "California," where she had moved.

Our dinner that night was the most delicious I had ever eaten. I could only pray in myself, "Thank You, Father." I forgot I had no money for the rent and only $15 in my purse and no job. My child and I ate and laughed together in happiness. Then we decorated the little tree and marveled at it. I put Peggy to bed and set up her gifts around the tree, and a sweet peace flooded me like a benediction. I had some hope again. I could even examine the sheaf of bills without cringing. Then I opened the two white envelopes. One contained a check for $30 from a company I had worked for briefly in the summer. It was, said a note, my "Christmas bonus." My rent!

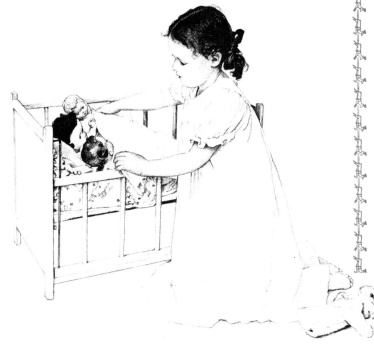

The other envelope was an offer of a permanent position with the government—to begin two days after Christmas. I sat with the letter in my hand and the check on the table before me, and I think that was the most joyful moment of my life up to that time.

The church bells began to ring. I hurriedly looked at my child, who was sleeping blissfully, and ran down to the street. Everywhere people were walking to church to celebrate the birth of the Saviour. People smiled at me and I smiled back. The storm had stopped, the sky was pure and glittering with stars.

"The Lord is born!" sang the bells to the crystal night and the laughing darkness. Someone began to sing, "Come, all ye faithful!" I joined in and sang with the strangers all about me.

I am not alone at all, I thought. *I was never alone at all.*

And that, of course, is the message of Christmas. We are never alone. Not when the night is darkest, the wind coldest, the world seemingly most indifferent. For this is still the time God chooses.

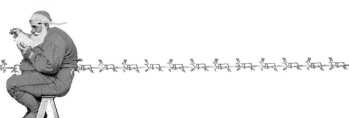

The Legend of the Christmas Rose

SELMA LAGERLÖF

Robber Mother, who lived in Robbers' Cave up in Göinge forest, went down to the village one day on a begging tour. Robber Father, who was an outlawed man, did not dare to leave the forest. She took with her five youngsters, and each youngster bore a sack on his back as long as himself. When Robber Mother stepped inside the door of a cabin, no one dared refuse to give her whatever she demanded; for she was not above coming back the following night and setting fire to the house if she had not been well received. Robber Mother and her brood were worse than a pack of wolves, and many a man felt like running a spear through them; but it was never done, because they all knew that the man stayed up in the forest, and he would have known how to wreak vengeance if anything had happened to the children or the old woman.

Now that Robber Mother went from house to house and begged, she came to Övid, which at that time was a cloister. She rang the bell of the cloister gate and asked for food. The watchman let down a small wicket in the gate and handed her six round bread cakes—one for herself and one for each of the five children.

While the mother was standing quietly at the gate, her youngsters were running about. And now one of them came and pulled at her skirt, as a signal that he had discovered something which she ought to come and see, and Robber Mother followed him promptly.

The entire cloister was surrounded by a high and strong wall, but the youngster had managed to find a little back gate which stood ajar. When Robber Mother got there, she pushed the gate open and walked inside without asking leave, as it was her custom to do.

Övid Cloister was managed at that time by Abbot Hans, who knew all about herbs. Just within the cloister wall he had planted a little herb garden, and it was into this that the old woman had forced her way.

At first glance Robber Mother was so astonished that she paused at the gate. It was high summertide, and Abbot Hans' garden was so full of flowers that the eyes were fairly dazzled by the blues, reds, and yellows, as one looked into it. But presently an indulgent smile spread over her features, and she started to walk up a narrow path that lay between many flower beds.

In the garden a lay brother walked about, pulling up weeds. It was he who had left the door in the wall open, that he might throw the weeds and tares on the rubbish heap outside.

When he saw Robber Mother coming in, with all five youngsters in tow, he ran toward her at once and ordered them away. But the beggar woman walked right on as before. The lay brother knew of no other remedy than to run into the cloister and call for help.

He returned with two stalwart monks, and Robber Mother saw that now it meant business! She let out a perfect volley of shrieks, and, throwing herself upon the monks, clawed and bit at them; so did all the youngsters. The men soon learned that she could overpower them, and all they could do was go back into the cloister for reinforcements.

As they ran through the passage-way which led to the cloister, they met Abbot Hans, who came rushing out to learn what all this noise was about.

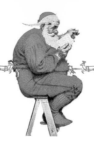

He upbraided them for using force and forbade their calling for help. He sent both monks back to their work, and although he was an old and fragile man, he took with him only the lay brother.

He came up to the woman and asked in a mild tone if the garden pleased her.

Robber Mother turned defiantly toward Abbot Hans, for she expected only to be trapped and overpowered. But when she noticed his white hair and bent form, she answered peaceably, "First, when I saw this, I thought I had never seen a prettier garden; but now I see that it can't be compared with one I know of. If you could see the garden of which I am thinking you would uproot all the flowers planted here and cast them away like weeds."

The Abbot's assistant was hardly less proud of the flowers than the Abbot himself, and after hearing her remarks he laughed derisively.

Robber Mother grew crimson with rage to think that her word was doubted, and she cried out: "You monks, who are holy men, certainly must know that on every Christmas Eve the great Göinge forest is transformed into a beautiful garden, to commemorate the hour of our Lord's birth. We who live in the forest have seen this happen every year. And in that garden I have seen flowers so lovely that I dared not lift my hand to pluck them."

Ever since his childhood, Abbot Hans had heard it said that on every Christmas Eve the forest was dressed in holiday glory. He had often longed to see it, but he had never had the good fortune. Eagerly he begged and implored Robber Mother that he might come up to the Robbers' Cave on Christmas Eve. If she would only send one of her children to show him the way, he could ride up there alone, and he would never betray them—on the contrary, he would reward them insofar as it lay in his power.

Robber Mother said no at first, for she was thinking of Robber Father and of the peril which might befall him should she permit Abbot Hans to ride up to their cave. At the same time the desire to prove to the monk that the garden which she knew was more beautiful than his got the better of her, and she gave in.

"But more than one follower you cannot take with you," said she, "and you are not to waylay us or trap us, as sure as you are a holy man."

This Abbot Hans promised, and then Robber Mother went her way.

It happened that Archbishop Absalon from Lund came to Övid and remained through the night. The lay brother heard Abbot Hans telling the Bishop about Robber Father and asking him for a letter of ransom for the man, that he might lead an honest life among respectable folk.

But the Archbishop replied that he did not care to let the robber loose among honest folk in the villages. It would be best for all that he remain in the forest.

Then Abbot Hans grew zealous and told the Bishop all about Göinge forest, which, every year at Yuletide, clothed itself in summer bloom around the Robbers' Cave. "If these bandits are not so bad but that God's glories can be made manifest to them, surely we cannot be too wicked to experience the same blessing."

The Archbishop knew how to answer Abbot Hans. "This much I will promise you, Abbot Hans," he said, smiling, "that any day you send me a blossom from the garden in Göinge forest, I will give you letters of ransom for all the outlaws you may choose to plead for."

The following Christmas Eve Abbot Hans was on his way to the forest. One of Robber Mother's wild youngsters ran ahead of him, and close behind him was the lay brother.

It turned out to be a long and hazardous ride. They climbed steep and slippery side paths, crawled over swamp and marsh, and pushed through windfall and bramble. Just as daylight was waning, the robber boy guided them across a forest meadow, skirted by tall, naked leaf trees and green fir trees. Back of the meadow loomed a mountain wall, and in this wall they saw a door of thick boards. Now Abbot Hans understood that they had arrived, and dismounted. The child

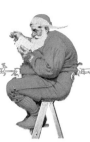

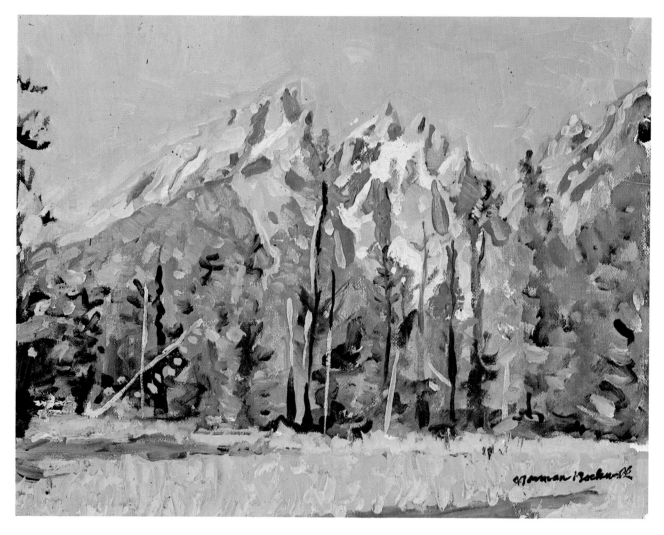

opened the heavy door for him, and he looked into a poor mountain grotto, with bare stone walls. Robber Mother was seated before a log fire that burned in the middle of the floor. Alongside the walls were beds of virgin pine and moss, and on one of these beds lay Robber Father asleep.

"Come in, you out there!" shouted Robber Mother without rising, "and fetch the horses in with you, so they won't be destroyed by the night cold."

Abbot Hans walked boldly into the cave, and the lay brother followed. Here were wretchedness and poverty! and nothing was done to celebrate Christmas.

Robber Mother spoke in a tone as haughty and dictatorial as any well-to-do peasant woman. "Sit down by the fire and warm yourself, Abbot Hans," said she; "and if you have food with you, eat, for the food which we in the forest prepare you wouldn't care to taste. And if you are tired after the long journey, you can lie down on one of these beds to sleep. You needn't be afraid of oversleeping, for I'm sitting here by the fire keeping watch. I shall awaken you in time to see that

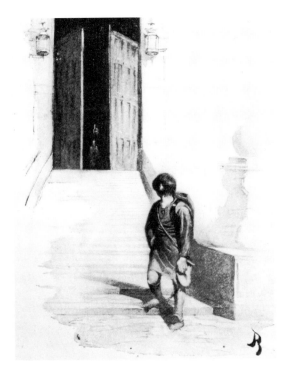

which you have come up here to see."

Abbot Hans obeyed Robber Mother and brought forth his food sack; but he was so fatigued after the journey he was hardly able to eat, and as soon as he could stretch himself on the bed, he fell asleep.

The lay brother was also assigned a bed to rest and he dropped into a doze.

When he woke up, he saw that Abbot Hans had left his bed and was sitting by the fire talking with Robber Mother. The outlawed robber sat also by the fire. He was a tall, raw-boned man with a dull, sluggish appearance. His back was turned to Abbot Hans, as though he would have it appear that he was not listening to the conversation.

Abbot Hans was telling Robber Mother all about the Christmas preparations he had seen on the journey, reminding her of Christmas feasts and games which she must have known in her youth, when she lived at peace with mankind.

At first Robber Mother answered in short, gruff sentences, but by degrees she became more subdued and listened more intently. Suddenly Robber Father turned toward Abbot Hans and shook his clenched fist in his face. "You miserable monk! did you come here to coax from me my wife and children? Don't you know that I am an outlaw and may not leave the forest?"

Abbot Hans looked him fearlessly in the eyes. "It is my purpose to get a letter of ransom for you from Archbishop Absalon," said he. He had hardly finished speaking when the robber and his wife burst out laughing. They knew well enough the kind of mercy a forest robber could expect from Bishop Absalon!

"Oh, if I get a letter of ransom from Absalon," said Robber Father, "then I'll promise you that never again will I steal so much as a goose."

Suddenly Robber Mother rose. "You sit here and talk, Abbot Hans," she said, "so that we are forgetting to look at the forest. Now I can hear, even in this cave, how the Christmas bells are ringing."

The words were barely uttered when they all sprang up and rushed out. But in the forest it was still dark night and bleak winter. The only thing they marked was a distant clang borne on a light south wind.

When the bells had been ringing a few moments, a sudden illumination penetrated the forest; the next moment it was dark again, and then light came back. It pushed its way forward between the stark trees, like a shimmering mist. The darkness merged into a faint daybreak. Then Abbot Hans saw that the snow had vanished from the ground, as if someone had removed a carpet, and the earth began to take on a green covering. The moss-tufts thickened and raised themselves, and the spring blossoms shot upward their swelling buds, which already had a touch of color.

Again it grew hazy; but almost immediately there came a new wave of light. Then the leaves of the trees burst into bloom, crossbeaks hopped from branch to branch, and the woodpeckers hammered on the limbs until the splinters fairly flew around them. A flock of starlings from up country lighted in a fir top to rest.

When the next warm wind came along, the blueberries ripened and the baby squirrels began playing on the branches of the trees.

The next light wave that came rushing in brought with it the scent of newly ploughed acres. Pine and spruce trees were so thickly clothed with red cones that they shone like crimson mantles and forest flowers covered the ground till it was all red, blue, and yellow.

Abbot Hans bent down to the earth and broke off a wild strawberry blossom, and, as he straightened up, the berry ripened in his hand.

The mother fox came out of her lair with a big litter of black-legged young. She went up to Robber Mother and scratched at her skirt, and Robber Mother bent down to her and praised her young.

Robber Mother's youngsters let out perfect shrieks of delight. They stuffed themselves with wild strawberries that hung on the bushes. One of them played with a litter of young hares; another ran a race with some young crows, which had hopped from their nest before they were really ready.

Robber Father was standing out on a marsh eating raspberries. When he glanced up, a big black bear stood beside him. Robber Father broke off a twig and struck the bear on the nose. "Keep to your own ground, you!" he said; "this is my turf." The huge bear turned around and lumbered off in another direction.

Then all the flowers whose seeds had been brought from foreign lands began to blossom. The loveliest roses climbed up the mountain wall in a race with the blackberry vines, and from the forest meadow sprang flowers as large as human faces.

Abbot Hans thought of the flower he was to pluck for Bishop Absalon; but each new flower that appeared was more beautiful than the others, and he wanted to choose the most beautiful of all.

Then Abbot Hans marked how all grew still; the birds hushed their songs, the flowers ceased growing, and the young foxes played no more. From far in the distance faint harp tones were heard, and celestial song, like a soft murmur, reached him.

He clasped his hands and dropped to his knees. His face was radiant with bliss.

But beside Abbot Hans stood the lay brother who had accompanied him. In his mind there were dark thoughts. "This cannot be a true miracle," he thought, "since it is revealed to malefactors. This does not come from God, but is sent hither by Satan. It is the Evil One's power that is tempting us and compelling us to see that which has no real existence."

The angel throng was so near now that Abbot Hans saw their bright forms through the forest branches. The lay brother saw them, too; but back of all this wondrous beauty he saw only some dread evil.

All the while the birds had been circling around the head of Abbot Hans, and they let him take them in his hands. But all the animals were afraid of the lay brother; no bird perched on his shoulder, no snake played at his feet. Then there came a little forest dove. When she marked that the angels were nearing, she plucked up courage and flew down on the lay brother's shoulder and laid her head against his cheek.

Then it appeared to him as if sorcery were come right upon him, to tempt and corrupt him. He struck with his hand at the forest dove and cried in such a loud voice that it rang throughout the forest, "Go thou back to hell, whence thou art come!"

Just then the angels were so near that Abbot Hans felt the feathery touch of their great wings, and he bowed down to earth in reverent greeting.

But when the lay brother's words sounded, their song was hushed and the holy guests turned in flight. At the same time the light and the mild warmth vanished in unspeakable terror for the darkness and cold in a human heart. Darkness sank over the earth, like a coverlet; frost came, all the growths shrivelled up; the animals and birds hastened away; the leaves dropped from the trees, rustling like rain.

Abbot Hans felt how his heart, which had but

lately swelled with bliss, was now contracting with insufferable agony. "I can never outlive this," thought he, "that the angels from heaven had been so close to me and were driven away; that they wanted to sing Christmas carols for me and were driven to flight."

Then he remembered the flower he had promised Bishop Absalon, and at the last moment he fumbled among the leaves and moss to try and find a blossom. But he sensed how the ground under his fingers froze and how the white snow came gliding over the ground. Then his heart caused him even greater anguish. He could not rise, but fell prostrate on the ground and lay there.

When the robber folk and the lay brother had groped their way back to the cave, they missed Abbot Hans. They took brands with them and went out to search for him. They found him dead upon the coverlet of snow.

When Abbot Hans had been carried down to Övid, those who took charge of the dead saw that he held his right hand locked tight around something which he must have grasped at the moment of death. When they finally got his hand open, they found that the thing which he had held in such an iron grip was a pair of white root bulbs, which he had torn from among the moss and leaves.

When the lay brother who had accompanied Abbot Hans saw the bulbs, he took them and planted them in Abbot Hans' herb garden.

He guarded them the whole year to see if any flower would spring from them. But in vain he waited through the spring, the summer, and the autumn. Finally, when winter had set in and all the leaves and the flowers were dead, he ceased caring for them.

But when Christmas Eve came again, he was so strongly reminded of Abbot Hans that he wandered out into the garden to think of him. And look! as he came to the spot where he had planted the bare root bulbs, he saw that from them had sprung flourishing green stalks, which bore beautiful flowers with silver white leaves.

He called out all the monks at Övid, and when they saw that this plant bloomed on Christmas Eve, when all the other growths were as if dead, they understood that this flower had in truth been plucked by Abbot Hans from the Christmas garden in Göinge forest. Then the lay brother asked the monks if he might take a few blossoms to Bishop Absalon.

When Bishop Absalon beheld the flowers, which had sprung from the earth in darkest winter, he turned as pale as if he had met a ghost. He sat in silence a moment; thereupon he said, "Abbot Hans has faithfully kept his word and I shall also keep mine."

He handed the letter of ransom to the lay brother, who departed at once for the Robbers' Cave. When he stepped in there on Christmas Day, the robber came toward him with axe uplifted. "I'd like to hack you monks into bits, as many as you are!" said he. "It must be your fault that Göinge forest did not last night dress itself in Christmas bloom."

"The fault is mine alone," said the lay brother, "and I will gladly die for it; but first I must deliver a message from Abbot Hans." And he drew forth the Bishop's letter and told the man that he was free.

Robber Father stood there pale and speechless, but Robber Mother said in his name, "Abbot Hans has indeed kept his word, and Robber Father will keep his."

When the robber and his wife left the cave, the lay brother moved in and lived all alone in the forest, in constant meditation and prayer that his hard-heartedness might be forgiven him.

But Göinge forest never again celebrated the hour of our Savior's birth; and of all its glory, there lives today only the plant which Abbot Hans had plucked. It has been named CHRISTMAS ROSE. And each year at Christmastide she sends forth from the earth her green stalks and white blossoms, as if she never could forget that she had once grown in the great Christmas garden at Göinge forest.

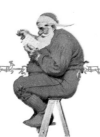

A Christmas Dream, and How It Came True

LOUISA MAY ALCOTT

"I'm so tired of Christmas I wish there never would be another one!" exclaimed a discontented-looking little girl, as she sat idly watching her mother arrange a pile of gifts two days before they were to be given.

"Why, Effie, what a dreadful thing to say! You are as bad as old Scrooge; and I'm afraid something will happen to you, as it did to him, if you don't care for dear Christmas," answered mamma, almost dropping the silver horn she was filling with delicious candies.

"Who was Scrooge? What happened to him?" asked Effie, with a glimmer of interest in her listless face, as she picked out the sourest lemon-drop she could find; for nothing sweet suited her just then.

"He was one of Dickens's best people, and you can read the charming story some day. He hated Christmas until a strange dream showed him how dear and beautiful it was, and made a better man of him."

"I shall read it; for I like dreams, and have a great many curious ones myself. But they don't keep me from being tired of Christmas," said Effie, poking discontentedly among the sweeties for something worth eating.

"Why are you tired of what should be the happiest time of all the year?" asked mamma, anxiously.

"Perhaps I shouldn't be if I had something new. But it is always the same, and there isn't any more surprise about it. I always find heaps of goodies in my stocking. Don't like some of them, and soon get tired of those I do like. We always have a great dinner, and I eat too much, and feel ill next day. Then there is a Christmas tree somewhere, with a doll on top, or a stupid old Santa Claus, and children dancing and scream-ing over bonbons and toys that break, and shiny things that are of no use. Really, mamma, I've had so many Christmases all alike that I don't think I *can* bear another one." And Effie laid herself flat on the sofa, as if the mere idea was too much for her.

Her mother laughed at her despair, but was sorry to see her little girl so discontented, when she had everything to make her happy, and had known but ten Christmas days.

"Suppose we don't give you *any* presents at all,—how would that suit you?" asked mamma, anxious to please her spoiled child.

"I should like one large and splendid one, and one dear little one, to remember some very nice person by," said Effie, who was a fanciful little body, full of odd whims and notions, which her friends loved to gratify, regardless of time, trou-ble, or money; for she was the last of three little girls, and very dear to all the family.

"Well, my darling, I will see what I can do to please you, and not say a word until all is ready. If I could only get a new idea to start with!" And mamma went on tying up her pretty bundles with a thoughtful face, while Effie strolled to the win-dow to watch the rain that kept her indoors and made her dismal.

"Seems to me poor children have better times than rich ones. I can't go out, and there is a girl about my age splashing along, without any maid to fuss about rubbers and cloaks and umbrellas and colds. I wish I was a beggar-girl."

"Would you like to be hungry, cold, and rag-ged, to beg all day, and sleep on an ash-heap at night?" asked mamma, wondering what would come next.

"Cinderella did, and had a nice time in the end. This girl out here has a basket of scraps on

her arm, and a big old shawl all round her, and doesn't seem to care a bit, though the water runs out of the toes of her boots. She goes paddling along, laughing at the rain, and eating a cold potato as if it tasted nicer than the chicken and ice-cream I had for dinner. Yes, I do think poor children are happier than rich ones."

"So do I, sometimes. At the Orphan Asylum to-day I saw two dozen merry little souls who have no parents, no home, and no hope of Christmas beyond a stick of candy or a cake. I wish you had been there to see how happy they were, playing with the old toys some richer children had sent them."

"You may give them all mine; I'm so tired of them I never want to see them again," said Effie, turning from the window to the pretty baby-house full of everything a child's heart could desire.

"I will, and let you begin again with something that you will not tire of, if I can only find it." And mamma knit her brows trying to discover some grand surprise for this child who didn't care for Christmas.

Nothing more was said then; and, wandering off to the library, Effie found "A Christmas Carol," and, curling herself up in the sofa corner, read it all before tea. Some of it she did not understand; but she laughed and cried over many parts of the charming story, and felt better without knowing why.

All the evening she thought of poor Tiny Tim, Mrs. Cratchit with the pudding, and the stout old gentleman who danced so gayly that "his legs twinkled in the air." Presently bedtime arrived.

"Come, now, and toast your feet," said Effie's nurse, "while I do your pretty hair and tell stories."

"I'll have a fairy tale to-night, a very interesting one," commanded Effie, as she put on her blue silk wrapper and little fur-lined slippers to sit before the fire and have her long curls brushed.

So Nursey told her best tales; and when at last the child lay down under her lace curtains, her head was full of a curious jumble of Christmas elves, poor children, snow-storms, sugar-plums and surprises. So it is no wonder that she dreamed all night, and this was the dream, which she never quite forgot.

She found herself sitting on a stone, in the middle of a great field, all alone. The snow was falling fast, a bitter wind whistled by, and night was coming on. She felt hungry, cold, and tired, and did not know where to go nor what to do.

"I wanted to be a beggar-girl, and now I am one; but I don't like it, and wish somebody would come and take care of me. I don't know who I am, and I think I must be lost," thought Effie, with the curious interest one takes in one's self in dreams.

But the more she thought about it, the more bewildered she felt. Faster fell the snow, colder blew the wind, darker grew the night; and poor Effie made up her mind that she was quite forgotten and left to freeze alone. The tears were chilled on her cheeks, her feet felt like icicles, and her heart died within her, so hungry, frightened, and forlorn was she. Laying her head on her knees, she gave herself up for lost, and sat there with the great flakes fast turning her to a little white mound, when suddenly the sound of music reached her, and starting up, she looked and listened with all her eyes and ears.

Far away a dim light shone, and a voice was heard singing. She tried to run toward the welcome glimmer, but could not stir, and stood like a small statue of expectation while the light drew nearer, and the sweet words of the song grew clearer.

From our happy home
Through the world we roam
One week in all the year,
Making winter spring
With the joy we bring
For Christmas-tide is here.

Now the eastern star
Shines from afar
To light the poorest home;

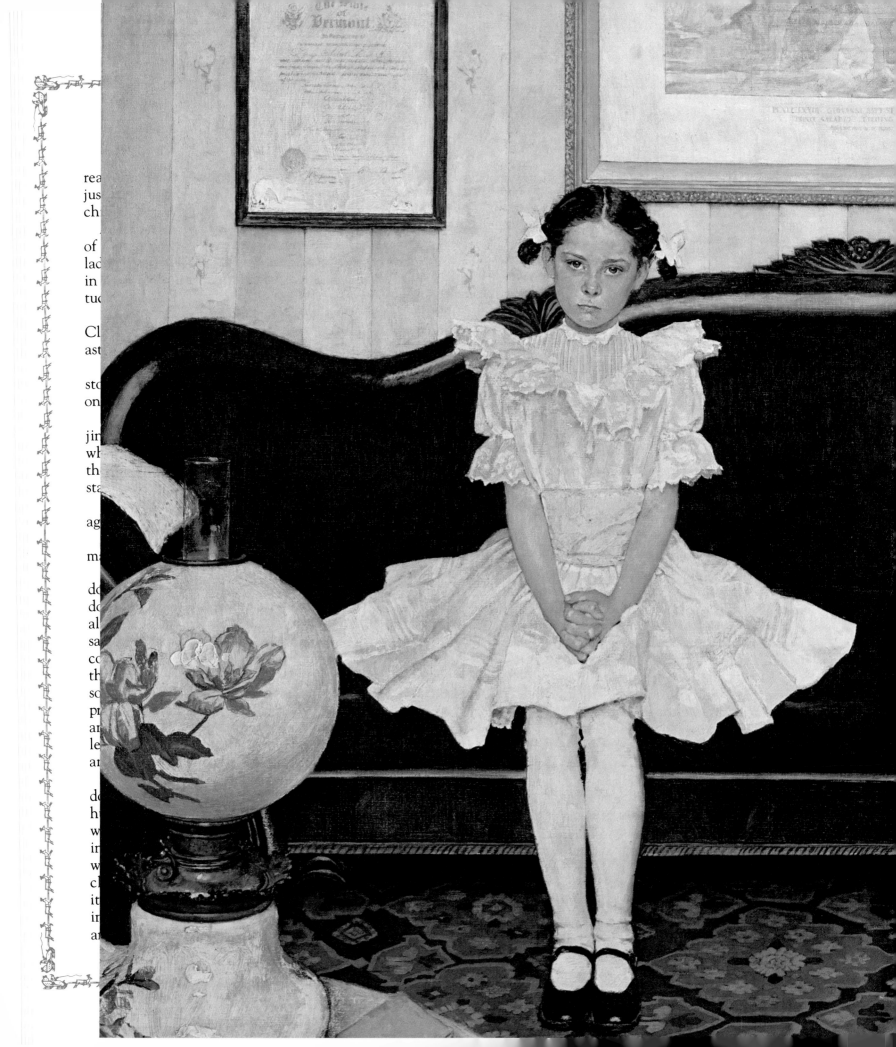

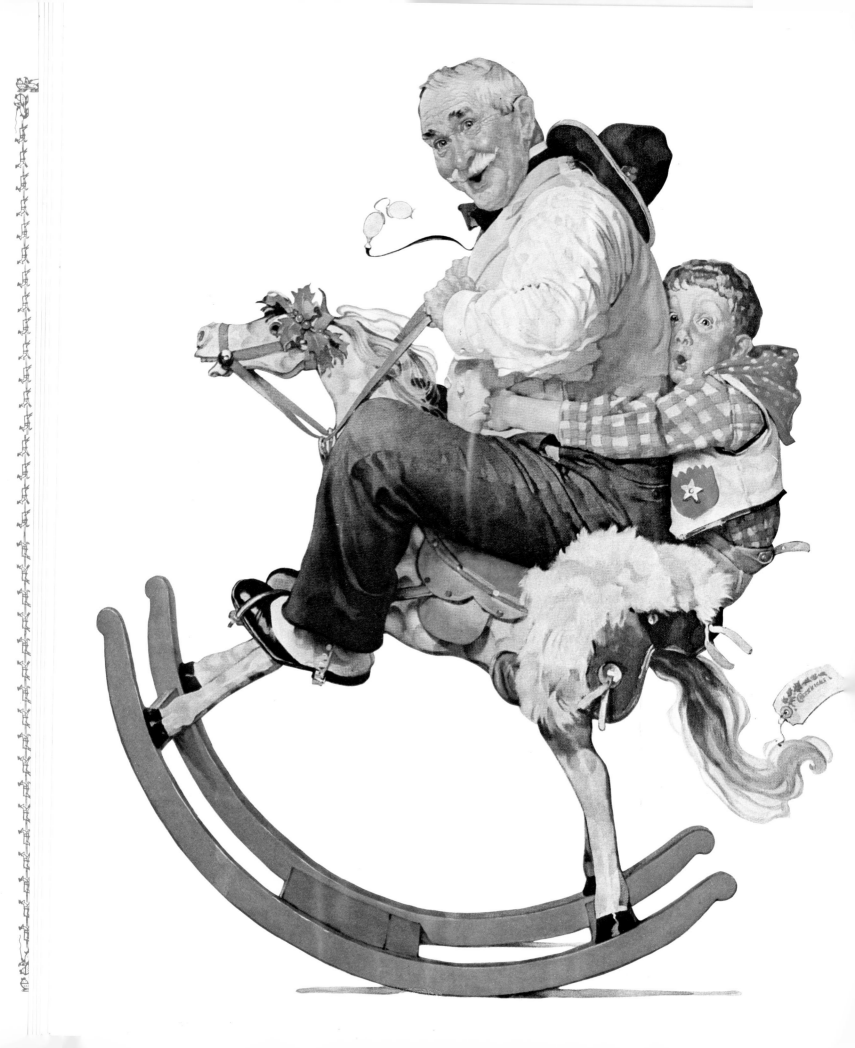

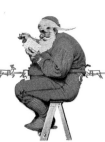

In Search of Christmas

JAMES E. FOGARTIE

Cliff Craig propped an elbow on his ancient typewriter, dropped his chin into the cup of his hand, and stared out across the deserted City Room.

For nineteen years he had coaxed news stories out of his machine. Some had fairly jumped from flying fingers, almost as fast as he could cover the long sheets of rough newsprint. Others had come harder, after mounds of paper had whipped out of the roller. Many had won him prizes and awards. But this was the toughest of all.

How simple it had seemed when his managing editor handed him the assignment, with an open expense account and all the time he needed. "Write a *new* Christmas story," Maxwell had said. That was all.

Now the deadline was just one day away—and there was nothing easy about it any more. His mind went back over his straining and searching for the elusive "angle" to make this a really new Christmas story.

He had set out to write a story that would leave out the old stuff—the Star, the Manger, the Inn, the Shepherds, and the Wise Men. All of these were good, understand, but worn thin by much writing and repeated telling. This was going to be completely new, something no one had yet uncovered.

He had gone through his files on Christmas and had reread many of his own stories, but none gave him a fresh cue. He had taken down an anthology of Christmas stories from his bookshelf and read the work of many an author; but still he could find nothing. He knew well the familiar accounts from the Gospels of Matthew and Luke, but after all, everybody knew them. This must be new, thoroughly new.

He found stories about the decree of Caesar Augustus, making comparisons between the Emperor and the Child.

Many efforts seemed to have exhausted the difficult journey of Mary and Joseph to Bethlehem—and the bright Star that shone over the City of David.

He lost count of stories about the Inn with no room, of the Stable, bleak and bare, and of the simple, rough-hewn Manger. Some had portrayed the Innkeeper as a good and godly man, who, with no room in his inn, had done the best he could for Mary and Joseph. At least he had furnished them shelter, a place away from the night air. Others had pictured the Innkeeper as a hardhearted businessman, concerned only with material gain, caring nothing for those for whom he had no room. The stable had merely been his way of ridding himself of the nuisance of a poor couple for whom he had no concern. These stories were all right; but he must have a new story, a fresh approach.

How many openings the Shepherds had provided! Tales had been told of the littlest shepherd, the oldest shepherd, the skeptical shepherd. Some had built their stories around the young son or daughter of one of the men who

spent that night on the Judean hillside. Shepherds were fine, but there was a limit to that angle, too.

Why, stories had even been written around the friendly beasts of the stable, but only so much could be written about animals.

He had given serious consideration to this business of the Wise Men. Certainly there was an air of mystery about them, and that should spur creative writing. He murmured aloud, "Strange old boys, those Wise Men from the East." Looking through his material he discovered Halford Luccock's column clipped from *The Christian Century*. It pictured these men of mystery as Wise Men from the West.

They could be dressed up a bit with Western garb. That would mean, of course, changing their gifts from gold, frankincense, and myrrh to more modern presents. After all, nobody knew anything about those ancient treasures, and cared less. Wise Men from the West. Everything would be changed.

As tradition had it, there were three Wise Men. The first was known as Kaspar. In our day he would be an industrialist, president of the Kaspar Manufacturing Company, Incorporated. His journey would take him out after bigger and better sales. He followed the Star, of course, but his primary concern was for new export outlets. He would get a lot of orders, but such a man would undoubtedly get so wrapped up in his own affairs that he would lose trace of the Star, and, in the end, never reach Bethlehem at all.

The second Wise Man is said to have been Balthazar. He was a Nubian prince, with skin of dark hue. Craig thought of him as an expert in military defense. He would recruit a great army before getting started to Bethlehem, for he might need protection on his journey. So he would spend most of his time in gathering recruits and in solving the problems of logistics. Rome, skeptical of such a force, would of course refuse to allow this army to pass through any of her provinces; thus, Balthazar would never get to Bethlehem either.

As for the third Wise Man, he was usually called Melchior. He, too, sought to find the King; but there were other important things on his mind. As president of Melchior, Melchior and Melchior, Advertising and Public Relations Consultants, he saw the possibility of a big promotion campaign, handled properly. He became busy giving out press releases in every hamlet and town through which he passed. That, along with entertaining local journalists, took time. To complete his coverage he made a detour into Egypt which took several months. By the time he arrived in Bethlehem, the infant King was gone. Melchior never saw Him, nor was he able to present his gift.

Craig mused over this possibility. It was different, yes, but perhaps too bitingly true to life. It was just as well, then, that the Wise Men came from the East. Leave the story that way.

Another clipping told of the efforts of a television star in trying to find a green Christmas tree. In New York City there were plenty of evergreens, but they were not green. All of them had been changed in order to improve their looks. There were silver trees, blue trees, pink trees. Some were even green, but not the natural green of the forest.

Could it be that we have tried to repaint Christmas in our own colors, attempting thereby to make it another novelty? And, in so doing, have we betrayed the shallowness of our own Christian understanding? Of course, this theme could be overplayed and might be misunderstood. Perhaps it would be better to leave it alone.

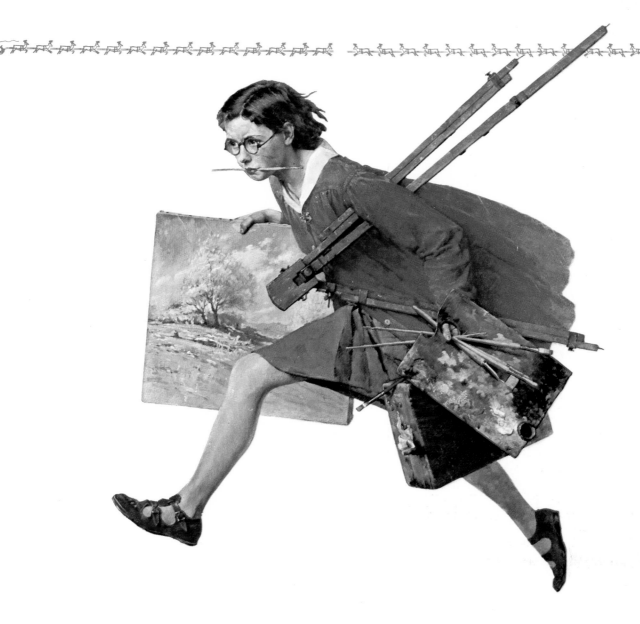

Pursuing still another idea to its fruitless end, he remembered the question asked in Jerusalem by those mysterious visitors from the East: "Where is he that is born King of the Jews? for we have seen his star in the east, and are come to worship him."

Perhaps the answer to that question would show him the new lead he sought. "Where is he that is born King of the Jews?" It was a haunting question, indeed. It disturbed him, prodded him up from his desk. He left the City Room partly to escape the question, or was it to find an answer to it? He did not know. But he did know that time was running out and that he must quickly find a new Christmas story.

Just outside the building he noticed several men, standing on the curb around a kettle hung from a tripod. With noisily ringing bells they called to passersby for contributions to the needy. "Well," he said, "they are still at it—the same old thing, year in and year out." There was nothing new here.

He passed on down the street. Craig's roving eyes caught the beautifully decorated windows of a large department store. He decided to go in and look around—why, he wasn't certain. Surely there could be nothing here to give him an idea. He took his time, browsing here and there.

As he had expected there were crowds of people—weary, harried people, all hurrying to make

last-minute purchases, wanting speedy service from overworked clerks. He was surprised to note that the clerks seemed cheerful despite their tired faces. "Merry Christmas," they called to departing customers. And the customers, though pushed and jostled and squeezed, managed to smile and say, "Thank you." "Well," he thought, "it seems as though the spirit of the King is here, even among these bustling, shoving crowds."

Out on the street again, he wandered toward one of the big fire stations. He knew the boys there—had covered some fires they had fought. The place seemed unusually busy, more like a toy shop than a fire station. And it was! He had forgotten. These men devoted many hours to repairing and repainting toys for youngsters who would otherwise have a toyless Christmas. Busy men they were, calling happily to one another as they worked. They greeted him enthusiastically, proudly exhibiting their handiwork. As he left, those words of the Master came to him, "Inasmuch as ye have done it unto one of the least of these . . . ye have done it unto me."

Suddenly he stopped, recalling an incident in his own home a few days before. His little daughter had been getting together some gifts for a basket which her Sunday school class was preparing to give to a family who needed help. She had come down from her room bearing one of her favorite dolls and announced she was going to put it in among the gifts. It was in excellent condition, having had wonderful care from its little mistress. With the doll she brought changes of clothing and miniature luggage. Here was a gift to thrill the heart of any little girl on Christmas morning.

He had almost chided her about giving away so fine a possession, but she had said gaily, "Daddy, I want to give this. I've had so much fun with this doll, I want someone else to have fun with her, too. That's what Christmas is all about, isn't it, Daddy?" Remembering her unselfishness and joy, he recalled some words from C. S. Lewis' au-

tobiography, in which he said that joy can be a means of bringing us to God. "Indeed," he thought, "my little girl seems to know better than I what Christmas is all about. I believe she knows where the King can be found. But that's not getting my story."

On he walked, passing a group of young people happily chatting about the caroling planned for that evening. "Oh, yes, we must go there," said one. "They always seem to appreciate our coming." And another broke in, "But we must not leave out the family down the street. They say it would not be Christmas without carols sung outside the door."

His path led to a great church. He paused to glance in the open door and watched a group busily decorating the sanctuary. Another group seemed to be in the midst of a rehearsal for a pageant or a play. What joy was in their faces! How happily they worked!

On and on he walked, and the sights that met his eyes were familiar and in keeping with the season. Occasionally he saw things that caused him to question whether they were really a part of Christmas; but for the most part the people he met had joy in their faces and a spring in their step. Certainly they seemed to have the spirit of Christmas.

Gradually he became aware of the question of the Wise Men, "Where is he that is born King of the Jews?" It seemed to be ringing louder in his ears. Could this—all that he had seen—give him his story? Could it be that these folk had found Christmas indeed? There were the men with the bells and the kettle, the smiles on the faces of the weary clerks, the words of gratitude expressed by bustling customers, the firemen in their unselfish work, the generosity of his little daughter, the carolers with their singing, the people in the church—all these had been asking the Wise Men's question.

Then he recalled something else. He remembered that one of his friends had refused to help

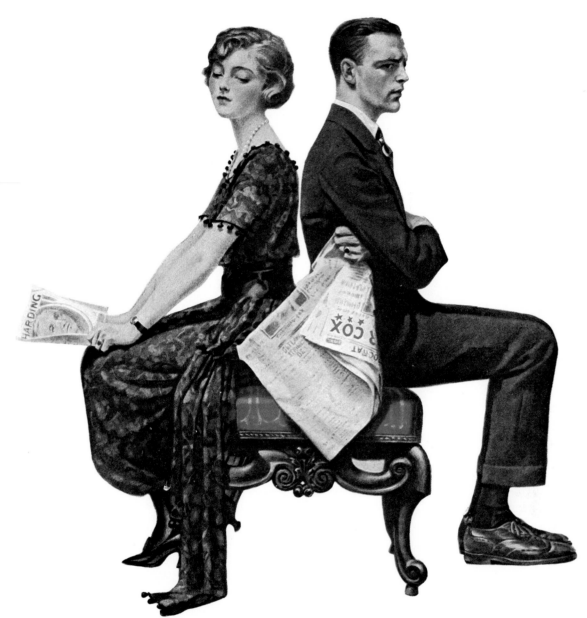

pay for the big office party. He had said, "I'm not against the idea of a party. But I have decided to give my part this year to CARE to help those who have suffered for their freedom and for their faith."

Yes, there was a difference in these people. As the Wise Men before them, they had made a tremendous discovery. They had found the King, and having found Him, they were not content with mere talk. They were worshiping Him with their gifts and with their lives.

Standing upon that city street, the truth dawned upon him. There was no new Christmas story! There never would be one. There was no reason to strive for novelty. The wondrous story of the Babe of Bethlehem was continuously new.

Cliff Craig walked confidently back to his waiting typewriter. There was no need to hurry. Already the story was taking shape in his mind, as if some unseen hand were tapping it out on a moving tape. This would be the best story he had ever written.

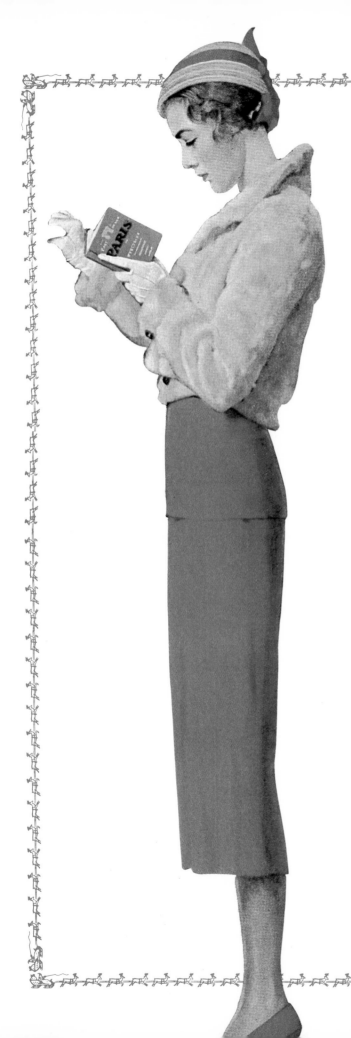

The Christmas Heart

GEORGE MATTHEW ADAMS

The Christmas heart is a beautiful heart for it is full of love and thoughtfulness for others.

And the Christmastime is a tribute to the most beautiful heart that ever beat.

It is also the time in which we are brought closest to our own inadequate abilities and helplessness of spirit. For we are so bathed with unselfishness that we feel our failures and lacks as never before in the entire year.

Perhaps it is well this way, so that we may resolve anew to live better and stronger lives for those who mean so much to us.

So let us cherish this Christmas heart and keep it a Christmas heart all through the year to come.

Let us put on all the lights in this heart so that it will be aglow to the world and let us push up the shades of the windows in this heart so that everyone who passes may be cheered and inspired.

Let us remember that the Christmas heart is a giving heart, a wide-open heart that thinks of others first.

The birth of the baby Jesus stands as the most significant event in all history, because it has meant the pouring into a sick world of the healing medicine of love which has transformed all manner of hearts for almost two thousand years and given beauty to human service it would never have had otherwise.

Underneath all the bulging bundles is this beating Christmas heart. Enwrapped about the tiniest gift is this same loveliness of thought and heart expression.

What a happy New Year for all if we would carry this same Christmas heart into every day during the coming year and make it a permanent thing in our lives. Let's do it!

The Light From the Cave

SIDNEY FIELDS

The innkeeper's wife, small and timid, was telling the story to her incredulous neighbors:

"You never saw such a light. And it wrought such strange events. How can I ever describe it?

"Do you remember that night last week when the town was so crowded? Everyone wanted a room. But we had none left. Zara, whose brother had struck my husband, was pleading with my husband not to press charges.

"Into this confusion came the man Joseph and his wife, Mary. She was but a girl. When Joseph asked for a room, my husband vented his anger upon him. Joseph bowed his head, and pointed to the cave outside.

"'Might we use the cave?' he begged. 'My wife is to be delivered of a child soon. We will not disturb the animals.'

"'Go elsewhere,' my husband said.

"In shame I followed Joseph outside to comfort him. His wife smiled gently, though she was troubled. It was no ordinary face. Quickly, without knowing why, I told them to use the cave.

Suddenly, there was a new strength in me. I feared not my husband's anger, though I could hear him shouting at Zara, 'Your brother tried to rob me. He will be stoned to death!' And Zara was pleading, 'Have you no forgiveness?'

"It was the servant boy on an errand for my husband who later discovered Joseph and Mary in the cave. My husband, his face white with anger, followed by Zara, quickly came out toward the cave. But their steps faltered. It was the soft cry of the Child that halted them.

"Mary held the Babe while Joseph knelt beside her. The radiance of Mary's face was bright. But still brighter was the light from the dark cave.

"A Child was born. And love was born then, too. For my husband's eyes filled with torment, and he spoke softly, 'Zara,' he said, 'ask your brother to forgive me.'

"And the light shone even brighter. Will you come and see it? The light is still there although the man, his wife and the Child are gone. I think the light will shine forever."

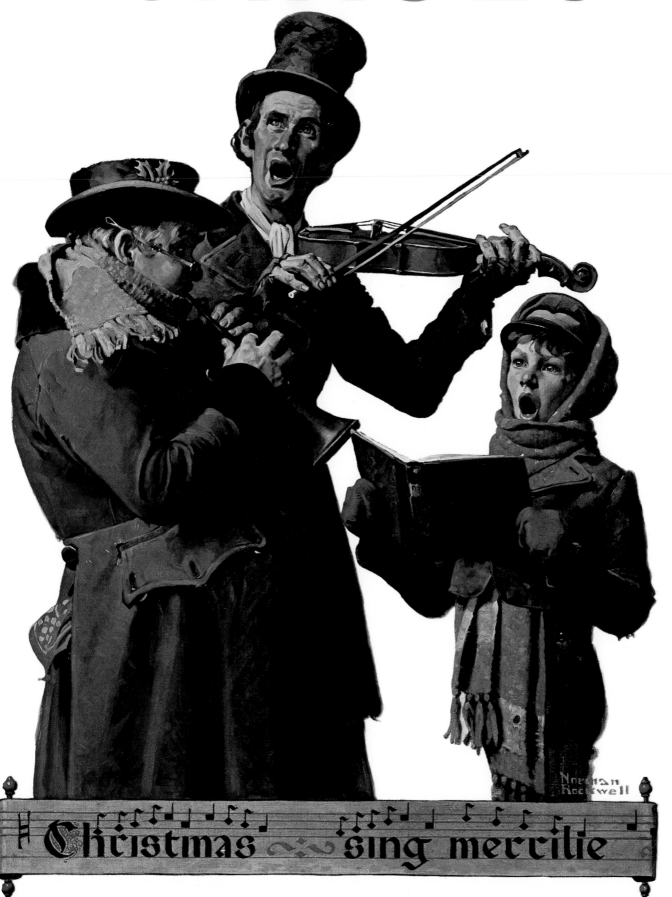

O Little Town of Bethlehem

Phillips Brooks (1835–1893)

Lewis H. Redner (1831–1908)

R.F.

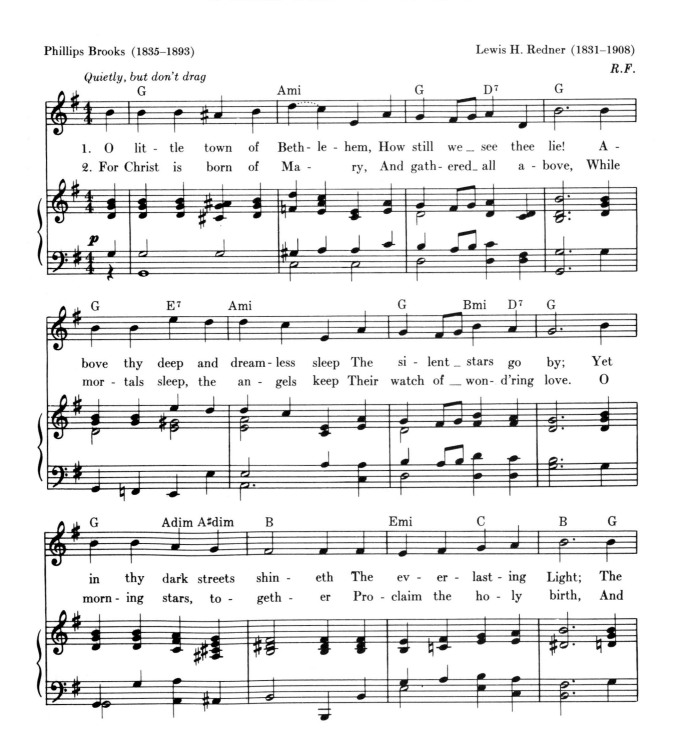

1. O lit - tle town of Beth - le - hem, How still we _ see thee lie! A -
2. For Christ is born of Ma - ry, And gath - ered _ all a - bove, While

bove thy deep and dream - less sleep The si - lent _ stars go by; Yet
mor - tals sleep, the an - gels keep Their watch of _ won - d'ring love. O

in thy dark streets shin - eth The ev - er - last - ing Light; The
morn - ing stars, to - geth - er Pro - claim the ho - ly birth, And

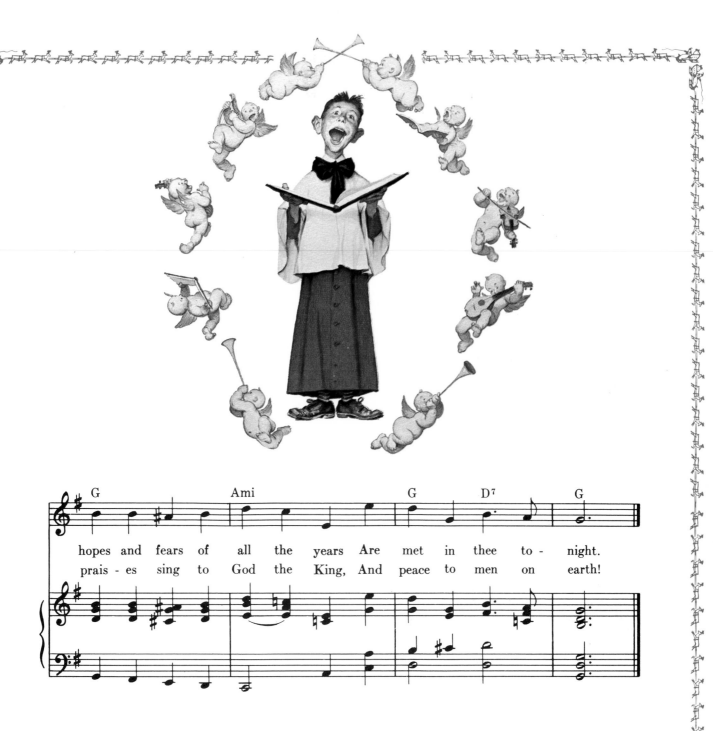

| G | | Ami | | G | D⁷ | G |

hopes and fears of all the years Are met in thee to - night.
prais - es sing to God the King, And peace to men on earth!

3. How silently, how silently,
 The wondrous gift is giv'n!
 So God imparts to human hearts
 The blessings of His heav'n.
 No ear may hear His coming,
 But in this world of sin,
 Where meek souls will receive Him still,
 The Dear Christ enters in.

4. O holy Child of Bethlehem,
 Descend to us, we pray;
 Cast out our sin and enter in;
 Be born in us today!
 We hear the Christmas angels
 The great glad tidings tell;
 O come to us, abide with us
 Our Lord Emmanuel!

We Three Kings of Orient Are

John Henry Hopkins, Jr. (1820–1891)

Simply and without dragging

John Henry Hopkins, Jr.

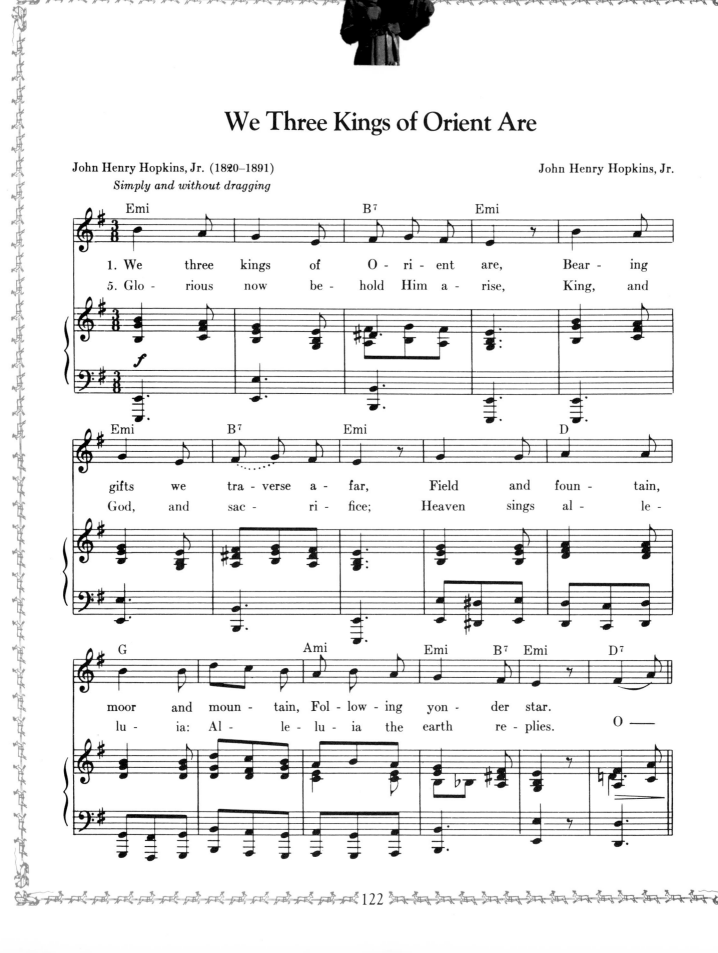

1. We three kings of O - ri - ent are, Bear - ing
5. Glo - rious now be - hold Him a - rise, King, and

gifts we tra - verse a - far, Field and foun - tain,
God, and sac - ri - fice; Heaven sings al - le -

moor and moun - tain, Fol - low - ing yon - der star.
lu - ia: Al - le - lu - ia the earth re - plies. O —

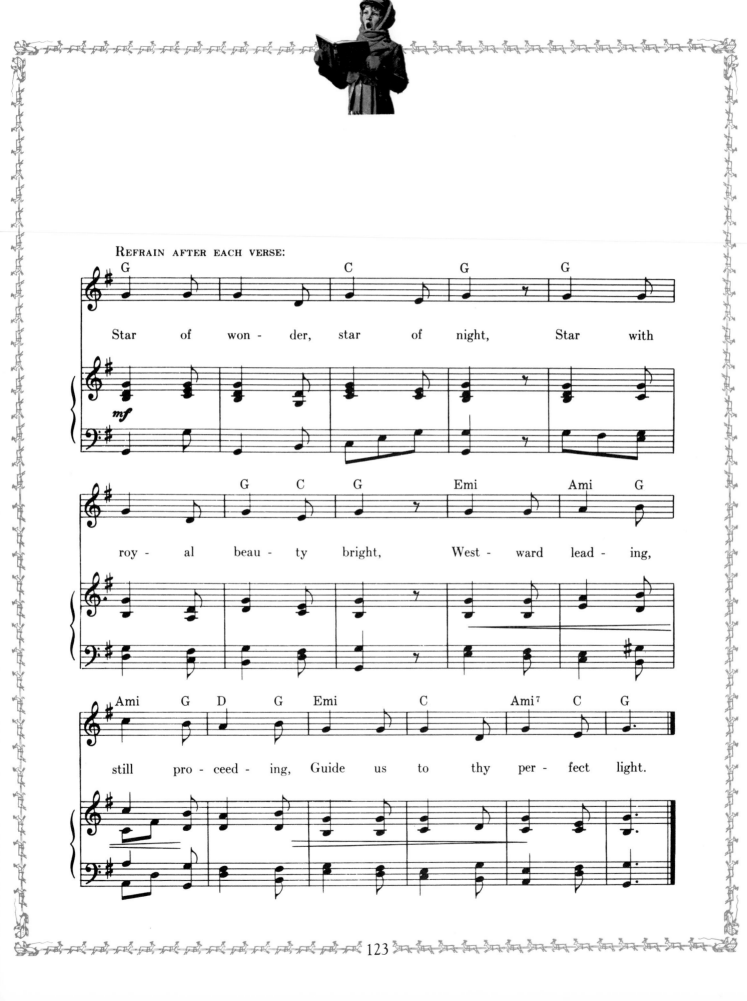

Star of won - der, star of night, Star with

roy - al beau - ty bright, West - ward lead - ing,

still pro - ceed - ing, Guide us to thy per - fect light.

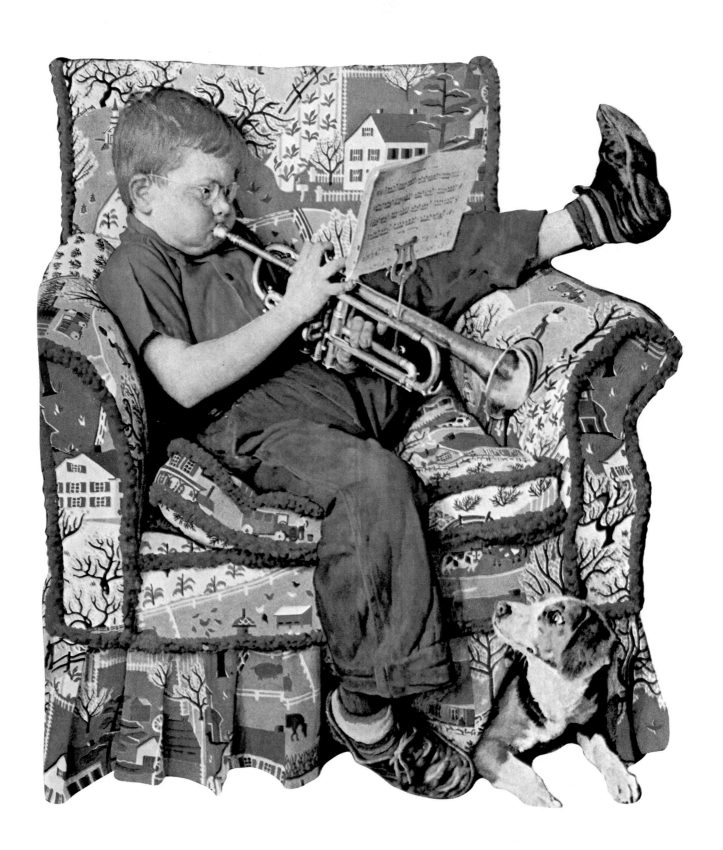

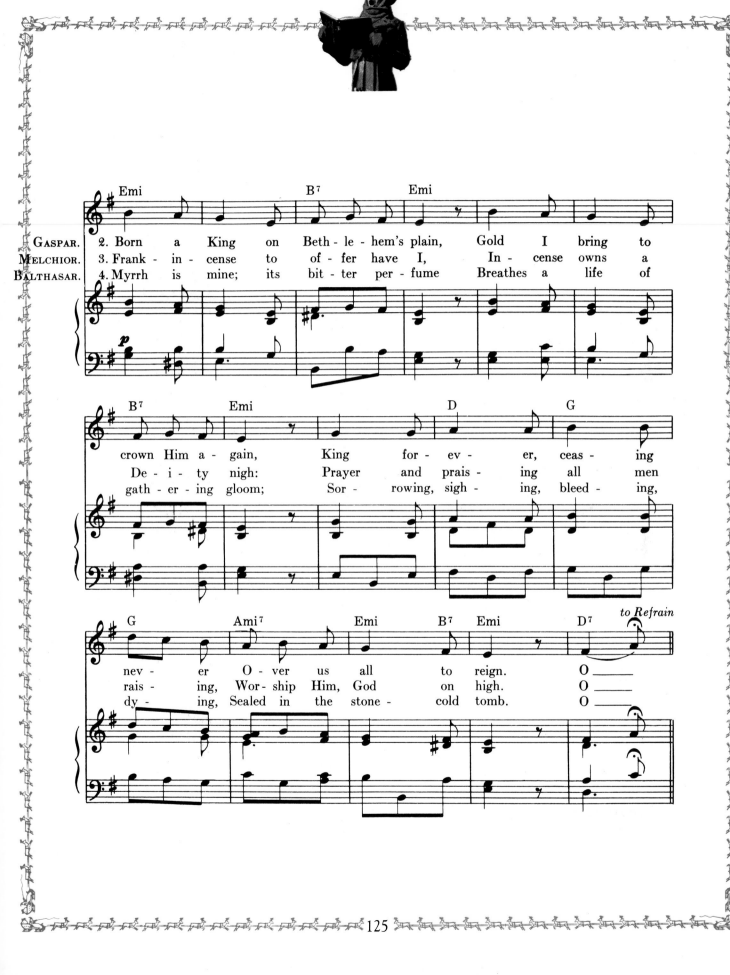

GASPAR. 2. Born a King on Beth - le - hem's plain, Gold I bring to
MELCHIOR. 3. Frank - in - cense to of - fer have I, In - cense owns a
BALTHASAR. 4. Myrrh is mine; its bit - ter per - fume Breathes a life of

crown Him a - gain, King for - ev - er, ceas - ing
De - i - ty nigh: Prayer and prais - ing all men
gath - er - ing gloom; Sor - rowing, sigh - ing, bleed - ing,

nev - er O - ver us all to reign. O
rais - ing, Wor - ship Him, God on high. O
dy - ing, Sealed in the stone - cold tomb. O

to Refrain

What Child Is This?

William Chatterton Dix (1837-1898)
With Motion

16th-century English
R.F.

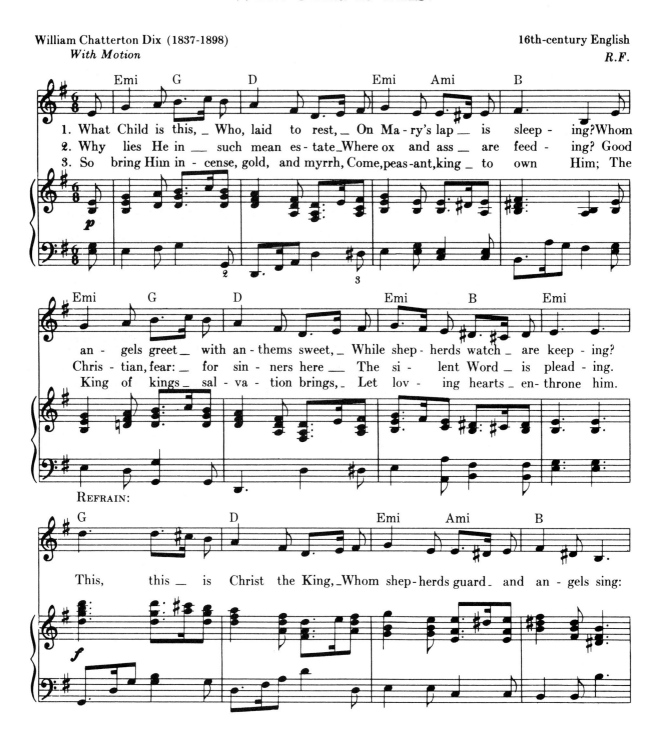

1. What Child is this, _ Who, laid to rest, _ On Ma-ry's lap _ is sleep - ing? Whom
2. Why lies He in _ such mean es-tate _ Where ox and ass _ are feed - ing? Good
3. So bring Him in-cense, gold, and myrrh, Come, peas-ant, king _ to own Him; The

an - gels greet _ with an - thems sweet, _ While shep - herds watch _ are keep - ing?
Chris - tian, fear: _ for sin - ners here _ The si - lent Word _ is plead - ing.
King of kings _ sal - va - tion brings, Let lov - ing hearts _ en - throne him.

REFRAIN:

This, this _ is Christ the King, _ Whom shep-herds guard _ and an - gels sing:

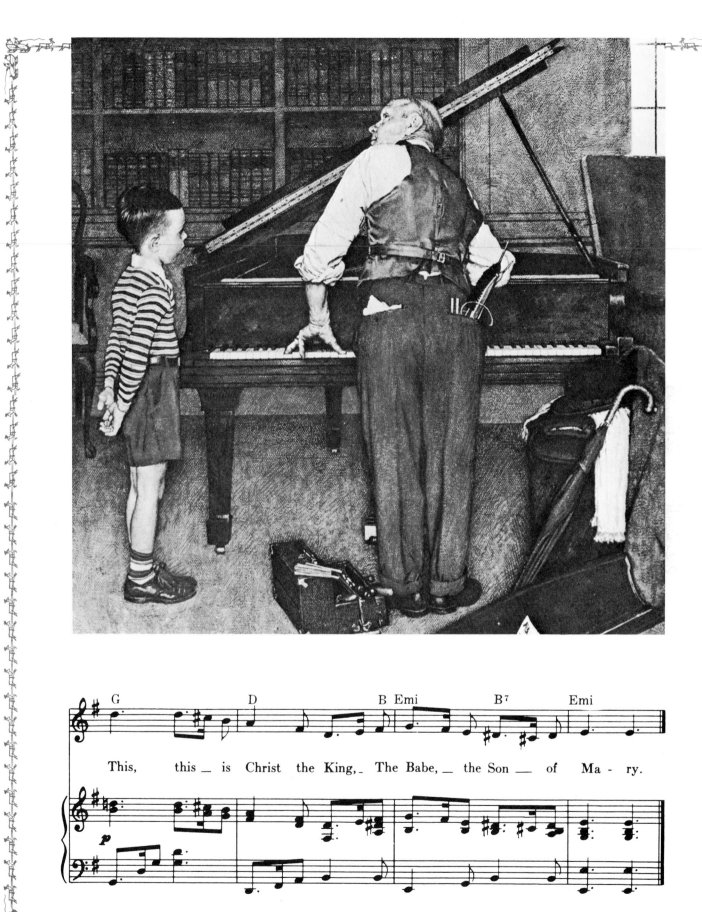

This, this _ is Christ the King, _ The Babe, _ the Son _ of Ma - ry.

It Came upon a Midnight Clear

Edmund H. Sears (1810–1876)
Flowing but not too fast

Richard S. Willis (1819–1900)
R.F.

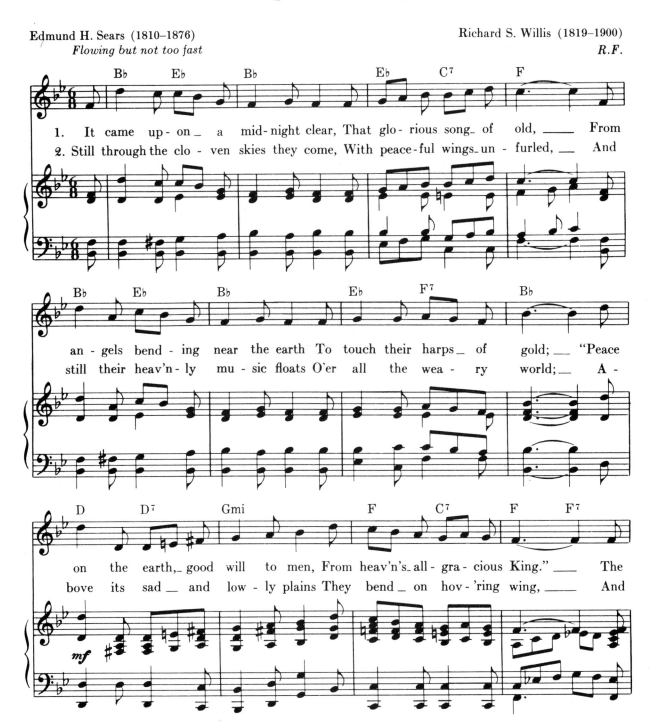

1. It came up-on a mid-night clear, That glo-rious song of old, ____ From an - gels bend - ing near the earth To touch their harps of gold; ____ "Peace on the earth, good will to men, From heav'n's all - gra - cious King." ____ The

2. Still through the clo - ven skies they come, With peace-ful wings un - furled, And still their heav'n - ly mu - sic floats O'er all the wea - ry world; ____ A - bove its sad and low - ly plains They bend on hov - 'ring wing, ____ And

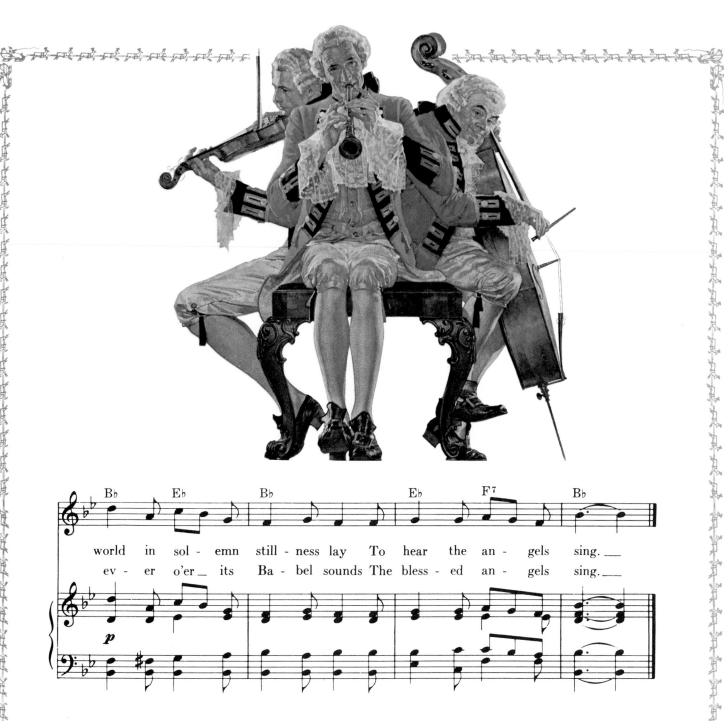

world in sol - emn still - ness lay To hear the an - gels sing. ___
ev - er o'er ___ its Ba - bel sounds The bless - ed an - gels sing. ___

3. O ye, beneath life's crushing load,
 Whose forms are bending low,
 Who toil along the climbing way,
 With painful steps and slow,
 Look now, for glad and golden hours
 Come swiftly on the wing:
 O rest beside the weary road,
 And hear the angels sing!

4. For lo! the days are hast'ning on,
 By prophets seen of old,
 When with the ever circling years,
 Shall come the time foretold,
 When the new heav'n and earth shall own
 The Prince of Peace their King,
 And the whole world send back the song
 Which now the angels sing.

Silent Night

Joseph Mohr (1792–1848)

Franz Xavier Gruber (1787–1863)

H.W.S.

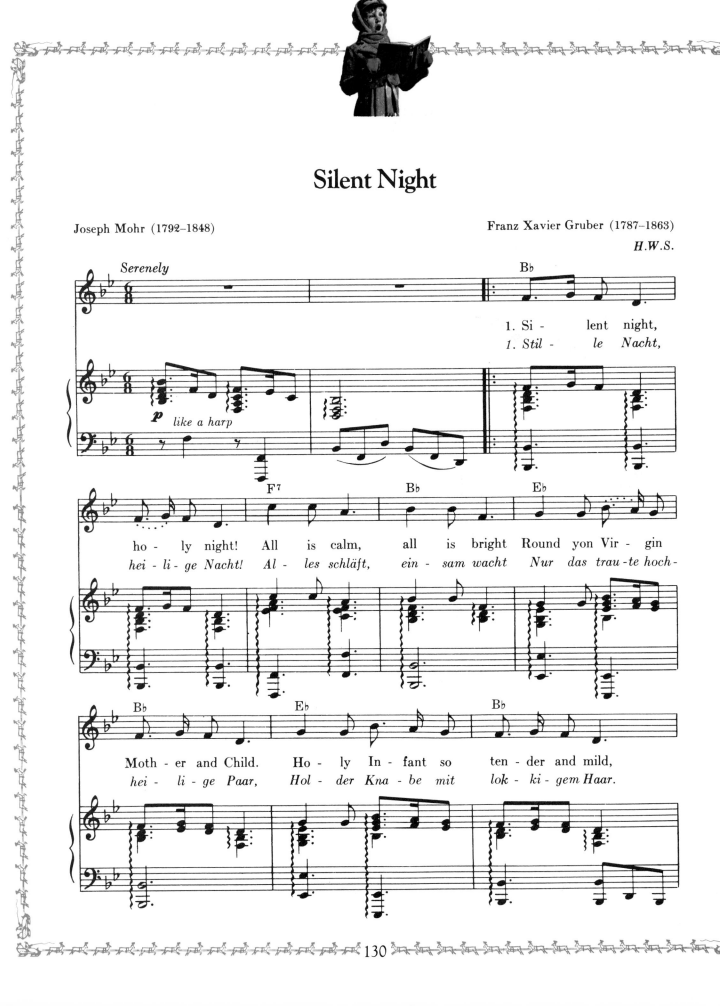

1. Si - lent night, ho - ly night! All is calm, all is bright Round yon Vir - gin Moth - er and Child. Ho - ly In - fant so ten - der and mild,

1. Stil - le Nacht, hei - li - ge Nacht! Al - les schläft, ein - sam wacht Nur das trau - te hoch- hei - li - ge Paar, Hol - der Kna - be mit lok - ki - gem Haar.

Sleep in heav - en - ly peace, _____ Sleep in heav - en - ly peace.
Schlaf in himm - li - scher Ruh, _____ Schlaf in himm - li - scher Ruh!

omit for last stanza

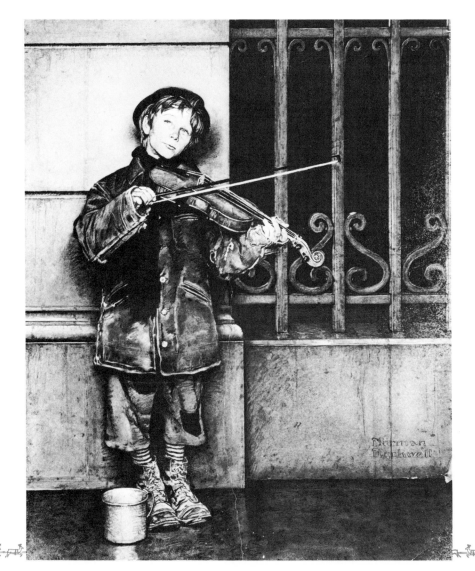

Hark! the Herald Angels Sing

Charles Wesley (1707–1788)

Felix Mendelssohn-Bartholdy (1809–1847)

R.F.

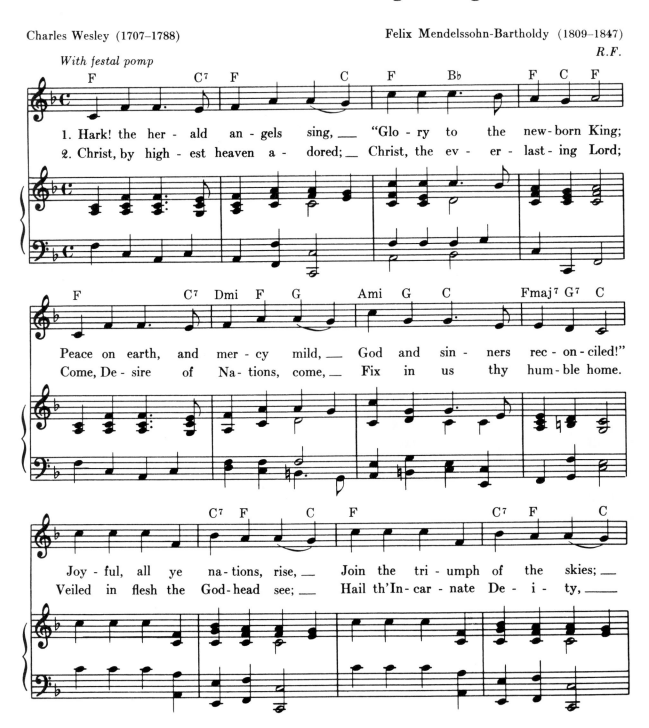

1. Hark! the her - ald an - gels sing, ___ "Glo - ry to the new-born King;
2. Christ, by high - est heaven a - dored; ___ Christ, the ev - er - last-ing Lord;

Peace on earth, and mer - cy mild, ___ God and sin - ners rec - on-ciled!"
Come, De - sire of Na - tions, come, ___ Fix in us thy hum - ble home.

Joy - ful, all ye na - tions, rise, ___ Join the tri - umph of the skies; ___
Veiled in flesh the God-head see; ___ Hail th'In - car - nate De - i - ty, ___

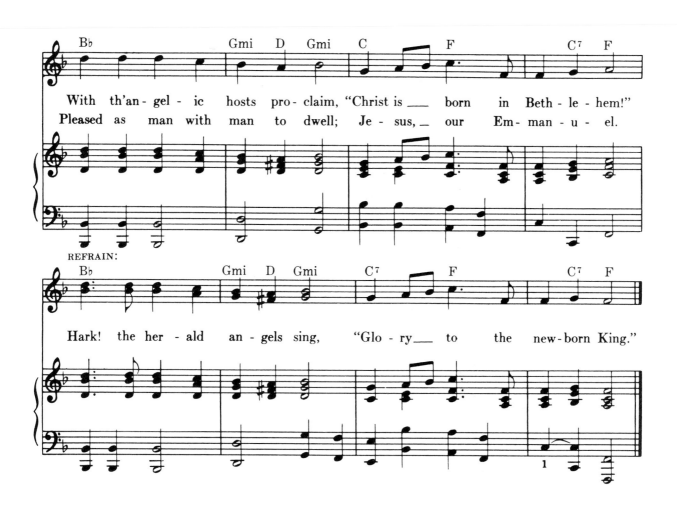

With th'an-gel-ic hosts pro-claim, "Christ is ___ born in Beth-le-hem!"
Pleased as man with man to dwell; Je-sus, ___ our Em-man-u-el.

REFRAIN:

Hark! the her-ald an-gels sing, "Glo-ry___ to the new-born King."

3. Hail, the heav'n-born Prince of Peace!
Hail, the Sun of Righteousness!
Light and life to all He brings,
Ris'n with healing in His wings;
Mild He lays His glory by,
Born that man no more may die,
Born to raise the sons of earth,
Born to give them second birth;

Refrain:

Angels We Have Heard on High

Les Anges dans nos campagnes

Traditional French
Swiftly, joyously

Traditional French
H.W.S.

An - gels we have heard on high,— Sweet - ly sing - ing o'er the plains,
Les an - ges dans nos cam-pa-gnes Ont en - ton - né l'hymne des cieux;

And the — moun-tains — in re - ply. Ech - o - ing their — joy - ous strains.
Et l'é - cho de nos mon-ta-gnes Re - dit — ce chant — mé - lo-dieux:

Glo - ri - a

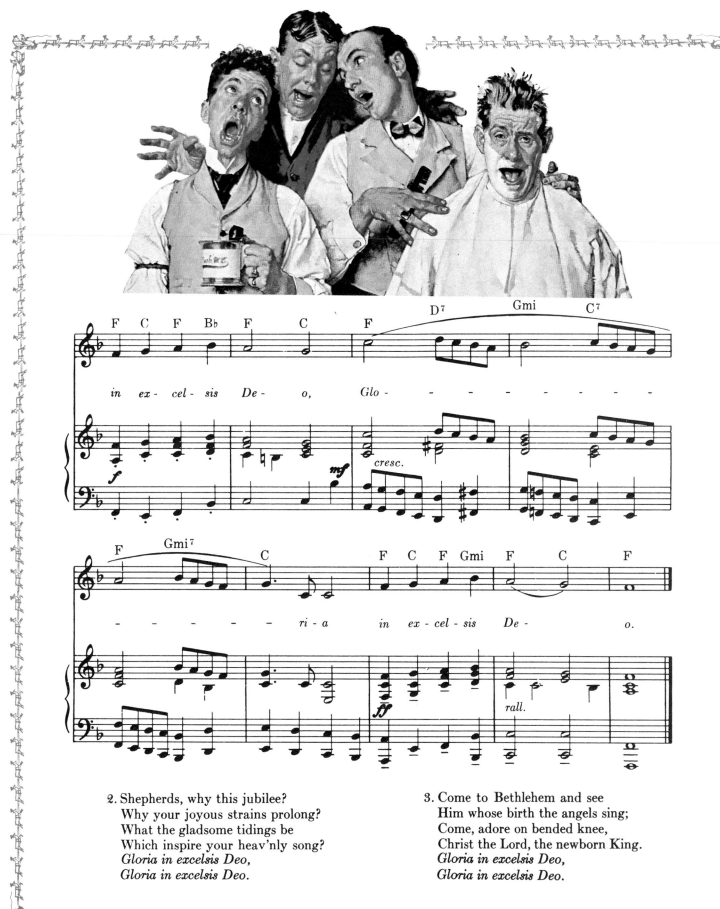

in ex - cel - sis De - o, Glo - - - - - - - - - ri - a in ex - cel - sis De - o.

2. Shepherds, why this jubilee?
 Why your joyous strains prolong?
 What the gladsome tidings be
 Which inspire your heav'nly song?
 Gloria in excelsis Deo,
 Gloria in excelsis Deo.

3. Come to Bethlehem and see
 Him whose birth the angels sing;
 Come, adore on bended knee,
 Christ the Lord, the newborn King.
 Gloria in excelsis Deo,
 Gloria in excelsis Deo.

The First Nowell

Traditional

Traditional
H.W.S.

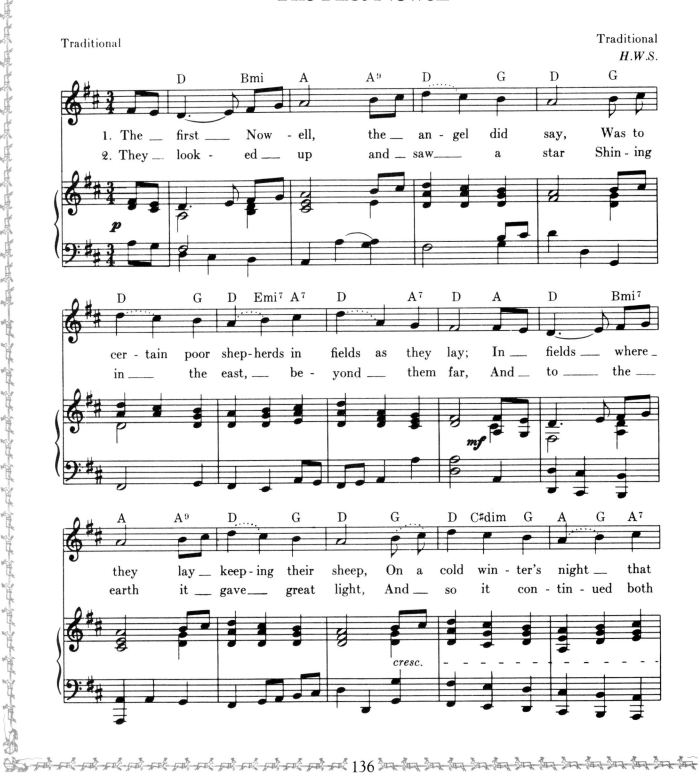

1. The __ first __ Now - ell, the __ an - gel did say, Was to cer - tain poor shep-herds in fields as they lay; In __ fields __ where __ they lay __ keep-ing their sheep, On a cold win - ter's night __ that

2. They __ look - ed __ up and __ saw __ a star Shin - ing in __ the east, __ be - yond __ them far, And __ to __ the __ earth it __ gave __ great light, And __ so it con - tin - ued both

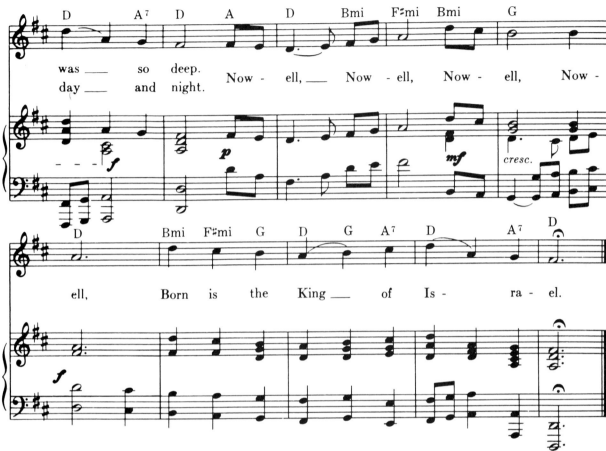

was __ so deep. Now - ell, __ Now - ell, Now - ell, Now -
day __ and night.

ell, Born is the King __ of Is - ra - el.

3. And by the light of that same star
 Three wisemen came from country far;
 To seek for a King was their intent,
 And to follow the star wherever it went.
 Refrain:

4. This star drew nigh to the northwest,
 O'er Bethlehem it took its rest;
 And there it did both stop and stay,
 Right over the place where Jesus lay.
 Refrain:

5. Then did they know assuredly
 Within that house the King did lie;
 One enter'd it them for to see,
 And found the Babe in poverty.
 Refrain:

6. Then entered in those wisemen three,
 Full reverently upon the knee,
 And offered there, in His presence,
 Their gold and myrrh and frankincense.
 Refrain:

7. Between an ox-stall and an ass,
 This Child truly there He was;
 For want of clothing they did him lay
 All in a manger, among the hay.
 Refrain:

8. Then let us all with one accord
 Sing praises to our heav'nly Lord;
 That hath made heaven and earth of naught,
 And with His blood mankind hath bought.
 Refrain:

9. If we in our time shall do well,
 We shall be free from death and hell;
 For God hath prepared for us all
 A resting place in general.
 Refrain:

God Rest You Merry, Gentlemen

Traditional English

Traditional English
R.F.

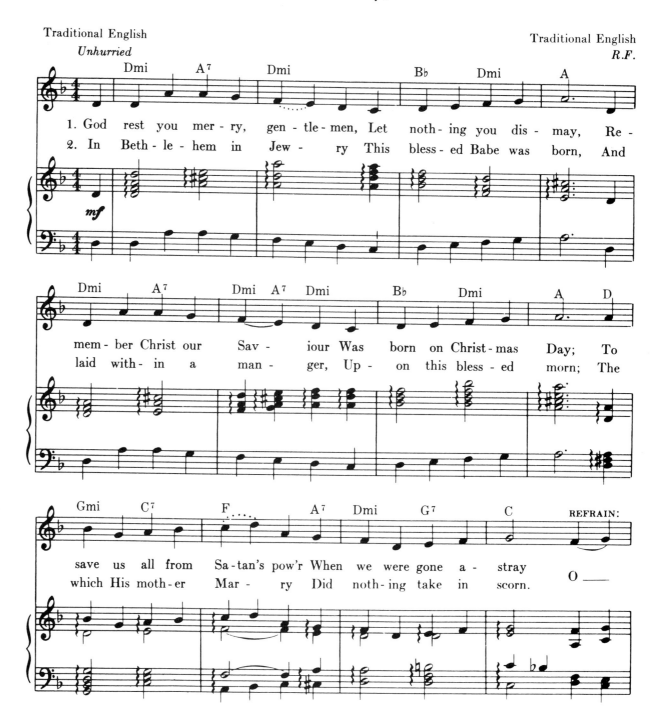

1. God rest you mer-ry, gen-tle-men, Let noth-ing you dis-may, Re-
2. In Beth-le-hem in Jew-ry This bless-ed Babe was born, And

mem-ber Christ our Sav-iour Was born on Christ-mas Day; To
laid with-in a man-ger, Up-on this bless-ed morn; The

save us all from Sa-tan's pow'r When we were gone a-stray
which His moth-er Mar-ry Did noth-ing take in scorn.

REFRAIN:

O —

ti - dings of com - fort and joy, com - fort and joy; O ____

ti - dings of com - fort and joy.

3. From God our heav'nly Father
 A blessed angel came;
 And unto certain shepherds
 Brought tidings of the same;
 How that in Bethlehem was born
 The son of God by name.
 Refrain:

4. "Fear not, then," said the angel,
 "Let nothing you affright,
 This day is born a Saviour
 Of a pure Virgin bright,
 To free all those who trust in Him
 From Satan's power and might."
 Refrain:

5. The shepherds at those tidings
 Rejoicéd much in mind,
 And left their flocks a-feeding,
 In tempest, storm, and wind,
 And went to Bethl'em straightway
 This blessed Babe to find.
 Refrain:

6. But when to Bethlehem they came,
 Whereat this Infant lay,
 They found Him in a manger,
 Where oxen feed on hay;
 His mother Mary kneeling,
 Unto the Lord did pray.
 Refrain:

7. Now to the Lord sing praises,
 All you within this place,
 And with true love and brotherhood
 Each other now embrace;
 This holy tide of Christmas
 All others doth deface.
 Refrain:

8. God bless the ruler of this house,
 And send him long to reign,
 And many a merry Christmas
 May live to see again;
 Among your friends and kindred
 That live both far and near—
 And God send you a happy new year, happy new year,
 And God send you a happy new year.

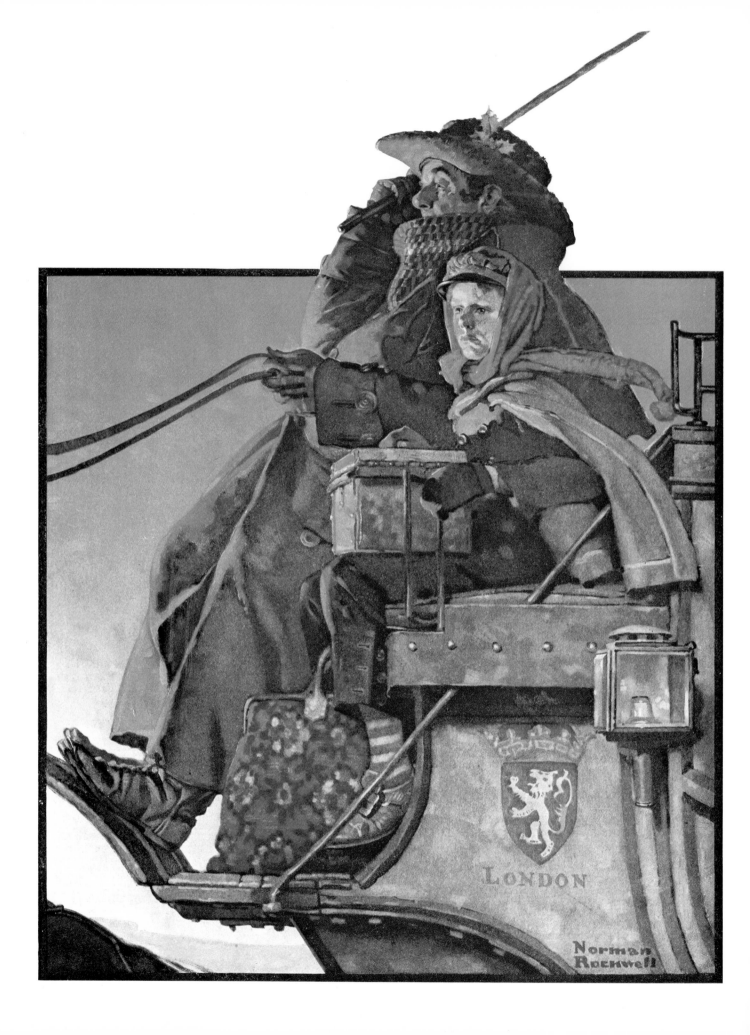

POEMS

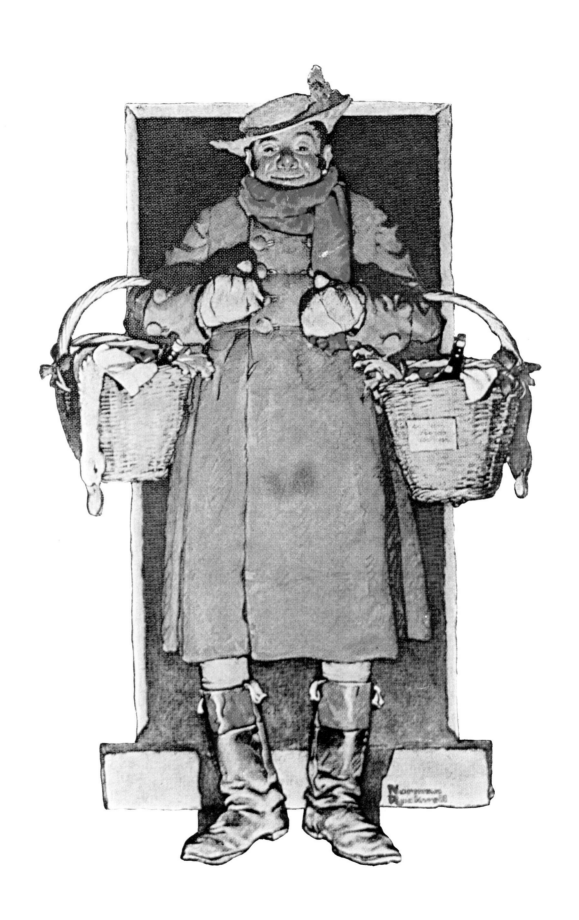

Christmas in a Village

JOHN CLARE

Each house is swept the day before,
And windows stuck with evergreens;
The snow is besomed from the door,
And comfort crowns the cottage scenes.
Gilt holly with its thorny pricks
And yew and box with berries small,
These deck the unused candlesticks,
And pictures hanging by the wall.

Neighbours resume their annual cheer,
Wishing with smiles and spirits high
Glad Christmas and a happy year
To every morning passer-by.
Milkmaids their Christmas journeys go
Accompanied with favoured swain,
And children pace the crumping snow
To taste their granny's cake again.

Hung with the ivy's veining bough,
The ash trees round the cottage farm
Are often stripped of branches now
The cottar's Christmas hearth to warm.
He swings and twists his hazel band,
And lops them off with sharpened hook,
And oft brings ivy in his hand
To decorate the chimney nook...

The shepherd now no more afraid
Since custom doth the chance bestow
Starts up to kiss the giggling maid
Beneath the branch of mistletoe
That 'neath each cottage beam is seen
With pearl-like berries shining gay,
The shadow still of what hath been
Which fashion yearly fades away.

And singers too, a merry throng,
At early morn with simple skill
Yet imitate the angel's song
And chant their Christmas ditty still;
And 'mid the storm that dies and swells
By fits—in hummings softly steals
The music of the village bells
Ringing round their merry peals.

And when it's past, a merry crew
Bedecked in masks and ribbons gay,
The morris dance their sports renew
And act their winter evening play.
The clown turned king for penny praise
Storms with the actor's strut and swell,
And harlequin a laugh to raise
Wears his hunchback and tinkling bell.

And oft for pence and spicy ale
With winter nosegays pinned before,
The wassail singer tells her tale
And drawls her Christmas carols o'er,
While prentice boy with ruddy face
And rime-bepowdered dancing locks
From door to door with happy pace
Runs round to claim his Christmas box.

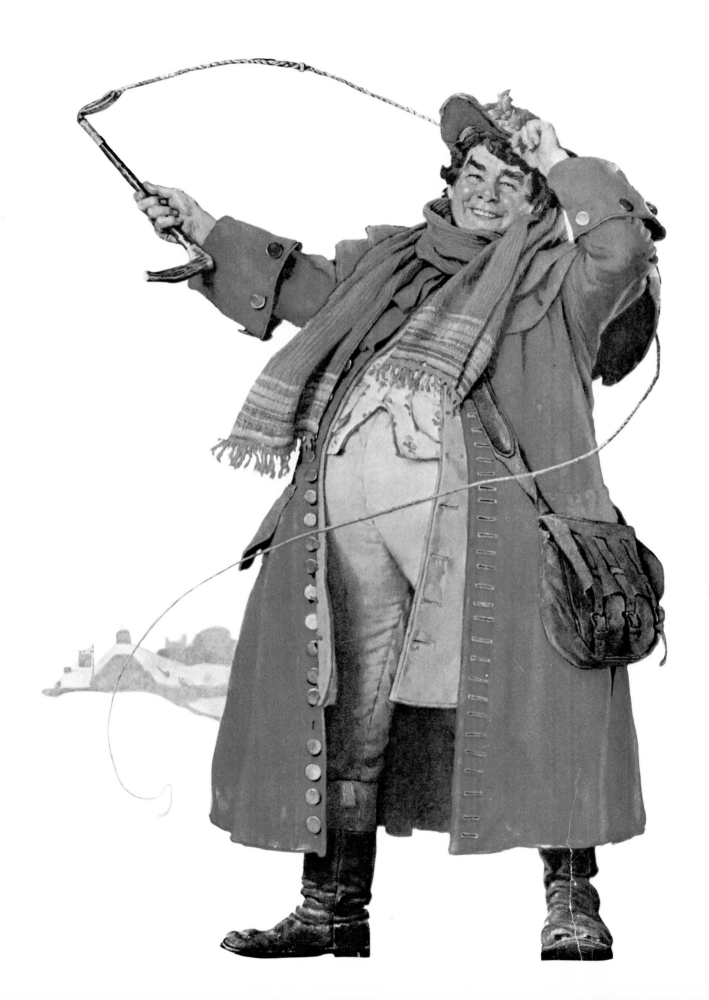

Christmas Eve in Our Village

PHYLLIS McGINLEY

Main Street is gay. Each lamppost glimmers,
 Crowned with a blue, electric star.
The gift tree by our fountain shimmers,
 Superbly tall, if angular
 (Donated by the Men's Bazaar).

With garlands proper to the times
 Our doors are wreathed, our lintels strewn.
From our two steeples sound the chimes,
 Incessant, through the afternoon,
 Only a little out of tune.

Breathless, with boxes hard to handle,
 The grocery drivers come and go.
Madam the Chairman lights a candle
 To introduce our club's tableau.
 The hopeful children pray for snow.

They cluster, mittened, in the park
 To talk of morning, half affrighted,
And early comes the winter dark
 And early are our windows lighted
 To beckon homeward the benighted.

The eggnog's lifted for libation,
 Silent at last the postman's ring,
But on the plaza near the station
 The carolers are caroling.
 "O Little Town!" the carolers sing.

Christmas Eve at Sea

JOHN MASEFIELD

A wind is rustling "south and soft,"
 Cooing a quiet country tune,
The calm sea sighs, and far aloft
 The sails are ghostly in the moon.

Unquiet ripples lisp and purr,
 A block there pipes and chirps i' the sheave,
The wheel-ropes jar, the reef-points stir
 Faintly—and it is Christmas Eve.

The hushed sea seems to hold her breath,
 And o'er the giddy, swaying spars,
Silent and excellent as Death,
 The dim blue skies are bright with stars.

Dear God—they shone in Palestine
 Like this, and yon pale moon serene
Looked down among the lowing kine
 On Mary and the Nazarene.

The angels called from deep to deep,
 The burning heavens felt the thrill,
Startling the flocks of silly sheep
 And lonely shepherds on the hill.

To-night beneath the dripping bows,
 Where flashing bubbles burst and throng,
The bow-wash murmurs and sighs and soughs
 A message from the angels' song.

The moon goes nodding down the west,
 The drowsy helmsman strikes the bell;
Rex Judaeorum natus est,
 I charge you, brothers, sing *Nowell,*
Nowell,
Rex Judaeorum natus est.

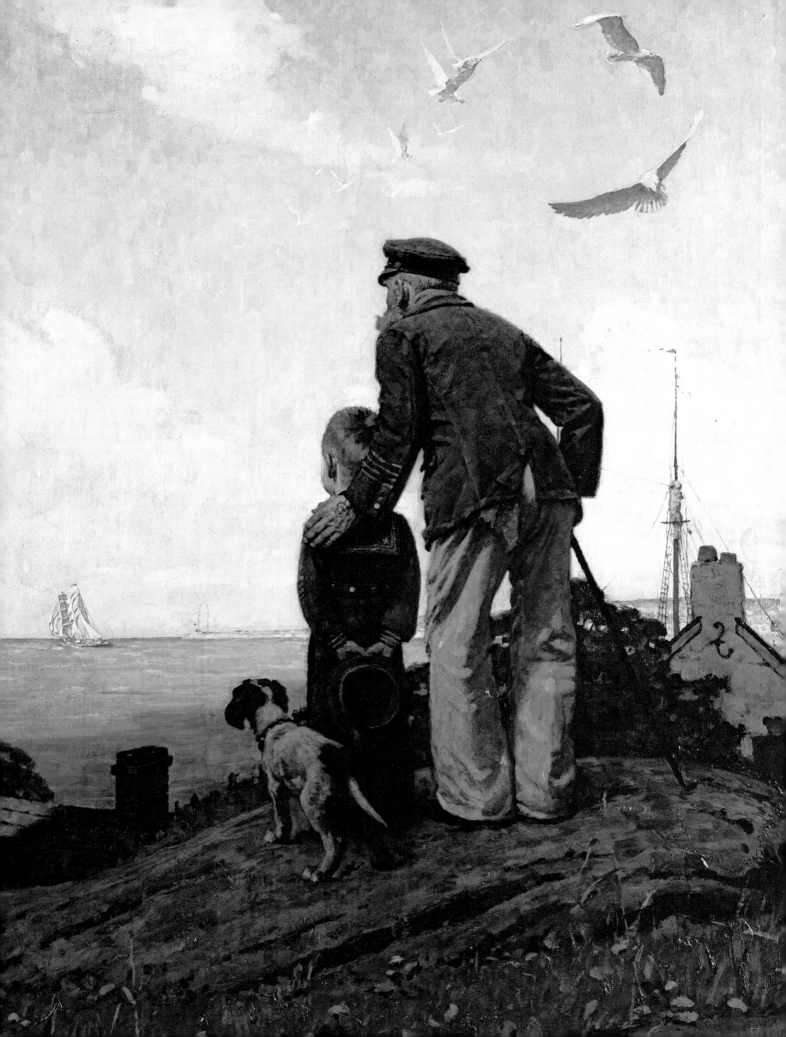

A Visit from St. Nicholas

CLEMENT CLARKE MOORE

'Twas the night before Christmas, when all through the house
Not a creature was stirring, not even a mouse.
The stockings were hung by the chimney with care,
In hopes that St. Nicholas soon would be there.
The children were nestled all snug in their beds,
While visions of sugar-plums danced in their heads;
And mamma in her kerchief, and I in my cap,
Had just settled our brains for a long winter's nap—
When out on the lawn there arose such a clatter
I sprang from my bed to see what was the matter.
Away to the window I flew like a flash,
Tore open the shutter, and threw up the sash.
The moon on the breast of the new-fallen snow
Gave a lustre of midday to objects below;
When what to my wondering eye should appear
But a miniature sleigh and eight tiny reindeer,
With a little old driver, so lively and quick,
I knew in a moment it must be St. Nick!
More rapid than eagles his coursers they came,
And he whistled and shouted and called them by name.
"Now, Dasher! now, Dancer! now, Prancer and Vixen!
On, Comet! on, Cupid! on, Donder and Blitzen!—
To the top of the porch, to the top of the wall,
Now, dash away, dash away, dash away all!"
As dry leaves that before the wild hurricane fly,
When they meet with an obstacle mount to the sky,
So, up to the housetop the coursers they flew,
With a sleigh full of toys—and St. Nicholas, too.
And then, in a twinkling, I heard on the roof
The prancing and pawing of each little hoof.
As I drew in my head and was turning around,
Down the chimney St. Nicholas came with a bound:
He was dressed all in fur from his head to his foot,
And his clothes were all tarnished with ashes and soot:
A bundle of toys he had flung on his back,
And he looked like a peddler just opening his pack.

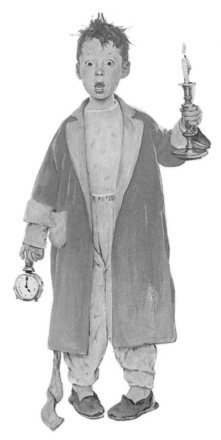

His eyes, how they twinkled! his dimples, how merry!
His cheeks were like roses, his nose like a cherry;
His droll little mouth was drawn up like a bow,
And the beard on his chin was as white as the snow.
The stump of a pipe he held tight in his teeth,
And the smoke, it encircled his head like a wreath.
He had a broad face and a little round belly
That shook, when he laughed, like a bowl full of jelly.
He was chubby and plump—a right jolly old elf:
And I laughed when I saw him, in spite of myself;
A wink of his eye, and a twist of his head,
Soon gave me to know I had nothing to dread.
He spoke not a word, but went straight to his work,
And filled all the stockings: then turned with a jerk,
And laying his finger aside of his nose,
And giving a nod, up the chimney he rose.
He sprang to his sleigh, to his team gave a whistle,
And away they all flew like the down of a thistle.
But I heard him exclaim, ere they drove out of sight,
"Happy Christmas to all, and to all a good-night!"

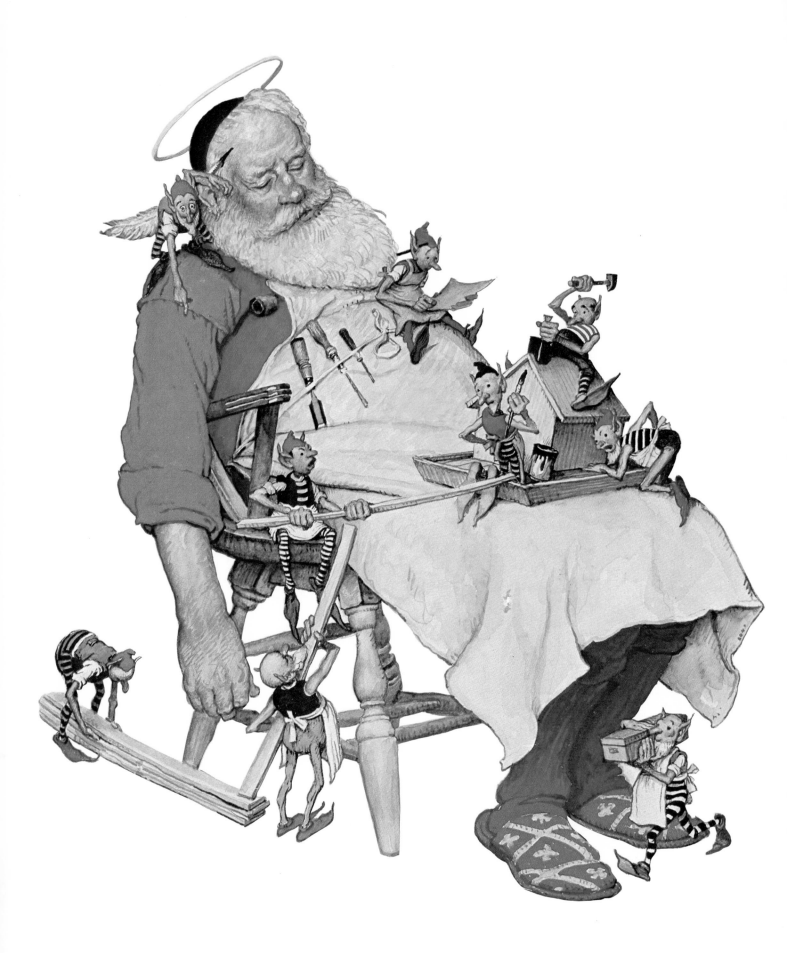

Christmas Greeting from a Fairy to a Child

LEWIS CARROLL

Lady, dear, if Fairies may
 For a moment lay aside
Cunning tricks and elfish play,
 'Tis at happy Christmas-tide.

We have heard the children say—
 Gentle children, whom we love—
Long ago on Christmas Day,
 Came a message from above.

Still, as Christmas-tide comes round,
 They remember it again—
Echo still the joyful sound,
 "Peace on earth, good-will to men!"

Yet the hearts must childlike be
 Where such heavenly guests abide;
Unto children, in their glee,
 All the year is Christmas-tide!

Thus, forgetting tricks and play
 For a moment, Lady dear,
We would wish you, if we may,
 Merry Christmas, glad New Year!

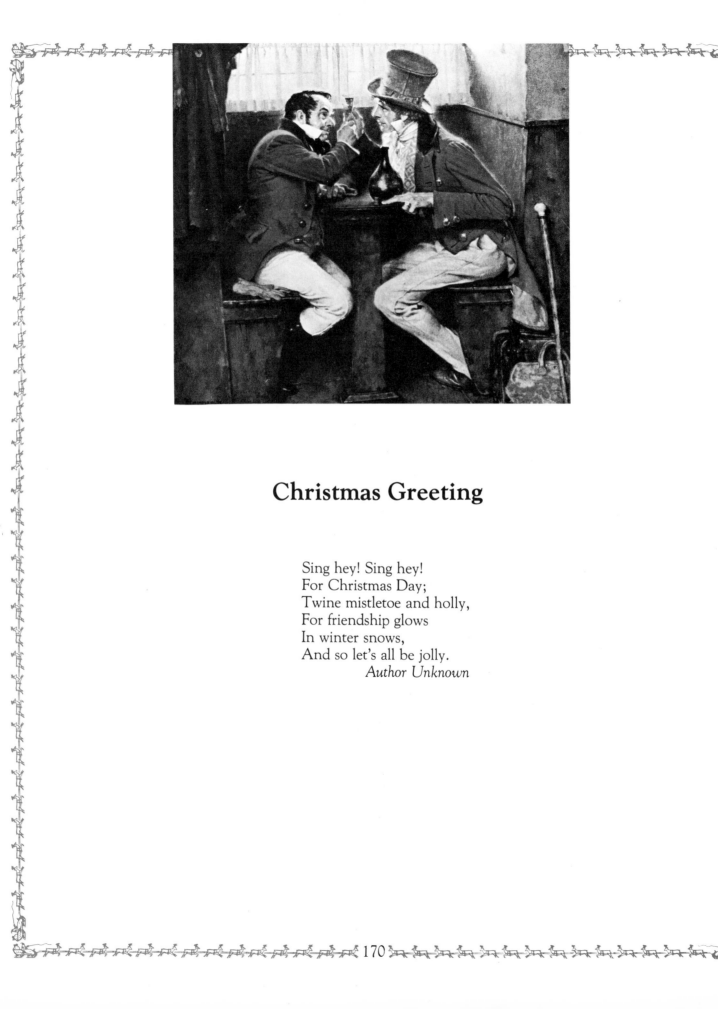

Christmas Greeting

Sing hey! Sing hey!
For Christmas Day;
Twine mistletoe and holly,
For friendship glows
In winter snows,
And so let's all be jolly.
Author Unknown

The Mahogany Tree

WILLIAM MAKEPEACE THACKERAY

Christmas is here:
Winds whistle shrill,
Icy and chill,
Little care we:
Little we fear
Weather without,
Sheltered about
The Mahogany Tree.

Once on the boughs
Birds of rare plume
Sang, in its bloom;
Night-birds are we:
Here we carouse,
Singing like them,
Perched round the stem
Of the jolly old tree.

Here let us sport,
Boys, as we sit;
Laughter and wit
Flashing so free.
Life is but short—
When we are gone,
Let them sing on,
Round the old tree.

Evenings we knew,
Happy as this;
Faces we miss,
Pleasant to see.
Kind hearts and true,
Gentle and just,
Peace to your dust!
We sing round the tree.

Care, like a dun,
Lurks at the gate:
Let the dog wait;
Happy we'll be!
Drink, every one;
Pile up the coals,
Fill the red bowls,
Round the old tree!

Drain we the cup. —
Friend, art afraid?
Spirits are laid
In the Red Sea.
Mantle it up;
Empty it yet;
Let us forget,
Round the old tree.

Sorrows, begone!
Life and its ills,
Duns and their bills,
Bid we to flee.
Come with the dawn,
Blue-devil sprite,
Leave us to-night,
Round the old tree.

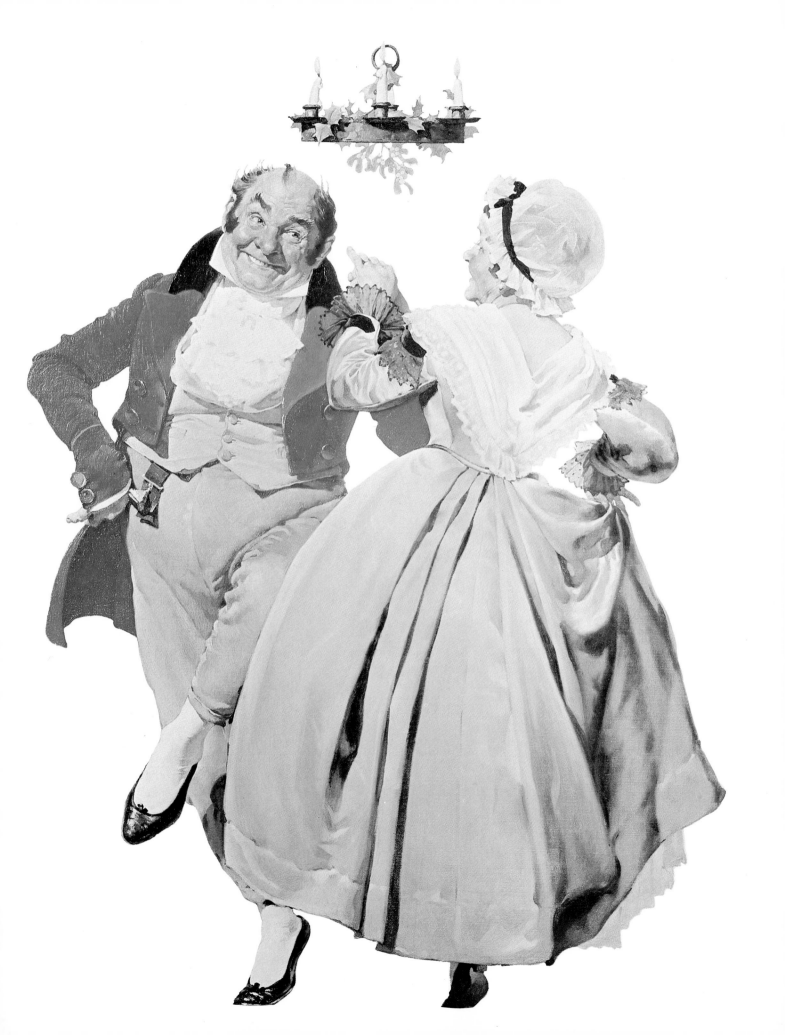

The Boy Who Laughed at Santa Claus

OGDEN NASH

In Baltimore there lived a boy.
He wasn't anybody's joy.
Although his name was Jabez Dawes,
His character was full of flaws.
In school he never led the classes,
He hid old ladies' reading glasses,
His mouth was open while he chewed,
And elbows to the table glued.
He stole the milk of hungry kittens,
And walked through doors marked No Admittance.

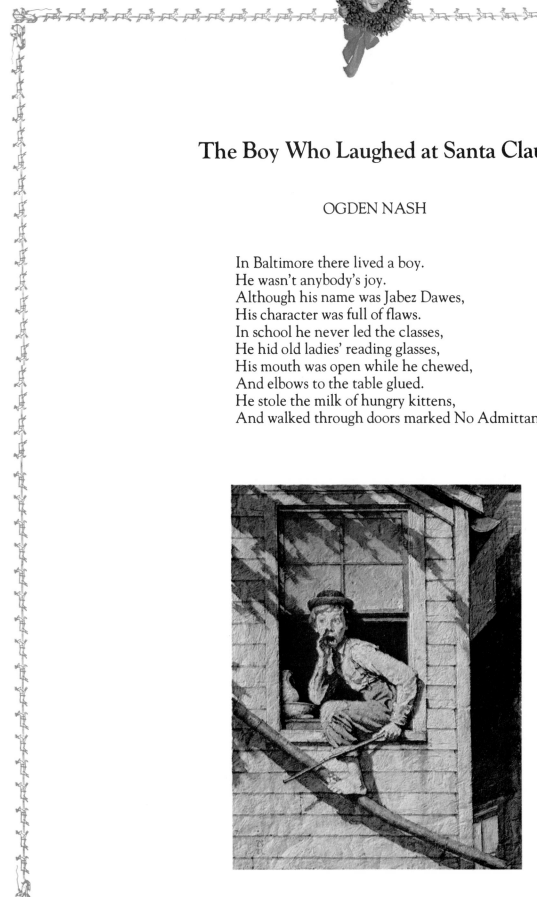

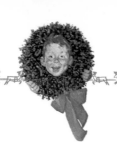

He said he acted thus because
There wasn't any Santa Claus.
Another trick that tickled Jabez
Was crying "Boo!" at little babies.
He brushed his teeth, they said in town,
Sideways instead of up and down.
Yet people pardoned every sin
And viewed his antics with a grin
Till they were told by Jabez Dawes,
"There isn't any Santa Claus!"
Deploring how he did behave,
His parents quickly sought their grave.
They hurried through the portals pearly,
And Jabez left the funeral early.
Like whooping cough, from child to child,
He sped to spread the rumor wild:
"Sure as my name is Jabez Dawes
There isn't any Santa Claus!"
Slunk like a weasel or a marten
Through nursery and kindergarten,
Whispering low to every tot,
"There isn't any, no, there's not!
No beard, no pipe, no scarlet clothes,
No twinkling eyes, no cherry nose,
No sleigh, and furthermore, by Jiminy,
Nobody coming down the chimney!"
The children wept all Christmas Eve
And Jabez chortled up his sleeve.
No infant dared to hang up his stocking
For fear of Jabez' ribald mocking.
He sprawled on his untidy bed,
Fresh malice dancing in his head,
When presently with scalp a-tingling,
Jabez heard a distant jingling;
He heard the crunch of sleigh and hoof
Crisply alighting on the roof.
What good to rise and bar the door?
A shower of soot was on the floor.
Jabez beheld, oh, awe of awes,
The fireplace full of Santa Claus!

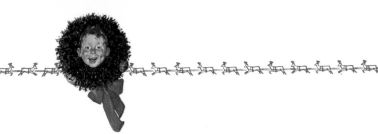

Then Jabez fell upon his knees
With cries of "Don't," and "Pretty please."
He howled, "I don't know where you read it.
I swear some other fellow said it!"
"Jabez," replied the angry saint,
"It isn't I, it's you that ain't.
Although there *is* a Santa Claus,
There isn't any Jabez Dawes!"
Said Jabez then with impudent vim,
"Oh, yes there is; and I am him!
Your language don't scare me, it doesn't—"
And suddenly he found he wasn't!
From grinning feet to unkempt locks
Jabez became a jack-in-the-box,
An ugly toy in Santa's sack,
Mounting the flue on Santa's back.
The neighbors heard his mournful squeal;
They searched for him, but not with zeal.
No trace was found of Jabez Dawes,
Which led to thunderous applause,
And people drank a loving cup
And went and hung their stockings up.
All you who sneer at Santa Claus,
Beware the fate of Jabez Dawes,
The saucy boy who told the saint off;
The child who got him, licked his paint off.

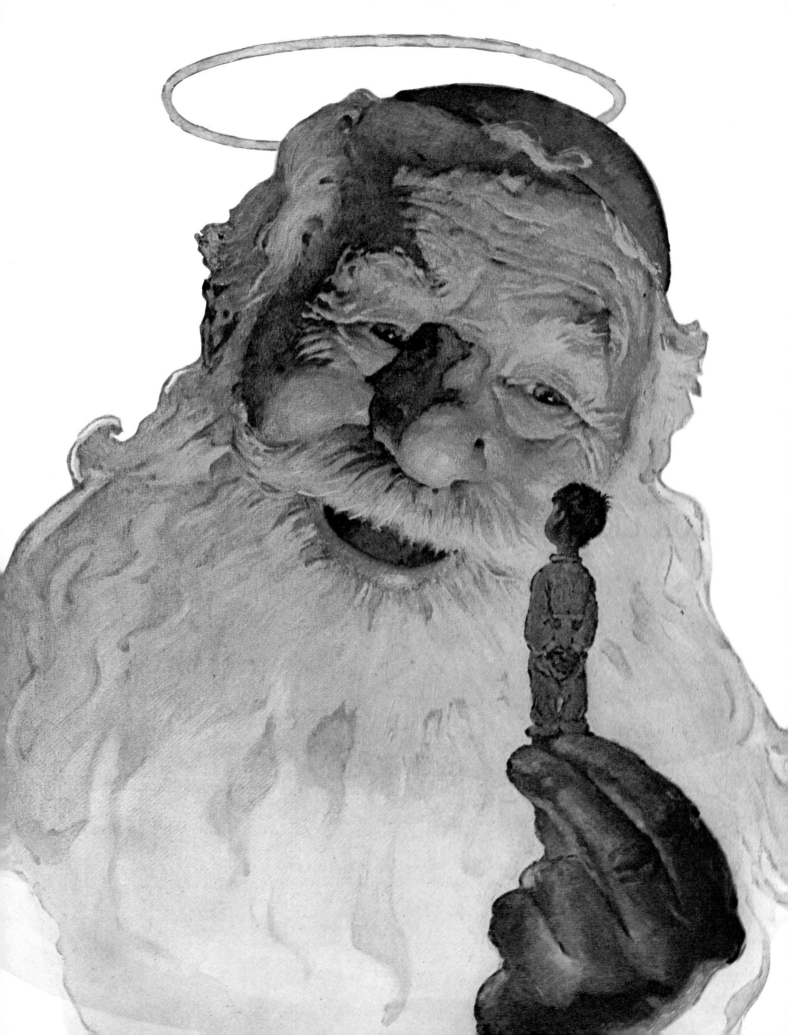

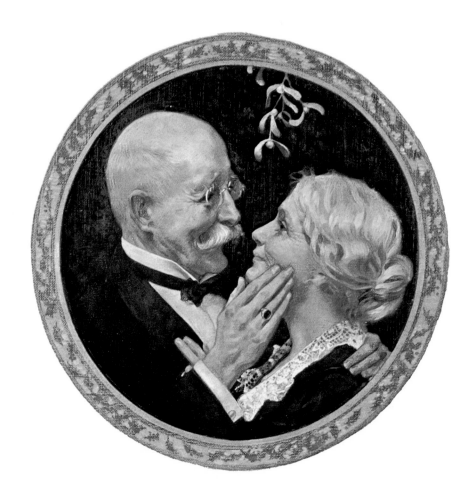

Mistletoe

WALTER DE LA MARE

Sitting under the mistletoe
(Pale-green, fairy mistletoe),
One last candle burning low,
All the sleepy dancers gone,
Just one candle burning on,
Shadows lurking everywhere:
Some one came, and kissed me there.

Tired I was; my head would go
Nodding under the mistletoe
(Pale-green, fairy mistletoe),
No footsteps came, no voice, but only,
Just as I sat there, sleepy, lonely,
Stooped in the still and shadowy air
Lips unseen—and kissed me there.

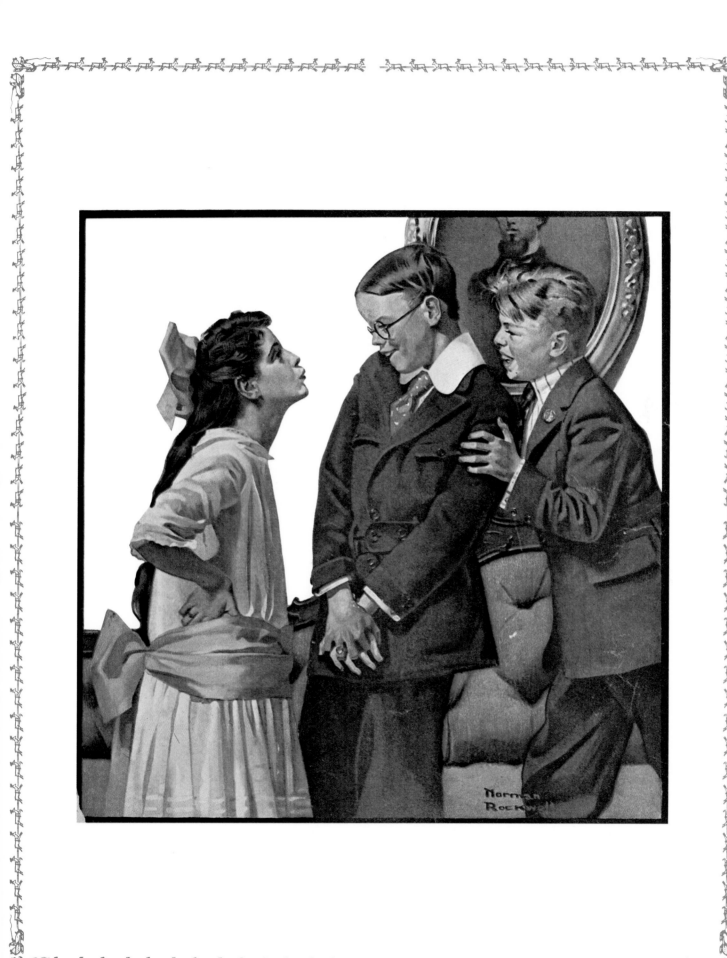

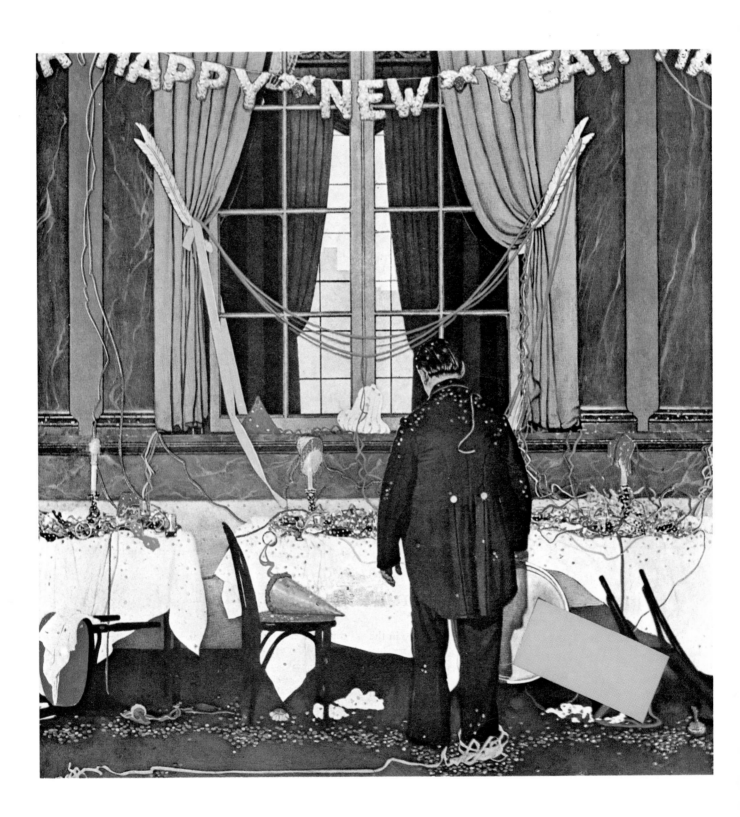

An Alphabet of Christmas

AUTHOR UNKNOWN

A *is for Animals who shared the stable.*
B *for the Babe with their manger for cradle.*
C *for the Carols so blithe and so gay.*
D *for December, the twenty-fifth day.*
E *for the Eve when we're all so excited.*
F *for the Fun when the tree's at last lighted.*
G *is the Goose which you all know is fat.*
H *is the Holly you stick in your hat.*
I *for the Ivy that clings to the wall.*
J *is for Jesus, the cause of it all.*
K *for the Kindness begot by this feast.*
L *is the Light shining way in the east.*
M *for the Mistletoe, all green and white.*
N *for the Nowells we sing Christmas night.*
O *for the Oxen, the first to adore Him.*
P *for the Presents Wise Men laid before Him.*
Q *for the Queerness that this should have been*
 Near two thouand years before you were seen.
R *for the Reindeer leaping the roofs.*
S *for the Stockings that Santa Claus stuffs.*
T *for the Toys, the Tinsel, the Tree.*
U *is for Us—the whole family.*
V *is for Visitors bringing us cheer.*
W *is Welcome to the happy New Year.*
X *Y Z bother me! All I can say,*
 Is this is the end of my Christmas day.
 So now to you all, wherever you be,
 A merry, merry Christmas, and many may you see!

Yule's Come, and Yule's Gane

ANONYMOUS

Yule's come, and Yule's gane,
And we hae feasted weel,
Sae Jock maun to his flail again,
And Jenny to her wheel.

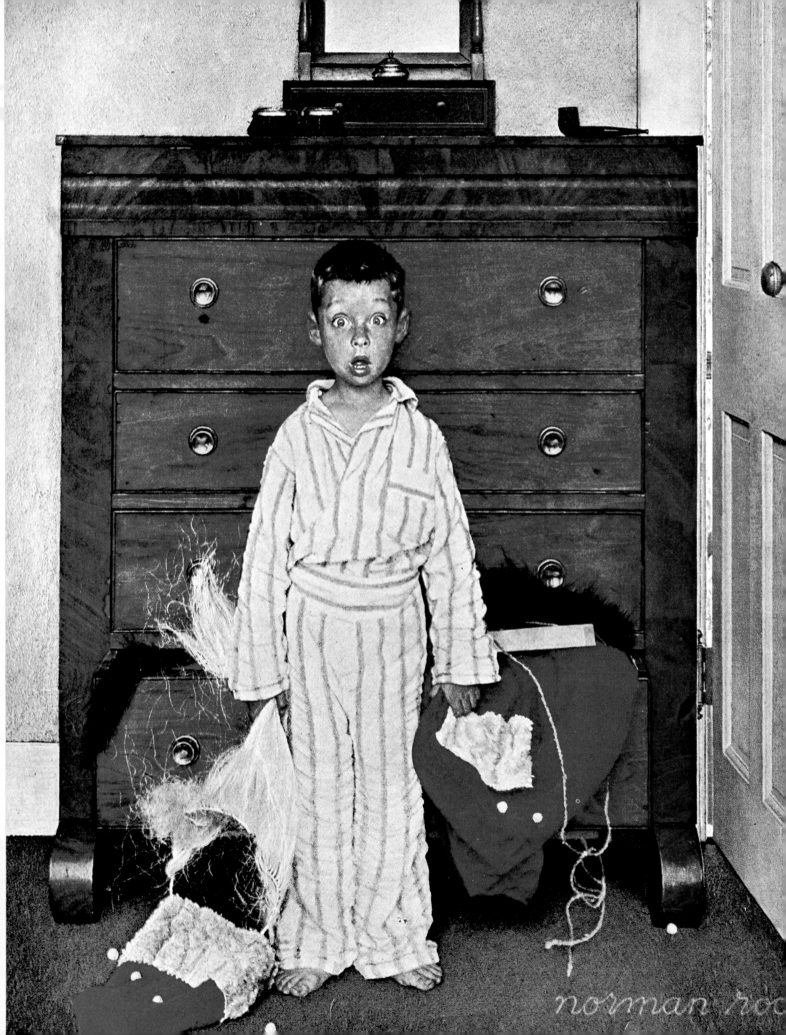

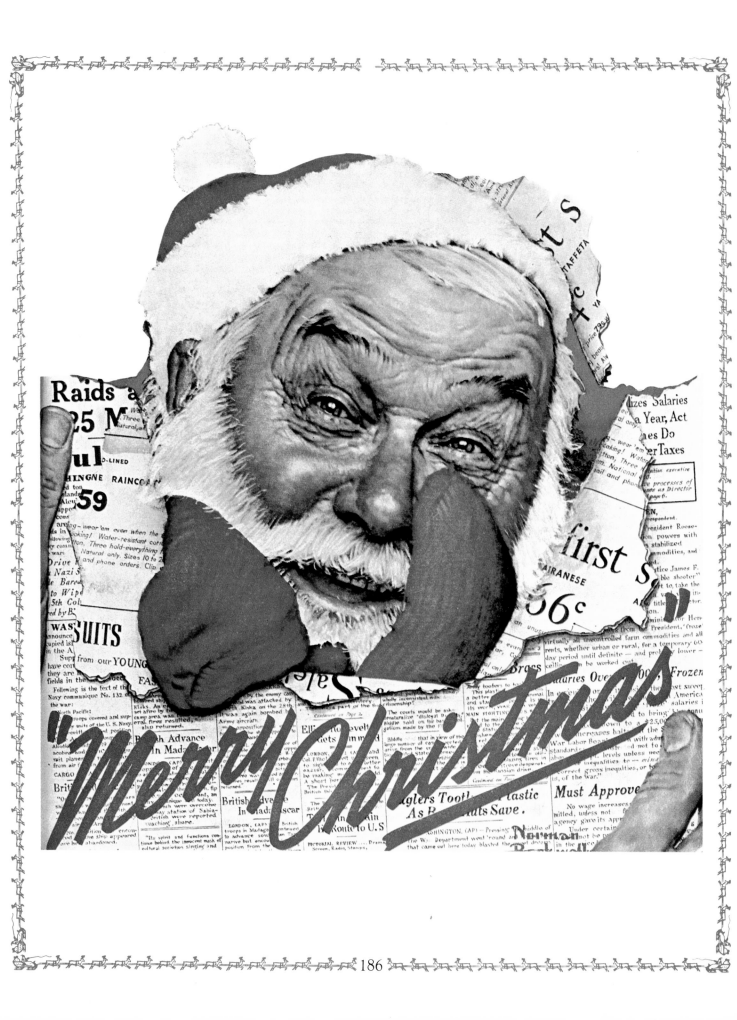

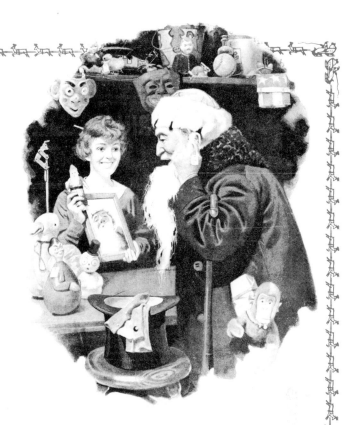

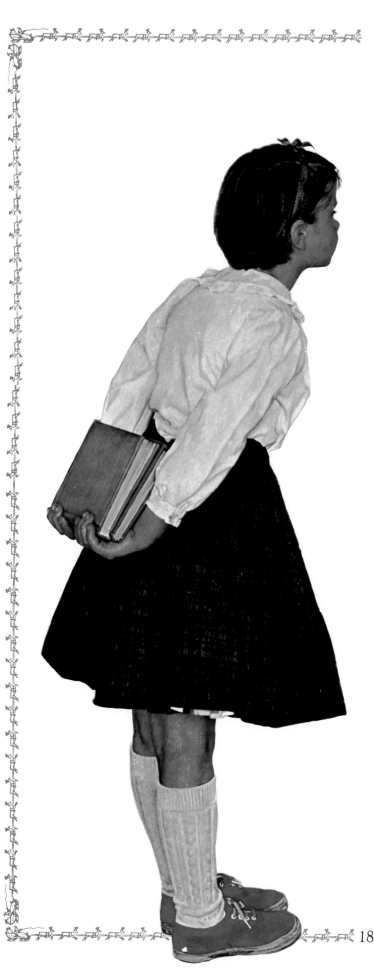

Yes, Virginia,
There Is a Santa Claus

FRANCIS P. CHURCH

Dear Editor: I am 8 years old.
 Some of my little friends say there is no Santa
Claus.
 Papa says "If you see it in *The Sun* it's so."
 Please tell me the truth; is there a Santa Claus?
 Virginia O'Hanlon

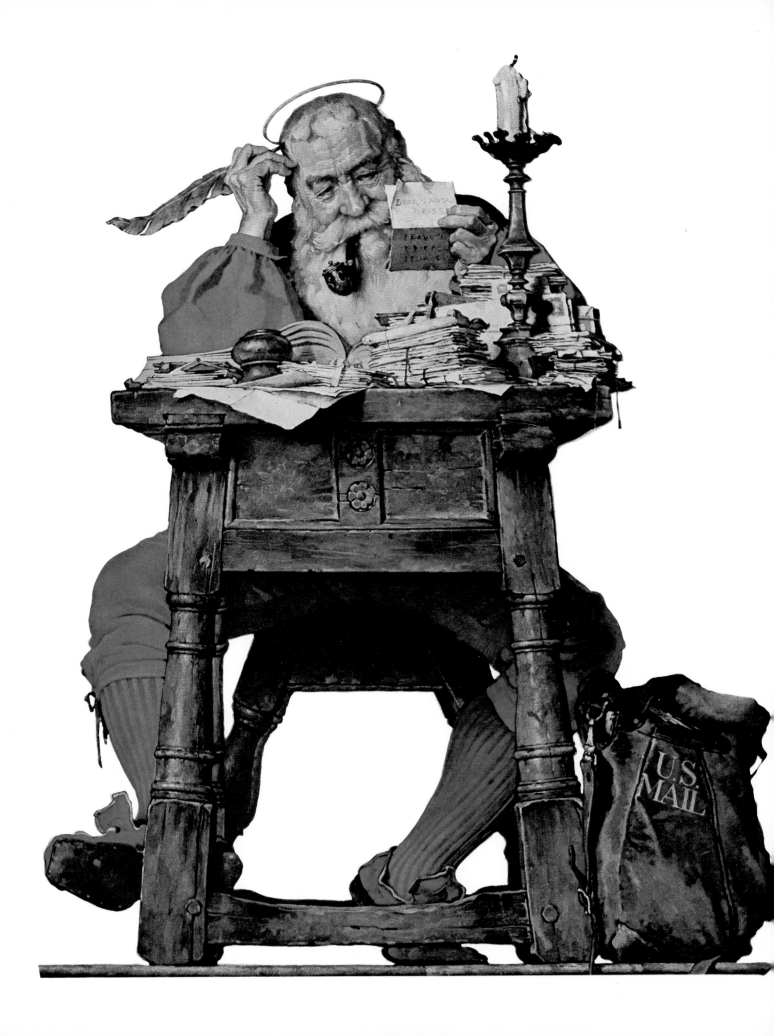

Virginia, your little friends are wrong. They have been affected by the skepticism of a skeptical age. They do not believe except they see. They think that nothing can be which is not comprehensible by their little minds. All minds, Virginia, whether they be men's or children's, are little. In this great universe of ours man is a mere insect, an ant, in his intellect, as compared with the boundless world about him, as measured by the intelligence capable of grasping the whole of truth and knowledge.

Yes, Virginia, there is a Santa Claus. He exists as certainly as love and generosity and devotion exist, and you know that they abound and give to your life its highest beauty and joy. Alas! how dreary would be the world if there were no Santa Claus! It would be as dreary as if there were no Virginias. There would be no childlike faith then, no poetry, no romance to make tolerable this existence. We should have no enjoyment, except in sense and sight. The eternal light with which childhood fills the world would be extinguished.

Not believe in Santa Claus! You might as well not believe in fairies! You might get your papa to hire men to watch in all the chimneys on Christmas Eve to catch Santa Claus, but even if they did not see Santa Claus coming down, what would that prove? Nobody sees Santa Claus, but that is no sign that there is no Santa Claus. The most real things in the world are those that neither children nor men can see.

No Santa Claus! Thank God, he lives, and he lives forever. A thousand years from now, Virginia, nay, ten times ten thousand years from now, he will continue to make glad the heart of childhood.

—*The New York Sun*, September 21, 1897

Once on Christmas

DOROTHY THOMPSON

It is Christmas Eve—the festival that belongs to mothers and fathers and children, all over the so-called Western world. It's not a time to talk about situations, or conditions, or reactions, or people who emerge briefly into the news. My seven-year-old son asked me this evening to tell him what Christmas was like when I was a little girl, before people came home for Christmas in airplanes, thirty odd years ago. And so I told him this:

A long, long time ago, when your mother was your age, and not nearly as tall as you, she lived with her mother, and father, and younger brother, and little sister, in a Methodist parsonage, in Hamburg, New York. It was a tall wooden house, with a narrow verandah on the side, edged with curley-cues of woodwork at the top, and it looked across a lawn at the church where father preached every Sunday morning and evening. In the backyard there were old Baldwin and Greening apple trees, and a wonderful, wonderful barn. But that is another story. The village now has turned into a suburb of the neighboring city of Buffalo, and fathers who work there go in and out every day on the trains and buses, but then it was just a little country town, supported by the surrounding farms.

Father preached in his main church there on Sunday mornings but in the afternoons he had to drive out to the neighboring village of Armor where there was just a little box of a church in the middle of the farming country. For serving both parishes, he received his house and one thousand dollars a year. But he didn't always get the thousand dollars. Sometimes the crops were bad,

and the farmers had no money, and when the farmers had no money the village people didn't have any either. Then the farmers would come to us with quarters of beef, or halves of pigs, or baskets of potatoes, and make what they called a donation. My mother hated the word, and sometimes would protest, but my father would laugh, and say, "Let them pay in what they can! We are all in the same boat together."

For weeks before Christmas we were very, very busy. Mother was busy in the kitchen, cutting up citron and sorting out raisins and clarifying suet for the Christmas pudding—and shooing all of us out of the room, when we crept in to snatch a raisin, or a bit of kernel from the butter-nuts that my little brother was set to cracking on the woodshed floor, with an old-fashioned flat-iron.

I would lock myself into my little bed-room, to bend over a handkerchief that I was hemstitching for my mother. It is very hard to hemstitch when you are seven years old, and the thread would knot, and break, and then one would have to begin again, with a little rough place, where one had started over. I'm afraid the border of that handkerchief was just one succession of knots and starts.

The home-made presents were only a tiny part of the work! There was the Christmas tree! Mr. Heist, from my father's Armor parish, had brought it from his farm, a magnificent hemlock, that touched the ceiling. We were transported with admiration, but what a tree to trim! For there was no money to buy miles of tinsel and boxes of colored glass balls.

But in the pantry was a huge stone jar of popcorn. When school was over, in the afternoons,

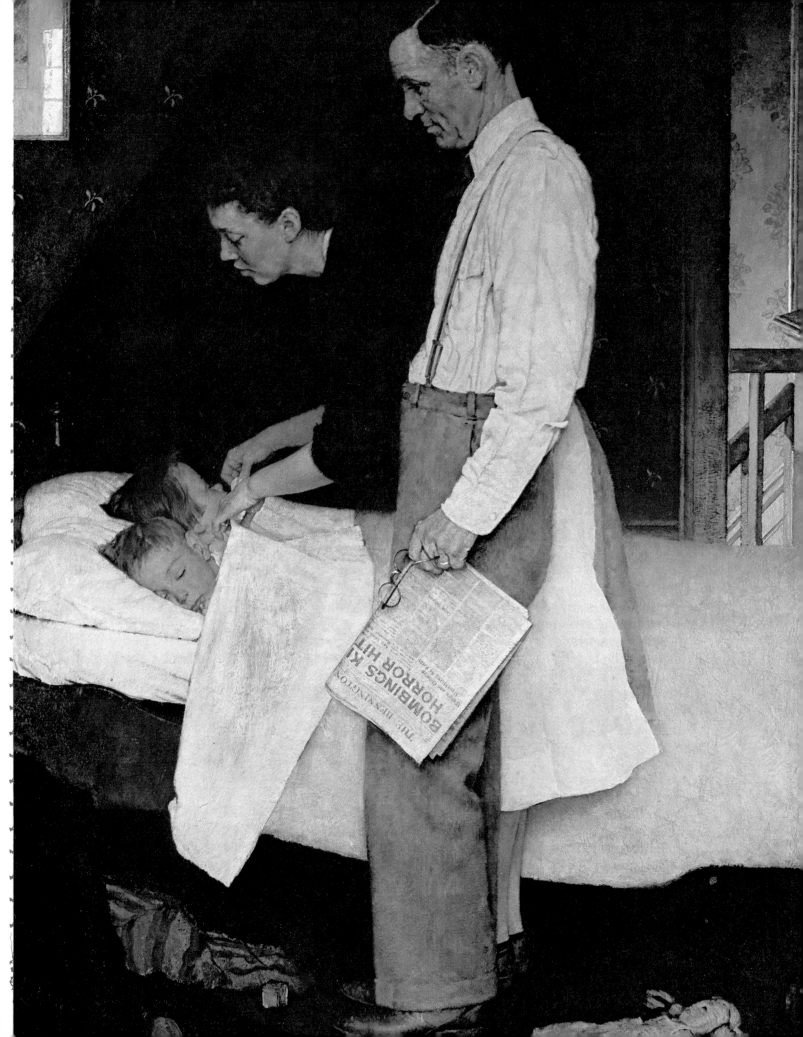

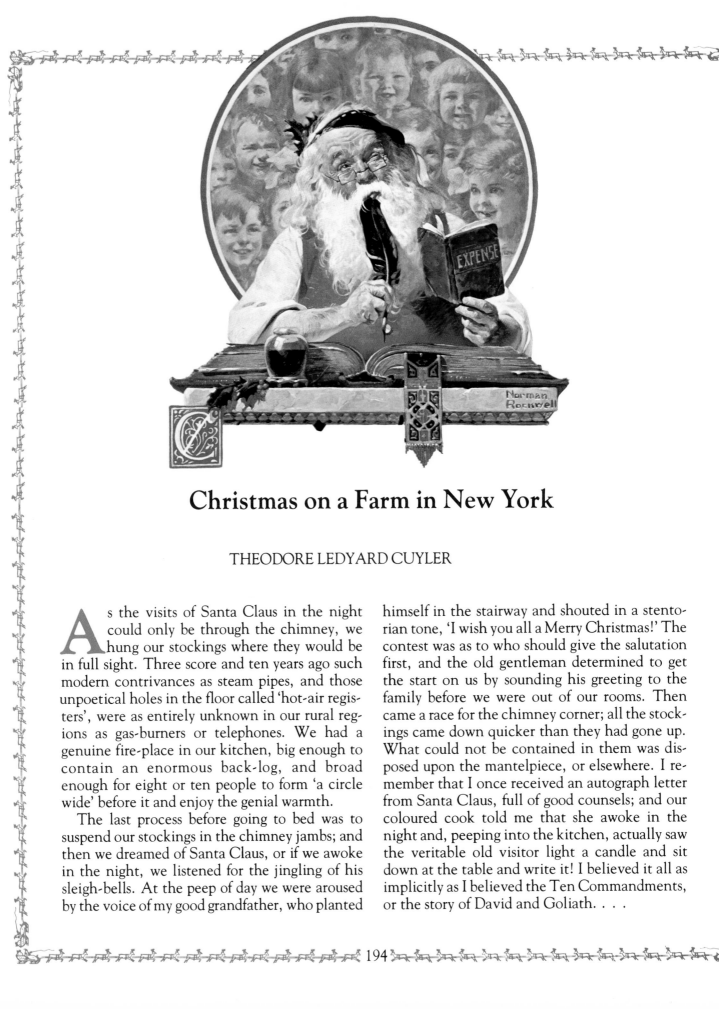

Christmas on a Farm in New York

THEODORE LEDYARD CUYLER

As the visits of Santa Claus in the night could only be through the chimney, we hung our stockings where they would be in full sight. Three score and ten years ago such modern contrivances as steam pipes, and those unpoetical holes in the floor called 'hot-air registers', were as entirely unknown in our rural regions as gas-burners or telephones. We had a genuine fire-place in our kitchen, big enough to contain an enormous back-log, and broad enough for eight or ten people to form 'a circle wide' before it and enjoy the genial warmth.

The last process before going to bed was to suspend our stockings in the chimney jambs; and then we dreamed of Santa Claus, or if we awoke in the night, we listened for the jingling of his sleigh-bells. At the peep of day we were aroused by the voice of my good grandfather, who planted himself in the stairway and shouted in a stentorian tone, 'I wish you all a Merry Christmas!' The contest was as to who should give the salutation first, and the old gentleman determined to get the start on us by sounding his greeting to the family before we were out of our rooms. Then came a race for the chimney corner; all the stockings came down quicker than they had gone up. What could not be contained in them was disposed upon the mantelpiece, or elsewhere. I remember that I once received an autograph letter from Santa Claus, full of good counsels; and our coloured cook told me that she awoke in the night and, peeping into the kitchen, actually saw the veritable old visitor light a candle and sit down at the table and write it! I believed it all as implicitly as I believed the Ten Commandments, or the story of David and Goliath. . . .

Christmas in Maine

ROBERT P. TRISTRAM COFFIN

If you want to have a Christmas like the one we had on Paradise Farm when I was a boy, you will have to hunt up a saltwater farm on the Maine coast, with bays on both sides of it, and a road that goes around all sorts of bays, up over Misery Hill and down, and through the fir trees so close together that they brush you and your horse on both cheeks. That is the only kind of place a Christmas like that grows. You must have a clear December night, with blue Maine stars snapping like sapphires with the cold, and the big moon flooding full over Misery, and lighting up the snowy spruce boughs like crushed diamonds. You ought to be wrapped in a buffalo robe to your nose, and be sitting in a family pung, and have your breath trailing along with you as you slide over the dry, whistling snow. You will have to sing the songs we sang, "God Rest You Merry, Gentlemen" and "Joy to the World," and you will be able to see your songs around you in the air like blue smoke. That's the only way to come to a Paradise Christmas.

And you really should cross over at least one broad bay on the ice, and feel the tide rifts bounce you as the runners slide over them. And if the whole bay booms out, every now and then, and the sound echoes around the wooded islands for miles, you will be having the sort of ride we loved to take from town, the night before Christmas.

I won't insist on your having a father like ours to drive you home to your Christmas. One with a wide moustache full of icicles, and eyes like the stars of the morning. That would be impossible, anyway, for there has been only one of him in the world. But it is too bad, just the same. For you won't have the stories we had by the fireplace.

You won't hear about Kitty Wells who died beautifully in song just as the sun came over the tops of the eastern mountains and just after her lover had named the wedding day, and you will not hear how Kitty's departure put an end to his mastering the banjo:

> *"But death came in my cabin door*
> *And took from me my joy, my pride,*
> *And when they said she was no more,*
> *I laid my banjo down and cried."*

But you will be able to have the rooms of the farmhouse banked with emerald jewels clustered on bayberry boughs, clumps of everlasting roses with gold spots in the middle of them, tree evergreens, and the evergreen that runs all over the Maine woods and every so often puts up a bunch of palm leaves. And there will be rose-hips stuck in pine boughs. And caraway seeds in every crust and cookie in the place.

An aunt should be on hand, an aunt who believes in yarrow tea and the Bible as the two things needed to keep children well. She will read the Nativity story aloud to the family, hurrying over the really exciting parts that happened at the stable, and bearing down hard on what the angels had to say and the more edifying points that might be supposed to improve small boys who like to lie too long abed in the mornings. She will put a moral even into Christmas greens, and she will serve well as a counterirritant to the over-eating of mince pies. She will insist on all boys washing behind their ears, and that will keep her days full to the brim.

The Christmas tree will be there, and it will have a top so high that it will have to be bent over

and run along the ceiling of the sitting room. It will be the best fir tree of the Paradise forests, picked from ten thousand almost perfect ones, and every bough on it will be like old-fashioned fans wide open. You will have brought it home that very morning, on the sled, from Dragonfly Spring.

Dragonfly Spring was frozen solid to the bottom, and you could look down into it and see the rainbows where you dented it with your copper-toed boots, see whole ferns caught motionless in the crystal deeps, and a frog, too, down there, with hands just like a baby's on him. Your small sister—the one with hair like new honey laid open—in the middle of a honeycomb—had cried out, "Let's dig him up and take him home and warm his feet!" (She is the same sister who ate up all your more vivid pastel crayons when you were away at school, and then ate up all the things you had been pretty sure were toadstools in Bluejay Woods, when you were supposed to be keeping an eye on her, but were buried so deep in "Mosses from an Old Manse" that you couldn't have been dug up with horses and oxen.)

Your dog, Snoozer, who is a curious and intricate combination of many merry pugs and many mournful hound-dogs, was snuffling all the time, hot on the feather-stitching the mice had made from bush to bush while you were felling the Christmas tree. A red squirrel was taking a white-pine cone apart on a hemlock bough, and telling Snoozer what he thought of him and all other dogs, the hour or so you were there.

There will be a lot of aunts in the house besides the Biblical one. Aunts of every complexion and cut. Christmas is the one time that even the most dubious of aunts take on value. One of them can make up wreaths, another can make rock candy that puts a tremble on the heart, and still another can steer your twelve-seater bobsled—and turn it over, bottom up, with you all in just the right place for a fine spill.

There will be uncles, too, to hold one end of the molasses taffy you will pull sooner or later,

yanking it out till it flashes and turns into cornsilk that almost floats in the air, tossing your end of it back and probably lassoing your uncle around his neck as you do it, and pulling out a new rope of solid honey.

The uncles will smoke, too, and that will be a help to all the younger brothers who have been smoking their acorn-pipes out in the wood-shed, and who don't want their breaths to give them away. The uncles will make themselves useful in other ways. They will rig up schooners no bigger than your thumb, with shrouds like cobwebs; they will mend the bob-sled, tie up cut fingers, and sew on buttons after you shin up to the cupola in the barn; and—if you get on the good side of them—they will saw you up so much birch wood that you won't have to lay hand to a bucksaw till after New Year's.

There will be cousins by the cart load. He-ones and she-ones. The size you can sit on, and the size that can sit on you. Enough for two armies, on Little Round Top and on Big, up in the haymow. You will play Gettysburg there till your heads are full of hay chaff that will keep six aunts busy cleaning it out. And then you will come in to the house and down a whole crock of molasses cookies—the kind that go up in peaks in the middle—which somebody was foolish enough to leave the cover off.

Every holiday that came along, in my father's house, was the gathering of an Anglo-Saxon clan. My father was built for lots of people 'round him. But Christmas was a whole assembly of the West Saxons! My father wanted people in squads. There were men with wide moustaches and men with smooth places on top of their heads, women wide and narrow. Cousins of the second and third water, even, were there. Hired men, too. They were special guests and had to be handled with kid gloves, as New England hired men must. They had to have the best of everything, and you could not find fault with them, as you could with uncles, if they smacked you for upsetting their coffee into their laps. Babies were

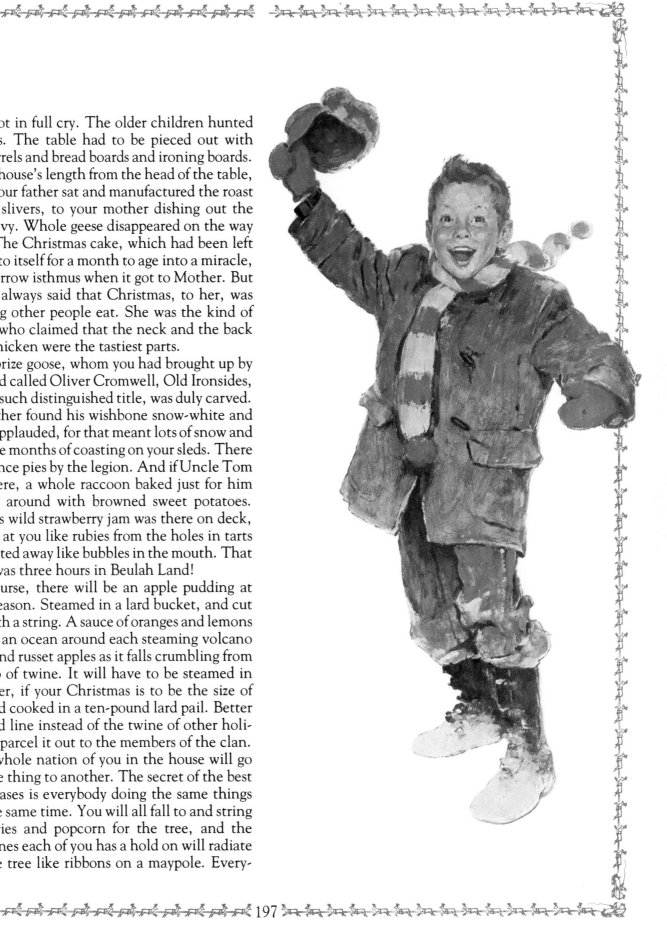

underfoot in full cry. The older children hunted in packs. The table had to be pieced out with flour barrels and bread boards and ironing boards. It was a house's length from the head of the table, where your father sat and manufactured the roast up into slivers, to your mother dishing out the pork gravy. Whole geese disappeared on the way down. The Christmas cake, which had been left sweetly to itself for a month to age into a miracle, was a narrow isthmus when it got to Mother. But Mother always said that Christmas, to her, was watching other people eat. She was the kind of mother who claimed that the neck and the back of the chicken were the tastiest parts.

The prize goose, whom you had brought up by hand and called Oliver Cromwell, Old Ironsides, or some such distinguished title, was duly carved. And Father found his wishbone snow-white and you all applauded, for that meant lots of snow and two more months of coasting on your sleds. There were mince pies by the legion. And if Uncle Tom were there, a whole raccoon baked just for him and girt around with browned sweet potatoes. Mother's wild strawberry jam was there on deck, winking at you like rubies from the holes in tarts that melted away like bubbles in the mouth. That dinner was three hours in Beulah Land!

Of course, there will be an apple pudding at such a season. Steamed in a lard bucket, and cut open with a string. A sauce of oranges and lemons to make an ocean around each steaming volcano of suet and russet apples as it falls crumbling from the loop of twine. It will have to be steamed in the boiler, if your Christmas is to be the size of ours, and cooked in a ten-pound lard pail. Better use a cod line instead of the twine of other holidays, to parcel it out to the members of the clan.

The whole nation of you in the house will go from one thing to another. The secret of the best Christmases is everybody doing the same things all at the same time. You will all fall to and string cranberries and popcorn for the tree, and the bright lines each of you has a hold on will radiate from the tree like ribbons on a maypole. Every-

body will have needles and thread in the mouth, you will all get in each other's way, but that is the art of doing Christmas right. You will all bundle up together for a ride in the afternoon. You had better take the horse-sled, as the pung will not begin to hold you. And even then a dozen or so of assorted uncles and aunts and cousins will have to come trooping after through the deep snow, and wait for their turn on the straw in the sled. Smaller cousins will fall off over the sides in great knots and never be missed, and the hullabaloo will roar on and send the rabbits flying away through the woods, showing their bobbing scuts.

Everybody will hang presents on the tree at once, when the sun has dipped down into the spruces in the west and you are back home in the sitting-room. There will be no nonsense of tiptoeing up and edging a package on when nobody is looking. Everybody knows who is giving him what. There is no mystery about it. Aunt Ella has made rag dinahs for all hands and the cook—for all under fourteen years of age—and she does not care who knows it. The dinahs are all alike, except that those for the children whose lower garments are forked have forked red-flannel pants instead of red-flannel petticoats. They all have pearl button eyes and stocking toes for faces. There will be so many hands at work on the tree at once that the whole thing will probably go over two or three times, and it will be well to make it fast with a hawser or so.

And then you will turn right around and take the presents off again, the minute you have got them all on and have lighted the candles up. There will be no waiting, with small children sitting around with aching hearts. The real candles will be a problem, in all that mass of spills. Boughs will take fire here and there. But there will be plenty of uncles around to crush out the small bonfires in their big brown hands. All the same, it would be well to have an Uncle Thomas who can take up a live coal in his thumb and finger, and light his pipe from it, cool as a cucumber. Better turn the extinguishing of the tree over to him.

There will be boughten presents, to be sure—a turtle of cardboard in a glassed, dainty box, hung on springs and swimming for dear life with all four feet, and popguns with their barrels ringed and streaked with red and yellow lines. Why popguns should be painted like broomsticks is one of the mysteries, along with the blue paint you always find on Maine cartwheels. Somebody will probably get one of those Swiss music-boxes that will eke out a ghostly "Last Rose of Summer," if tenderly cranked. There should be those little bottles of transparent candies, with real syrup in them, which I used to live for through the years. And there must be a German doll for every last girl, with mountains of yellow hair and cheeks looking as if life were a continuous blowing of bubbles. Boughten things are all right.

But if it is going to be our kind of Christmas, most of the presents will be home-made. Socks knit by the aunt who swears only by useful gifts. You have seen those socks growing up from their white toes for the last two weeks. Wristers, always red. A box of Aunt Louise's candied orange peel that she will never let on to anybody how she makes. Your father will have made a sled for every mother's son and daughter of you, with a bluebird, or robin redbreast, more real than life, painted on each one and your name underneath. You will never have another present to match that, though you grow up and become Midases. Popcorn balls, big as muskmelons, will be common ware. They will be dripping with molasses, and will stick your wristers and socks and other treasures together.

But the pith of the party is not reached until the whole nation of you sits down in rocking chairs, or lies down on their bellies in front of the six-foot gulf of the fireplace. The presents are all stowed, heaped and tucked away, stuck fast with cornballs. The last lamps are out. The firelight dances on the ceiling. It lights up the steel engraving of Major McCullock leaping from Kentucky to Ohio, with ten thousand mounted redskins yelling and reining in their steeds behind him. It lights up Daniel Boone's daughters as they

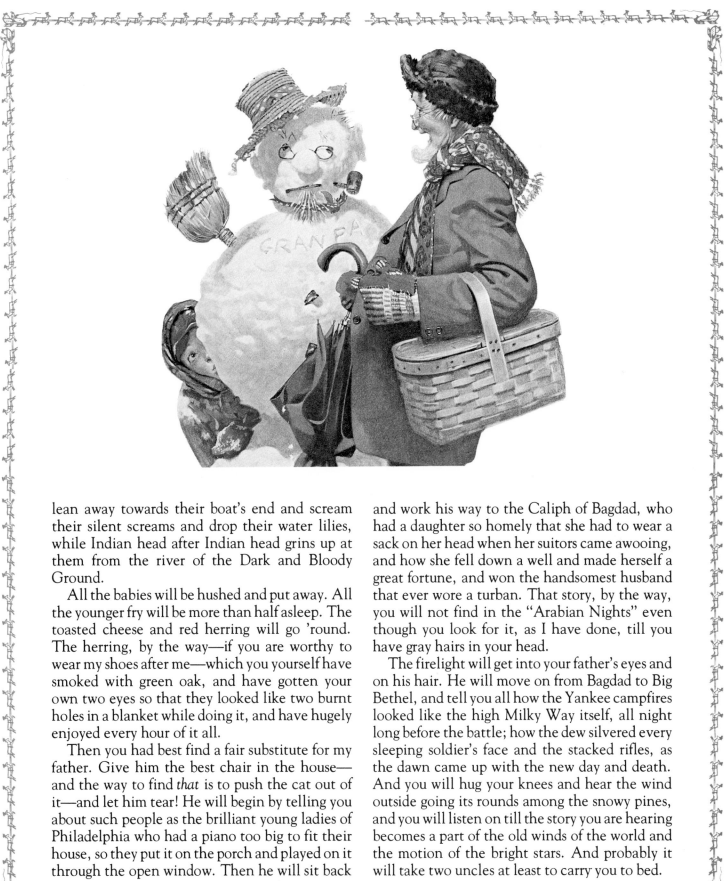

lean away towards their boat's end and scream their silent screams and drop their water lilies, while Indian head after Indian head grins up at them from the river of the Dark and Bloody Ground.

All the babies will be hushed and put away. All the younger fry will be more than half asleep. The toasted cheese and red herring will go 'round. The herring, by the way—if you are worthy to wear my shoes after me—which you yourself have smoked with green oak, and have gotten your own two eyes so that they looked like two burnt holes in a blanket while doing it, and have hugely enjoyed every hour of it all.

Then you had best find a fair substitute for my father. Give him the best chair in the house—and the way to find *that* is to push the cat out of it—and let him tear! He will begin by telling you about such people as the brilliant young ladies of Philadelphia who had a piano too big to fit their house, so they put it on the porch and played on it through the open window. Then he will sit back

and work his way to the Caliph of Bagdad, who had a daughter so homely that she had to wear a sack on her head when her suitors came awooing, and how she fell down a well and made herself a great fortune, and won the handsomest husband that ever wore a turban. That story, by the way, you will not find in the "Arabian Nights" even though you look for it, as I have done, till you have gray hairs in your head.

The firelight will get into your father's eyes and on his hair. He will move on from Bagdad to Big Bethel, and tell you all how the Yankee campfires looked like the high Milky Way itself, all night long before the battle; how the dew silvered every sleeping soldier's face and the stacked rifles, as the dawn came up with the new day and death. And you will hug your knees and hear the wind outside going its rounds among the snowy pines, and you will listen on till the story you are hearing becomes a part of the old winds of the world and the motion of the bright stars. And probably it will take two uncles at least to carry you to bed.

A Surprise for the Teacher

SAM LEVENSON

Three days before Christmas one year when I was teaching Spanish at Tilden High School in Brooklyn, New York, there was more than the usual commotion among my students. I overheard snatches of whispered exchanges, and I gathered that a "surprise" present for the teacher was being discussed surreptitiously—and somewhat anxiously.

I didn't know how to go about discouraging the customary display of Christmas spirit I knew they couldn't afford.

Finally, uncertain myself how to begin, I asked, "All right, kids, what's up?"

There was a long silence. At last, in the rear of the classroom, a timid little girl rose. "Mr. Levenson," she began, glancing around for encouragement in her decision, "we've got a problem. . . ."

"Well, suppose you tell me about it, Gracie, and we'll see what's to be done."

Her words came pouring out. "It's your Christmas present, Mr. Levenson. We know just what we want to get you. We have it all picked out. And it's something you need. Except. . . ."

"Except?" I asked hesitantly.

"Except, Mr. Levenson, we've only been able to raise three dollars and. . . ." No one in the room moved. Gracie stared shyly at the floor and whispered, "It cost ten dollars."

I glanced around the class. All my students were sitting forward on their seats. It was a strange sight, for this was the only time during the entire term that my class gave me its undivided attention. There wasn't a face that didn't reflect Gracie's concern at the dilemma.

"Mr. Levenson," she said, "we feel very badly."

"We feel very bad," I corrected her absentmindedly.

"We hope you'll understand," she continued.

"Kids," I said, "the thought behind your gift actually means more to me than the gift itself. Your merry Christmas wishes are all . . ." I stopped in the middle of my sentence. From my desk I could see Gracie's eyes begin to fill with tears.

I couldn't find the words to discourage the class from buying its teacher a present. I rummaged through my pockets and counted out six dollars and a seventh in change. I walked over to Gracie's desk, put the money in her hand, and whispered in her ear, "You make a wonderful chairman."

Then the Christmas spirit overcame me. "Class is dismissed," I said.

After the room had emptied, I sat at my desk considering how I would raise the trolley fare to get home that evening. I had given the children my last pfennig.

Suddenly Mr. O'Hara, the principal, walked into my room, looking at me quizzically. "Mr. Levenson," he said, "as I was coming up the stairs I was nearly bowled over by a pack of wild Indians. They wouldn't by any chance be your students, would they? I didn't hear the final bell."

Sheepishly I told Mr. O'Hara the whole story of my Christmas gift. He dipped into his wallet and handed me a dollar. "Here," he said. "Treat yourself to a taxi home."

A Gift of the Heart

NORMAN VINCENT PEALE

New York City, where I live, is impressive at any time, but as Christmas approaches it's overwhelming. Store windows blaze with lights and color, furs and jewels. Golden angels, 40 feet tall, hover over Fifth Avenue. Wealth, power, opulence... nothing in the world can match this fabulous display.

Through the gleaming canyons, people hurry to find last-minute gifts. Money seems to be no problem. If there's a problem, it's that the recipients so often have everything they need or want that it's hard to find anything suitable, anything that will really say, "I love you."

Last December, as Christ's birthday drew near, a stranger was faced with just that problem. She had come from Switzerland to live in an American home and perfect her English. In return, she was willing to act as secretary, mind the grandchildren, do anything she was asked. She was just a girl in her late teens. Her name was Ursula.

One of the tasks her employers gave Ursula was keeping track of Christmas presents as they arrived. There were many, and all would require acknowledgment. Ursula kept a faithful record, but with a growing sense of concern. She was grateful to her American friends; she wanted to show her gratitude by giving them a Christmas present. But nothing that she could buy with her small allowance could compare with the gifts she was recording daily. Besides, even without these gifts, it seemed to her that her employers already had everything.

At night from her window Ursula could see the snowy expanse of Central Park and beyond it the jagged skyline of the city. Far below, taxis hooted and the traffic lights winked red and green. It was so different from the silent majesty of the Alps that at times she had to blink back tears of the homesickness she was careful never to show. It was in the solitude of her little room, a few days before Christmas, that her secret idea came to Ursula.

It was almost as if a voice spoke clearly, inside her head. "It's true," said the voice, "that many people in this city have much more than you do. But surely there are many who have far less. If you will think about this, you may find a solution to what's troubling you."

Ursula thought long and hard. Finally on her day off, which was Christmas Eve, she went to a large department store. She moved slowly along the crowded aisles, selecting and rejecting things in her mind. At last she bought something and had it wrapped in gaily colored paper. She went out into the gray twilight and looked helplessly around. Finally, she went up to a doorman, resplendent in blue and gold. "Excuse, please," she said in her hesitant English, "can you tell me where to find a poor street?"

"A poor street, Miss?" said the puzzled man.

"Yes, a very poor street. The poorest in the city."

The doorman looked doubtful. "Well, you might try Harlem. Or down in the Village. Or the Lower East Side, maybe."

But these names meant nothing to Ursula. She thanked the doorman and walked along, threading her way through the stream of shoppers until she came to a tall policeman. "Please," she said, "can you direct me to a very poor street in... in Harlem?"

The policeman looked at her sharply and shook his head. "Harlem's no place for you, Miss." And he blew his whistle and sent the traffic swirling past.

Holding her package carefully, Ursula walked on, head bowed against the sharp wind. If a street looked poorer than the one she was on, she took it. But none seemed like the slums she had heard about. Once she stopped a woman, "Please, where do the very poor people live?" But the woman gave her a stare and hurried on.

Darkness came sifting from the sky. Ursula was cold and discouraged and afraid of becoming lost.

She came to an intersection and stood forlornly on the corner. What she was trying to do suddenly seemed foolish, impulsive, absurd. Then, through the traffic's roar, she heard the cheerful tinkle of a bell. On the corner opposite, a Salvation Army man was making his traditional Christmas appeal.

At once Ursula felt better; the Salvation Army was a part of life in Switzerland too. Surely this man could tell her what she wanted to know. She waited for the light, then crossed over to him. "Can you help me? I'm looking for a baby. I have here a little present for the poorest baby I can

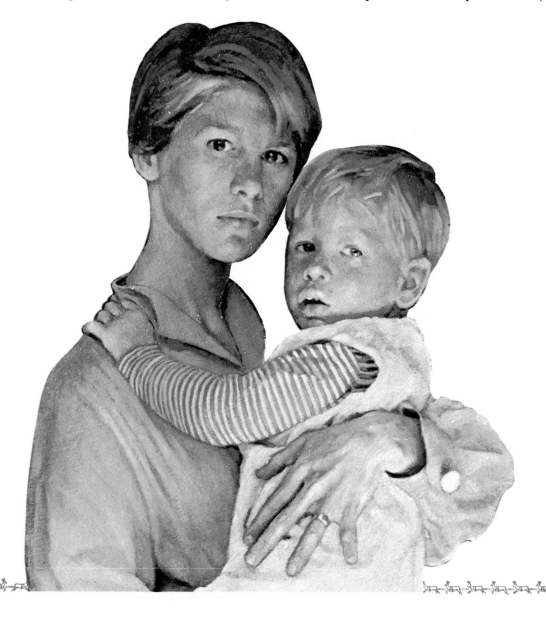

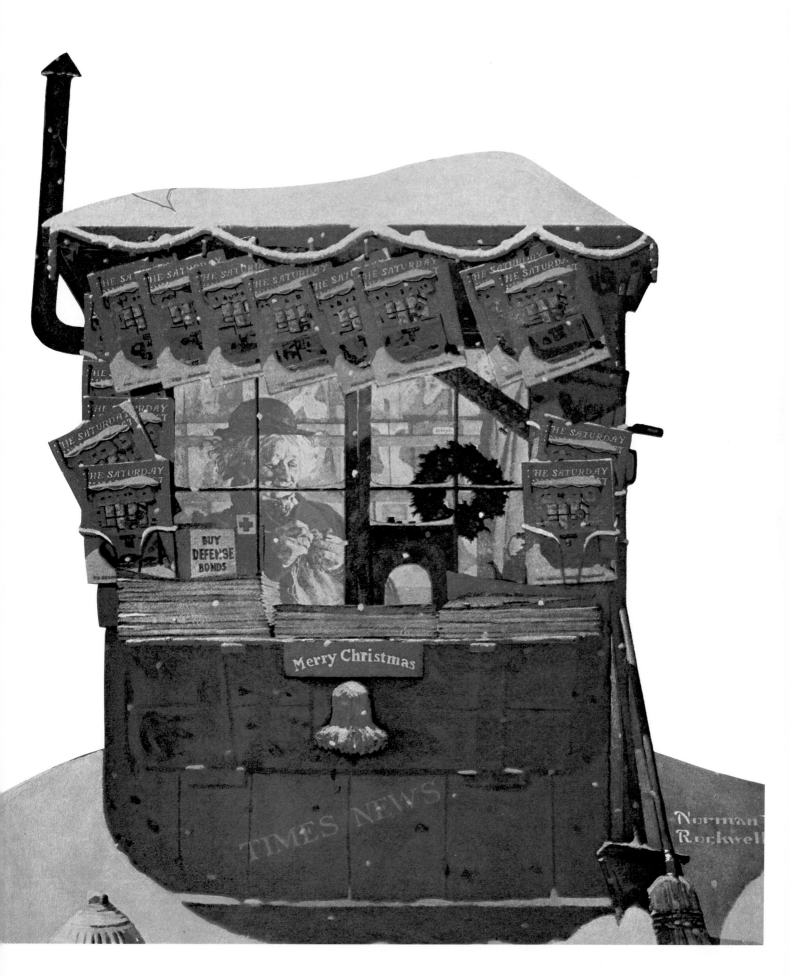

find." And she held up the package with the green ribbon and the gaily colored paper.

Dressed in gloves and overcoat a size too big for him, he seemed a very ordinary man. But behind his steel-rimmed glasses his eyes were kind. He looked at Ursula and stopped ringing his bell. "What sort of present?" he asked.

"A little dress. For a small, poor baby. Do you know of one?"

"Oh, yes," he said. "Of more than one, I'm afraid."

"Is it far away? I could take a taxi, maybe?"

The Salvation Army man wrinkled his forehead. Finally he said, "It's almost six o'clock. My relief will show up then. If you want to wait, and if you can afford a dollar taxi ride, I'll take you to a family in my own neighborhood who needs just about everything."

"And they have a small baby?"

"A very small baby."

"Then," said Ursula joyfully, "I wait!"

The substitute bell-ringer came. A cruising taxi slowed. In its welcome warmth, Ursula told her new friend about herself, how she came to be in New York, what she was trying to do. He listened in silence, and the taxi driver listened too. When they reached their destination, the driver said, "Take your time, Miss. I'll wait for you."

On the sidewalk, Ursula stared up at the forbidding tenement, dark, decaying, saturated with hopelessness. A gust of wind, iron-cold, stirred the refuse in the street and rattled the ashcans. "They live on the third floor," the Salvation Army man said. "Shall we go up?"

But Ursula shook her head. "They would try to thank me, and this is not from me." She pressed the package into his hand. "Take it up for me, please. Say it's from . . . from someone who has everything."

The taxi bore her swiftly back from dark streets to lighted ones, from misery to abundance. She tried to visualize the Salvation Army man climb-ing the stairs, the knock, the explanation, the package being opened, the dress on the baby. It was hard to do.

Arriving at the apartment house on Fifth Avenue where she lived, she fumbled in her purse. But the driver flicked the flag up. "No charge, Miss."

"No charge?" echoed Ursula, bewildered.

"Don't worry," the driver said. "I've been paid." He smiled at her and drove away.

Ursula was up early the next day. She set the table with special care. By the time she had finished, the family was awake, and there was all the excitement and laughter of Christmas morning. Soon the living room was a sea of gay discarded wrappings. Ursula thanked everyone for the presents she received. Finally, when there was a lull, she began to explain hesitantly why there seemed to be none from her. She told about going to the department store. She told about the Salvation Army man. She told about the taxi driver. When she finished, there was a long silence. No one seemed to trust himself to speak. "So you see," said Ursula, "I try to do a kindness in your name. And this is my Christmas present to you. . . ."

How do I happen to know all this? I know it because ours was the home where Ursula lived. Ours was the Christmas she shared. We were like many Americans, so richly blessed that to this child from across the sea there seemed to be nothing she could add to the material things we already had. And so she offered something of far greater value: a gift of the heart, an act of kindness carried out in our name.

Strange, isn't it? A shy Swiss girl, alone in a great impersonal city. You would think that nothing she could do would affect anyone. And yet, by trying to give away love, she brought the true spirit of Christmas into our lives, the spirit of selfless giving. That was Ursula's secret—and she shared it with us all.

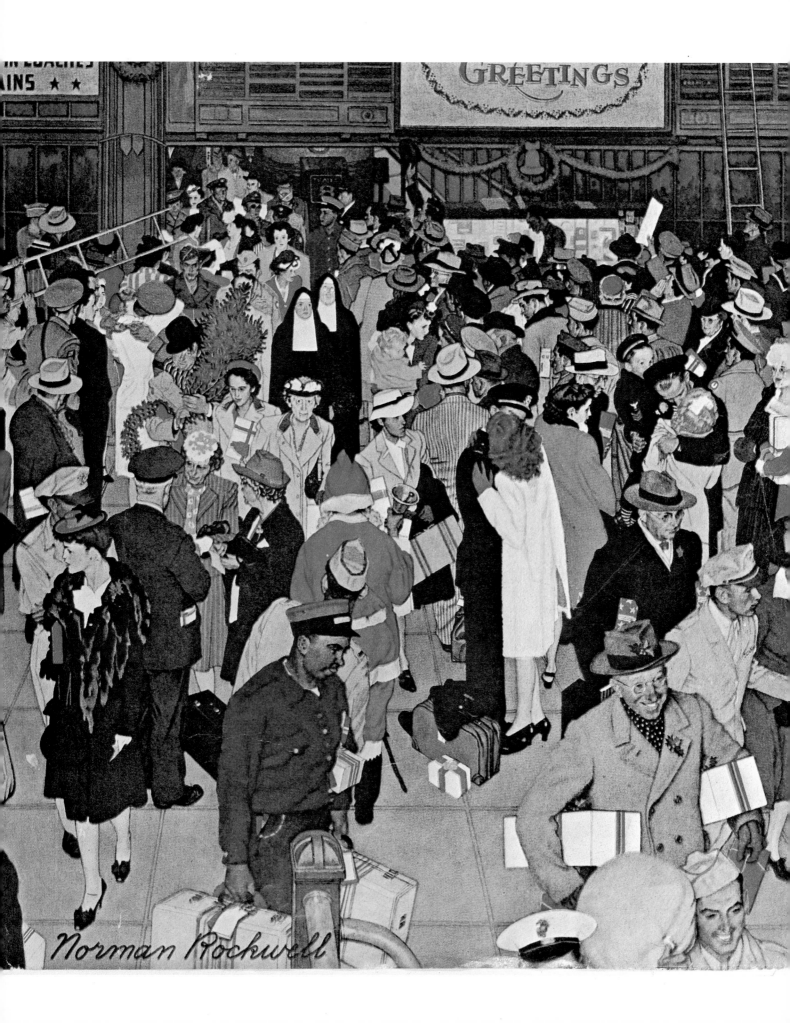

Christmas This Year

BOOTH TARKINGTON

Something more than a dozen years ago, at Princeton, I heard from one of the "Art Professors" that a painting by Mainardi, a fine example from the Florentine Renaissance of the high period, could be bought in New York for far less than its worth. The great Depression was then upon us; the picture had been put through an auction sale and a dealer had bid it in for a fiftieth of what had once been paid for it.

I went to his galleries; he brought out the painting and I stood puzzled before it. The central figure was that of the blonde Virgin enthroned and holding the Christ child upon her lap. That was plain enough; but who were the two tall saints flanking the throne? One, holding a book, was a woman, probably identifiable as Ste. Justina; the other one was the problem—a long, thin, elderly man, bearded, ecclesiastically robed, red-gloved and carrying four loaves of bread in token of what function I couldn't guess.

One thing was certain: this ancient gentleman was immeasurably compassionate. That was markedly his expression. A deep world sadness underlay the look of pity; he was visibly a person who suffered less his own anguish and more that of others. You saw at once that he was profoundly sorry for all of humankind.

When I had the painting on my own wall at home, I found that a gentle melancholy pervaded the room and the old saint seemed to add a wistfulness. "Don't you really wish to know who I am?" he inquired to me whenever I looked his way.

I did indeed wish to know him and to understand his sorrow, which was one of the kind we call "haunting"—all the more so because it was universal. Of all the saints, he was the one who most mourned over the miseries of this tangled world. We got out our books, wrote to iconographical experts—and lo! we had our man. The sad old saint is—Santa Claus!

He is St. Nicholas of Bari and his four loaves of bread signify his giving, his generosity. In time, as the legend grew and changed, the most jocund and hearty of all symbolic figures emerged from this acutely sad and grieving one. St. Nicholas of Bari became "Old Saint Nick," "Kriss-kringle" (a most twisted alliterative) and Santa Claus.

He, the troubled and unhappy, now comes laughing down the chimney, fat and merry, to be the jovial inspiration of our jolliest season of the year. We say that time changed him, made this metamorphosis; but it was we—"we-the-people"—who did it. Time only let us forget that St. Nicholas was a sorrowful man.

Mainardi put a date on the painting. It is clear and neat upon a step of the Virgin's throne—1507. In the long march of mankind, the four hundred and thirty-eight years that have elapsed since the Tuscan painter finished his picture is but a breath. St. Nicholas as we know him now, our jolly, shouting friend, a frolic for the children, may become the saddest of all the saints again, someday. What made us brighten him into Santa Claus was our knowledge that the world was growing kinder than it was in 1507.

St. Nicholas of Bari knew only a cruel world. Christmas of this year needs the transfigured image of him—the jolly one who is merry because the world is wise—and kind.

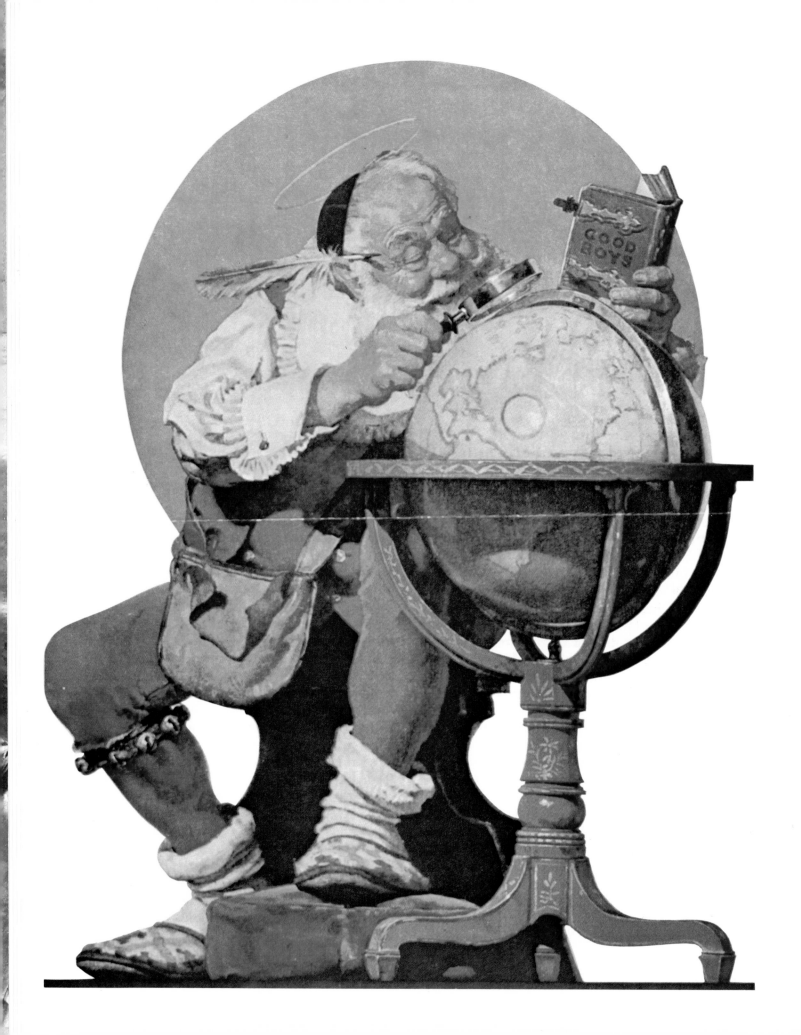

SECOND DAY: Skim fat off broth. Prepare apples. Measure after they are cut. Leave a few peels for color. Cook apples and raisins in a small amount of water until apples are tender, but not broken up.

Add broth, meat and all the fruit with juices, sugar, cinnamon and vinegar. Simmer only until heated through. Stir very little; try to keep the fruit whole.

Use only amount needed for pies. Freeze remainder of mincemeat mixture.

Add 1 tablespoon flour per pie with additional sugar to taste, if desired, to mincemeat mixture when ready to make into pies. Dot with butter or oleo. Use your favorite double-crust recipe.

Bake at 450°F for 10 minutes, then lower to 350°F for 30 minutes or until crust is nicely browned on top.

After baking, store in refrigerator. Take out in time to eat at room temperature.

SQUASH PIE

1¼ cups steamed and strained squash.	¼ teaspoon cinnamon, ginger, nutmeg, or
¼ cup sugar.	½ teaspoon lemon extract.
½ teaspoon salt.	1 egg.
	⅞ cup milk.

Mix sugar, salt, and spice or extract, add squash, egg slightly beaten, and milk gradually. Bake in one crust, in quick oven at first to set rim, decrease the heat afterwards, as egg and milk in combination need to be cooked at low temperature. If a richer pie is desired, use one cup squash, one-half cup each of milk and cream, and an additional egg yolk.

APPLE PIE

4 or 5 sour apples.	⅛ teaspoon salt.
⅓ cup sugar.	1 teaspoon butter.
¼ teaspoon grated nutmeg.	1 teaspoon lemon juice.
Few gratings lemon rind.	

Line pie plate with paste. Pare, core, and cut the apples into eighths, put row around plate one-half inch from edge, and work towards centre until

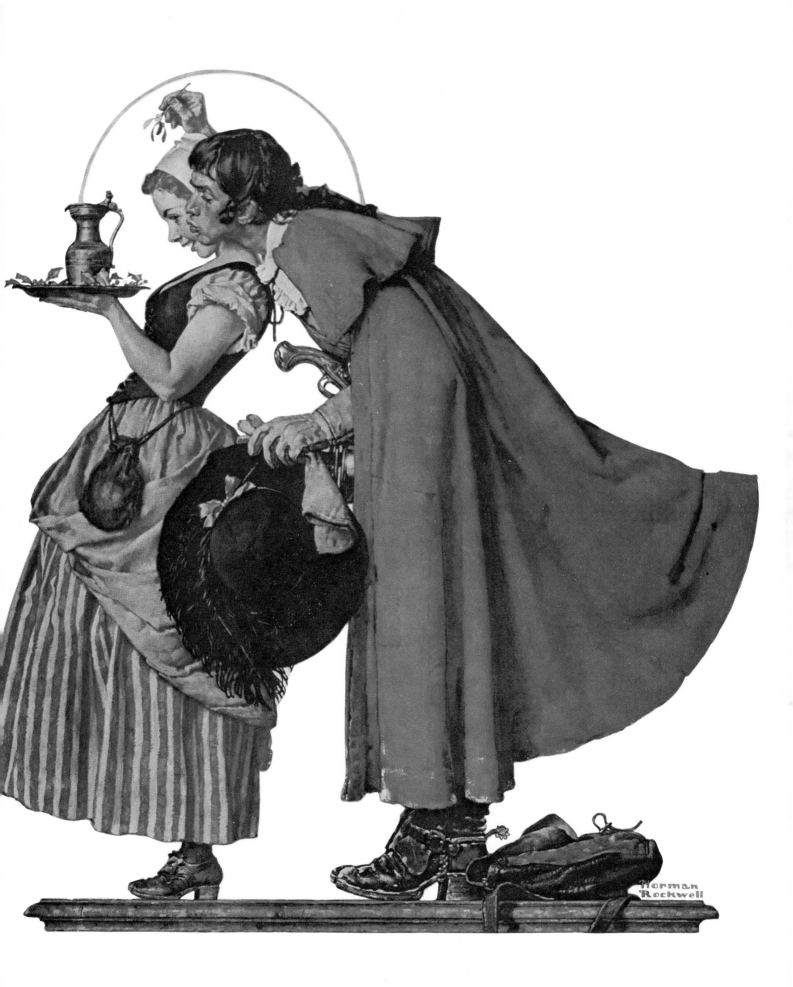

Fennel	*Foeniculum vulgare*	herbaceous perennial
Winter Savory	*Satureja hortensis*	woody perennial
Peppermint	*Mentha piperita vulgaris*	herbaceous perennial

EASY TO BUY, BUT NICE TO GROW

Parsley	*Petroselinum crispum*	biennial
Cilantro	*Coriandrum sativum*	annual
Dill	*Anethum graveolens*	annual

FOR ADVENTUROUS COOKS

Lovage	*Levisticum officinale*	herbaceous perennial
Garden Sorrel	*Rumex acetosa*	herbaceous perennial
Rose Geranium	*Pelargonium graveolens*	tender perennial
Shiso	*Perilla frutescens*	annual
Angelica	*Angelica archangelica*	biennial
Cinnamon Basil	*Ocimum basilicum* 'cinnamon'	annual

the HERBAL KITCHEN

the HERBAL KITCHEN

COOKING WITH FRAGRANCE AND FLAVOR

JERRY TRAUNFELD

PHOTOGRAPHS BY JOHN GRANEN

WILLIAM MORROW

An Imprint of HarperCollinsPublishers

HarperCollins books may be purchased for educational, business, or sales promotional use. For information please write: Special Markets Department, HarperCollins Publishers, 10 East 53rd Street, New York, NY 10022.

Designed by Vertigo Design NYC www.vertigodesignnyc.com

LIBRARY OF CONGRESS CATALOGING-IN-PUBLICATION DATA

Traunfeld, Jerry, 1959–

The herbal kitchen: Cooking with fragrance and flavor / Jerry Traunfeld; photographs by John Granen.

p. cm.

ISBN 0-06-059976-6

1. Cookery (Herbs) 2. Herbs I. Title.

TX819.H4T7224 2005

641.6′57—dc22 2004060924

07 08 09 IM/❖ 10 9 8 7 6 5 4

for STEVIE
and in memory of IRVING

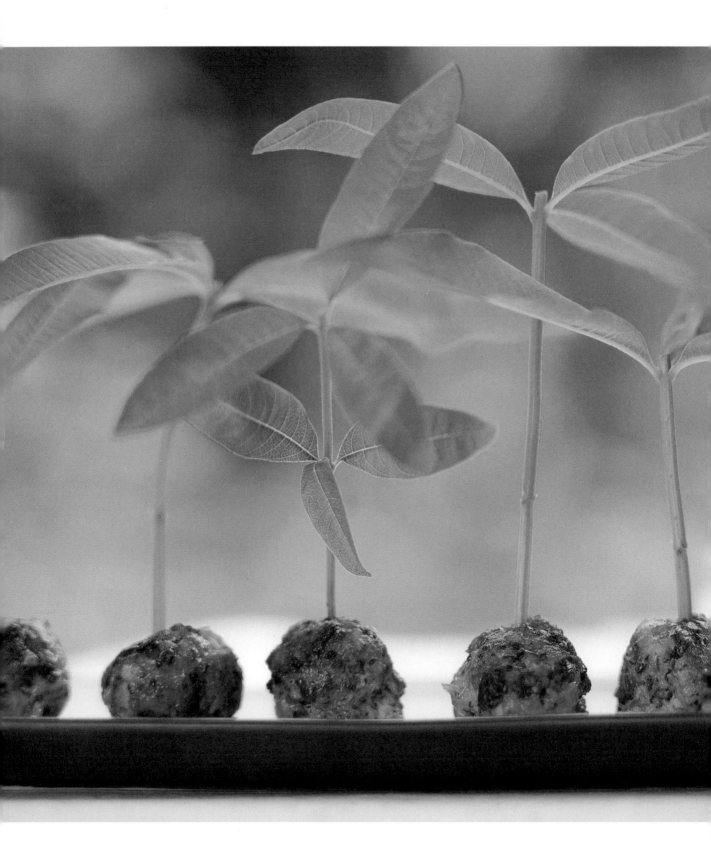

CONTENTS

Acknowledgments

WHEN I BEGAN WRITING MY FIRST COOKBOOK IN 1997, as a chef who never wrote as much as a letter but wanted to pen his own words, I had a lot to learn, beginning with how to type. This time around I had a head start, and this book was truly a joy to create. I enjoyed every minute of the time I spent on it, in large part because of the many people who helped and supported me. I send a genuine thanks to all of them.

John Granen arrived at my house every other week during the summer to photograph the food in my garden or kitchen as I styled it. With his skill, patience, and keen eye, he delivered stunning results and I thank him for the rewarding collaboration.

Judith Riven, my superagent, enabled me to produce the kind of book I dreamed about and I deeply thank her for her attention throughout the whole process, from proposal to press.

At Morrow, a huge thank-you to Harriet Bell, my editor, for her confidence in the project, for being such a pleasure to work with, and for making this a gorgeous book, and thanks to Lucy Baker, Carrie Bachman, Diane Aronson, Ann Cahn, Leah Carlson-Stanisic, and Vertigo Design.

At The Herbfarm, thanks to its owners, Ron Zimmerman and Carrie Van Dyck, for the opportunities they've given me over the fourteen years we've worked together, and for their dedication to creating an extraordinary dining experience for every one of our guests. Toby Kim was a great help with assisting during the photo shoots, and thanks to him and the rest of my kitchen staff, including John Payne, Joe Ritchie, Dan Gilmore, Jeanette Smith, Becky Selengut (for the soup idea), Savuthy Dy, Steve Hansen, and Candido Hernandez-Reyes, for their hard work every day. Thanks for the support of the Herbfarm office staff and the dining room staff, with a special thanks to our Wine Goddess (sommelier), Christine Mayo. And finally a big applause for EagleSong, our head gardener, for her remarkable understanding of plants and the soil, and thanks to her, Julie Wuestehoff, and Robert Mills for the splendid herbs and vegetables they grow.

Thanks to Sur La Table for their generosity and to Bob Kramer at Bladesmith for his knives that are works of art.

I'm grateful to all those who gave me feedback on the recipes after trying them in their own home kitchens. Thanks to Heidi Gregory, Sally Toffic, Katie Thacher, Anna Hurwitz, Nancy Scharf, and Sara Bowen.

And thanks most of all to Stevie, who helps and supports me in so many ways, who keeps me laughing, and whose opinion I always trust.

Introduction

FOR AS MANY YEARS AS I'VE BEEN A CHEF, I've always been asked the same three questions: Do you cook at home? What do you cook at home? And why aren't you fat?

Yes, I cook at home—very often. I'm bound to my restaurant stove four nights a week, but on the other three you'll find me in my Seattle bungalow's kitchen, and it's pretty hard to drag me away. I love to fiddle at home, but not fuss. When I cook on my nights off I don't want to feel like I'm at work, so Monday through Wednesday—my nights at home—I put on a completely different hat than the chef's toque I wear in my restaurant. I cook food that I crave or that pleases my partner Stephen and my guests, and though we eat very well, the preparations have to be simple. The common thread, whether I'm cooking at home or at The Herbfarm, is fresh herbs. Herbs appear in most every dish I prepare for my nine-course restaurant menus, and they make their way from my backyard garden into much of the food I cook in my home kitchen.

Like most home cooks, I search for fast and easy-to-prepare recipes that taste extraordinary. When I cook with fresh herbs it's easy to achieve amazing results with little effort. As I experiment at the restaurant, inventing dishes and pondering different ways of incorporating the herbs, I always think about how I can translate the same techniques into no-fuss home recipes. I've collected the best of those recipes, added some favorite versions of familiar classics that I've enlivened with herbs, like lasagna and stuffed eggs, and organized them according to the occasion, whether a workday supper for the family, a special dinner for two or four, or a feast for a table full of guests. If you're already accustomed to cooking with fresh herbs, these recipes will inspire you with new ideas. If you're just discovering them, I know you'll get hooked when you taste what they can do for your cooking.

As much as teaching how to cook with herbs, I strive to encourage more people to grow them, so I've included important tips on the varieties, culture, and characteristics of each herb I cook with. A backyard herb garden, or even a big planter filled with herbs, is an endlessly rewarding project for any avid cook. Instead of spending a couple of dollars each time you buy a few sprigs of questionable freshness, you'll have a rejuvenating supply with just a small initial investment of time and money. Freshly picked culinary herbs are far more vibrant tasting and you'll have a much wider selection of varieties, including those you can't buy as a cut herb in any store. Beyond that, there's great pleasure in the very act of harvesting the herbs you are going to cook with. Even though you might have only plopped the plants in the ground and watered them, you can't help but feel the accomplishment of raising these useful and delightful ingredients yourself.

As to why I'm not fat, what if the herbs . . . ?

FROM
THE HERB
GARDEN
to the
cutting
board

starting an herb garden

IF YOU RANDOMLY CHOOSE A GROUP OF GARDEN PLANTS, they'll likely have differing needs. Some prefer moist roots in dappled shade, some rich soil in full sun, but luckily most culinary herbs like the same conditions and will grow quite happily with one another in the same plot of earth with little fuss. With a little attention they'll flourish.

CULINARY HERBS ARE SUN-LOVERS. Put your herb garden or herb planters where they will receive at least 6 hours of direct sun a day. There are a few exceptions, such as chervil and sorrel, which do well in part shade.

BE SURE THE SOIL DRAINS WELL. When you water, it should soak into the soil within a minute or so, rather than standing and pooling at the surface. If you have heavy soil, you'll either need to dig in lots of organic matter, like compost, or create raised beds.

BEGIN WITH GOOD SOIL. Even though some herbs are native to dry, rocky hillsides, they will grow best in your garden if you provide nutrient-rich soil with good tilth. Compost, readily available at garden centers, is the best thing you can add to your soil, as it improves both its fertility and structure. A 2-inch layer, worked in with a garden fork, will yield a dramatic improvement. Supplement it with an application of a balanced organic fertilizer in the beginning and middle of the growing season.

ONCE ESTABLISHED, some herbs (particularly sage, rosemary, thyme, and lavender) are quite drought tolerant, but all your herbs will be their most productive if you water them regularly and keep them from drying out completely.

PRUNE YOUR HERBS BACK DURING OR SHORTLY AFTER THEY FLOWER. The exceptions are rosemary, bay, and scented geraniums.

UNLESS YOU LIVE IN AN AREA WITH WARM WINTERS, plant your perennial herbs where they get warmth from the sun in the winter and shelter from winds, such as along a south wall. They'll also appreciate a blanket of winter mulch.

HAVING ALL YOUR HERBS TOGETHER IN ONE PLOT OF EARTH IS CONVENIENT and can be very beautiful, but I also like to tuck and scatter them throughout my small backyard garden. Weave their shapes and leaf textures into mixed plantings for their beauty and their bounty.

two rules for harvesting your herbs

ALWAYS CUT SPRIGS, not individual leaves. Cutting sprigs encourages new growth; removing only the leaves will weaken the plant. The exceptions are bay laurel, sorrel, or chives.

Plants that branch should be cut at the stem above a set of leaves. Plants in the parsley family (Umbelliferae) should be cut at the base of the stem.

storing fresh-cut herbs

IF YOU GROW YOUR OWN HERBS, cut them just before you need them. Once harvested, they lose essential oils, and, therefore, flavor, the longer they wait for you to cook with them. If you cut more than you need, or have freshly cut bunches from a market or friend, pack them (without washing first, so that their leaves are dry) in resealable freezer bags, press the excess air out, and keep them in the vegetable drawer or on a shelf of the refrigerator. I've always disagreed with the pervasive advice of standing herb sprigs in a container of water; I find they hold longer and better in the bags. The exceptions are lemon verbena and basil, both of which can blacken from the chill of the refrigerator and do best held in water like cut flowers on a kitchen counter.

separating leaf from stem

FIRST OF ALL, don't make more work for yourself than you need to; it's not always crucial to remove every bit of stem from the herbs you cook with. The most important thing is to remove anything twiggy, wiry, or woody, which you wouldn't want to chew on. Umbelliferae like parsley, chervil, dill, and cilantro have soft stems; just pull out the very thick ones and chop up the sprigs, small stems and all. And if you are adding the herbs to something that will be strained, or if the herbs will be pulled out after they release their flavor, you certainly don't need to stem them.

To get the job done quickly, hold the sprig at the bottom and strip the leaves off in one motion. If you get to the top and the soft stem breaks, just leave it in. Sometimes it's easier to strip the leaves in the other direction, in which case hold it an inch or two from the top and pull down.

chopping, slicing, tearing

WHEN CULINARY SCHOOL GRADUATES first start working in my kitchen, they invariably want to chop herbs to dust. Even many home cooks are inclined to finely mince fresh herbs, as if they should look like the tiny flakes from jars of dried herbs. Easy does it! When you over-chop herbs they bruise and loose their identity. Unless you are making a pesto or puree, lean toward a coarser chop. Herbs can better express themselves in a dish if you can recognize them.

Here's how to interpret the terms I use in this book:

"CHOPPED" implies that the herbs are cut to a consistency halfway between coarse and fine. Since "medium chopped" is poor English, I just say "chopped." Exactly how much to chop is open to your own interpretation, but an average-sized piece of leaf would be between ⅛ inch and ¼ inch across. Thyme, which has tiny leaves to begin with, would be smaller.

CLOCKWISE FROM TOP LEFT: Whole leaves, small leaves, strips, finely chopped, chopped, coarsley chopped

"COARSELY CHOPPED" means the herbs should be quite identifiable. An average-sized piece would be larger than ¼ inch.

"VERY COARSELY CHOPPED" means running your knife through the herbs a couple of times. Some of the leaves may be left whole.

"FINELY CHOPPED," a phrase I seldom use when it comes to herbs, means chopped until you have a pile of tiny green flakes. Each piece would be about 1/16 inch across.

"CUT IN STRIPS" is the same thing as a chiffonade. Line several leaves up in a pile, all facing in one direction, and fold them in half lengthwise to make a tight bundle. Slice at intervals anywhere between 1/16 inch and ¼ inch apart in one direction so that you end up with thin strands or ribbons.

"TORN LEAVES" are sometimes a better choice than chopped ones in rustic and robust dishes. Basil is often treated this way. Just tear the leaves in large pieces of varied size, averaging about an inch across.

"CHOPPING WITH A ROCKING CUT" might sound complicated, but this is a very simple technique. If you master it, you'll be able to chop your herbs in no time.

Choose a sharp knife that has a curve to the edge, like a typical chef's knife. Make sure that your cutting board is level and stable; put a damp towel underneath it if it slides. Gather the herb leaves into a mound. Grab the handle of the knife and hold the palm of your other hand firmly across the top of the front end of the knife to steady it and use as a pivot. Keeping your pivot hand stationary, lift the handle up and down in a rocking motion over the mound about eight or ten times, rotating the handle away from you a little after each stroke, as if you were cutting eight or ten thin slices from one-quarter of a pie (the center of the pie is your pivot hand). Do it quickly and with determination. Gather the herbs back into a mound using the side of the knife blade and repeat the rocking cut. Continue until the herbs are as fine as you wish. If you're chopping large leaves, like sage or basil, you can take a shortcut: Begin by gathering the herbs into a tight bunch and slice down the bunch in one direction as if you were cutting strips, then go to the rocking cut.

measuring

EXACT MEASUREMENTS OF FRESH HERBS are difficult to standardize. A quarter cup of coarsely chopped sage leaves that you let fall into a measuring cup will be a fraction of the amount of a quarter cup of tightly packed, finely chopped sage. And herbs vary in strength. Tarragon from your summer garden will be much stronger than the sprigs from the supermarket in winter. But relax; a little more or a little less of an herb will never ruin a dish.

I've tested the recipes in this book with herbs from my garden that I consider to have good strength of flavor. All the measurements are for gently packed herbs, which means filling the measuring spoon or cup with whole or chopped leaves, then softly pressing or tapping on them.

It's implied that all herbs in these recipes are fresh unless dried alternatives are suggested.

HERB GARDEN
beginnings

POPCORN CHICKPEAS

RYE-THYME CHEESE STRAWS

JUMP-IN-THE-MOUTHS

SIMPLER SUMMER ROLLS

PROSCIUTTO MELON WITH LIME
AND CILANTRO

WARM FIGS FILLED WITH GOAT
CHEESE AND BACON

MINTED LENTIL AND GOAT
CHEESE STRUDEL

SMOKED TROUT TOASTS

SMOKED SALMON STUFFED EGGS

ROASTED OYSTERS WITH SORREL
SAUCE

ROSEMARY MUSSEL SKEWERS

SPICY VERBENA MEATBALLS

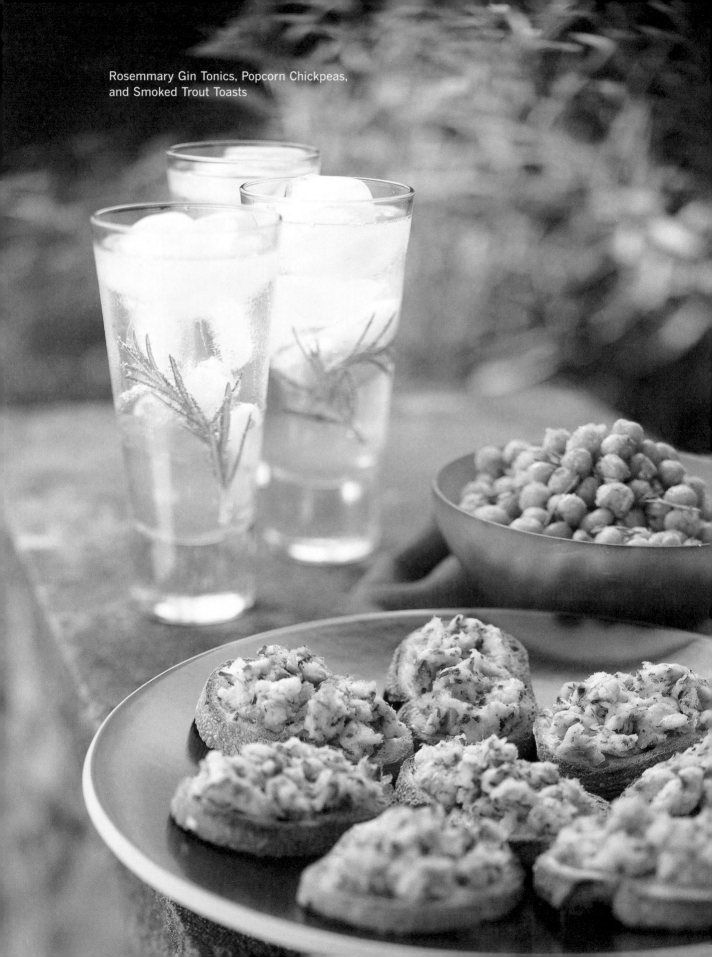

Rosemmary Gin Tonics, Popcorn Chickpeas,
and Smoked Trout Toasts

TOSS CANNED CHICKPEAS IN A HOT SKILLET with lots of olive oil, then finish them with rosemary and garlic, and they transform into this warm, chewy, and irresistible cocktail munch.

popcorn CHICKPEAS

2 CUPS

One 15-ounce can chickpeas

3 tablespoons olive oil

1 tablespoon coarsely chopped rosemary

1 tablespoon finely chopped garlic

¾ teaspoon kosher salt

Freshly ground black pepper

Drain and rinse the chickpeas in a strainer. Turn them out onto paper towels or a clean dish towel and pat them dry. Pour the olive oil in a large skillet over medium-high heat and toss in the chickpeas. Cook them for 5 to 7 minutes, shaking the pan often. They won't really brown, but they'll turn several shades darker, shrink a bit, and form a light crust. Pour the chickpeas back into the strainer to drain the excess oil and then return them to the pan. Lower the heat to medium and add the rosemary and garlic. Stir for another minute or two until the garlic begins to brown. Sprinkle with the salt and a few grindings of pepper. Toss again and pour them into a serving bowl. Serve warm.

SALT

I use three kinds of salt in my kitchen:

KOSHER SALT is my all-purpose salt. I used Diamond Crystal brand to test the recipes in this book. If you must substitute table salt or fine sea salt for kosher salt, use one-third less.

FINE SALT is best for baking. I use fine sea salt, but ordinary table salt is fine.

COARSE SEA SALT is best sprinkled on food, especially meats and seafood, at the last minute. *Fleur de sel* is a wonderful French pure white salt, but there are many other good ones, such as Celtic gray or *sel gris*.

remember ROSEMARY

Most rosemary plants are upright shrubs growing 4 to 6 feet tall, though some varieties trail and can be used as a ground cover. Even though there are many specific rosemary cultivars, they essentially all taste similar. If I had to choose a favorite it would be Tuscan Blue, which has lush branches, an attractive upright shape, and brilliant blue flowers in early spring.

ROSEMARY WILL NOT SURVIVE THE WINTER outdoors in very cold climates. In zone 6 or lower, you'll have to grow it in a pot and bring it indoors in winter, or put it in the ground and replant it each spring. In zone 7, you'll have to plant it in a protected spot and mulch it well. Some varieties are more cold tolerant than others; Arp, though not the prettiest with its sparse gray needles, makes it through winters that other rosemary cultivars don't.

LIKE SAGE, ROSEMARY IS BEST WHEN COOKED, rather than adding it at the last minute or using it raw, as in a salad.

THE INTENSITY OF THE FLAVOR OF ROSEMARY VARIES, depending on growing conditions. It is strongest in hot weather and can be very mild in the winter. You might need to adjust the amount you add to a recipe if you sense your rosemary is at one extreme.

ROSEMARY BLOOMS IN EARLY SPRING with tiny blue (or in certain varieties, pink or white) flowers. If you patiently gather them they are delicious sprinkled on salads or on any dish that rosemary would enhance.

ROSEMARY IS AN EXCEPTION TO THE RULE that you should cut herbs back after they flower. Trim rosemary like any shrub, at any time, paying attention to the shape and size you want to achieve.

THIN, STIFF ROSEMARY BRANCHES make excellent skewers. Just strip the leaves off the lower portion and cut the lower tip at an angle so you can pierce the food.

SUBSTITUTING RYE FLOUR for part of the white flour in a flaky dough results in a crisp pastry with fuller flavor and much more character, and makes the dough easier to handle. It's especially so in these cheese straws, laced with thyme and hopelessly addictive.

rye-thyme CHEESE STRAWS

48 STRAWS

½ cup rye flour

1 cup all-purpose flour

1 teaspoon kosher salt

3 tablespoons coarsely chopped thyme

8 tablespoons (4 ounces) unsalted butter, chilled

1 cup (3 ounces) Gruyère, shredded on the medium side of a box grater

½ cup ice water

Combine the flours, salt, and thyme in a medium mixing bowl. Cut in the butter with a pastry blender until it is the size of grains of barley, or if you prefer, you can pulse the ingredients in a food processor and then transfer them to the mixing bowl. Toss in the shredded cheese. Sprinkle with the ice water and stir with a wooden spoon or with your hands until all the crumbs are gathered up. When you squeeze a handful it should form a dough that doesn't crumble apart. Squeeze it all together, wrap it in plastic wrap, and chill for 15 minutes.

Preheat the oven to 400°F.

Roll out the dough on a floured surface into a long rectangle about 5 × 24 inches and ¼ inch thick. Use a pastry wheel or pizza wheel to cut ½-inch-wide strips in the short direction. Pinch in the sides of each strip in several places to begin to round them, then roll each on the board into a straw shape. Place the straws about ½ inch apart on baking sheets lined with parchment paper or Silpat.

Bake the straws, one pan at a time, for 18 to 22 minutes, or until golden brown. They will become very crisp as you allow them to cool on the pan. Once cool, they can be stored in an airtight container for up to a day.

herbal improvisations In place of the thyme, add 3 tablespoons of chopped rosemary or savory. Or, if you have caraway thyme in your garden, try it instead of English thyme.

SALTIMBOCCA, which means "jump-in-the-mouth," is a classic Italian dish of veal scallops sandwiched with sage leaves and prosciutto and sometimes cheese. The filling itself is so good it doesn't need the veal. I just dip bite-sized bundles of it in a light tempura batter and fry them until crisp.

JUMP-in-the-mouths

ABOUT 20 PIECES

4 ounces Italian washed-rind Fontina cheese or Gruyère

2 ounces very thinly sliced prosciutto (5 large slices)

40 medium sage leaves

BATTER

2 cups all-purpose flour

2 tablespoons cornstarch

2 teaspoons baking powder

2½ cups ice water

1 quart vegetable oil for frying

Cut the rind off the cheese then cut the cheese into slices ⅜ inch thick and then into rectangles slightly smaller than the size of the sage leaves (½ × 1½ inches).

Tear or cut off small pieces of prosciutto, approximately 2 × 3 inches, and wrap them around the pieces of cheese to completely cover them. This keeps them from leaking out when fried. Sandwich the packages between two sage leaves of similar size. The leaves won't adhere until the bundles are dipped in the batter.

Whisk the flour, cornstarch, and baking powder together in a mixing bowl. Pour in the ice water and stir briefly, only to moisten the dry ingredients. The batter should be lumpy. Pour the oil into a 3-quart saucepan and heat it until it reads 360°F on a deep-fry thermometer. One by one, lift the bundles by holding onto both sage leaves at one end and dip them into the batter. Let the excess batter drip from them for a moment, and then drop them into the hot oil. Fry 6 or 8 at a time until very lightly browned and crisp, 2 to 3 minutes, flipping them in the oil to brown both sides. Lift them out with a wire skimmer and drain on paper towels. Fry another batch when the oil returns to 360°F. When all the bundles are fried and drained, transfer them to a platter and serve right away.

EVERYONE'S FALLING FOR THE BEAUTIFUL SOUTHEAST ASIAN SUMMER ROLLS (formerly known as spring rolls) that are offered in many restaurants. An expertly made one is a work of art—a perfect balance of herbs, vegetables, cellophane noodles, and often shrimp or pork, rolled tightly in a translucent rice wrapper. Believe me, making them at home takes practice and patience. I wanted to create a simpler version so I took what I like best about them—the fragrant herbs—and tossed them with shredded iceberg, which has just the right crunch and weight to upholster them. They're rolled up with peanuts as if they were crepes with open ends and served with *nuoc cham,* a Vietnamese dipping sauce.

simpler SUMMER ROLLS

1 2 ROLLS

DIPPING SAUCE

¼ cup Thai fish sauce

¼ cup fresh lemon juice

2 tablespoons water

2 tablespoons sugar

2 fresh Thai bird chiles, thinly sliced, or other small hot chile

1 tablespoon finely chopped shallots

½ cup coarsely chopped spearmint or small leaves

½ cup coarsely chopped cilantro

½ cup coarsely chopped sweet or Thai basil, or small whole leaves

1½ cups shredded iceberg lettuce

Twelve 6-inch rice paper rounds

½ cup roasted peanuts, coarsely chopped

Stir the ingredients for the dipping sauce together in a small bowl.

Toss the herbs and lettuce in a bowl until evenly combined. Fill a shallow bowl with warm tap water and drop in 4 of the rice papers, one at a time. In about 3 minutes they should be very soft and pliable. Lift them from the water and lay them out on a clean kitchen towel. Divide one-third of the herb mixture among the 4 papers, arranging each portion in a strip lengthwise across the center. Sprinkle with peanuts. Roll each one up into a snug cylinder and place it on a platter. Repeat the soaking, filling, and rolling in two more batches. Serve the rolls right away with the dipping sauce or cover them with a damp paper towel and then plastic wrap; they'll hold for about 2 hours in a cool spot (not the refrigerator).

THINLY SLICED ITALIAN PROSCIUTTO DRAPED OVER PERFECTLY RIPE MELON—how can you improve on that? Well, I've guiltlessly taken liberties with this Italian classic. I've added a stroke of lime marmalade, which captures sweet, sour, salty, and bitter flavors, and tucked in cooling sprigs of cilantro. Every bite is a thrill.

At an informal gathering, these can be passed as finger food; otherwise, offer plates and forks. You can also prepare this dish with larger pieces of melon and prosciutto to serve as a first course for a sit-down dinner.

PROSCIUTTO MELON with lime and cilantro

ABOUT 16 PIECES

LIME MARMALADE

2 limes

½ cup sugar

½ cup water

1 teaspoon kosher salt

8 thin slices quality prosciutto (about 5 ounces)

1 bunch cilantro, washed and spun dry

Half of a ripe melon, such as cantaloupe, honeydew, or galia, in thin slices

Remove the zest from the limes in thin strips (use a citrus zester, not a microplane). Slice the tops and bottoms off the limes and stand them on a cutting board. Cut off the pith in vertical strips, slicing just beneath the white layer, then slice the limes in ½-inch-thick rounds and cut each round in quarters.

Bring the sugar, water, lime zest, and salt to a boil in a small saucepan. Drop in the lime pieces and boil, uncovered and without stirring, for 8 minutes. Allow the marmalade to cool at room temperature (it will thicken and gel as it does).

Work with one slice of prosciutto at a time. Cut it in half and spread the middle of each portion with about ½ teaspoon marmalade. Lay several sprigs of cilantro across each piece, allowing the leaves to extend over the edges, and top with melon slices. Wrap the prosciutto around the melon. These are best served as soon as possible; the melon slices will weep as they sit.

herbal improvisation In place of cilantro sprigs, use small leaves or fine strips of spearmint.

ALTHOUGH FIGS RIPEN IN SUMMER, they love wintry herbs like thyme and rosemary, and both herbs flavor the filling for these easy appetizers. Start with really ripe sweet figs, warm them with the herby-smoky-salty filling and a bit of goat cheese, and you'll have an unforgettable beginning.

WARM FIGS filled with goat cheese and bacon

1 2 PIECES

1 teaspoon olive oil

4 ounces bacon, finely chopped

¼ cup finely chopped onion

1 tablespoon chopped rosemary

1 tablespoon chopped thyme, plus whole leaves for garnish

½ teaspoon salt

6 large ripe figs, at room temperature

¼ cup soft goat cheese

Preheat the oven to 350°F.

Heat the olive oil over medium heat in a small skillet and render the bacon in it until it browns and is nearly crisp. Pour off half the fat and add the onion, rosemary, thyme, and salt. Cook, stirring often, until the onion softens, about 3 minutes, then remove it from the heat.

Cut the figs in half and press your thumb into the center of each half to make a small depression. Arrange them cut side up in a small shallow baking dish. Divide the filling among the figs, forming each portion into a small mound covering the top of the fig. Crumble the goat cheese and place a scant teaspoon of it on top of each mound of filling. Sprinkle with whole thyme leaves.

When ready to serve, bake the figs until just warmed through, about 5 minutes. Serve while still warm.

WHEN YOU BITE INTO THIS STRUDEL, you'll find it hard to believe that it's made with lentils. Lentils combined with mint, thyme, and goat cheese becomes a richly flavored filling that almost tastes as if it were made with lamb.

Be sure to follow the phyllo's package directions for defrosting and handling; the dough is easy to work with when fresh and in good condition, but frustrating if the sheets become dry and torn. Phyllo sheets vary in size, depending on the brand, but the 9 × 14-inch size seems the most common; cut them to that size if they are larger. Once assembled, the strudels can be refrigerated until you are ready to bake them.

MINTED LENTIL and goat cheese strudel

SIX 12-INCH STRUDELS; ABOUT 48 PIECES

2 tablespoons olive oil

½ large onion, finely chopped

1 clove garlic, finely chopped

1 cup dry French-style lentils, such as *lentilles du Puy*

1¾ cups water

1½ teaspoons kosher salt

1½ tablespoons chopped thyme

¼ cup chopped spearmint

¼ cup chopped flat-leaf parsley

Freshly ground black pepper

6 ounces soft goat cheese

24 sheets phyllo dough, 9 × 14 inches

12 tablespoons (6 ounces) unsalted butter, melted

Heat the olive oil in a small saucepan over medium heat and cook the onion and garlic in it until they soften, about 3 minutes. Stir in the lentils, water, and salt and bring to a boil. Lower the heat to a simmer, cover the pan, and cook until the lentils are tender, about 45 minutes. Transfer the lentils to a mixing bowl, draining off any liquid that might be left, and stir in the herbs and a good grinding of black pepper. Stir in the goat cheese.

Open up the package of phyllo. Always keep the sheets covered with a piece of plastic wrap and then a damp towel to keep them from drying out while you are working. Lift one sheet of phyllo and lay it on a piece of parchment paper. Brush the entire surface with melted butter. Cover with another piece of phyllo and more butter, and repeat until you have 4 layers with butter on the top. Divide the filling into 6 equal parts and form one part into a cylinder across the long side of the phyllo, about an inch from the edge. Lift the edge of the dough to begin to cover the filling, then grab the parchment from two corners and lift it so that the strudel rolls itself up loosely. It's important not to roll it tightly or the filling will burst through the side as it expands in the oven. Lift the strudel onto a baking sheet lined with parchment and brush it with more melted butter. Form the remaining 5 strudels in the same way.

Preheat the oven to 375°F. Bake the strudels for 25 to 30 minutes, or until golden brown. Expect a small amount of the filling to pop out of the open ends as it bakes. Let cool on the pan until warm, then transfer to a board, and cut each strudel into 8 pieces.

THE SMOKY, HERBY SPREAD THAT TOPS THESE LITTLE TOASTS has a texture something like *brandade*, a French dish of pounded salt cod, but it's so much easier to prepare.

SMOKED TROUT toasts

MAKES ABOUT 20

8 ounces smoked trout, skinned

4 tablespoons unsalted butter, softened

2 tablespoons sour cream

2 tablespoons chopped marjoram

2 tablespoons chopped chives

Freshly ground black pepper

A good crusty baguette

Extra virgin olive oil

Crumble the trout into the bowl of an electric mixer fitted with a paddle. Add the butter, sour cream, herbs, and a good grinding of black pepper. Mix on medium speed until the fish is broken down, the butter is incorporated, and you have a coarse spread (if you don't have a stand mixer, pulse the ingredients briefly in a food processor).

Preheat your broiler to high with the oven rack in the top third of the oven. Cut ¼-inch slices from the baguette with a serrated knife. Lay them out on a baking sheet and brush both sides lightly with olive oil. Put them under the broiler until the tops are nicely toasted.

Flip the toasts and spread about 2 teaspoons of the trout topping on each. Right before you are ready to serve them to your guests, run the toasts under the broiler until the edges brown and the topping is warm. Serve while still warm.

EVERYONE LOVES DEVILED EGGS. This version has the two herbs that are synonymous to both eggs and smoked salmon: chives and chervil.

SMOKED SALMON
stuffed eggs

12 large eggs

½ cup sour cream

¾ teaspoon kosher salt

½ cup (3 ounces) diced cold smoked salmon

2 tablespoons finely chopped chives, plus small tips for garnish

2 tablespoons chopped chervil, plus small sprigs for garnish

Freshly ground black pepper

Put the eggs in a large pot and cover with cold water. Bring the water to a boil, cover the pot, and remove it from the heat. Exactly 18 minutes later, pour the hot water out and run cold water into the pot until the eggs are cool. Peel the eggs.

Cut the eggs in half lengthwise and remove the yolks. For a very smooth and creamy filling, push the yolks through a sieve with the back of a spoon; otherwise, just mash them with a fork in a mixing bowl. Beat in the sour cream and salt, then stir in the salmon, chives, chervil, and as much black pepper as you like. Spoon the filling back into the hollows of the whites. Cover and refrigerate the eggs until you are ready to serve. Garnish with the chive tips and chervil sprigs.

herbal improvisations In place of chervil, add 1 tablespoon chopped dill or 2 teaspoons chopped tarragon.

I CAN'T DENY THAT THE MOST EXALTED WAY to eat a pristine oyster is raw and on the half shell, but to be honest I most often prefer my oysters cooked, and I've never found a preparation that I like better than this one. The tart vegetal flavor of sorrel sauce perfectly highlights the brininess of the oysters.

ROASTED OYSTERS with sorrel sauce

18 OYSTERS; SERVES 6

Rock salt or kosher salt for lining the baking dish

18 live half-shell oysters, shucked and in their shells

4 ounces sorrel leaves, washed and spun dry (about 5 cups gently packed)

2 tablespoons unsalted butter

2 tablespoons finely chopped shallots

¼ cup heavy cream

2 teaspoons fresh lemon juice

½ teaspoon kosher salt

Freshly ground black pepper

Preheat the oven to 425°F.

Spread rock salt about ½ inch deep in a large shallow baking dish that you will serve the oysters from. Arrange the oysters on the salt, keeping them as level as possible to prevent their liquor from spilling out.

Pull the stems off the sorrel. Stack a small bunch of the leaves on a cutting board, fold them in half, cut them into very fine strips, and set them aside for garnish. Chop the remaining leaves very coarsely. Melt the butter in a medium saucepan over medium heat and cook the shallots in it for about half a minute. Stir in the chopped sorrel, which will quickly wilt and melt into a drab green puree. Stir in the cream. When the sauce comes to a strong simmer, remove it from the heat. Stir in the lemon juice, ½ teaspoon Kosher salt, and a good grinding of black pepper.

Lift an oyster and put a heaping teaspoon of the sauce in the shell. Tuck the oyster back in the shell on top of the sauce. Repeat with all the oysters and sauce. Bake the oysters for 7 to 8 minutes, or until their liquor begins to bubble gently. Top them with the fine strips of sorrel. Serve the oysters from the baking dish of salt; your guests can lift them and eat them with cocktail forks as hors d'oeuvres, or serve them on plates as a first course.

sour SORREL

Sorrel's particular flavor comes from oxalic acid (which is also contained in spinach) rather than from essential oils like most other herbs. Another name for it is sour grass. The two most common types are garden sorrel, *Rumex acetosa*, which has large thin green leaves, and buckler leaf sorrel, *Rumex scutatus*, which has much smaller, quarter-sized leaves that are green or silver gray. Don't pay attention to the term "French sorrel," because both types can be labeled as that. There's a new non-blooming variety with very broad, thick, and dark green leaves, but its fleshy texture is unpleasant to eat. Garden sorrel is the best choice for cooking, and buckler leaf sorrel is best in salads.

BEFORE COOKING GARDEN SORREL, pull off the stem and thick vein.

SORREL HAS TWO UNUSUAL CHARACTERISTICS: It magically melts into a sauce when you heat it, and it turns an unfortunate drab green color. To keep the color brighter, combine it with parsley.

TORN INTO PIECES, sorrel adds an interesting accent to green salads or to cooked greens like spinach and chard.

SLUGS AND SNAILS LOVE SORREL, so keep them at bay or you'll have to share it with them.

SORREL HAS A VERY LONG GROWING SEASON. In mild climates it comes up in very early spring and you can harvest it until winter.

HARVEST SORREL BY CUTTING THE STEMS BACK all the way to the ground. You can cut the entire plant down and it will grow back quickly.

CUT THE FLOWER STALKS BACK whenever they appear to keep the plants from producing new leaves.

CHANCES ARE IF SOMEONE SAYS THEY DISLIKE EATING MUSSELS, they've never had them pan-fried. When you steam live mussels and take them out of the shell, then dredge them in flour and brown them in a skillet, they take on an entirely different character that appeals to just about everyone who likes seafood. I thread them on small woody stems of rosemary before frying to make hors d'oeuvres, flavored from the inside out, and they are especially good when dipped in oregano aïoli.

If you have a large rosemary plant in your garden, you shouldn't have trouble gathering the correct size of sprigs. You want them to be woody enough to hold the mussels securely but thin enough not to mangle them when they are skewered. If you don't grow it, keep your fingers crossed that the rosemary sprigs at your market will be just the right size, or substitute small bamboo skewers.

ROSEMARY MUSSEL skewers

10 TO 16 SKEWERS

2 pounds medium to large fresh mussels (30 to 40), washed and beards removed

½ cup dry white wine

10 to 16 (depending on the size of the mussels) thin woody rosemary sprigs, 4 to 5 inches long

1 cup all-purpose flour

Fine sea salt

½ teaspoon freshly ground black pepper

Olive oil for frying

Oregano Aïoli (recipe follows)

Put the cleaned mussels in a large pot. Pour the wine over them, and cook them covered over high heat until they are all open, and then for an additional minute after that. Drain them into a colander (you can reserve the liquor for a chowder). Spread the mussels out on a baking sheet and refrigerate until cool. Remove the meat from the shells, using a paring knife to aid if they cling.

Cut the bottom of the rosemary sprigs at a sharp angle to create a point that can pierce the mussels. Strip the needles off the bottom three-quarters of the stems, leaving a tuft at the top. Spear 3 mussels onto each skewer. The skewers can be loaded ahead of time and kept covered in the refrigerator for up to a day.

When ready to serve, mix the flour with 1 teaspoon salt and the pepper on a large plate. Pour a ¼-inch layer of olive oil into a large skillet placed over medium heat. Dredge the skewers

with the seasoned flour and shake off the excess. One by one, carefully arrange the skewers in the skillet, keeping the tufts of needles propped against the sloping sides of the pan and out of the oil if possible. The mussels might sputter and pop, so if you have a splatter screen, use it. Cook them until lightly browned on both sides. Drain the skewers on paper towels. Sprinkle lightly with more salt and serve them warm with the aïoli.

oregano AÏOLI

1½ CUPS

THIS WILL MAKE MUCH MORE THAN YOU NEED FOR 16 SKEWERS, but it's tricky to make it in a smaller batch. The leftovers can be used as a sandwich spread or vegetable dip.

 2 large egg yolks

 2 tablespoons fresh lemon juice

 2 cloves garlic

 ½ teaspoon kosher salt

 A dash of Tabasco sauce

 ¼ cup Greek oregano leaves

 1 cup extra virgin olive oil

Put the egg yolks, lemon juice, garlic, salt, Tabasco, and oregano in a food processor. Turn the machine on and slowly pour in the olive oil in a steady stream.

herbal improvisations In place of the oregano, add the same quantity of marjoram or spearmint.

I HAVE NO LUCK GROWING LEMON GRASS in the Pacific Northwest, but each summer my lemon verbena erupts into a shrub as tall as I am. Its piercing lemon flavor is very similar to lemon grass—maybe even more intense—and its leaves are easier to chop and incorporate. I use it to flavor these Southeast Asian-inspired meatballs, which make light summer cocktail bites when served with minted yogurt. Or you can build a meal around them with a bowl of steamed rice. Be sure the pork is not too lean or the meatballs will be dry.

spicy VERBENA MEATBALLS

24 TO 30 MEATBALLS

1 pound ground pork butt

3 cloves garlic, finely chopped

1 jalapeño pepper, finely chopped, or an equivalent amount of any other fresh hot chile

4 green onions, finely chopped

¼ cup plus 2 tablespoons finely chopped lemon verbena

1 cup coarsely chopped cilantro

1½ tablespoons finely chopped fresh ginger

1½ teaspoons kosher salt

2 tablespoons vegetable oil

2 tablespoons coarsely chopped spearmint

1 cup plain yogurt

Stiff branches of lemon verbena or rosemary for skewers

Put the pork, garlic, jalapeño, green onions, lemon verbena, cilantro, ginger, and salt in a large mixing bowl. Dig in with your hands and toss, squeeze, and knead it all together until evenly combined. Pinch off pieces of the meat, about 1½ tablespoons in size, and roll them into balls. Put them on a baking sheet, cover with plastic wrap, and refrigerate until you're ready to cook them.

Pour the oil into a 12-inch or larger skillet set over medium heat. When it's hot, place the meatballs quite closely together in the pan. You should be able to fit them all in. Unless your pan is nonstick, they will stick, but just let them stay where they are until the bottoms are deeply browned, then loosen by scraping them from the pan with a thin spatula. Flip and keep cooking and turning them until most of the surfaces are browned, about 10 minutes total. Cut

into one to make sure it is cooked through. Transfer the meatballs to a platter, and keep them warm in a very low oven if you're not ready to serve them right away.

Stir the mint into the yogurt and pour it into a small bowl for dipping. Arrange the meatballs on a platter and spear them with skewers made of lemon verbena or rosemary branches.

herbal improvisation No lemon verbena? Add the same quantity of chopped spearmint in its place.

BOTANICAL
beverages

GREETING TEA

ROSEMARY GIN TONIC

BERRY ROSE SANGRÍA

BASIL LIME FIZZ

ULTIMATE LEMON DROP

SAGE RUSH

LAVENDER MAI TAI

AT THE HERBFARM, IN THE LATE SUMMERTIME, we offer a big punch bowl of this iced tea to our early guests. Lemon verbena and anise hyssop infuse a whirlwind of lemon, anise, and mint flavors. If you steep the purple flower heads of the anise hyssop along with the leaves they will tint the tea a lovely rose color.

greeting TEA

2 QUARTS

2 quarts water

1 large bunch anise hyssop sprigs (2 ounces)

1 large bunch lemon verbena sprigs or lemon geranium leaves (2 ounces)

2 tablespoons fresh lemon juice

3 tablespoons mild honey

Bring the water to a full boil in a large saucepan. Stir in the herb sprigs, bending the stems first, if necessary. Remove the pan from the heat, cover it, and allow the herbs to steep for 15 minutes. Strain into a large pitcher and stir in the lemon juice and honey. Refrigerate until cold.

anise HYSSOP

This gorgeous perennial, with spires of deep purple flowers, is in fact unrelated to anise or hyssop. Its fragrance is equal parts mint and licorice, and the leaves, especially the very young ones, have a potent sweetness. Be sure to buy the true *Agastache foeniculum*; there are other ornamental agastaches that have different scents, most leaning toward mint.

STEEP THE LEAVES AND FLOWERS IN HOT LIQUID, such as milk, cream, or simple syrup, to extract the flavor, and then strain them out. Use the infused milk or cream to make custards or ice creams or the syrup for beverages, sorbets, or poaching fruit. The flavor is fabulous with raspberries, apricots, peaches, and nectarines.

SCATTER SMALL ANISE HYSSOP LEAVES or leaf tips in green salads, or any salad with fruit like raspberries or cherries, for little bursts of sweet minty-anise flavor.

CUT THE PLANTS BACK BY HALF after the flowers begin to fade, and you will often see another flush of blossoms in the fall.

ADDING A SPRIG OF ROSEMARY gives this old friend of a cocktail such flair! The oils from the herb and lime zest will release in the fizz of the tonic and lightly scent each sip.

rosemary GIN TONIC

1 DRINK

1 lime wedge

One 3-inch sprig rosemary

2 ounces gin

Tonic water

Lightly crush the lime wedge and rosemary in a 10- to 12-ounce glass with a few strokes of a muddler or the end of a wooden spoon. Pour in the gin. Fill the glass with ice and top off with tonic water. Stir to position the lime and rosemary in the middle of the glass.

THIS FLIRTY PUNCH, combining berries, rosé wine, and the scent of rose geranium, is quenching, not too potent, and always up for a summer party.

berry rose SANGRÍA

2½ QUARTS

¼ cup sugar

¾ cup water

12 medium rose geranium leaves

½ cup crème de cassis

1 bottle dry rosé wine, chilled

1 pint ripe strawberries, washed, hulled, and sliced, or 1½ cups fresh raspberries, or a combination of both

1 lemon, very thinly sliced

4 cups club soda or sparkling water, chilled

First prepare a syrup: Bring the sugar and water to a boil in a small saucepan. Stir in the rose geranium leaves, cover, and remove from the heat. Wait at least 10 minutes, then strain the syrup, pressing out all the liquid in the leaves, and chill it in the refrigerator or over ice.

Stir together the syrup, crème de cassis, wine, berries, and lemon in a punch bowl or in a pitcher with a wide opening. Chill for at least 30 minutes to allow the berries to release some of their juice into the wine. The berry flavor will be more intense if you let it chill longer. Stir in the club soda. Ladle the sangría into glasses while it's still cold.

Fennel

IT'S THE PERFECT QUENCHER FOR A HOT SUMMER DAY in the herb garden, or to offer as a nonalcoholic option at cocktail hour.

BASIL LIME fizz

1 DRINK

2 tablespoons basil syrup (recipe follows)

2 tablespoons lime juice

Chilled sparkling water or club soda

Pour the syrup and lime juice into the bottom of a 12-ounce tumbler. Fill the glass about two-thirds full with ice. Pour in the sparkling water as you stir with a spoon.

THE PINCH OF BAKING SODA in this recipe might seem odd, but it helps keep the syrup bright green.

BASIL syrup

¾ CUP

1½ cups basil leaves

½ cup fine (baker's) sugar

½ cup water

⅛ teaspoon baking soda

First blanch the basil leaves: Plunge them into a small pot of rapidly boiling water for 10 seconds, then drain and plunge them into a small bowl of ice water. Drain again and gently squeeze the excess water from the leaves.

Puree the blanched basil in a blender with the sugar, water, and baking soda until you have a dark green liquid, about 30 seconds. Pour the syrup through a fine strainer, stirring with the back of a spoon to help push it through. Store the syrup in a tightly sealed container in the refrigerator, where it will keep for 2 to 3 days.

FRESH LEMON VERBENA, lemon wedges, and citrus-flavored vodka give a triple hit of lemon to this cocktail. If you're remembering a cloyingly sweet version of a lemon drop, trust me that this one is different. The drink itself is quite bracing, and the sugared rim of the glass lets the imbiber control the sweetness of each sip.

ultimate LEMON DROP

2 DRINKS

¼ of a large lemon, cut into 2 wedges

Sugar for the rims of the glasses

2 large sprigs lemon verbena, plus 2 small sprigs or leaves for garnish

3 ounces citrus-flavored vodka

1 ounce orange curaçao or Cointreau

Run one of the lemon wedges around the rims of two martini glasses to moisten them. Spread a generous amount of sugar on a small plate and turn the glasses upside down into it so that the rim is coated with a quarter-inch ring of the crystals. Stand the glasses up and let the sugar dry until it hardens.

Put the lemon wedges and lemon verbena in a cocktail shaker and crush them together with about a dozen determined strokes of a cocktail muddler or the end of a slender rolling pin or wooden spoon. Add the vodka, curaçao, and a large scoop of ice cubes.

Cap and shake vigorously. Strain into the sugared glasses and garnish with the reserved lemon verbena.

MUDDLED SAGE LEAVES ECHO THE HERBACEOUS FLAVORS of gin and the astringency of grapefruit in this elegant cocktail.

SAGE rush

2 DRINKS

6 medium sage leaves

¼ of a large lemon, cut into 2 wedges

2 teaspoons sugar

4 ounces gin

4 ounces fresh grapefruit juice

2 twists of grapefruit peel for garnish

Put the sage leaves, lemon wedges, and sugar in a cocktail shaker and crush them together with about a dozen determined strokes of a cocktail muddler or the end of a slender rolling pin or wooden spoon. Add the gin, grapefruit juice, and a large scoop of ice cubes. Cap and shake vigorously. Strain into 2 martini glasses and garnish with the grapefruit peel twists.

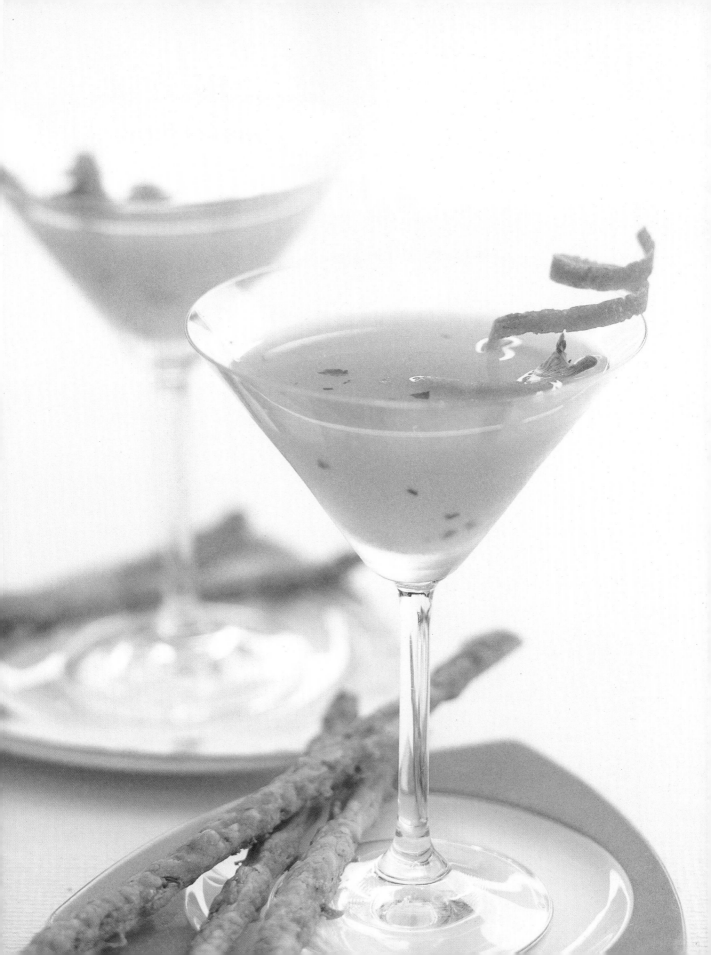

SOUNDS LIKE A FROUFROU COCKTAIL, you say? Maybe, but try it; it's very refreshing and not overly sweet. A classic mai tai is made with an almond-flavored syrup called orgeat, but this one uses a homemade lavender-ginger syrup in its place.

lavender MAI TAI

2 DRINKS

3 ounces white rum

1 ounce orange curaçao or Cointreau

1 ounce Lavender-Ginger Syrup (recipe follows)

1½ ounces fresh lemon juice

Sparkling water

2 lavender sprigs for garnish

Shake the rum, curaçao, lavender-ginger syrup, and lemon juice with plenty of ice in a cocktail shaker. Strain into two 10-ounce tumblers filled with ice and top off with just a splash of sparkling water. Garnish with lavender sprigs.

lavender-ginger SYRUP

½ cup sugar

½ cup water

1 tablespoon chopped fresh ginger

2 tablespoons lavender buds, fresh or dried

Bring all the ingredients to a full boil in a small saucepan. Turn off the heat and steep the syrup for at least 15 minutes. Strain.

savory SOUPS

SOMETHING MADE IN 15 MINUTES WITH EGGS, rice, lemon, and broth might sound like everyday comfort food. This soup is undoubtedly soothing, but it also dazzles with elegant flavor and silkiness. I've added chervil to this classic Greek recipe because it has a suave peppery-anise flavor that doesn't intrude on the simplicity of the soup.

chervil AVGOLEMONO

4 SERVINGS

4 cups chicken broth

¼ cup plus 2 tablespoons long-grain white rice

3 large eggs

3 tablespoons fresh lemon juice

¼ cup chopped chervil

Kosher salt if needed

Bring the chicken broth to a boil in a medium saucepan. Stir in the rice and simmer over low heat, partially covered, until it is tender but still firm, 10 to 12 minutes.

Whisk together the eggs and lemon juice until very smooth. Whisk a couple of ladles of the hot broth into the eggs, then vigorously whisk the eggs back into the soup. Switch to a wooden spoon and stir the soup over low heat until it thickens enough to lightly coat the spoon, which should only take a minute. Do not let it come close to a simmer or it might curdle. Remove it from the heat and stir in the chervil. The soup will thicken a little more as it sits for the next minute. Taste for salt. If you used commercially prepared salted broth it probably won't need more, but if you made the soup with unsalted broth, you'll need to add as much as a teaspoon. Serve the soup right away, or keep it warm by putting the saucepan in a larger pot of simmering water, stirring occasionally.

herbal improvisations Instead of the chervil, stir in 2 tablespoons chopped dill, 1½ tablespoons chopped tarragon, or ¼ cup finely chopped chives.

THIS IS THE MOST REQUESTED RECIPE at The Herbfarm. You have to taste it to believe that fresh corn pulp, warmed with nothing but a touch of butter and salt, becomes such an intensely flavored and luxurious vegetable soup.

Because there is essentially nothing but corn in the soup, the particular corn that you make it with can dramatically change its character. The new super-sweet varieties will yield a super-sweet soup (still very good), while old-fashioned varieties release a more complex corn flavor. Younger ears will give you a lighter-bodied soup while more mature corn with a higher starch content will result in a thicker soup.

To prepare this soup you must cream the corn, which means to scrape the corn pulp from the kernels without taking their skins. The quickest way to do this is with an inexpensive kitchen gadget called a corn cutter and creamer (see page 251), a long strip of wood or metal that has a retractable blade and teeth set in the middle of it. When you slide the ears over it with the blade retracted, the teeth cut open the kernels while the pulp and milk are squeezed out and fall below. If you don't have this gadget you can still accomplish the task with a paring knife and a spoon, but it will take longer (see opposite).

essence of CORN SOUP

4 SERVINGS

6 ears sweet corn, husked and silk removed

2 tablespoons unsalted butter

¾ teaspoon kosher salt

Basil leaves, sliced in thin strips for garnish

Using a corn creamer, scrape the pulp from the ears of corn into a large bowl. Do this in a sink or outside, because the corn and juices will splatter. You should end up with about 3 cups of pulp.

Put 2 or 3 of the scraped corncobs in a saucepan and cover with cold water. Simmer for 30 minutes and strain. This is a corn stock that might be necessary to thin the soup.

Put the corn pulp in a blender and puree it until smooth. Pour it into a fine strainer set on top of a saucepan and push it through with the back of a spoon, using a stirring motion. Add the butter and salt to the saucepan. Stir the soup with a whisk over medium heat until it is hot but not yet simmering and it thickens a little. Do not let it boil. Whisk in as much corn stock as you need to thin it to a consistency where it will just lightly coat a spoon. Depending on the corn, it could range from none at all to as much as a cup. Ladle the hot soup into small bowls and top with small pinches of the basil.

TO SCRAPE THE CORN WITHOUT A CORN CREAMER

Stand an ear in a large mixing bowl, holding it at the top. Draw the tip of a paring knife down through each row, cutting a slit through the center of each kernel (once you get the hang of it you can do this quite fast). After all the kernels are slashed, firmly scrape downward along the cob with the side of a sturdy tablespoon (expect it to splatter). The skin of the kernels will remain on the cob while the pulp and milk will fall into the bowl.

herbal improvisations In place of the basil, top the soup with a light sprinkle of chopped lovage, cilantro, shiso, or dill.

FENNEL BLOOMS IN MIDSUMMER with airy umbels of tiny yellow flowers that have a sweet anise flavor. Soon after, the umbels are covered with soft, intensely flavored green seeds. A spice called fennel pollen is made from the sieved dried fennel flowers. Use whichever form you can find: flowers, green seeds, or dried pollen. All will impart a similar wild, grassy fennel flavor to this soup, which can be served hot or chilled as the weather suggests.

fennel blossom SOUP

6 SERVINGS

2 cups sliced leeks, white parts only (about 1 large)

2 tablespoons unsalted butter

3 cups diced fennel bulb (about 2 medium, trimmed)

4 cups chicken broth

2 teaspoons fresh green fennel, fresh fennel flowers, or dried fennel pollen, plus additional for garnish

Freshly ground black pepper

Kosher salt

Cook the leeks in the butter in a saucepan over medium heat until the leeks wilt. Add the fennel bulb and chicken broth. Cover and simmer over low heat for 30 minutes. Stir in the fennel flowers, green seeds, or pollen.

Puree the soup in 2 batches in a blender until very smooth. Be very careful when doing this: Fill the blender no more than half full so that the hot soup does not splash out, and pulse it in quick spurts before switching it on continuously. Pour it back into the saucepan and reheat it until it simmers. Taste the soup, season with pepper, and add salt if you think it needs it. If you used canned or boxed broth, it might need very little. Serve hot or chilled, garnished with a small pinch of fennel flowers, chopped fresh seeds, or dried pollen.

I KNOW, PARSLEY SOUP SOUNDS STRANGE, but to me, parsley is as much a green vegetable as an herb. Nibble on a leaf; it tastes delightfully herbaceous and pungent. Cook with huge quantities of it and you have a dish that comes forth as vibrant and revitalizing, like an invigorating tonic. Here, I've intensified the fresh green flavor with some mint.

parsley and mint SOUP

6 SERVINGS

3 cups sliced leeks, white and light green parts only

2 tablespoons unsalted butter

4 cups chicken broth

1 tablespoon white rice

4 cups gently packed flat-leaf parsley sprigs, large stems removed

½ cup spearmint leaves

Salt and freshly ground black pepper

¼ cup heavy cream

Cook the leeks in the butter in a saucepan over medium heat, stirring often until they begin to wilt, about 3 minutes. Add the broth and rice. When the soup begins to boil, cover the pot and let the soup slowly simmer at low heat for 20 minutes, or until the rice is very tender.

Stir the parsley, mint, and a few grindings of black pepper into the simmering soup and then remove it from the heat. Puree it in 2 batches in a blender until very smooth. Be very careful when doing this: Fill the blender no more than half full so that the hot soup does not splash out, and pulse it in quick spurts before switching it on continuously. Allow the blender to run at least a full minute for each batch, or until the soup is golf-course green and the texture is very smooth. Pour the soup back into the saucepan, stir in the cream (which can be left out if you like), and reheat it. Taste it and add salt if you think it needs it. If you cooked with salted canned broth the soup may not need additional salt.

PARSLEY, MINT, AND WALNUT (OR HAZELNUT) SOUP

Just before serving, whisk in 2 tablespoons of excellent-quality walnut or hazelnut oil. It will enrich the soup and harmonize with the herbal flavors. Top each bowl with a dollop of crème fraîche and a sprinkle of chopped toasted walnuts or hazelnuts.

BECAUSE AMERICAN CHESTNUT TREES were wiped out in the early part of the twentieth century by blight, most fresh chestnuts sold in this country were, until recently, from Europe. Now American growers are planting a hybrid variety called Colossal with great success. They come to the market much fresher and more carefully handled than the European ones (unlike other nuts, chestnuts must be refrigerated after harvesting) and they have a smoother pellicle (the brown covering of the nut under the shell) that makes them easier to peel. You can also buy these American chestnuts dried and already shelled; they're just as good in this soup and require a whole lot less work.

I've flavored this soup with fresh bay laurel leaves, which when combined with a tiny bit of vanilla bean add a heavenly sweet spice flavor. Although I don't usually recommend you do this, you can substitute 2 California bay leaves for the 10 bay laurels. The flavor will be different, but still pleasant. Be sure you have positive identification of your bay leaves before you make this soup. Bay laurel is mild in flavor, but California bay leaves are so strong your soup would be inedible if you added 10 of them. (Read more about bay leaves on page 79.)

This soup is perfect for the winter holidays, especially served with a small glass of dry sherry.

bay-scented
CHESTNUT SOUP

8 SERVINGS

1 pound fresh chestnuts in their shells, or ½ pound dried chestnuts, or two 7-ounce jars vacuum-packed peeled chestnuts

1 medium onion, chopped

1½ cups sliced celery

2 tablespoons unsalted butter

4 cups chicken broth

¾ cup fresh apple cider

1 small bunch thyme, tied with cotton string

10 fresh bay laurel leaves, lightly crushed, or 2 fresh California bay leaves

A quarter of a vanilla bean, split

½ cup heavy cream

¼ cup dry or medium-dry sherry

Kosher salt and freshly ground black pepper

2 ounces bacon, cut into small dice

½ unpeeled apple, cored and cut into small dice

For fresh chestnuts, bring a saucepan of water to a boil. Cut the chestnuts in half from top to bottom with a sharp chef's knife. Put them in the freezer for 10 minutes, then drop them into the boiling water, boil 8 minutes, and drain. While they are still hot, pop out the meat by squeezing on each half. The darker brown pellicle surrounding the meat should come off as well. Work quickly, because the cooler they are, the harder they are to shell.

If using dried chestnuts, bring a large pot of water to a boil. Add the chestnuts, simmer for 10 minutes, then remove from the heat and let them soak for 1 hour. Vacuum-packed chestnuts can be added straight from the jar.

Cook the onion and celery in the butter in a large saucepan over medium heat, stirring often, until they soften, about 5 minutes. Stir in all but ½ cup of the chestnuts, then the broth, cider, thyme, 5 of the bay laurel leaves (or 1 California bay), and vanilla bean. Cover and simmer the soup over very low heat for 45 minutes. Remove and discard the thyme, bay leaves, and vanilla.

Puree the soup in 2 batches in a blender (not a food processor) until very smooth. Don't fill the blender more than half full, and begin blending in quick pulses to prevent the hot soup from splashing out. Pour the soup back into the saucepan, stir in the cream and sherry, and reheat it to the simmering point. Taste and add as much salt and pepper as you think it needs (if you used canned salted broth you may need very little). Stir in the remaining 5 bay laurel leaves (or 1 California bay) and steep for at least 5 minutes to perfume the soup.

Cook the bacon in a medium skillet until it renders out most of its fat but is not quite crisp. Tip the skillet to drain off the excess fat. Dice the reserved ½ cup chestnuts, add them to the bacon, and cook for another minute. Add the apple and cook until warmed through.

Remove and discard the bay leaves. Ladle the soup into warm bowls and put a spoonful of the apple-chestnut garnish in the center of each.

herbal improvisations

For chestnut-sage soup, cook the onion and celery with ¼ cup coarsely chopped sage. Decrease the bay to 2 bay laurel leaves, fresh or dried, adding them both with the broth. Add 1 tablespoon chopped sage with the chestnuts when cooking the garnish.

OF ALL THE LEMONY HERBS, LEMON THYME IS FRIENDLIEST to vegetables. Here it meets up with asparagus in a silky soup that captures the green push of spring in its flavor and color. Although I usually prefer thick asparagus spears, thin spears are a better choice in this case because more green skin yields a prettier soup.

asparagus and LEMON THYME SOUP

4 SERVINGS

2 cups thinly sliced leeks, white and light green parts only (1 large or 2 small)

2 tablespoons unsalted butter

4 cups chicken broth

1½ tablespoons white rice

1½ pounds asparagus, preferably thin stalks

2 tablespoons lemon thyme leaves

Kosher salt and freshly ground black pepper

Crème fraîche (optional)

Begin the soup in a medium saucepan by cooking the leeks in the butter over medium heat, stirring from time to time until they soften but don't color. Add the broth and rice. Cover and simmer over low heat until the rice is very soft, about 15 minutes.

While the soup is simmering, cut off and discard the tough inch or two at the bottoms of the asparagus stalks. Slice the spears thinly—no wider than ½ inch—so that they cook quickly. When the rice is soft, stir the sliced asparagus into the soup and cook it at a low boil for 4 to 5 minutes. The asparagus should be tender but bright green. Stir in the lemon thyme.

Puree the hot soup in 2 batches in a blender until very smooth. Be very careful when doing this: Fill the blender no more than half full so that the hot soup does not splash out, and pulse it in quick spurts before switching it on continuously. Once the soup is blending, let the motor run for about 30 seconds (which will seem like a very long time), or until it's completely smooth and uniformly colored.

Return the soup to the pan and reheat it (or refrigerate and reheat it later). Taste and season with salt and pepper. If you prepared the soup with canned or boxed chicken broth it might not need additional salt. Serve in warmed soup bowls, topped with a drizzle of crème fraîche if you wish.

herbal improvisations In place of the lemon thyme, add ½ cup dill or 2 tablespoons tarragon.

LEMON heaven

Many herbs contain citrus-scented essential oils, giving them a lemony commonality, but each lemon herb has its own very distinct flavor and uses in cooking.

LEMON VERBENA

Smelling and tasting intensely of lemon peel, this delightful herb is consistently potent from one plant to the next.

FINELY CHOPPED LEMON VERBENA leaves make a good substitute for lemongrass in Southeast Asian dishes.

DESSERTS AND BEVERAGES FLAVORED WITH LEMON VERBENA are out of this world. One way to extract the flavor is to steep the leaves in hot simple syrup or cream and then strain them out, but for a stronger, brighter flavor, use a no-heat method: Grind the leaves with fine sugar in a blender, food processor, or spice grinder, dissolve the herb-sugar paste in cold water, lemon juice, or cream, and then strain the liquid.

LEMON VERBENA WILL GROW INTO AN ENORMOUS SHRUB in frost-free climates. In climates with mild winters but some frost, like Seattle's zone 8, it will often live through the winter. Come spring, the bare twigs will look dead, but chances are it will break with growth later in the season—often after you've given up hope. In colder climates you'll need to replant it each spring, or keep it in a pot indoors in winter.

HARVEST YOUR LEMON VERBENA IN AUTUMN and hang it to dry. It makes fantastic tea, and you can substitute the dry for fresh in recipes in which it's steeped.

LEMON GERANIUM

There are several named varieties of scented geraniums with lemon fragrance. Mabel Grey is the best, with large, deeply lobed lime green leaves, showy pink flowers, and a powerful lemon scent very much like lemon verbena's, if not even stronger. Another good variety is Frencham Lemon.

LEMON GERANIUM IS A GOOD SUBSTITUTE for lemon verbena in recipes in which it is steeped, or blended up and strained out. Its texture is too coarse for recipes that call for the chopped herb.

LEMON THYME

Lemon thyme smells little like English thyme; it's predominantly citrusy, but in a way that makes you think of savory foods rather than sweets. There are upright and creeping varieties, with the upright being the most useful for cooking. The most common type is golden lemon thyme, a beautiful variegated plant whose foliage is dappled with gold and light green. A vigorous green-leaved lemon thyme is available as well, but its fragrance is usually milder.

LEMON THYME'S FLAVOR IS FLEETING. Try to harvest it as close to when you cook with it as you can. Chop the leaves right before you add them to a dish because they'll develop a bruised scent as they sit and oxidize. Packaged lemon thyme in markets is often flavorless.

GROW LEMON THYME IN THE SAME WAY as other thymes (see page 167). It is less hardy, so plan on replanting it each spring.

LEMON BASIL

There are several varieties of this herb, all with leaves that are smaller and lighter green than sweet basil's, and with only a hint of its complex spice. The flavor is predominantly citrusy, not with the over-the-top slam of lemon verbena, but with enough subtlety to fit with most seafood and vegetables. The two commonly available strains are Mrs. Burns Lemon and Sweet Dani. I prefer Mrs. Burns for its more focused lemon flavor.

LEMON BALM

The somewhat soapy scent and taste of lemon balm makes it a tricky herb to cook with. A hint of it is nice with mild fish, a sprinkle works with root vegetables like carrots and beets, and small leaves are good in salads. It always makes very good tea, fresh or dried.

LEMON BALM IS A VERY VIGOROUS GROWER, even more so than mint. To keep it from spreading by seed, cut back the plant as soon as it starts to flower.

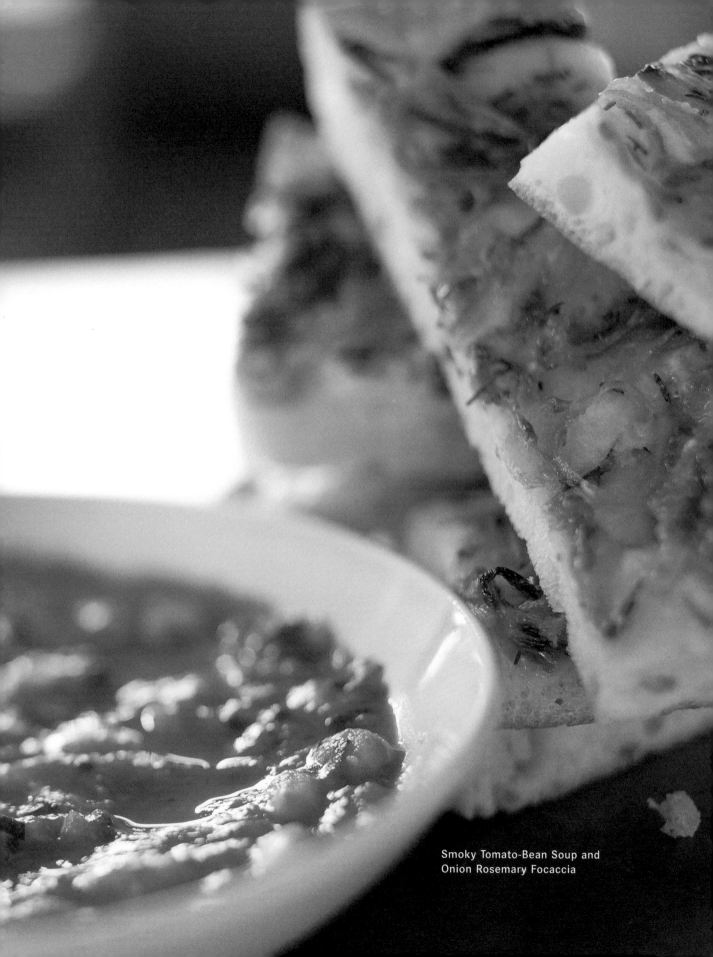

Smoky Tomato-Bean Soup and
Onion Rosemary Focaccia

I COUNT MYSELF AMONG THE MANY COOKS who have been seduced by Spanish smoked paprika (*pimentón*). Unlike sweet Hungarian paprika, this product from La Vera region of Spain is made from peppers that are smoked before they are ground. The resulting spice has a deep, sultry flavor, which makes the soup taste as if it took all day to prepare. This soup is hearty enough for a main course, but you can leave the beans out for a lighter soup to serve as a first course, or leave out the bacon for a flavorful vegetarian version.

smoky TOMATO-BEAN SOUP

6 SERVINGS

4 ounces good-quality smoky bacon, finely diced

1 tablespoon olive oil

1 medium onion, finely diced

3 tablespoons chopped sage

3 cloves garlic, finely chopped

1 tablespoon sweet smoked paprika

3 pounds ripe tomatoes, peeled, seeded, and diced, or substitute one 28-ounce can, plus one 14.5-ounce can diced tomatoes

2 teaspoons kosher salt (½ teaspoon if using canned tomatoes)

2 tablespoons coarsely chopped sweet marjoram

1½ cups cooked white beans (one 15-ounce can, rinsed)

Freshly ground black pepper

Cook the bacon in the olive oil over medium heat in a large saucepan, stirring often, until it renders and begins to crisp. Pour off about half of the fat. Add the onion, sage, garlic, and paprika and continue to cook until the onion softens, about 3 minutes. Stir in the tomatoes and salt, partially cover, and simmer for 30 minutes. Stir in the marjoram and beans. Season with pepper and more salt if you think it needs it. Serve at once or keep the soup warm on very low heat until you're ready.

four seasons of SALADS

MELONS AND TOMATOES ARE TECHNICALLY BOTH FRUITS, so combining them in a salad isn't such a stretch. Like many things from the garden that enjoy the same growing conditions and ripen together, they make ideal partners. Of course, the riper and sweeter the fruit, the better this simple salad will be.

CHERRY TOMATO, MELON, and mint salad

8 SERVINGS

4 cups melon balls, scooped from ripe melon, such as cantaloupe, honeydew, or galia, at room temperature

2 cups ripe cherry tomato halves, at room temperature

4 teaspoons fresh lemon juice

¼ cup plus 2 tablespoons coarsely chopped spearmint

¾ teaspoon kosher salt

Gently toss all of the ingredients together in a large mixing bowl. That's it. This salad is best served within an hour of assembling it.

FILLET BEANS, THE SLENDER GREEN BEANS that are sometimes called haricots verts or "French beans," are perfect for this salad, but you can use other types of fresh beans, like Romano beans or runner beans, if you angle-cut them into bite-sized pieces. Just be sure they're snappy, tender, and sweet.

GREEN BEAN, BASIL, and radish salad

6 SERVINGS

¼ cup finely chopped shallots

2 tablespoons sherry vinegar

1 pound fresh fillet green beans

1 bunch radishes, cut into wedges (about 2 cups)

½ cup coarsely chopped basil

2 tablespoons extra virgin olive oil

1 teaspoon kosher salt

Freshly ground black pepper

½ cup thin shavings Parmigiano-Reggiano

Stir the shallots and vinegar together in a large mixing bowl and let them sit to mellow the raw bite of the shallots.

Boil the beans in a large pot of heavily salted water until just tender but still have some crunch. Drain the beans and then plunge them into a large bowl of ice water. Drain again and dry on paper towels.

Add the beans to the bowl with the shallots. Toss in the radishes, basil, olive oil, salt, and a few grindings of black pepper. Turn out onto a serving platter and top with the shaved cheese.

herbal improvisations In place of the basil, add 3 tablespoons coarsely chopped tarragon and top the salad with crumbled goat cheese instead of Parmesan. Or add ¼ cup coarsely chopped dill and top with crumbled feta.

THIS SPARKLING SUMMER SALAD goes with anything from the grill or picnic basket. Be sure to tear the basil in large pieces so you get big bursts of its flavor. Ordinary sweet basil is very good in this recipe, but lemon basil, if you grow it, will really find its groove in this dish.

CORN, ORZO, and basil salad

10 SERVINGS

½ medium red onion, finely diced

¼ cup white wine vinegar

3 tablespoons fresh lime juice

2 teaspoons kosher salt

¾ teaspoon freshly ground black pepper

4 ears sweet corn, shucked

8 ounces orzo pasta

¼ cup plus 2 tablespoons extra virgin olive oil

1 red bell pepper, seeded and diced into ¼-inch pieces

1½ cups torn leaves of sweet basil or lemon basil

Stir the red onion, vinegar, lime juice, salt, and pepper together in a large mixing bowl. Let it sit while you continue with the recipe, allowing the acidic ingredients to mellow the raw bite of the onion.

Hold the ears of corn upright on a large cutting board and cut off the kernels, being careful not to cut so deep you shave the cob. They should give you about 5 cups of kernels.

Bring a large pot of salted water to the boil. Add the orzo and when it is just tender, after about 8 minutes, add the corn kernels to the pot. Cook until the water boils again, then drain in a colander, and rinse with cold water.

Stir the olive oil into the bowl with the dressed onion. Toss in the pasta and corn, red bell pepper, and basil until evenly combined. Refrigerate at least 1 hour before serving.

THIS VIBRANT-TASTING SLAW gets its heat from Sriracha sauce, a Thai hot pepper sauce that's in so many American refrigerators it's practically the ketchup of the '00s. It's sold in plastic squeeze bottles in Asian grocery stores and many supermarkets.

spicy cilantro SLAW

8 SERVINGS

¼ cup mayonnaise

¼ cup apple cider vinegar

2 tablespoons fresh lime juice

1 tablespoon sugar

¼ cup soy sauce

2 teaspoons Sriracha sauce (Thai hot pepper sauce)

1 pound green cabbage, very finely sliced

1 large carrot, grated

1 red bell pepper, seeded and finely sliced

1 cup coarsely chopped cilantro

Whisk together the mayonnaise, vinegar, lime juice, sugar, soy sauce, and Sriracha sauce in a large bowl. Toss in the remaining ingredients. Refrigerate at least an hour to wilt the cabbage and blend the flavors.

A VINAIGRETTE IS OFTEN THE BEST CHOICE for dressing a salad, but sometimes only a good-old creamy dressing will hit the spot, especially when the salad is the meal or you're dunking vegetables as a snack. Here's where I admit to one of my guilty pleasures: I adore ranch dressing. This is a homemade take on it, full of bright green herbs and zesty flavor. It calls for powdered buttermilk, which I'd doubt is in your cupboard at the moment, but it is more widely available than you might think; you can find it in many supermarkets and natural foods markets. It gives the dressing a thick and creamy consistency without adding heaps of mayonnaise. I like to drizzle it on a crisp wedge of organically grown iceberg alongside a hard-boiled egg and ripe tomato wedges.

branch DRESSING

1 ½ CUPS

¼ cup dill sprigs

¼ cup parsley sprigs

1 teaspoon thyme leaves

¼ medium shallot

½ clove garlic

1 tablespoon fresh lemon juice

1 teaspoon Dijon mustard

Splash of Tabasco or other hot sauce

1¼ teaspoons kosher salt

½ cup canola oil

¾ cup buttermilk

3 tablespoons powdered buttermilk

Puree all of the ingredients in a blender until very smooth. Refrigerate the dressing for at least an hour to allow it to thicken.

herbal improvisations In place of the dill and thyme, add one of the following: ¼ cup basil leaves and 1 tablespoon marjoram leaves, 2 tablespoons tarragon leaves, or 2 tablespoons dill and 1 tablespoon lovage leaves.

BAY: laurel or leave it

There are two kinds of culinary bay leaves: bay laurel and California bay. Now that fresh bay leaves are showing up in stores, it's important for cooks to know the difference between them. Bay laurel leaves come from the tree *Laurus nobilis*, known as Turkish bay or sweet bay. California bay leaves also come from a large tree, the totally unrelated *Umbellularia californica*. There is some similarity in the scent, but California bay is ten times stronger than bay laurel, and if you substitute it in a recipe calling for bay laurel you will ruin the dish with its overpowering flavor. The shocking thing is that when you buy fresh bay leaves in the supermarket, nine times out of ten they are California bay, even though they don't say that on the label.

Here's how to tell the difference: Bay laurel leaves are a glossy deep green and shaped in an oval that's evenly tapered and pointed at the top and bottom ends. They often have wavy edges. California bay leaves have a narrow oval shape, but more like the silhouette of a slender flame, with the widest part of the leaf near the bottom, then gradually tapering to a point at the top. They are grayer, especially on the underside, have smooth straight edges, and are usually thinner and more pliable than bay laurel. When you tear or crush a bay laurel leaf you will smell a mild, sweet, nutmeglike scent, whereas a California bay leaf will smell powerfully of menthol and petroleum overtones.

I RECOMMEND AVOIDING CALIFORNIA BAY ALTOGETHER. In most cases it's better to cook with dried bay laurel leaves if fresh are not available.

FRESH BAY LAUREL LEAVES GIVE A SUBTLE SWEET SPICE FLAVOR to desserts, almost like nutmeg, vanilla, and butterscotch. Steep them in hot milk or cream used for custards and strain them out, or cook them with winter fruits, then pull them out before serving.

YOU CAN GROW BAY LAUREL OUTDOORS IN ZONE 8 OR WARMER. In climates with colder winters, it must be grown in a large pot and taken indoors when the weather cools. When inside, put it in a cool spot with plenty of light and keep it on the dry side.

IF YOU ARE AT THE COLDER RANGE OF BAY'S HARDINESS ZONE, plant it in a sheltered spot that receives plenty of winter sun. It will grow slowly at first, but once it gets established it will double in size each year, and in a number of years you'll have a huge shrub.

WHEN YOU HARVEST, TUG THE BAY LEAF DOWNWARD until it snaps off. Mature leathery leaves have more flavor than soft new ones. Fresh bay leaves will keep for more than a month in a small freezer bag in the refrigerator.

LEFT: California Bay
RIGHT: Bay Laurel

MORE OF A SALAD THAN A PICKLE, these snappy colorful vegetables are just the thing to have on hand as a refreshing accompaniment to grilled meats and spicy foods, and will keep for a week in the refrigerator. Have fun experimenting with different herb combinations—just about anything works.

herbed fresh
VEGETABLE PICKLE

2 QUARTS

½ cup kosher salt

2 quarts cool water

2 quarts prepared vegetables, such as strips of bell pepper, fennel bulb or cabbage, carrot sticks, seeded cucumber half-moons, or cauliflower florets

2 cups white wine vinegar

¾ cup sugar

2 cups water

4 dried Szechwan or Thai bird chiles or ¼ teaspoon hot pepper flakes

3 bay laurel leaves, fresh or dry

One 1-ounce bunch of herb sprigs; try one of these combinations:

> Thyme and lovage
> Lemon verbena and mint
> Tarragon and fennel seed
> Sage and lemon thyme

Stir the salt and 2 quarts water together in a large plastic container or glass bowl until the salt dissolves. Add the vegetables and let them sit in this brine at room temperature for 4 to 6 hours.

Bring the vinegar, sugar, 2 cups water, chiles, and bay leaves to a boil in a saucepan. Drop in the herb bunch, turn off the heat, and let the liquid cool to room temperature.

Drain the vegetables, put them back in the container, and pour the pickling liquid with the herbs over the top. Press the vegetables down under the liquid if they are exposed. Cover and refrigerate. The pickles will be ready to eat the next day.

THIS WINTER SALAD, pairing the juicy snap of Asian pear and celery, then studded with hazelnuts and laced with dill, gets its inspiration from the classic Waldorf salad. It's especially nice served alongside a wedge of blue-veined cheese, such as Point Reyes Blue, Maytag Blue, or Bleu d'Auvergne.

DILLED CELERY, ASIAN PEAR, and hazelnut salad

6 SERVINGS

1½ tablespoons sherry vinegar

2 teaspoons whole-grain mustard

1 teaspoon kosher salt

¼ cup hazelnut oil or extra virgin olive oil

2 cups thinly sliced celery

¼ cup coarsely chopped dill weed

1 medium unpeeled Asian pear or Bosc pear, cored and cut into thick matchsticks

½ cup coarsely chopped toasted hazelnuts

Whisk together the vinegar, mustard, and salt in a small mixing bowl. Whisk rapidly as you pour in the oil in a slow stream. Just before you serve, toss the celery and dill with the dressing in a large mixing bowl, and then gently toss in the Asian pear and hazelnuts. Mound the salad on individual plates and serve.

DRIED TART CHERRIES ARE RELATIVELY NEW to grocery shelves. I couldn't do without them in the winter. I add them to sauces for pork or game birds, to desserts, and to salads, where their sweet-tart flavor is just the right counterpoint to slightly bitter winter greens. They're so good steeped with red wine and fresh sage you might devour them without the salad. Serve this salad as a first course; for a light supper, add a warmed goat cheese *crottin* and toasted bread.

winter greens with
SAGE-POACHED CHERRIES

6 SERVINGS

1 cup full-bodied red wine

Four 3-inch sprigs sage

¾ cup dried tart cherries (sweetened), about 4 ounces

3 tablespoons sherry vinegar

2 teaspoons Dijon mustard

¼ cup plus 2 tablespoons extra virgin olive oil

Kosher salt and freshly ground black pepper

2 quarts mixed winter greens, such as frisée, endive, radicchio, arugula, mâche, baby spinach, or Belgian endive, washed, dried, and in bite-sized pieces

¾ cup toasted, coarsely chopped walnuts

Bring the wine to a simmer in your smallest saucepan. Stir in the sage sprigs and cherries. Cook until the wine begins to simmer again, and then take the pan off the heat. If the cherries are not submerged, tilt the pan at a 45-degree angle and prop it in that position. Let the cherries steep in the wine for at least half an hour.

Whisk together the vinegar and mustard in a small bowl. Slowly whisk in the olive oil and ½ teaspoon salt. Drain the cherries and discard the sage sprigs.

Put the greens in a large mixing bowl and pour the dressing over them. Sprinkle with a large pinch of salt and a few grindings of black pepper, and toss with tongs until the greens are evenly dressed. Arrange the salad on a large platter or on individual serving plates. Sprinkle with the walnuts and cherries. Serve right away.

I'LL ADMIT NOT EVERYONE FALLS IN LOVE with the flavor of shiso at first taste, but it doesn't take long to be charmed by its knack for enhancing certain foods. Traditionally, shiso is added to some types of sushi and used to flavor rice or pickled vegetables. Over the many years that I've cooked with it I've discovered it's the perfect counterpoint to fresh crabmeat.

If you don't grow shiso in your own garden you can find the fresh leaves in Asian grocery stores. There are both green and deep purple varieties. Choose either for this elegant crab cocktail.

shiso CRAB COCKTAIL

6 SERVINGS

¼ cup finely chopped red onion

¼ cup seasoned rice wine vinegar (sushi vinegar)

1½ tablespoons finely chopped shiso (perilla)

2 tablespoons extra virgin olive oil

8 ounces best-quality fresh crabmeat, picked over for shells and cartilage

Pulp from 2 ripe avocados, cut into ½-inch dice

Freshly ground black pepper

Coarse sea salt or kosher salt if needed

Stir the onion, vinegar, and shiso together in a medium mixing bowl and let it sit at room temperature for at least 30 minutes to mellow the onion flavor.

Stir in the olive oil and then gently toss in the crab and avocado. Season the salad with a few grindings of black pepper and taste it; add salt if you think it needs it. Some crabmeat is already quite salty so the salad might not need additional salt. Spoon the salad into stemmed glasses and serve cold.

she sells SHISO

Shiso is the Japanese name for a type of perilla, an annual in the mint family that grows with abandon and has a distinct spicy scent reminiscent of cinnamon and cumin. This herb is poised to be discovered by more and more cooks in the coming years because its unique flavor flatters many types of foods and it grows easily in most areas.

Here's something to watch for: After growing and cooking with shiso for many years, I've had a recent frustration. Much of the seed we've bought lately produces plants with almost no flavor, and sometimes shiso plants that are sold in nurseries are grown from this inferior seed. If you purchase the plants as starts, rub the leaves and be sure they have the very prominent and distinct scent they should. If you buy seed, I recommend you purchase it from a seed company that specializes in Asian vegetables, but you have no way of telling how it will taste until it grows its first true leaves. There are two commonly grown types of shiso: a green variety with large, slightly ruffled leaves, and a red one with deep mahogany leaves that are very ruffled. Once you grow shiso you are happy with, save its seed to plant next year, although it often self-sows.

Fresh shiso is used in many sushi restaurants and is grown commercially in California. If there is a Japanese grocery in your area, they will probably sell it, often in small bundles of perfectly uniform leaves. Fortunately, all of the commercially grown shiso that I've tried is good and flavorful.

SHISO LIKES THE SAME GROWING CONDITIONS AS BASIL. Plant it when the weather warms.

GREEN AND RED SHISO TASTE SIMILAR, but many consider the green's flavor to be superior.

RED SHISO WILL BLEED A BEAUTIFUL MAGENTA COLOR into clear marinades or vinegars.

SHISO LOSES FLAVOR WITH COOKING; use it raw or add it at the end of the cooking process.

THE FLOWER BUDS OF SHISO HAVE A POTENT FLAVOR and are traditionally used for tempura.

KOREAN PERILLA HAS A DIFFERENT FLAVOR than Japanese shiso and should not be substituted for it.

GREEK OREGANO'S BRASH FLAVOR doesn't jive with everything, but it certainly fits in this salad, where it stands up to the sharpness of the peppers and enlivens the neutral flavor of the squid.

Piquillo peppers are imported from Spain and are mildly spicy, slightly bitter, and thin fleshed. They are wood-roasted and peeled and come in jars or tins, or sometimes you'll see them sold in well-stocked deli cases.

Squid is now available at many fish counters already cleaned; in fact, it's sometimes harder to find in its uncleaned state. It saves a lot of time and mess, but be aware that it's never cleaned thoroughly enough and still requires a once-over in your kitchen.

SQUID and piquillo pepper salad with oregano

4 SERVINGS

1 pound cleaned squid (calamari), tubes and tentacles

¼ cup extra virgin olive oil

½ red onion, sliced ¼ inch thick from root to top

1½ teaspoons kosher salt

3 tablespoons red wine vinegar

1½ tablespoons chopped Greek oregano

4 ounces piquillo peppers, cut into thin 2-inch-long strips (¾ cup)

½ cup coarsely chopped flat-leaf parsley

Even if you purchase the squid cleaned, rinse out the tubes and run your finger in the pocket to be sure they are empty. Cut the tentacles right above where they are connected (they often have viscera attached), then check to be sure the hard round beak is removed. Cut the tubes into ¾-inch rings. Pat the rings and tentacles between paper towels to dry.

Heat 1 tablespoon of the olive oil in a large skillet. Add the red onion and cook over medium heat until it just begins to soften, about 2 minutes. Increase the heat to high and add the squid. Sprinkle with ½ teaspoon salt and stir it around until the squid firms up and whitens, about 2 more minutes. Scoop the squid and onion into a strainer or colander to drain, then spread them out on a large plate to cool.

When the squid is no longer hot, mix it with the vinegar, the remaining 3 tablespoons olive oil, the oregano, peppers, parsley, and 1 teaspoon salt. Cover and refrigerate the salad for at least several hours before serving. It will keep up to 2 days.

fast SUPPERS

THIS IS LIKE A HYBRID OF A SOUFFLÉ AND A FRITTATA, but much easier to prepare than either. It's the perfect quick dish to use up odds and ends from your garden or herb bunches in your refrigerator. Add whatever combination of herbs you like, but for a good balance remember to take into consideration the strength of the particular leaves. For instance, you can add big handfuls of sorrel, chervil, basil, or parsley to the mix because they are mild, but don't use more than a tablespoon of more assertive herbs like marjoram or tarragon. Chives and dill fall in between.

herbed SKILLET SOUFFLÉ

3 TO 4 SERVINGS

3 tablespoons fine dry bread crumbs

½ cup milk, whole or low fat

8 large eggs, separated

½ to ¾ cup chopped mixture of soft-leaved herbs, such as basil, chervil, parsley, sorrel, chives, dill, marjoram, or tarragon

¾ teaspoon kosher salt

¼ teaspoon freshly ground black pepper

¾ cup shredded Gruyère

2 tablespoons unsalted butter

Preheat the oven to 400°F. Stir the bread crumbs into the milk in a large mixing bowl and let them soak until they become pasty, 10 to 15 minutes. Whisk in the egg yolks, herbs, salt, and pepper. Stir in ½ cup of the cheese.

Just before you are ready to cook the frittata, beat the egg whites with an electric mixer until they form very soft (not stiff) peaks. When you scoop up some on a rubber spatula they should hold their shape in mounds, but the peak at the top of the spatula should flop over instead of standing straight up—any stiffer and they won't incorporate as easily. Scoop the whites into the yolk mixture and quickly fold them in.

Heat a 12-inch ovenproof skillet over medium heat. Add the butter when the pan is hot enough for it to sizzle but not brown, and swirl it until it melts. Pour the batter into the pan and sprinkle with the remaining cheese. Immediately put the skillet on the middle rack of the oven and bake for 15 to 17 minutes, or until the soufflé is puffed and deeply browned. Serve it right away, spooned from the skillet, or at room temperature, cut into wedges.

THE COMBINATION THE FRENCH call fines herbes is like Indian curry powder, a mixture whose components may vary a bit, but still delivers an identifiable flavor. Most often it includes chives, tarragon, parsley, and chervil. Here the gently flavored quartet of herbs cozies up to the soft, sweet richness of ricotta to create a quick sauce for fresh pasta.

FETTUCCINE fines herbes

2 SERVINGS

1 tablespoon unsalted butter

⅓ cup whole-milk ricotta

1 tablespoon finely chopped chives

1 tablespoon chopped tarragon

2 tablespoons chopped flat-leaf parsley

2 tablespoons chopped chervil (or additional parsley)

3 tablespoons finely grated Parmigiano-Reggiano

¼ teaspoon kosher salt

6 ounces fresh fettuccine noodles

Freshly ground black pepper

Bring a large pot of salted water to a boil. Put the butter in a large stainless steel mixing bowl and set it on top of the boiling water. When the butter is melted, take it off the water and stir in the ricotta, herbs, Parmesan, and salt.

Boil the pasta until tender but still slightly firm, usually 2 to 4 minutes. Scoop about ½ cup of the cooking water from the pot, then drain the noodles. Using tongs, toss them with the ricotta and herbs, along with as much of the reserved pasta water as it takes to create a creamy sauce. Grind some black pepper on top and serve in warm bowls.

MY MOST VALUED HOME RECIPES are those that I can whip together with ingredients I always have at hand in my pantry and herb garden. I often prepare this pasta when I crave something homey and satisfying after work. Try to search out and stock up on premium tuna packed in olive oil or natural juices—there really is a huge difference in flavor and texture. You can find excellent brands of line-caught albacore from the Pacific Northwest as well as imported ones from Spain labeled "bonita."

HERBED BOW TIES and tuna

2 TO 4 SERVINGS, DEPENDING ON APPETITES

Kosher salt

12 ounces bow-tie pasta (farfalle)

2 tablespoons extra virgin olive oil

1 medium onion, halved and sliced ¼ inch thick from root end to tip

3 tablespoons coarsely chopped sage

One 6-ounce can tuna packed in olive oil or in natural juices, drained

3 tablespoons capers, rinsed (first soaked for 15 minutes if salt-packed)

Freshly ground black pepper

¼ cup coarsely chopped dill or flat-leaf parsley leaves

Bring a large pot of water to a boil with 2 tablespoons salt. Stir in the bow ties.

Pour the olive oil into a large skillet over medium heat. Stir in the onion and sage and cook until the onion softens and loses its raw bite but still has some snap, 3 to 4 minutes. Add the tuna, capers, ½ teaspoon salt, and a good grinding of black pepper and use the back of a wooden spoon to break up the tuna into chunks. Remove the skillet from the heat.

When the pasta is done, drain it and toss it into the tuna and onion in the skillet. Sprinkle with the dill or parsley and toss it again. Serve right away in warm bowls.

THIS IS A QUICK PASTA to satisfy cool-weather cravings for greens. I've been making it ever since I tasted a similar dish in Rome many years ago. I was so enthused, I brought back seeds for the slender-leaved black kale that it was made with, and planted them in my own garden with great success. Now I often see this *cavalo nero* sold in markets here, but any kind of kale, green or red, will be just as good in the dish.

ORECCHIETTE with kale, pancetta, and oregano

4 SERVINGS

1 bunch kale (12 ounces)

12 ounces orecchiette pasta

4 ounces pancetta, diced

1 tablespoon olive oil

2 cloves garlic

¼ teaspoon red pepper flakes

2 tablespoons chopped Greek oregano

Kosher salt

½ cup grated Parmigiano-Reggiano

Bring a large pot of salted water to a boil. Wash the kale, leaving the leaves wet, and chop it into 1-inch sections, discarding the tough bottom inch or two of the stems.

Stir the orecchiette into the boiling water. While the pasta is cooking, render the pancetta in the olive oil in a large skillet over medium heat, stirring often, until it begins to brown. Stir in the garlic and red pepper flakes, and after half a minute or so, add as much of the chopped kale as will fit in the pan. Toss the kale with tongs until it wilts down, and then add the rest of the kale. Ladle about ¼ cup of the pasta cooking liquid into the pan, toss in the oregano, and continue to cook until the kale is no longer tough (it will not be completely tender either), 3 to 4 minutes. Taste and add salt if it needs it (the pancetta might contribute enough).

When the pasta is tender but still firm, drain it and add it to the skillet. Sprinkle with the cheese, toss it all together, and serve in warm shallow bowls.

organizing OREGANOS

The genus of herbs that includes oregano and marjoram can be hair pulling to sort out. Not only are there scores of species, subspecies, and crosses, but even within a species the plants can be highly variable in flavor and appearance.

I like to narrow this group of herbs to the three members that are most useful to a cook.

GREEK OREGANO This is the species, *Origanum vulgare* subsp. *hirtum*, that you want when a recipe calls for fresh oregano. It's highly fragrant, aggressively spicy, and, if eaten raw, leaves a burning heat in your mouth. This rugged perennial dies to the ground each fall and reappears around the time tulips bloom. In summer it sends up lacy inflorescences bearing tiny white flowers. Cook with this oregano cautiously; its forceful flavor can be overpowering. It works well with summer vegetables like tomato, eggplant, and peppers, with white beans, or with robust meat dishes.

SWEET MARJORAM This herb is actually a perennial, but nearly always grown as an annual. Though its aroma is forcefully herbaceous, it's softer than oregano's; when you nibble on a leaf it will be strong tasting and slightly camphoric but not fiery. When it blooms, its upper stems are covered with tight green balls, sometimes called knots, which hold the tiny white flowers. Unlike Greek oregano, marjoram's flavor is compatible with a great variety of foods, from summer vegetables to mushrooms, fish, meat, and poultry.

ITALIAN OREGANO A cross between Greek oregano and sweet marjoram, Italian oregano tastes like marjoram but has the perennial habit of oregano (though not as hardy). It offers a longer season of harvest than marjoram, coming up early in the spring and growing late into the fall.

BEWARE OF COMMON OREGANO. This is an aggressive grower that looks nearly identical to Greek oregano except its flowers are pink instead of white. It has almost no flavor. Occasionally, you will find it sold in garden centers as oregano (which it is), but it is not a culinary herb. Sometimes it crosses with culinary oreganos and you end up with something in between, and sometimes it invades other oreganos, overtaking them. It's always wise to smell and taste oregano before you buy a plant to be sure it has a strong flavor.

IN ADDITION TO SWEET MARJORAM, other types of marjoram often show up in garden centers, such as golden marjoram or curly marjoram. They are attractive plants but tend to be very mild in flavor. Choose sweet marjoram if you are going to cook with it.

ANY TIME A RECIPE CALLS FOR MARJORAM, you can substitute Italian oregano, but not Greek oregano.

ALL MEMBERS OF THIS FAMILY SHOULD BE CUT BACK during flowering to promote new leaf growth and keep them lush. Just grab onto the tops and shear them at least halfway down, well below the level at which the flowers begin. They will quickly put on new growth.

THESE HERBS ARE ROBUSTLY FLAVORED, but soft-leaved, which means you can add them at the beginning or the end of cooking. Their flavor will be stronger and more forward if you add them at the end.

PASTA WITH PESTO CAN BE A SPRINGBOARD FOR ALL SORTS OF VARIATIONS, and this one, with walnuts and creamy cubes of roasted eggplant, is a favorite for late-summer suppers.

PENNE with walnut pesto and eggplant

4 SERVINGS

2 small or 1 large eggplant (1½ pounds)

2 tablespoons olive oil

1 teaspoon kosher salt

PESTO

2 cups lightly packed basil leaves (2 ounces)

½ cup toasted walnuts

2 cloves garlic

½ teaspoon kosher salt

¼ cup olive oil

½ cup freshly grated Parmigiano-Reggiano

¾ pound penne pasta

½ cup roughly chopped toasted walnuts to finish

Preheat the oven to 425°F. Cut the unpeeled eggplant into ¾-inch cubes. Spread them out on a baking sheet that is either nonstick or lined with parchment paper. Drizzle with the olive oil and sprinkle with 1 teaspoon salt. Toss the cubes with your hands to distribute the oil and salt as evenly as you can and shake them out into a single layer. Bake the cubes for 25 to 30 minutes, or until they brown on the edges and are very soft.

While the eggplant is roasting, bring a large pot of salted water to a boil. Prepare the pesto by pulsing the basil, walnuts, garlic, and ½ teaspoon salt in a food processor. With the machine running, pour in the olive oil. Scrape down the bowl and add the cheese, then pulse again until combined.

Boil the pasta until it is tender but still slightly firm. Scoop ½ cup of the cooking water into a glass measuring cup, and then drain the pasta. Return the pasta to the pot, top with the pesto, pour in the water, and stir until it is evenly sauced. Scrape the eggplant cubes into the pot and stir gently. Scoop the pasta into a warmed large serving bowl or individual shallow bowls, sprinkle with the chopped walnuts, and serve right away.

A LAST-MINUTE SHOWER OF FRESH SPEARMINT brightens the smokiness of the bacon and cools the fiery chiles that spice up this simple dish of steamed clams.

CLAMS with mint, chiles, and bacon

2 SERVINGS AS A MAIN COURSE;
4 SERVINGS IN A MULTICOURSE MEAL

2 teaspoons olive oil

4 ounces bacon

3 cloves garlic, finely chopped

6 Thai bird or Szechwan chiles, fresh or dried

½ cup dry white wine or vermouth

2 pounds live Manila clams, washed

½ cup coarsely chopped spearmint leaves

Heat the olive oil over medium heat in a large saucepan and cook the bacon in it, stirring often, until it renders most of its fat and just begins to crisp. Scrape it out into a strainer, leaving a film of fat behind. Add the garlic, chiles, and wine to the saucepan. When the wine simmers, add the clams and cover the pot tightly. Cook over medium-high heat until all the clams open up, and then a minute or two past that, 5 to 7 minutes total.

Use a slotted spoon or skimmer to lift the clams into warmed serving bowls. Boil the liquid left behind for a minute or two, and then stir in the bacon and mint. Pour the sauce over the warm clams. Serve right away with crusty bread.

THE BOOMING CELERYLIKE FLAVOR OF LOVAGE might seem too strong for seafood, but it really complements most kinds, especially shellfish. I think mussels and lovage are a triumphant combination.

Lovage is an Old Faithful of an herb. You plant it once and early every spring it shoots from the earth and soars 6 or 7 feet in a couple of months—if you let it. The trick is to keep cutting back the flowering stalks so that it continues to produce young leaves, which are the only ones that are good to cook with. As the leaves get older and turn pale green or yellowed they become bitter and unpalatable.

STEAMED MUSSELS
with lovage

2 SERVINGS AS A MAIN COURSE;
4 SERVINGS IN A MULTICOURSE MEAL

2 pounds mussels, washed and beards removed

½ cup dry white wine

2 tablespoons chopped shallots

3 tablespoons coarsely chopped young lovage leaves

2 cups diced ripe tomatoes, or halved cherry tomatoes

3 tablespoons unsalted butter

Generous grinding of black pepper

Put everything but 1 tablespoon of the lovage in a large skillet or saucepan and cover.

Cook over high heat until most of the mussels open up, then shake the pan and continue to cook for another minute. Spoon the mussels and their liquid into large serving bowls, sprinkle with the lovage that was set aside, and serve with crusty bread.

FILLET OF SOLE, WITH ITS DELICATE FLAVOR AND TEXTURE, makes a wonderful home supper, and I cook it often. This recipe is a variation of classic sole meunière, in which the fish is floured and cooked in butter, then topped with sizzling lemon and parsley butter. All that I've added is a lavish handful of other herbs along with the parsley, which turns the dish into something else entirely.

SOLE with wilted herbs

4 SERVINGS

1½ pounds skinned sole fillet, such as Dover or petrale

1 cup milk

1 cup all-purpose flour

Kosher salt

2 tablespoons vegetable oil

5 tablespoons butter

¼ cup coarsely chopped flat-leaf parsley

½ cup very coarsely chopped soft-leafed herbs, including a mixture of any of the following: sweet basil, lemon basil, chervil, chives, dill, spearmint, or tarragon

2 tablespoons fresh lemon juice

Check for and remove any stray bones in the fish. Pour the milk into a shallow baking dish. Mix the flour with 2 teaspoons of salt and spread it out on a baking sheet or platter. Dip each piece of fish in the milk, then dredge with the flour, shake off the excess, and place it on a piece of parchment paper.

For the full recipe you'll need to cook the fish in 2 batches. Heat 1 tablespoon of the oil in a 12-inch or larger skillet over medium-high heat. Add 1 tablespoon of the butter when the skillet is hot enough for the butter to sizzle but not brown. Position about half of the fish fillets in the pan without overlapping the edges. Cook until the underside is golden brown, 2 to 3 minutes, shaking the skillet from time to time to ensure the fish are not sticking. Flip each piece and brown the other side, then slide the pieces out onto warm plates or a large warm platter. Wipe out the pan and repeat the steps with 1 tablespoon more of both oil and butter, and the remaining fish.

When the second batch of fish comes out of the skillet you'll need to work quickly. Add the remaining 2 tablespoons butter to the hot pan and turn off the heat. Add a large pinch of salt if your butter is unsalted. When it melts, toss in the parsley and other herbs all at once. Stir for a moment—the herbs will absorb most of the butter—then add the lemon juice. As it sizzles, spoon the herb butter over the fish. Serve right away.

WHEN A CULINARY STUDENT FROM JAPAN VISITED MY KITCHEN, she told me about her most frequent home-cooked meal, called chirashi sushi. It's like deconstructed sushi, where all the elements—rice, seafood, and vegetables—are layered in a bowl. This is my own interpretation, with seared tuna—and plenty of herbs, of course—which I often prepare for a quick supper. It's hugely satisfying and healthful, and as easy to make as throwing together a salad.

TUNA rice bowls

4 SERVINGS

DRESSING

½ cup seasoned rice wine vinegar

2 tablespoons fresh lemon juice

2 teaspoons grated peeled ginger

½ small red onion, finely chopped

1½ cups short-grain rice for sushi (I like Kokuho Rose brand)

2 tablespoons vegetable oil

1½ pounds fresh tuna steaks, such as albacore or ahi

Kosher salt

2 ripe avocados, peeled and sliced

½ cucumber, cut in half lengthwise and thinly sliced

1 green onion, finely chopped

1 sheet nori, cut into small strips with scissors

¼ cup coarsely chopped spearmint

½ cup coarsely chopped cilantro

4 to 6 shiso (perilla) leaves, cut into thin strips (optional)

Soy sauce

Stir the dressing ingredients together in a mixing bowl and let it sit while you prepare the rest of the dish to mellow and soften the onion.

Prepare the rice according to the package directions.

Heat a grill pan or large skillet over high heat. Pour the oil onto a large plate and slide both sides of the fish in it. Season both sides with salt. Keeping the heat high, sear the tuna for 1 to

2 minutes per side, or until it is crusted on the outside but still translucent in the center. Let the fish cool slightly, and then cut it into ¼-inch-thick slices with a sharp knife.

Scoop the cooked rice into 4 shallow bowls. Arrange the tuna slices, avocados, and cucumber over the top. Sprinkle with the green onion and nori. Toss the herbs together and sprinkle them over everything. Spoon the dressing evenly over the bowls. Serve with soy sauce and chopsticks.

TARRAGON SINGS OUT MOST BEAUTIFULLY WHEN ADDED to a dish with simple flavors. This one, which takes just 20 minutes to prepare, is a perfect example. Chicken breasts are tucked into a bed of soft buttery leeks to braise and finished with a small handful of fresh anise-flavored leaves.

tarragon CHICKEN BREASTS with buttered leeks

4 SERVINGS

2 cups thinly sliced leeks, white and light green parts only (1 large or 2 small)

2 cups chicken broth

4 tablespoons unsalted butter

4 boneless skinless chicken breasts, about 1½ pounds

Kosher salt and freshly ground black pepper

2 teaspoons fresh lemon juice

2 tablespoons coarsely chopped tarragon

Put the leeks in a large skillet with the chicken broth and 2 tablespoons of the butter. Cook them at a gentle boil over medium heat until they are tender and the broth has boiled down far enough that the leeks are no longer completely submerged. This should take about 8 minutes.

Sprinkle both sides of the chicken breasts with salt and pepper. Place them on top of the simmering leeks, spoon some of the leeks over the chicken, and cover the pan tightly.

Reduce the heat to low. In 10 minutes test the chicken for doneness. It should feel firm when you press on it, and if you cut a slit into the thickest part of a breast, there should be no sign of translucence. If the breast pieces are large, it could take as much as 15 minutes, but don't overcook them.

When the chicken is done, lift the pieces from the leeks and put them on a warm platter. Increase the heat under the leeks to high and stir in the lemon juice, the remaining 2 tablespoons butter, and the tarragon. When the butter melts, taste the sauce and add salt and pepper if you think it needs it. Pour the leek sauce over the chicken and serve.

herbal improvisations
Instead of the tarragon, stir in 2 tablespoons chopped marjoram or ½ cup chopped dill or chervil.

TARRAGON: the french, of course

There are two kinds of tarragon: French and Russian. Always choose French. It's rarely labeled as either, but luckily most tarragon that we see in markets and garden centers these days is the French variety. Growing only about 2 feet high, it has small narrow leaves with an intense herbaceous anise flavor. Russian tarragon is much taller, lusher, and more vigorous, but it has a mild and far inferior flavor. You can always tell the difference from the taste.

THE TARRAGON THAT YOU BUY IN THE PRODUCE SECTION, particularly in winter, is often much milder tasting than what you harvest from your garden. When you cook with it, taste as you go and add more if you wish.

TARRAGON'S FLAVOR DOESN'T MIX WELL WITH MANY OTHER HERBS, but it does work with chives, chervil, and parsley. Combine all four for the classic mixture called fines herbes.

ADD TARRAGON TO A DISH AT THE END OF THE COOKING to keep its flavor most vibrant.

TARRAGON CAN BE FUSSY IN THE GARDEN. It likes loose rich soil, lots of sun, and to be kept evenly moist. If it sulks, try another spot in the garden.

TARRAGON IS A PERENNIAL BUT IT WILL OFTEN DIE IN WINTER ANYWAY. You might need to replant every season.

FRENCH TARRAGON DOES NOT PRODUCE VIABLE SEEDS, so you must begin with a plant that was started from a cutting or division. Russian tarragon does grow from seed.

IT'S A SIMPLE TRICK TO SLICE AND STUFF A POCKET in a chicken breast, and there are endless possibilities of what to put inside. Herb butters and pestos are perfect because they help keep the meat moist while delivering herbal flavors from the inside out. Here I use a classic basil pesto. As the chicken cooks, it shrinks and pushes some of the filling out into the skillet to combine with the cherry tomatoes as a colorful pan sauce. If your freezer is full of your own supply of pesto from your summer basil crop, you'll love this recipe. Just use ½ cup and omit the pesto step.

pesto-stuffed CHICKEN BREASTS with cherry tomatoes

4 SERVINGS

PESTO

2 cups basil leaves, gently packed

3 tablespoons pine nuts

1 clove garlic, coarsely chopped

½ teaspoon kosher salt

¼ cup extra virgin olive oil

¼ cup finely grated Parmigiano-Reggiano

4 boneless chicken breasts, skin on, 1½ to 2 pounds

Kosher salt and freshly ground black pepper

2 tablespoons extra virgin olive oil

1 pint ripe cherry tomatoes, preferably of varied colors, washed, stemmed, and halved

½ cup coarsely torn basil leaves

To make the pesto, pulse the basil, pine nuts, garlic, and salt in a food processor until they turn into a coarse puree. With the motor running, pour in ¼ cup olive oil. Stop the machine and add the cheese. Process until just incorporated; it should have some texture and not be a smooth puree.

Insert a sharp boning knife horizontally into the thick end of a chicken breast. Sweep the knife sideways to create an ample pocket without piercing through the other side of the breast. Slice the other 3 breasts in the same way. Divide the pesto into 4 equal parts and fill each pocket with a portion.

Season both sides of the chicken with salt and pepper. Heat 2 tablespoons olive oil in a large skillet over medium heat. Carefully lower the chicken breasts into the pan, skin side down. Cook until the skin is a deep golden brown, about 5 minutes. Flip the breasts, cover the pan, and adjust the heat to medium-low. Cook for another 5 to 8 minutes, or until the chicken is cooked through. You can check by peeking into the pocket or cutting into the thickest part of a breast to see that there is no sign of translucence. Lift the chicken out with tongs and put it on a warm platter or warm plates, leaving behind the pan drippings and any pesto that escaped from the pockets. If it seems like there's quite a bit of fat in the skillet, pour off about half of it.

Add the halved cherry tomatoes to the skillet and increase the heat to medium. Stir to scrape up anything clinging to the bottom of the pan and cook for a minute or two, until the tomatoes are hot and begin to exude juices. Stir in the torn basil. Pour the tomatoes over the chicken and serve right away.

BONELESS DARK CHICKEN MEAT IS NOW COMMON in grocery stores and butchers' counters and it's just the thing for quick, flavorful dinners. In this one-skillet dish the chicken is embellished with Mediterranean-inspired ingredients that balance tangy, sweet, salty, and herbaceous flavors.

lemon rosemary CHICKEN

4 SERVINGS

1½ pounds boneless chicken thighs, or legs and thighs, cut into 1-inch chunks

Kosher salt and freshly ground black pepper

2 tablespoons olive oil

1 medium red onion, cut in half and sliced from root to top

1½ tablespoons coarsely chopped rosemary

½ cup chicken broth

Finely grated zest of 1 lemon

⅓ cup dried currants

⅓ cup chopped pitted green olives

3 tablespoons fresh lemon juice

Season the chicken pieces with salt and pepper. Heat the olive oil in a large skillet over high heat. When the pan is very hot, add the chicken pieces, spreading them in a single layer. Cook them undisturbed until the bottoms of the chunks brown lightly, about 3 minutes. Scrape the chicken pieces loose with a spatula, stir them around, and cook them another 3 minutes, stirring several more times, to lightly brown the other sides. Slide the chicken out of the pan onto a warm platter.

Adjust the heat to medium-low. Add the onion and rosemary to the skillet and cook until they become limp, about 3 minutes. Pour in the chicken broth and stir to dissolve the browned layer on the bottom of the pan. Stir in the lemon zest, currants, olives, ½ teaspoon salt, a few grindings of black pepper, and the browned chicken. Cover tightly and cook over low heat for 15 minutes, or until the chicken is tender.

Uncover the pan and increase the heat to high. Stir in the lemon juice, and cook until the sauce reduces and thickens enough to coat the meat with a glaze, 2 to 3 minutes. Serve while still hot.

herbal improvisation In place of the rosemary, cook ¼ cup coarsely chopped sage with the onion.

THE PARTICULAR HERB CALLED CINNAMON BASIL, which tastes like a cross between the herb and the spice, inspired this dish of chicken braised with cinnamon sticks and tomatoes and finished with a heavy shower of fresh sweet basil. It might seem like too much basil, but don't hold back; it gives the dish its freshness and verve. If you do have cinnamon basil in your garden, so much the better; use it instead of sweet basil for even more spice flavor.

If you can, try to find "true cinnamon" sticks, which have a more complex and less cinnamon red-hot flavor than the cassia cinnamon sticks you usually find in supermarkets. Their bark is papery thin and rolled in brittle layers as opposed to the rigid bark of cassia sticks. Star anise pods add a nice dimension to the dish also, but you can leave them out if they're not on hand.

cinnamon basil CHICKEN

4 SERVINGS

1 frying chicken, about 4½ pounds, cut into 8 pieces without the backbone

Kosher salt and freshly ground black pepper

2 tablespoons olive oil

1 large onion, halved and sliced from root end to top

2 cloves garlic, finely chopped

1½ tablespoons finely chopped fresh ginger

One (28-ounce) can diced tomatoes, drained of half the liquid

Three 3-inch cinnamon sticks, preferably "true" cinnamon

3 star anise pods

1½ cups torn leaves of sweet basil or cinnamon basil, gently packed

Season all sides of the chicken with salt and pepper. Heat the olive oil over medium-high heat in a large skillet with a tight-fitting lid. When the pan is hot, put the chicken pieces in the pan, skin side down, and cook uncovered until the skin turns deep golden brown, at least 6 to 8 minutes. Turn the chicken and cook another 2 to 3 minutes on the other side. Take the chicken out of the pan and pile it on a platter.

Reduce the heat to medium and add the onion, garlic, and ginger to the pan. Stir them around for 3 to 4 minutes, or until they soften and begin to brown. Add the tomatoes, cinnamon sticks, star anise, and 1 teaspoon kosher salt. Put the chicken back in the pan. When the toma-

toes come to a simmer, cover the pan, turn the heat to very low, and cook for about 50 minutes, or until there is little resistance when you pierce a thigh with the tip of a paring knife. If the sauce seems watery, turn the heat to high and boil it uncovered until it thickens. Scatter in the basil as you toss the chicken in the sauce with tongs. Serve right away.

BASILS: sweet and otherwise

When a recipe calls for basil, it means sweet basil, the herb with an Italian pedigree that has a complex flavor, combining clove, cinnamon, camphor, anise, citrus, and mint. It's unlikely you'll see anything labeled more specifically than "basil" in produce sections and ordinary garden centers, but when you flip through seed catalogs you'll see lots of choices.

There are many strains with sweet basil flavor, and their leaves can vary from tiny to gigantic, light green to burgundy colored, smooth to ruffled. Genovese is one of the best tasting, with medium-sized puckered leaves that are fleshy enough to make excellent pesto. Spicy Bush, Dwarf Italian, Bouquet, Piccolo, and Spicy Globe are all strains that grow into short rounded plants with very small leaves. Napoletano, Lettuce Leaf, and Mammoth all have enormous wide leaves that make harvesting and stemming very easy. Opal, Purple Ruffles, and Red Rubin have ruddy purple leaves that turn green when cooked. Though there are distinct differences in the flavors between the varieties, they are similar enough to be used interchangeably.

Other basil varieties are quite distinct in taste, emphasizing one of the flavor elements. For instance, lemon basil and lime basil both have a bright, citruslike flavor with almost no hint of sweet basil's taste. Cinnamon basil really does taste like cinnamon; licorice basil and Thai basil have an aniselike flavor. Some basils are very camphoric and should not be invited into the kitchen at all—these include holy basil, African blue basil, and camphor basil.

BASIL DOES NOT LIKE TO BE STORED below 45°F—it can blacken. If you've just harvested it or bought a fresh bunch at a farmer's market, stand it in a pitcher of water like a bouquet and keep it on the kitchen counter, where it will keep a day or so. Better yet, if you happen to have a temperature-controlled wine storage area, put it in a freezer bag and pop it in there. Otherwise, you'll have to bag it and keep it in the vegetable compartment of your refrigerator. Pack it loosely and don't set anything on top of it, and it will be fine for 3 or 4 days.

UNLESS YOU ARE PREPARING PESTO, basil is best left quite coarsely chopped or torn into pieces. When cutting it, use a very sharp knife so that you don't bruise it.

WHEN ADDING BASIL TO A COOKED DISH, stir it in at the end.

DON'T PLANT BASIL IN YOUR GARDEN until night temperatures stay above 60°F. Most cooks will want at least half a dozen plants for a continuous supply.

LIKE MOST HERBS, BASIL LIKES LOOSE SOIL, but it will grow best if given more water and fertilizer than the others. If you grow tomatoes, treat your basil the same way.

BASIL IS AN ANNUAL AND ITS GOAL IS TO BLOOM AND SET SEED. Once it accomplishes this, it diminishes its leaf production. In order to keep the plants producing leaves all summer, it's important to keep them from flowering. To begin with, when the plants are young, pinch off the top set or two of leaves every week to encourage branching. When the plants mature, cut the branches back when they form buds at the top. It's better to cut an individual plant down quite far (at least one-half or two-thirds of the way down) than to cut the top one or two leaf pairs of each stem (which encourages it to produce twice as many flowers). The plant will grow back in a few weeks. Some of the specialty basils, like cinnamon and lemon, are particularly determined to flower, and at a certain point you have to let them.

FOR EASY FAMILY DINNERS, roasted chicken is always at the top of my list. It's nice to have a few variations in your recipe file, and this is a good one. Here, the backbone is cut out and the chicken is laid flat, stuffed under the skin with an herby olive paste, and then roasted on top of potatoes and fennel, which become saturated in the flavorful juices. If you buy a big roasting chicken (6 pounds), it's easier to stuff and you'll have enough for six hungry people.

black olive ROAST CHICKEN

6 SERVINGS

HERBED OLIVE PASTE

½ cup pitted oil-cured black olives

2 tablespoons thyme leaves

3 tablespoons rosemary leaves

Grated zest and juice of 1 large lemon

2 cloves garlic

½ teaspoon kosher salt

2 tablespoons olive oil

1½ pounds Yukon Gold potatoes (or any other variety), cut into 2-inch chunks

2 fennel bulbs, white parts only, sliced 1 inch thick

1 roasting chicken (about 6 pounds), rinsed and patted dry

Kosher salt and freshly ground black pepper

Preheat the oven to 425°F.

Spin all of the olive paste ingredients together in a food processor until they form a semi-smooth puree.

Put the potatoes and fennel in a roasting pan or large baking dish. Dot them with about one-quarter of the olive paste and toss them around a bit.

Using poultry shears, cut along either side of the backbone to remove it. Turn the chicken over and spread it out flat. Bend the wing tips behind. Wriggle your hand between the skin and the flesh of the bird to loosen the skin over the breast, thigh, and leg. Taking a small handful at a time, stuff the remaining olive paste under the skin, distributing it as evenly as you can over

the dark and white meat. It will be a little messy—some of the olive paste may end up on the outside of the skin—but it doesn't matter. Lay the chicken over the vegetables and position the legs so that the knee joints point inward. Sprinkle the skin generously with salt and pepper.

Roast the chicken for 60 to 70 minutes (50 to 60 if it's a smaller fryer), or until the skin is deeply browned and there is no sign of pink when you cut and peek between the thigh and the lower breast. Let the bird rest for 10 to 20 minutes before you carve it.

herbal improvisation In place of the rosemary, add the same quantity of marjoram or savory.

I LIKE LAMB SHOULDER CHOPS as much as expensive rib chops. They might not be as tender, but they have heaps more flavor and really satisfy a gnaw-on-the bone grilled meat craving. You can begin to eat them with a knife and fork, but after a while pick them up to get true gratification; with their herby-garlicy coating, it's a messy pleasure.

MESSY LAMB SHOULDER CHOPS with four herbs

4 SERVINGS

4 lamb shoulder blade chops, 2½ to 3 pounds

2½ teaspoons kosher salt

1 tablespoon coarsely chopped rosemary

1 tablespoon coarsely chopped thyme

2 tablespoons coarsely chopped Greek oregano

4 cloves garlic, finely chopped

¼ cup plus 2 tablespoons olive oil

¼ cup coarsely chopped spearmint

Sprinkle both sides of the lamb chops with 2 teaspoons of the salt. Stir the rosemary, thyme, oregano, garlic, and olive oil together in a large mixing bowl. Scoop half of this marinade into a small saucepan for a topping after the chops are grilled. Smear both sides of the chops with the remaining marinade and let them sit in the bowl until you are ready to grill (refrigerate them if it will be more than an hour).

Light a fire in a charcoal grill or preheat a gas grill to high. When it's ready, grill the chops until they are approaching medium-well. Grills vary a great deal, and the cooking time might also, but over hardwood charcoal in my kettle grill the chops take a total of 15 minutes for both sides, and I cook them covered for about half of that time to keep the flames extinguished. You must cook them long enough so that the connective fat has a chance to render and relax, but not so long that the chops become dry.

Let the chops rest on a platter for 5 to 10 minutes. Put the saucepan with the reserved marinade over medium heat and stir it until the garlic cooks, 1 to 2 minutes. Stir in the mint and the remaining ½ teaspoon salt. Brush the herb oil over the chops and serve.

THERE'S SOMETHING IRRESISTIBLE ABOUT GRILLED BEEF that has been marinated with soy sauce and sugar, as with teriyaki or Korean barbecue. In this variation on the theme, I've infused a similar sweet soy marinade with the piney flavor of rosemary and the citrus punch of lemon verbena.

The long-neglected cut known as onglet, or hanger steak, is showing up at many butchers' counters, which is great news because it's flavorful, tender, and a great value. The steaks are shaped like a narrow taper, each an individual serving size. If they're not available, substitute flank steak. This is good with the Herbed Fresh Vegetable Pickle (page 80) and plenty of steamed rice.

grilled lemon–rosemary
HANGER STEAK

4 SERVINGS

½ cup soy sauce

3 tablespoons sugar

3 cloves garlic

1 cup very coarsely chopped chives or green onion

¼ cup rosemary leaves

¾ cup lemon verbena leaves, gently packed (or zest of 2 lemons)

4 hanger steaks (beef onglet), about 2 pounds

Puree the soy sauce, sugar, garlic, and herbs in a blender until fairly smooth. Pour the mixture over the steaks in a large freezer bag, seal it, and squish things around to coat the steaks all over. Let the steaks marinate in the refrigerator for 4 to 6 hours or overnight.

Build a fire in a charcoal grill or preheat a gas grill to medium-high. When the coals are glowing or the gas grill is hot, grill the steaks, turning them several times, until they are done to your liking, 12 to 15 minutes for medium-rare. The steaks will inevitably char a bit because of the sugar in the marinade, but keep them away from the hottest part of the grill and watch them carefully so they don't blacken. Allow the steaks to rest for 10 minutes, then carve them into ½-inch-thick slices and serve.

delighting a CROWD

HERB GARDEN LASAGNA

GRILLED CHICKEN WITH
BEFORE AND AFTER MARINADES

VERDANT SEAFOOD PAELLA

SIDE OF SALMON SLOW-
ROASTED IN DILL

PORK LOIN ROASTED IN
GREEN SAUCE

BRAISED PORK SHOULDER
WITH PEARS AND THYME

EVERYONE WHO LIKES TO COOK has their favorite lasagna recipe. I'm particularly fond of this version, which is lighter and fresher tasting than most, but still familiar and satisfying, with richly flavored layers of pesto sauce, herbed tomatoes, and creamy ricotta. I developed it when playing around with oven-ready lasagna noodles, a product I never gave much attention to in the past, but one I am now devoted to. If you've made lasagna the traditional way, where you must boil the noodles before you layer them, it takes a leap of faith to believe that this odd stack of rigid pasta and thick sauces is going to bake into a beautifully browned, perfectly constructed lasagna, but if you follow the directions, it does. And it saves a huge chunk of time and work. Be sure you use a baking dish that is exactly 9 × 13 inches, preferably with straight sides, or the noodles will not cook properly.

herb garden LASAGNA

8 SERVINGS

One 28-ounce can plus one 14.5-ounce can crushed tomatoes

¼ cup chopped marjoram

Kosher salt

5 tablespoons unsalted butter

½ cup all-purpose flour

3 cups milk, whole or low fat

1 pound whole milk ricotta

4 ounces basil, stems removed (2 cups gently packed)

1 cup flat-leaf parsley, gently packed

2 cloves garlic

½ cup freshly grated Parmigiano-Reggiano cheese

8 ounces oven-ready lasagna noodles (12 noodles)

8 ounces fresh mozzarella, shredded

Boil the tomatoes in a large skillet over medium-high heat, stirring occasionally, for about 10 minutes, or until they turn into a thick sauce. Stir in the marjoram and 1 teaspoon salt.

Melt the butter in a large saucepan over medium heat. Whisk in the flour and cook the roux for about a minute. Pour in the cold milk all at once. Whisk until all the lumps disappear, then occasionally until the sauce comes to a full boil and thickens. Season with 1½ teaspoons salt.

Blend the ricotta with one-third of the white sauce in a food processor until smooth. Scrape the cheese out into a bowl.

Without washing the food processor, pulse the basil, parsley, garlic, and ½ teaspoon salt until finely chopped. Add the remaining white sauce and the Parmesan and process until well combined.

Preheat the oven to 375°F.

If it's your first time dealing with oven-ready noodles the process will seem strange, but just trust it. Spread half of the tomato sauce in the bottom of a 9 × 13-inch baking dish. Arrange 3 noodles on top of the sauce; they should fit without touching each other or the sides of the pan. Dab half of the basil sauce over the noodles, covering the pasta as best you can. As you build the lasagna think about layering the ingredients in 3 stacks, spreading the filling just over the noodles rather than worrying about the gaps between and around the noodles, but if some spills over that's fine. Top the basil sauce with 3 more noodles in the same position. For the next layer, distribute the entire amount of ricotta by scooping it in spoonfuls onto the top noodles and spreading it a bit, pressing down as little as possible. Top with 3 more noodles, then the remaining tomato sauce. Finally, put the last 3 noodles in place and spread the top with the remaining pesto sauce.

Cover the dish with aluminum foil, tenting it a little so it doesn't touch the lasagna, and bake for 30 minutes. Remove the foil and sprinkle the mozzarella evenly over the top. Bake for an additional 30 to 35 minutes, or until the cheese is evenly browned. Let the lasagna rest for at least 15 minutes before you serve it; it will be very loose at first, but will firm up as it sits. The lasagna can be assembled ahead and kept refrigerated until you are ready to bake it (allow an extra 10 minutes in the oven under the foil), or baked ahead of time and reheated in a 350°F oven.

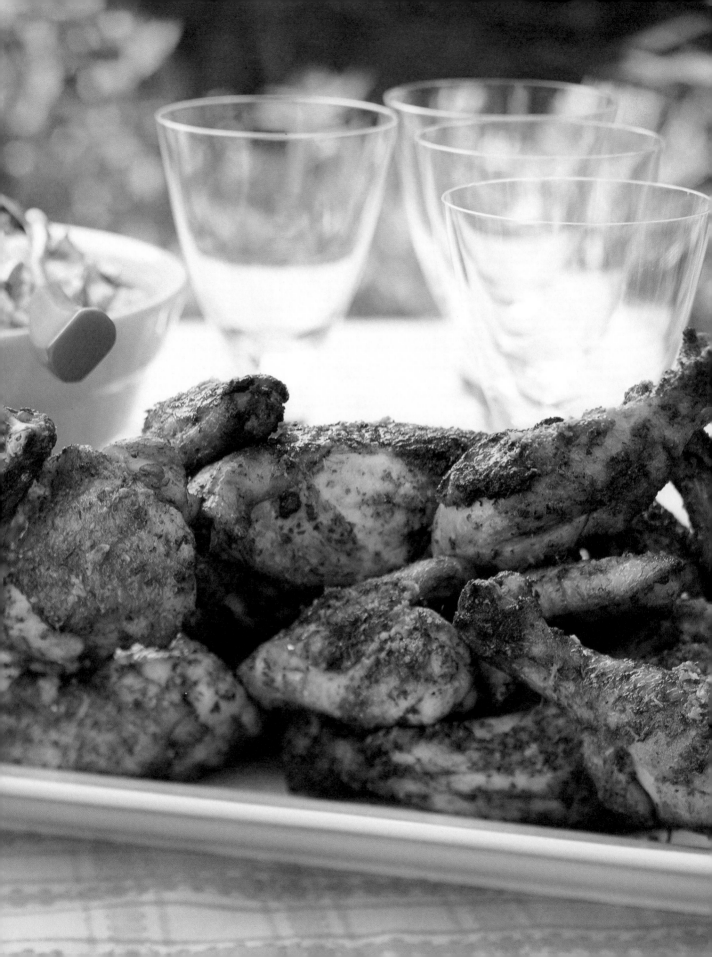

BECAUSE THE FLAVORS IN CHICKEN MARINADES OFTEN BECOME MUFFLED while the birds cook on the smoky grill, I like to set aside some of the marinade, stir in a bit of extra lemon or lime juice, and brush it onto the chicken pieces after they're fully cooked and still hot. Then, when you bite into a piece, the crisp skin is doused with bright-tasting bits of herb and a little extra tang. I'm including three of my favorite combinations for the marinades, but once you get the hang of this technique you can easily improvise your own.

The chicken is noticeably more tender and flavorful if you allow plenty of time for it to bathe in the "before" marinade. And be conscientious about not contaminating the "after" marinade with anything that touched raw chicken; switch to clean platters, brushes, and tongs after the chicken is cooked.

GRILLED CHICKEN with before and after marinades

4 SERVINGS PER CHICKEN

One of the following for each 4½-pound chicken, cut in 8 pieces without the back:

PROVENÇAL HERB

1 tablespoon lavender buds, fresh or dried

1 tablespoon thyme leaves

1 tablespoon savory leaves (or substitute rosemary)

Grated zest of 1 lemon

2 tablespoons chopped shallots

2 teaspoons kosher salt

¼ cup plus 2 tablespoons extra virgin olive oil

3 tablespoons fresh lemon juice

CUBAN ADOBO

2 tablespoons coarsely chopped sage leaves

2 tablespoons Greek oregano leaves

4 cloves garlic

2 teaspoons ground cumin seeds

Grated zest of 1 lime

2 teaspoons kosher salt

¼ cup plus 2 tablespoons vegetable oil

¼ cup fresh lime juice

SMOKED PAPRIKA

1½ tablespoons smoked paprika (*pimentón*), sweet or hot

1 tablespoon marjoram leaves

2 tablespoons rosemary leaves

¼ cup flat-leaf parsley leaves

3 cloves garlic

2 teaspoons kosher salt

¼ cup plus 2 tablespoons olive oil

3 tablespoons fresh lemon juice

Blend all the marinade ingredients except 1 tablespoon of the lemon or lime juice in a food processor until you have a coarse puree. Spoon about one-third of the marinade into a small container, stir in the last tablespoon of lemon or lime juice, and cover and refrigerate it until you cook the chicken. Toss the chicken pieces with the remaining two-thirds of the marinade and refrigerate it in a covered bowl or resealable freezer bag for at least 8 hours or as much as 24.

Start a charcoal fire in a kettle grill or preheat a gas grill to medium. When the grill is hot, cook the chicken, with the grill lid down most of the time, until the skin is well browned on both sides and the meat is cooked through. Check the meat frequently, rotating it often and keeping it away from hot spots so that the skin does not burn. The breast pieces will likely cook faster, so remove them first to keep the white meat from drying out, and continue to cook the dark meat and wings until the meat starts to pull away from the bottom of the drumsticks.

Brush all the chicken pieces with the reserved marinade and serve warm or at room temperature.

PAELLA LOVES A PARTY, and this exuberant rendition, with a puree of summery herbs, is a knockout. The only drawback is that it can't be made ahead—all the prep can be done in advance, but once you cook it, you should serve it. There are lots of variables, such as the particular seafood available in your area, the type of rice you use, and the quirks of your oven, so it's not a bad idea to practice this dish for family or your closest friends before your big dinner party. This way you can figure out the timing and get all the moves practiced, then prepare it effortlessly as your guests marvel. You will need a special pan to prepare it properly. An inexpensive 18-inch steel paella pan (which needs to be seasoned with oil) is a worthwhile investment—you'll likely be making paella often.

verdant SEAFOOD PAELLA

8 LARGE SERVINGS

2 cups clam juice (bottled is fine)

4 cups chicken broth

¼ teaspoon saffron threads

HERB PUREE

2 cups basil leaves, gently packed

¼ cup marjoram leaves, gently packed

1 cup flat-leaf parsley sprigs, gently packed

4 cloves garlic

¾ teaspoon salt

¼ cup extra virgin olive oil

¼ cup extra virgin olive oil

1 large yellow or white onion, diced

1 fennel bulb, diced

1 large red bell pepper, diced

½ to 1 jalapeño pepper, depending on taste, finely chopped

3 cups short-grain Spanish rice, such as Bollo, or substitute Arborio or California Pearl

1 pound mussels, scrubbed and beards removed

1 pound small Manila clams, scrubbed*

1½ pounds large shrimp, peeled and deveined if necessary*

1 pound cleaned squid, tubes sliced in rings, and beaks removed from tentacles

Preheat the oven to 450°F.

Heat the clam juice, chicken broth, and saffron in a saucepan until the mixture comes to a very low simmer.

Put all the ingredients for the herb puree in a food processor and process until it breaks down to a rough paste.

Place a seasoned 18-inch paella pan over a large burner turned to medium heat. Pour in the olive oil, and then add the onion, fennel, and peppers. Cook the vegetables, stirring constantly, until they are softened, about 8 minutes. Stir in the rice until it is well coated with oil.

Pour the hot broth over the rice and vegetables. Cook, stirring from time to time, until the rice has absorbed more than half the liquid, 10 to 12 minutes.

Stir in the herb puree. Arrange the mussels and clams, hinge side down, all over the surface and push them down into the rice so they are mostly submerged. Put the pan in the center of the oven (the pan might be slightly too large for the door to close completely on some ovens, but it shouldn't matter) and bake for 10 minutes. Remove it from the oven and distribute the shrimp and squid over the top. Nudge them down into the rice with a spoon and try to moisten the top layer of rice as you do. Return the paella to the oven and bake until the clams and mussels open and the rice is just tender but slightly underdone, another 5 to 10 minutes. Remove the pan from the oven and let the dish rest for 5 to 10 minutes to allow the rice to finish cooking. Serve while still hot.

*If you purchase seafood that takes longer to cook, like larger prawns or cherrystone clams, you'll need to make adjustments. If the prawns are huge (10 to the pound), add them to the pan with the clams and mussels. If you have larger clams, steam them open with a little wine in a separate pan before you start the paella, then use their liquor as some of the measured clam juice and add them to the pan near the end of the cooking.

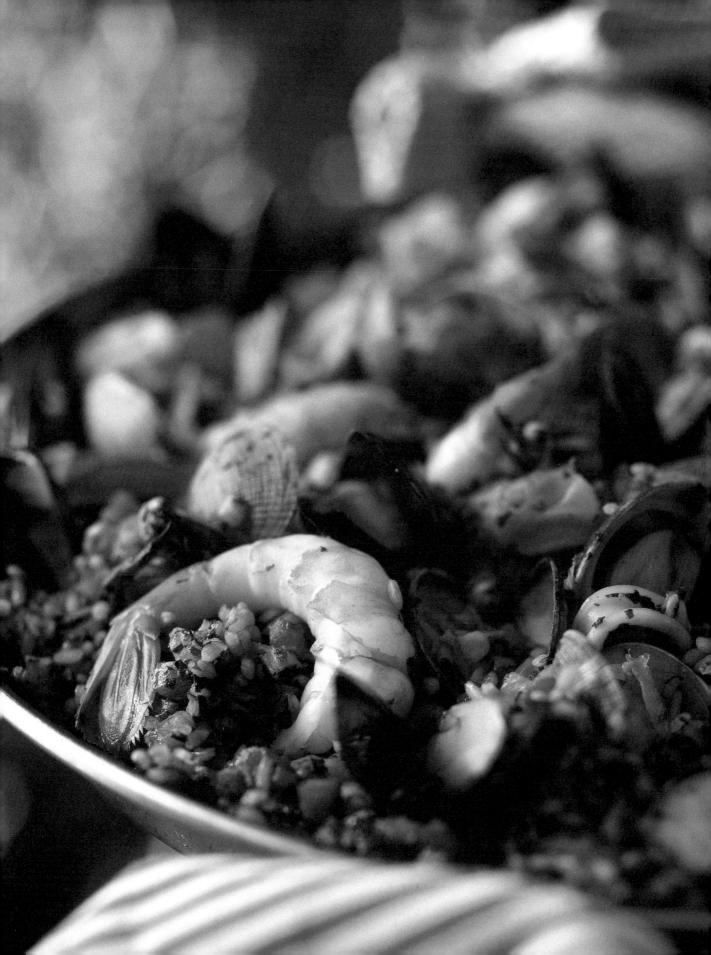

A WHOLE SIDE OF SALMON always makes an impressive buffet dish, and this is a remarkably easy way to prepare it. The low temperature keeps the fish moist and colorful, while the bed and blanket of dill infuses flavor throughout the salmon without overpowering it. If you have a huge oval ovenproof serving dish that will fit the salmon, it's truly a breeze, because it can go from oven to table.

SIDE OF SALMON
slow-roasted in dill

10 TO 12 SERVINGS

1 side wild king salmon or 2 sides wild sockeye salmon, 4 to 5 pounds, filleted, skinned, and pinbones removed

½ cup extra virgin olive oil

Kosher salt

4 ounces fresh dill weed (2 large bunches), plus additional dill for garnish

Rémoulade Sauce (recipe follows)

Preheat the oven to 225°F, or 200°F if you have the option of convection bake.

Generously slather both sides of the salmon with the olive oil, and then generously season both sides with salt.

Spread half of the dill sprigs in an oversized shallow baking dish or baking sheet that is big enough to fit the salmon. Place the salmon on top, skinned side down (if you are cooking 2 smaller fillets, alternate the direction of the head and tail ends so they fit neatly). Cover the fish with the remaining sprigs. Put it in the oven and check it after 30 minutes. The first sign that the fish is done is the appearance around the edges of a little of the white protein that comes out of salmon when it's baked. Test it further; the fat between the layers of fish will just begin to turn opaque, a small amount of liquid will collect under the sides, and the fish will separate between the layers when nudged with your finger. It might seem to be underdone because the color will be vivid and it will be very moist and warm—not hot—but it will be fully cooked. The fish might take as long as 50 minutes to cook, depending on its size, its initial temperature, and your oven.

Once the salmon is out, lift off the dill from the top. If you used a shallow baking dish, pull off and clean up any dill that doesn't look good and serve the fish directly. If you used a baking sheet, very carefully slide the fish to a warm platter, taking the dill with it. Garnish with additional fresh dill. Lift the fish off of the bed of dill as it's served. Serve with Rémoulade Sauce or the frothy tarragon sauce for asparagus on page 180.

THIS IS MY TAKE ON THE CLASSIC MAYONNAISE-BASED SAUCE, with plenty of herbs and no pickle.

RÉMOULADE sauce

3 large egg yolks

3 tablespoons fresh lemon juice

1 teaspoon Dijon mustard

A few dashes Tabasco or other hot sauce

¾ teaspoon kosher salt

1 cup olive oil

¼ cup chopped chives

2 tablespoons chopped tarragon

¼ cup chopped flat-leaf parsley

3 anchovy fillets, rinsed and finely chopped (first soaked for 30 minutes if salt-packed)

2 tablespoons capers, rinsed and chopped (first soaked for 15 minutes if salt-packed)

To make the mayonnaise, put the egg yolks, lemon juice, mustard, Tabasco, and salt in a food processor. With the motor running, pour in the olive oil from a spouted measuring cup in a very slow steady stream. When all the oil is added, the sauce should be thick.

Scrape the mayonnaise into a mixing bowl and stir in the remaining ingredients. Store, covered in the refrigerator, for no more than 2 days.

THE GREEN SAUCE HERE is based on the lively Italian pounded sauce called salsa verde, but with the addition of sage, the quintessential pork herb. Half of the sauce is used as a marinade and the other half is blended into the pan juices. I prepare this with a frenched bone-in pork loin roast, which means the rib bones are attached and trimmed at the top so that they are exposed. It looks like a very long and fat rack of lamb. If this cut is not available to you, a boneless pork loin roast can fill in, but start checking the temperature sooner because it will cook quite a bit faster.

PORK LOIN ROASTED in green sauce

8 TO 10 SERVINGS

2 cups flat-leaf parsley sprigs, gently packed

½ cup coarsely chopped sage leaves

¼ cup marjoram leaves

Grated zest of 1 large lemon

¼ cup fresh lemon juice

2 tablespoons capers, rinsed (first soaked for 15 minutes if salt-packed)

6 anchovy fillets

3 cloves garlic

1 tablespoon kosher salt

¼ cup plus 2 tablespoons extra virgin olive oil

One 10-rib, bone-in pork loin roast, frenched, about 5 pounds

Put the herbs, lemon zest, lemon juice, capers, anchovies, garlic, and salt into a food processor and turn it on for about 15 seconds. Scrape down the sides, then turn it on again and pour in the olive oil in a steady stream. Half of this puree will be used to marinate the pork and the other half will finish the sauce after it comes out of the oven.

The pork should have about a ¼-inch layer of fat covering the rounded side. If it's much thicker than that, trim some off. Put the pork in a roasting pan or baking dish in which it fits comfortably (you can cut the roast in two equal pieces if you wish) and slather all sides of the roast with half of the green sauce. If time permits, refrigerate the roast and allow it to marinate in the sauce for several hours or even overnight. Bring it out to room temperature about an hour before you are ready to roast it.

Preheat the oven to 425°F. Roast the pork for 30 minutes, then pour 1 cup hot water into the pan. Turn the oven down to 350°F and continue to roast it until a thermometer inserted horizontally into the interior registers 150°F. Figure on a total roasting time of 1 to 1½ hours. Allow the pork to rest in the roasting pan at room temperature for about 10 minutes, and then transfer it to a board for carving. Pour the drippings into a liquid measuring cup, ladle off the fat, and return them to the roasting pan (if it is safe for the stovetop, otherwise pour them into a saucepan). Put the pan over low heat, whisk in the reserved green sauce, and bring it to a simmer.

Carve the roast between the bones into individual chops. Arrange them on a warm platter. Pour the remaining sauce over the pork or pass it separately in a sauceboat.

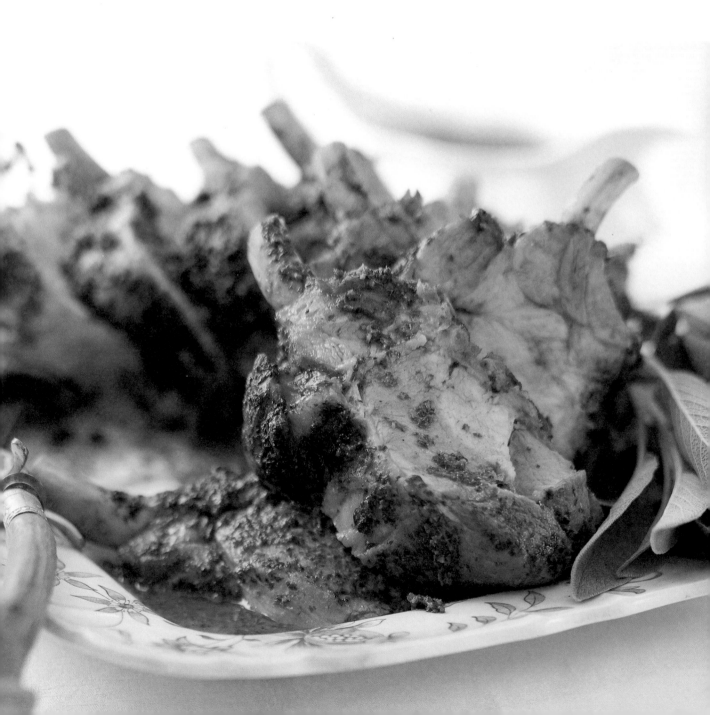

SAGE advice

There are many sage cultivars to choose from, but as far as I'm concerned, every herb garden should have common garden sage. Its gray-green leaves have excellent flavor and are fairly thin (which I consider a merit), and it blooms profusely in spring. Many sage varieties do not bloom, which keeps them neater and bushier, but you miss out on the beautiful purple sweet-tasting flowers that you can sprinkle on salads, vegetables, and pasta dishes. I have a particular bias against the cultivar Berggarten, which produces huge rounded leaves with a thick and felty texture that I find annoying on the tongue.

If you want to grow other varieties of sage, golden sage (which is variegated gold and light green) and purple sage are good choices. They both have colorful leaves that provide contrast to all the green in an herb garden, and they also do nicely tucked into an ornamental border or in planters on the patio. Neither blooms, but you can cook them with the leaves in the same way as green sage. I also like to grow a dwarf sage that is like a miniature version of garden sage, with tiny leaves you can cook with whole, without chopping.

SAGE IS ALWAYS BEST COOKED IN FOODS rather than added at the last minute or left raw. Its medicinal flavor mellows with heat, and its felty texture becomes more palatable.

SAGE IS PARTICULARLY GOOD when cooked in some sort of fat. If a stovetop recipe begins with cooking onion or garlic in butter or oil, add the sage at that point.

IF YOUR SAGE PLANT BLOOMS, be sure to cut it back after most of the flowers fade. Just snip all of the flowering stems well below where the blooms began. It might look massacred at first, but it will bush out again very quickly. If you don't cut it back, the plant will become lanky and spindly.

SAGE STAYS SOMEWHAT EVERGREEN in the winter, depending on how cold it gets. The leaves wither a bit, and won't be as strongly flavored, but they are still a pleasure to harvest for the kitchen. Just remember that the plant will not grow again until spring, so don't cut it back too hard.

TO HARVEST THE FLOWERS, gently tug on the blossoms individually to release them from their calyxes. Gather them in the coolness of the morning or evening. They have the flavor of sage, but milder and with a distinct sweetness. Sprinkle them on salads or on any dish that would taste good with sage, right before you serve it.

PINEAPPLE SAGE AND OTHER FRUIT SAGES have a completely different flavor. The leaves are best saved for tea. The showy flowers make a striking edible garnish for salads or desserts.

AS I GREW AS A COOK, I figured out why my grandmother made pot roast nearly every time she had large family gatherings on Sunday afternoons. With a big dining table and a tiny kitchen, she knew a braised dish is the way to feed a crowd without last-minute stress. You make it ahead and it just gets better until you're ready to serve it.

All braised meat dishes follow the same procedure. You brown the meat, add vegetables, flavorings, and liquid, and then slowly simmer it in a covered pot. This one made with inexpensive pork shoulder is essentially as simple to prepare as Grandma's pot roast. I've added loads of fragrant thyme, ripe pear, and a touch of another unexpected ingredient, vanilla bean. Its exotic yet familiar scent gently underscores the sweetness of the pears and the succulence of the pork. Serve it with creamy polenta (see Tip).

BRAISED PORK SHOULDER
with pears and thyme

10 SERVINGS

5 pounds boneless pork shoulder blade (Boston butt), cut into 10 rectangular pieces, or 5 pounds thick pork shoulder blade chops

Kosher salt and freshly ground black pepper

¼ cup olive oil

2 medium onions, sliced

2 cloves garlic, finely chopped

2 cups white wine

2 cups chicken broth

4 pears, such as Bosc or Bartlett, ripe but not soft, peeled, cored, and cut into ½-inch dice

1 small bunch (1 ounce) thyme sprigs

4 bay laurel leaves, fresh or dry

½ vanilla bean, split in half lengthwise

3 tablespoons coarsely chopped thyme

½ cup coarsely chopped flat-leaf parsley

1 tablespoon fresh lemon juice

Sprinkle all sides of the pork generously with salt and pepper. Heat the olive oil in a large heavy pot (at least 8 quart), such as a Dutch oven, over medium-high heat. Use tongs to care-

fully lower in as much of the pork as will fit in a single layer and cook until the meat turns a deep caramel brown on the underside, about 3 minutes. Turn the pieces and brown the other side, then lift them out and put them on a platter. Brown the remaining meat in the same way.

Turn the heat under the pot to medium-low. Pour most of the fat from the pan, leaving just a thin layer. Add the onions and garlic and stir them around for several minutes until they wilt down. Pour in the wine and broth and scrape the bottom of the pan with a wooden spoon to dissolve the browned layer. Stir in the pears, and then put the pieces of pork back in the pot. Tie the thyme sprigs, bay leaves, and vanilla bean together with kitchen twine to make a large bouquet garni and tuck it in between the pieces of meat. Cover the pot tightly, turn the heat to very low, and cook at a very gentle simmer until the meat is very tender, about 2 hours.

Lift the pork from the pan to a large warm platter and cover it loosely with aluminum foil to keep it warm. Discard the bouquet garni. Add the chopped thyme to the braising sauce that remains in the pot, increase the heat, and boil the sauce until it thickens enough to coat a spoon. Stir in the parsley and lemon juice. Taste a spoonful and, if you think it needs it, add more salt or pepper. Return the pork to the pot and toss it gently in the sauce. Keep it warm until you are ready to serve, or make the whole dish days ahead, spread it out in a single layer so it cools quickly, refrigerate, then reheat it in the pot on the stovetop or in the oven before serving.

A VERY EASY WAY TO COOK POLENTA

Preheat the oven to 350°F. Stir 2 cups polenta and 2 teaspoons kosher salt into 8 cups cold water in a large shallow baking dish. Bake for 30 minutes, stir in 2 tablespoons butter, and continue to bake until thick enough to hold its shape on a spoon, 20 to 30 minutes longer.

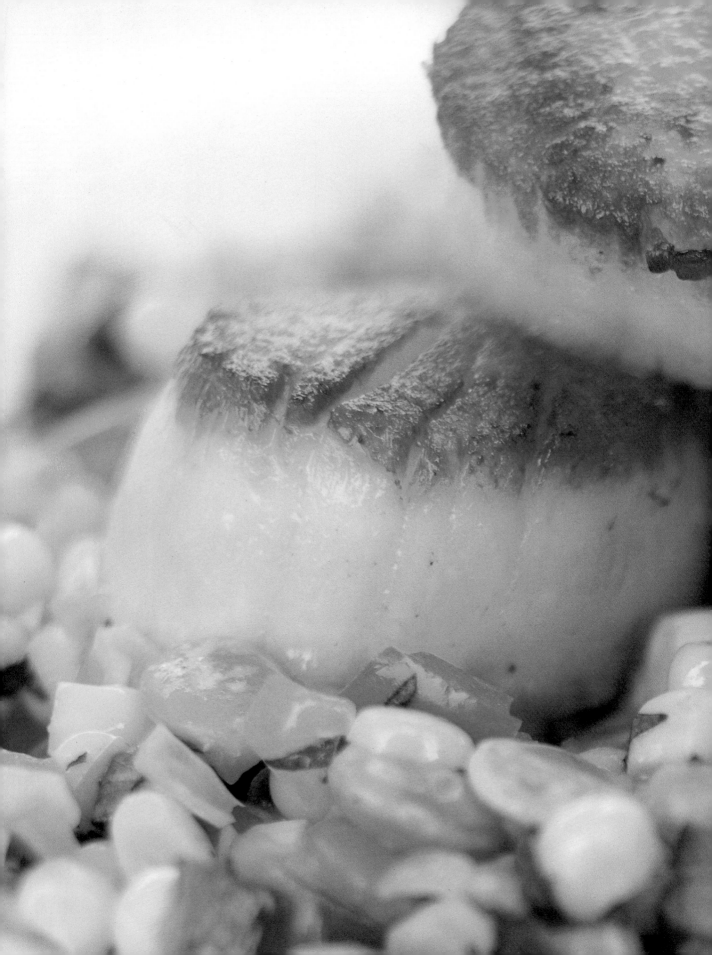

intimate
FEASTS

GOAT CHEESE HANDKERCHIEFS
WITH TART CHERRIES AND SAGE

SLOW-ROASTED SALMON WITH
SPRING HERB SAUCE

HALIBUT IN CARROT-CILANTRO
BROTH

SHRIMP IN GARLIC-SAGE
BUTTER

SEA SCALLOPS ON SUMMER
SUCCOTASH

CRAB AND LEMON THYME FLAN
WITH SHAVED MUSHROOMS

TARRAGON OYSTER STEW

LAVENDER-RUBBED DUCK
BREAST WITH APRICOTS AND
SWEET ONIONS

BEEF TENDERLOIN POACHED IN
AN OLIVE OIL AND THYME BATH

LAMB CHOPS WITH PARSLEY,
MINT, AND OLIVE SAUTÉ

EACH YEAR I COUNT THE DAYS TO CHERRY SEASON because I can't wait to put this dish on the menu at The Herbfarm. We serve it as one of our nine courses, paired with one of the excellent Rieslings from our state. Sublime but simple, it's nothing more than cheese-filled pasta squares with a quick sauce, and it can begin a multicourse dinner or romantic supper or be the main dish for a special luncheon or brunch.

This recipe has two ingredients that you might have to search for, fresh tart cherries and fresh pasta sheets. Tart cherries (aka sour or pie cherries) are a very different fruit from sweet cherries, such as Bings. Raw, they have a pucker-your-mouth sour flavor, but when cooked and sweetened they have the bright intense cherry pie flavor that sweet cherries can never express. Unfortunately, most commercially grown tart cherries are processed as soon as they are picked and rarely make it to supermarkets, so your best chance for finding them is to go to a farmer's market in June, or make friends with a neighbor who has a tree full of them. They're easy to pit using the closed end of a bobby pin. You can make this dish with sweet cherries, but the flavor will be quite different. As for the pasta, good-quality fresh sheets used for lasagna or ravioli are sometimes available in supermarkets or specialty food shops, and you can simply cut them into 4-inch squares. Or better yet, make your own pasta dough and roll it very thin with a pasta machine.

GOAT CHEESE handkerchiefs with tart cherries and SAGE

4 SERVINGS

2 ounces soft mild goat cheese (½ cup)

½ cup whole milk ricotta

½ cup hot water

3½ tablespoons unsalted butter, softened

¼ cup very small sage leaves, or larger sage leaves cut into ¼-inch strips

12 ounces tart (sour or pie) cherries, pitted

1½ tablespoons mild honey

¼ teaspoon kosher salt

Eight 4-inch squares of fresh pasta

Heat your oven to 150°F or its lowest temperature, then turn it off. Crumble the goat cheese into a small bowl, stir in the ricotta, and put it in the oven to warm. Put the hot water and ½

tablespoon of the butter in a glass pie plate or shallow baking dish and place it in the oven also (this is for holding the pasta once it's cooked). Bring a large pot of salted water to a boil.

Melt 1 tablespoon of the butter with the sage leaves in a medium skillet over medium heat and stir until the sage leaves wilt, then turn a darker green color, about 2 minutes. Add the cherries, honey, and salt, and toss them over the heat until the cherry skins pop and they release a small amount of juice, about 3 minutes. Add the remaining 2 tablespoons butter to the pan and stir, still over the heat, until it melts and incorporates into the sauce. Remove the pan from the heat.

Boil the pasta squares until they are tender but firm, usually 2 to 3 minutes. Lift them out of the water with a skimmer and slip them into the warm water and butter in the pie plate.

Now you can assemble the dish. Lift 4 of the pasta squares from the dish and lay them out on a piece of parchment paper or on a baking sheet (this is easy to do with your hands if you wear disposable latex gloves). Spread a tablespoon of the warm goat cheese in the center of each square and fold them in half on the diagonal. Transfer the triangles in pairs to warm dinner plates. Fill the second batch of pasta squares the same way. Spoon the cherries and sauce over the handkerchiefs and serve right away.

I'VE BECOME A DEVOTEE OF THIS METHOD OF BAKING SALMON in a very slow oven. It comes out glistening, deeply colored, and slightly translucent, as if the fillets were still rare, though they will be cooked throughout and yield to your fork with moist flakes of a rich buttery texture and fresh delicate flavor. To achieve this fish perfection, you should avoid farmed salmon and seek out beautifully fresh wild king or sockeye salmon.

The sauce is similar to a beurre blanc (a classic butter and white wine sauce), but it's much lighter in body than the traditional version. At the last minute you stir in big handfuls of coarsely chopped soft-leafed herbs, which give body to the sauce and load it with a lush bouquet of flavor. I call it a spring herb sauce, but you can make it in any season as long as you choose herbs with tender leaves.

SLOW-ROASTED SALMON
with spring herb sauce

4 SERVINGS

1½ pounds fresh wild king or sockeye salmon fillet

¼ cup extra virgin olive oil

Kosher salt

1 cup dry white wine

3 tablespoons finely chopped shallots

1 tablespoon fresh lemon juice

6 tablespoons unsalted butter, at room temperature

½ cup mixed coarsely chopped soft-leafed herbs, such as basil, chervil, chives, dill, fennel, lovage, mint, sorrel, or tarragon, plus additional small tender herb sprigs for garnish

Coarse sea salt for finishing

Pull out any small bones that were left in the salmon and, if you wish, trim off the gray fat that was next to the skin. Holding your knife at a 30-degree angle to the cutting board, cut the salmon into 4 wide slices that are about ¾-inch thick. Lay them in a shallow baking dish and pour in the olive oil, rubbing it around the fillets to coat all the sides. Let the fish sit in the oil as it comes to room temperature, 30 to 60 minutes.

Preheat the oven to 225°F, or 200°F if you have the option of convection bake. Lift the fillets from the oil and evenly space them on a baking sheet lined with parchment paper. Sprinkle

the fish lightly with salt. Bake for 15 to 20 minutes. When it's done, the fat between the layers of fish will just begin to turn opaque, a small amount of liquid will collect under the fillets, and the fish will flake slightly when nudged with your finger. Pick up a piece and it should easily break apart between the layers rather than holding firmly together. It might appear to be underdone because the color will be vivid, but it will be fully cooked.

While the fish is roasting, make the sauce. Boil the wine, shallots, lemon juice, and ¼ teaspoon salt together in a small saucepan until you have half as much as you started with. Turn the heat to medium-low and whisk in the butter, one-third of it at a time, until it is all incorporated. If you have an immersion blender, use it to blend the sauce for about 10 seconds, which gives it a creamier consistency. If the fish is not quite ready, keep the sauce warm by putting the saucepan in a larger pan of hot water.

When the salmon is done, transfer the fillets to individual warmed plates (since the sauce will run, choose plates with deep rims that will contain it, or use shallow bowls). Stir the coarsely chopped herbs into the sauce, taste it and add more salt if you think it needs it, then ladle it around the fish. Sprinkle each fillet with a pinch of coarse sea salt. Toss the reserved herb sprigs onto the plates in a casual way and serve.

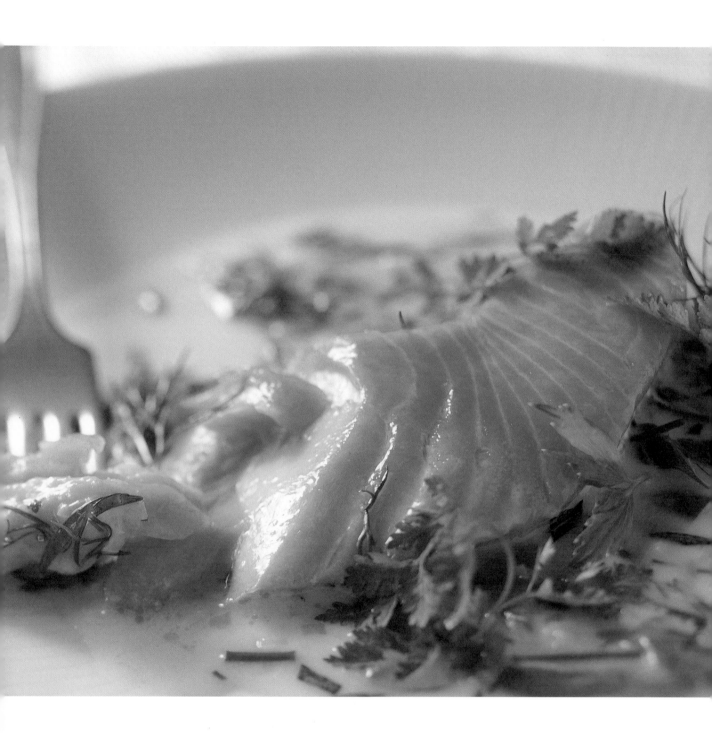

IN MY RESTAURANT KITCHEN I make sauces by boiling down a combination of carrot juice, citrus juice, wine, and shallots until it becomes syrupy. At home I briefly simmer the same ingredients together and poach fish in them. This carrot poaching liquid, spiked with fresh herbs, becomes a fragrant sweet-sour broth to serve the fish in. It's a quick and healthful dinner with bright flavor and lots of eye appeal. Any fish that poaches well—such as salmon, skate, or sea bass, can be substituted for the halibut.

HALIBUT in carrot-cilantro broth

4 SERVINGS

1½ pounds skinless halibut fillet

2 cups fresh carrot juice

½ cup dry vermouth or white wine

2 tablespoons fresh lime juice

2 tablespoons finely chopped shallots

1 tablespoon grated fresh ginger

Kosher salt

3 tablespoons unsalted butter

8 ounces baby spinach leaves, washed and spun dry

¾ cup coarsely chopped cilantro

Check the fish for any stray bones and slice it into 4 pieces of equal size and thickness. Combine the carrot juice with the vermouth or wine, lime juice, shallots, ginger, and ¾ teaspoon salt in a saucepan that's wide enough to hold the fish in a single layer. Bring the ingredients to a boil, then simmer over medium-low heat for 5 minutes, whisking often. Place the fish in the carrot broth (it should be covered by the liquid) and cook very gently, adjusting the heat so that the broth never simmers, until the fish flakes apart when you bend it and is just at the point when it loses its last bit of translucence in the center, 7 to 10 minutes.

While the fish is cooking, melt 1 tablespoon of the butter in a large skillet over medium heat. Add as much spinach as will fit, sprinkle with salt, and toss with tongs until it wilts. Add the rest of the spinach and cook until it is all wilted.

Put mounds of the spinach in the center of 4 warm shallow bowls and position a piece of the poached fish on top of each. Over medium heat, add the remaining 2 tablespoons butter to the broth, whisking vigorously until it is incorporated (or with an immersion blender if you own one). Stir in the cilantro and ladle the broth into the bowls. Serve right away.

I'VE PREPARED SHRIMP A HUNDRED WAYS, but I never enjoy them as much as when they're cooked unpeeled in a skillet with lots of butter and garlic. The only way I've found to improve on that is to add a handful of fresh sage leaves. Grab a stack of paper napkins, a loaf of crusty bread, a crisp white wine, and dig in.

SHRIMP in garlic-sage butter

2 SERVINGS

1 pound very large shrimp (10 to 16)

8 tablespoons (4 ounces) unsalted butter, cut into cubes

4 cloves garlic, finely chopped

Leaves from a 1-ounce bunch sage (16 to 20)

Coarse sea salt

Holding a shrimp with the legs pointing down, stick the tip of the bottom blade of a pair of scissors into the head end. Cut along the backside, slicing about a quarter of the way down into the flesh. Repeat with the rest of the shrimp. Rinse them under running water, removing the dark vein that runs along the backs. Pat them dry on paper towels.

Put the butter, garlic, and sage leaves in a large skillet over medium heat and stir from time to time. When the garlic begins to show the first signs of browning and the sage leaves are speckled with darker green spots, add the shrimp. Stir them around, lower the heat to medium-low, and cook uncovered for 5 to 8 minutes, turning them once, or until the shells are pink, the shrimp curl a bit, and the flesh no longer looks translucent. Spoon the shrimp into warm shallow bowls and pour any remaining butter and sage leaves over the top. Sprinkle with salt or offer it in small dishes at the table. Peel the shrimp as you eat them and soak up the butter with crusty bread.

SUCCOTASH IS A SOUTHERN SIDE DISH, sea scallops come from northern waters, and the cilantro and basil are an eastern influence, but it all comes together in a colorful, healthy, one-dish dinner that's a summer favorite. When purchasing scallops, ask if they're dry-pack, which means they're not treated with chemicals that make them absorb water.

SEA SCALLOPS on summer succotash

4 SERVINGS

1½ pounds large sea scallops (dry-pack)

Kosher salt

2 tablespoons olive oil

½ large onion, diced

½ red bell pepper, seeded and diced

Kernels from 2 ears sweet corn

¾ cup beans, such as shelled limas or edamame (frozen are fine, but blanched fresh if you can get them), or blanched green beans cut into ½-inch pieces

2 tablespoons dry white wine or vermouth

½ cup water

½ cucumber, seeded and diced (unpeeled if not waxed)

2 tablespoons unsalted butter

¼ cup coarsely chopped cilantro

¼ cup coarsely chopped basil

Freshly ground black pepper

Pull off the small white piece of muscle that is attached to the side of the scallops (some might not have it). Pat them dry on paper towels and season them lightly with salt. Heat the olive oil in a large heavy-bottomed skillet over high heat. When the pan is very hot, use tongs to lower in each scallop, flat side down. Cook, without shaking or moving the scallops, until the undersides are a deep brown color. Flip them and brown the other side (if they stick, loosen them with the edge of a sharp metal spatula). Put the scallops on a warm platter or plate and cover loosely with foil while you prepare the succotash in the same skillet.

Lower the heat to medium, add the onion and bell pepper to the pan, and stir them around until they soften, 2 to 3 minutes. Stir in the corn, beans, wine or vermouth, water, and 1 teaspoon salt. Cook, stirring from time to time, until about half of the liquid boils away and the vegetables are nearly cooked through. Add the cucumber and cook another minute to heat it through. Stir in the butter until it melts, then the cilantro and basil. Tip any juices that collected under the scallops into the succotash. Taste the succotash and add pepper and more salt if you think it's needed.

Spoon the succotash onto warmed dinner plates. Arrange the scallops over the top and serve right away.

THIS DELICATE PAIRING of crab, soft custard, and thinly sliced mushrooms gilded with lemon thyme is quite luxurious, yet truly quick and easy to prepare. Serve it as a light main course following a salad or as a starter at a special dinner party (bake it in smaller ramekins).

When I serve this dish at The Herbfarm, I prepare it with *Boletus edulis* (the same species as porcini or cèpe) from the Cascade Mountains, or local matsutake (pine mushroom). This recipe is just as good with ordinary button mushrooms, but if you're lucky enough to get ahold of fresh firm specimens of wild mushrooms, here's the dish to celebrate them.

CRAB and lemon thyme flan with shaved mushrooms

4 SERVINGS

⅔ cup milk

⅓ cup heavy cream

Small bunch freshly harvested lemon thyme (about six 3-inch sprigs)

1 large egg

1 large egg yolk

4 tablespoons unsalted butter, melted

Kosher salt

8 ounces fresh crabmeat, picked over for shells and cartilage

6 ounces large button or cremini mushrooms, cleaned (or fresh *Boletus edulis* or matsutake)

1 teaspoon lemon thyme leaves

Chervil sprigs or small flat-leaf parsley leaves for garnish

Preheat the oven to 325°F.

Heat the milk and cream in a small saucepan. When it comes to a boil, stir in the lemon thyme, cover, and remove it from the heat. Let the herbs steep for about 10 minutes, and then pour the milk through a fine sieve. Whisk the egg and egg yolk with the salt in a small mixing bowl. Whisk in the infused milk.

Brush the insides of four 6-ounce ramekins with a light coat of the melted butter and set them in a shallow baking dish.

Pick out 4 pieces of claw from the crabmeat and set aside as a garnish. Squeeze the remaining crabmeat gently to rid it of excess liquid, and then evenly divide it among the ramekins. Pour the custard over the crab. Put the baking dish in the center of the oven, pour hot water into it to come halfway up the sides of the ramekins, and bake the flans until they are set when you press lightly in the center, 25 to 35 minutes, depending on how warm the custard was when it first went in the oven.

While the flans are baking, shave the mushrooms very thinly; the easiest way to do this is on a Japanese mandoline (one of my favorite kitchen tools). If you don't have one, slice them as thinly as you can with a thin-bladed sharp knife. Spread them out on a baking sheet, in as close to a single layer as you can, and brush them with the remaining butter. Sprinkle with ½ teaspoon salt and the lemon thyme leaves. Place the reserved crab claws on a corner of the baking sheet to warm with the mushrooms. When the flans come out of the oven, put the mushrooms in. Bake just until they are hot and they sweat and shrink slightly, 3 to 4 minutes.

Run a paring knife around the sides of each flan, hugging the blade to the ramekin, to loosen them. Tip the ramekins upside down onto the middle of 4 warm plates. If the flan doesn't fall out, nudge it gently on an edge to create an air pocket that should release it. Decorate the tops of the flans with 12 of the nicest-looking mushroom slices and arrange the remaining mushrooms around them. Top with the warm crab claws and tuck the chervil sprigs or parsley leaves here and there around the plates. Serve right away.

FOR A FIRST-COURSE SIZE: Divide the crab and custard among six 4- to 6-ounce ramekins, and set aside 6 claws. Check the flans for doneness 5 minutes sooner.

herbal improvisations
In place of the lemon thyme, infuse the milk and cream with a small bunch of tarragon or dill. Sprinkle the mushroom slices with 2 teaspoons tarragon or dill before heating them.

TOUGH THYMES

Shrubby sturdy thymes are the must-have backbone of any herb garden. Unless you're more specific, thyme means English thyme (sometimes called garden thyme or common thyme), whose familiar flavor doesn't vary much from plant to plant. There are other thymes with the same flavor, particularly silver thyme and French thyme, but if you choose just one for your herb garden, I'd suggest the English.

Several other thyme species are worth growing as well. Lemon thyme has a citrus flavor that's quite distinct from other lemon herbs, and is delicious with spring vegetables and with seafood. Orange balsam thyme is a vigorous variety with a powerful orange peel scent that fits with fall and winter fruit desserts. Another good one is caraway thyme, a creeping plant that smells and tastes exactly like fragrant caraway seeds and is excellent with mushrooms, cabbage, or lamb.

THYMES ARE QUITE UNDEMANDING OF ATTENTION, but they do appreciate pruning. If nothing else, it's important to cut the whole plant back to about two-thirds of its height when the flowers start to fade. For a really lush plant, it's best to prune it back several times a year. Begin in early spring when it is starting to wake up and put on new growth. Shear the whole plant back by one-third to one-half. Cut it back again after it flowers, then finally give it another cropping toward the end of summer, early enough that it has time to put on new growth before frost hits.

EVEN THOUGH ENGLISH THYME IS A RUGGED COLD-HARDY PERENNIAL, it tends to die back or loose vigor after a few years. Yank it up and plant a new one. Lemon thyme is more delicate and it's best to begin each season with new plants.

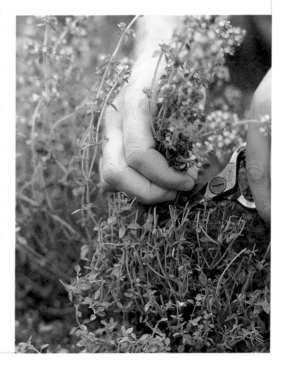

THYME KEEPS MOST OF ITS LEAVES IN THE WINTER, though it won't grow new ones. You can harvest from it in cold months if you are careful not to cut it back too severely.

IT TAKES A LITTLE PATIENCE TO PICK THYME LEAVES OFF THE STEMS. It's quickest to hold the stem at the bottom and strip the leaves off with your thumb and forefinger, which is easiest if the stems are stiff. If the stem breaks, the portion above the break is often soft enough to chop with the leaves.

THYME IS USUALLY ADDED EARLY IN THE COOKING PROCESS, but for a more forward flavor it can go in near the end as well.

UNLESS YOU WANT TO GO TO THE TROUBLE of shucking live oysters, very good-quality preshucked oysters sold in jars or plastic tubs will work just fine in this recipe. We picked some up at a little store while driving to the cold, damp, windy, crowded, and utterly miserable campsite where I first made this stew on a butane stove. On the bright side, the dinner was delicious.

tarragon OYSTER STEW

2 SERVINGS AS A MAIN COURSE;
4 SERVINGS IN A MULTICOURSE MEAL

2 tablespoons unsalted butter

1 cup very thinly sliced leeks, white parts only (½ large or 1 small)

1 tablespoon very finely chopped fresh ginger

¼ cup dry white wine

½ cup heavy cream or half-and-half

10 ounces freshly shucked extra-small oysters in their liquor

1½ tablespoons coarsely chopped fresh tarragon

1 tablespoon fresh lemon juice

¾ teaspoon kosher salt

Melt the butter in a small saucepan over medium-low heat. Add the leeks (it's important to slice them very fine) and stir frequently until very wilted and soft, about 3 minutes. Add the ginger and wine and cook at a low boil for another minute.

Stir in the cream. When it comes to a simmer, add the oysters and their liquor and the tarragon. Poach them gently, without letting the stew simmer again, until the oysters become slightly firm and the thin flaps at their edges become wavy, 2 to 3 minutes. Stir in the lemon juice and salt, and then taste it to see if it needs more. Serve right away in heated bowls with crusty bread or biscuits.

herbal improvisation In place of the tarragon, stir in ¼ cup coarsely chopped chervil.

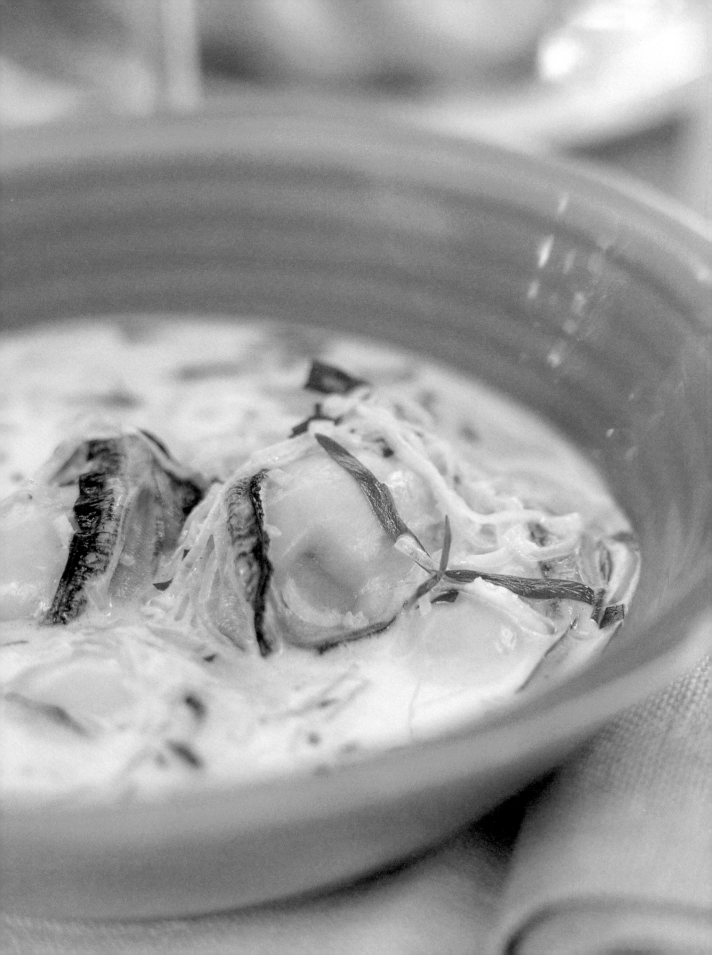

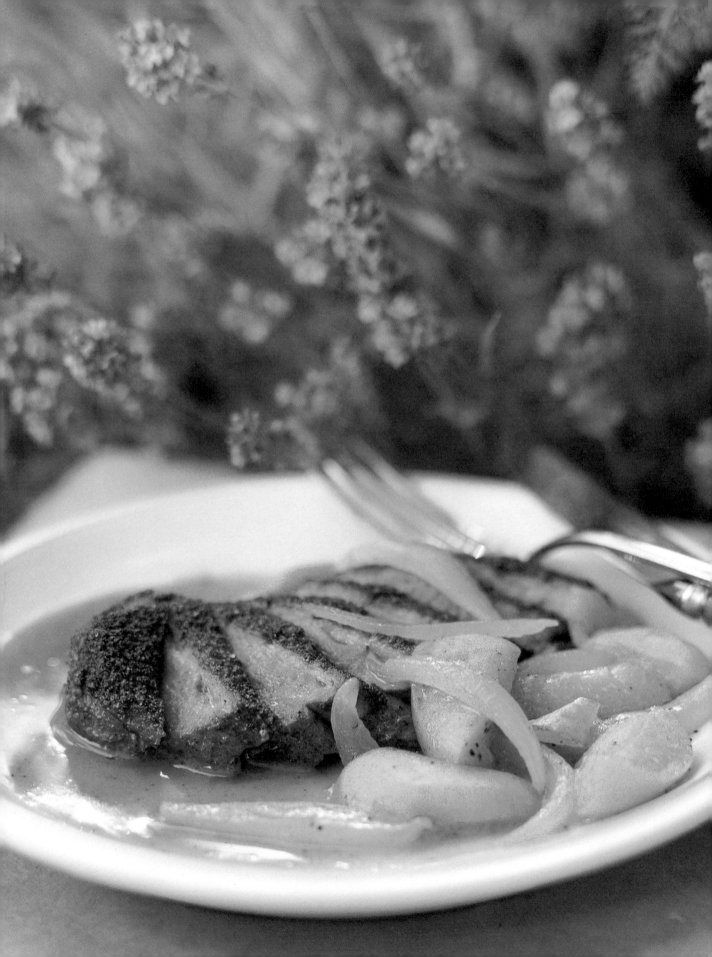

A DUCK BREAST DOESN'T TAKE MUCH LONGER TO COOK than a chicken breast, yet its rich dark meat and flavorful crisp skin are an indulgent treat. Look for muscovy duck in your market; it has a larger proportion of breast meat and less fat in the skin than the more common Pekin.

Fresh apricots are in season when lavender blooms in late spring, but any other time of year dried lavender buds and dried apricots will give you delicious results.

LAVENDER-RUBBED DUCK
breast with apricots and sweet onions

4 SERVINGS

4 large boneless duck breasts, preferably muscovy, skin on, about 2 pounds

RUB

2 tablespoons lavender buds, fresh or dried

1 tablespoon dried coriander seeds

1 teaspoon dried fennel seeds

½ teaspoon black peppercorns

Grated zest of ½ lemon

1½ teaspoons kosher salt

1 tablespoon olive oil

½ large sweet onion, thickly sliced

8 fresh apricots (12 ounces), pitted and quartered, or 1 cup (4 ounces) sliced dried apricots

½ cup dry white wine or vermouth

½ cup chicken broth

1 to 2 teaspoons sherry vinegar if needed

Freshly ground black pepper

Trim any excess skin from the sides of the duck breasts. Score the skin with the tip of a sharp knife in a diagonal grid pattern, about 1 inch wide, being careful to cut just deep enough to slice the skin but not pierce the flesh.

Put all the rub ingredients into a spice grinder (rotary coffee mill) and spin until very finely ground. Rub both sides of the duck breasts with the spices, spreading it on as evenly as you can and working some into the score marks on the skin side. If you are not ready to cook the duck, wrap it and store it in the refrigerator for up to a day, which will actually improve the flavor.

Swirl the olive oil in a large skillet placed over medium-low heat. Place the duck breasts skin side down in the pan and cook them gently, shaking the pan occasionally and adjusting the heat as necessary. Most of the cooking takes place on the skin side; you want go about it slowly enough that the skin has a chance to render out as much fat as possible before it, and the spices, get too dark. In about 15 minutes a considerable amount of fat should fill the skillet, some red juices should collect on the surface of the duck, and the duck skin should be a deep bronze color. If it's not, turn up the heat to medium and cook further. When the skin is well browned, turn the breasts and cook the other side for 3 to 5 minutes, or until they feel springy and an instant-read thermometer inserted horizontally into the center registers 135°F to 140°F (for medium). Lift them out onto a warm plate and allow them to rest while you prepare the sauce in the same skillet.

Pour out all but 2 tablespoons of the duck fat. Stir in the onion over medium heat until it softens and picks up a rich brown color from the pan, 3 to 4 minutes. Add the apricots, wine, and broth and simmer the sauce until it reduces to about half its original volume and thickens lightly, about 5 minutes. Taste it and add the vinegar (depending on the tartness of the apricots), pepper, and salt if you think it needs it.

Put the duck breasts skin side down on a cutting board and slice them into ½-inch-thick pieces (it's easier to make neat slices if the skin is on the bottom). Flip them skin side up and fan the slices on warmed plates. Spoon the sauce over the top and serve right away.

A LIGHT hand with lavender

Lavender is wildly popular these days and no wonder; it's a beautiful drought-tolerant perennial with heavenly scented flower spikes that you can cook with. There are several species that are widely available and it's wise to know one from another.

English lavenders are low-growing hardy herbs that bloom in early summer and have the sweetest scents. If you grow one type of lavender, this is the one to choose. Sometimes you'll see the generic, unnamed variety in garden centers, but there are dozens of cultivars varying in color, size, and subtleties of flavor. The most popular are Hidcote and Munstead. If you're unsure if it's English, look on the label for the Latin name, *Lavendula angustifolia*.

Another group of culinary lavenders are technically called lavendins, and are a cross between English lavender and a species known as spike lavender. These are taller, thicker-stemmed lavenders that are grown commercially in southern France. They're loaded with essential oils and, though sweet smelling, have a more potent camphoric perfume. They bloom a little later than the English, so if you grow both types in your garden, you'll prolong the blooming season. Two common lavendin cultivars are Grosso and Provence.

Other lavender species are pretty in the garden, but not as suitable for cooking. These include the French lavender, *Lavendula dentata*, which has toothed leaves, and Spanish lavender, *Lavendula stoechas*, which has the long purple petals that erupt from the top of the flower head like bunny ears.

ALTHOUGH ALL PARTS OF THE PLANT have a pleasant fragrance, it's the individual flower buds that you are after for cooking. The ideal time to harvest them is right before they open, but they are useful at any stage when they show color.

ALWAYS USE A LIGHT HAND when cooking with lavender. Its flavor is most successful when it lags in the background, hinting that there's an interesting flavor enhancing your food, but not so bold that you immediately recognize it.

BEYOND ITS USE IN DESSERTS, small amounts of lavender add intrigue to savory dishes, especially those with lamb, chicken, or potatoes.

IF YOU DON'T GROW LAVENDER, or it's not in bloom in your garden, the dried flower buds make an excellent substitution for the fresh. They are often sold in bulk herb sections. Be sure you buy food-grade lavender, not the product that's sprayed with additional scent for use in potpourri.

AS SOON AS THE FLOWERS FADE on your lavender, trim the plants, cutting the stems down to the top of the foliage. With food and a little water, they will usually offer another smaller flush of bloom in the fall.

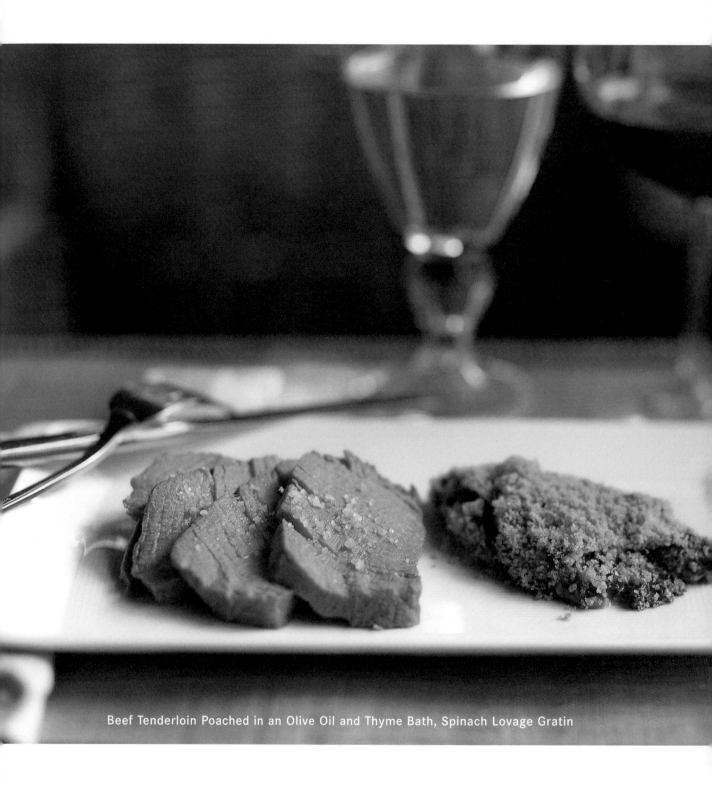

Beef Tenderloin Poached in an Olive Oil and Thyme Bath, Spinach Lovage Gratin

IT'S FAIR TO ASK why you'd want to coddle your expensive beef tenderloin in a half quart of olive oil if it's going to emerge gray. Slice into it and you'll understand. It will be extraordinarily tender and a perfect even rosy color throughout the interior, and have a captivating flavor that's both gentle and yet deeply aromatic; it is entirely different from a steak that is seared or grilled.

Ask your butcher for steaks cut from the center of the tenderloin fillet, and use your everyday olive oil, not the precious bottle you carried back from Italy.

BEEF TENDERLOIN poached in an olive oil and thyme bath

4 SERVINGS

Three 7- to 8-ounce beef tenderloin steaks

1 large bunch fresh thyme

3 cloves garlic, smashed

2 to 3 cups extra virgin olive oil

Coarse sea salt (such as *fleur de sel*)

Preheat the oven to 225°F. Choose a small baking dish or ovenproof saucepan that's just large enough to fit the steaks without their touching one another or the sides of the dish. Arrange the steaks in it, tucking the thyme sprigs and garlic cloves in between. Pour in enough olive oil to cover the tops.

Put the dish in the oven, and after 20 minutes turn the steaks over in the oil. Bake another 10 minutes and then probe one of the steaks with an instant-read thermometer. It needs to come to 135°F for medium-rare, which is higher than if you were searing it, but with this technique the meat won't continue to cook once you take it out. Once the oil gets hot the steaks will cook quickly, so if the meat is not up to temperature, continue to check it every few minutes. Figure on 30 to 40 minutes total.

When the meat is at 135°F, lift it out of the oil onto a cutting board. Cut it into ¼-inch-thick slices and arrange them on warm serving plates. Sprinkle the cut surfaces of the meat with salt. Serve right away.

I'M FOND OF COOKING PARSLEY as if it were a green vegetable. Laced with lemon balm or lovage, it makes a green bed for delicate fish like halibut or skate, cooked with bacon it suits meaty tuna or swordfish steaks, spiked with capers it perks up a veal chop, and with black olives and mint, as in this recipe, it's just the right accompaniment to lamb chops.

Lamb rib chops are a bit of a splurge, as they are cut from the precious lamb rack, but they are well worth the price over loin chops, which aren't nearly as tender or succulent.

LAMB CHOPS with parsley, mint, and olive sauté

4 SERVINGS

2 cloves finely chopped garlic

2 tablespoons fresh lemon juice

¼ cup finely chopped spearmint

1½ teaspoons kosher salt

¼ teaspoon freshly ground black pepper

8 lamb rib chops, 2 to 2½ pounds

2 tablespoons olive oil

3 cups flat-leaf parsley sprigs (about 2 bunches)

¾ cup coarsely chopped spearmint

½ cup chopped, pitted, brine-cured black olives (such as Kalamata or Niçoise)

Stir together the garlic, lemon juice, the spearmint, salt, and pepper in a mixing bowl. Toss in the chops and use your hands to coat all surfaces with the marinade. Let the chops sit at room temperature for about an hour (less time is okay if you are in a hurry).

Preheat the oven to 400°F. Heat the olive oil in a large ovenproof skillet over medium-high heat. When the pan is very hot, carefully lower in the chops and brown all 4 sides. Put the skillet in the oven and cook the chops until they are medium-rare to medium, 5 to 10 minutes, depending on the size. If you are experienced at cooking meat, you'll be able to feel when they are done by pressing and checking their firmness. If you're not, an instant-read thermometer inserted into the center of the eye should register 125°F for medium-rare, 130°F for medium. Lift the chops onto a warm serving platter and tip the excess oil out of the pan. Pour

½ cup water into the skillet and scrape and stir to loosen all the browned bits. Add the parsley and a light sprinkle of salt, toss over medium heat until it wilts down, and then cook another 2 minutes. Stir in the coarsely chopped mint and olives. If any juice collects on the platter under the chops, add it into the skillet. Mound the parsley on top of the chops, between the bones. Serve right away.

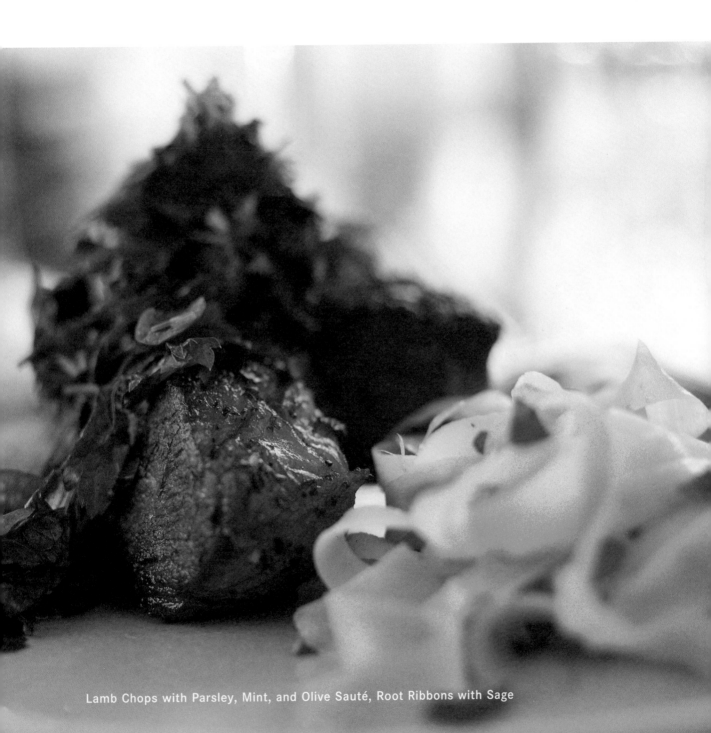

Lamb Chops with Parsley, Mint, and Olive Sauté, Root Ribbons with Sage

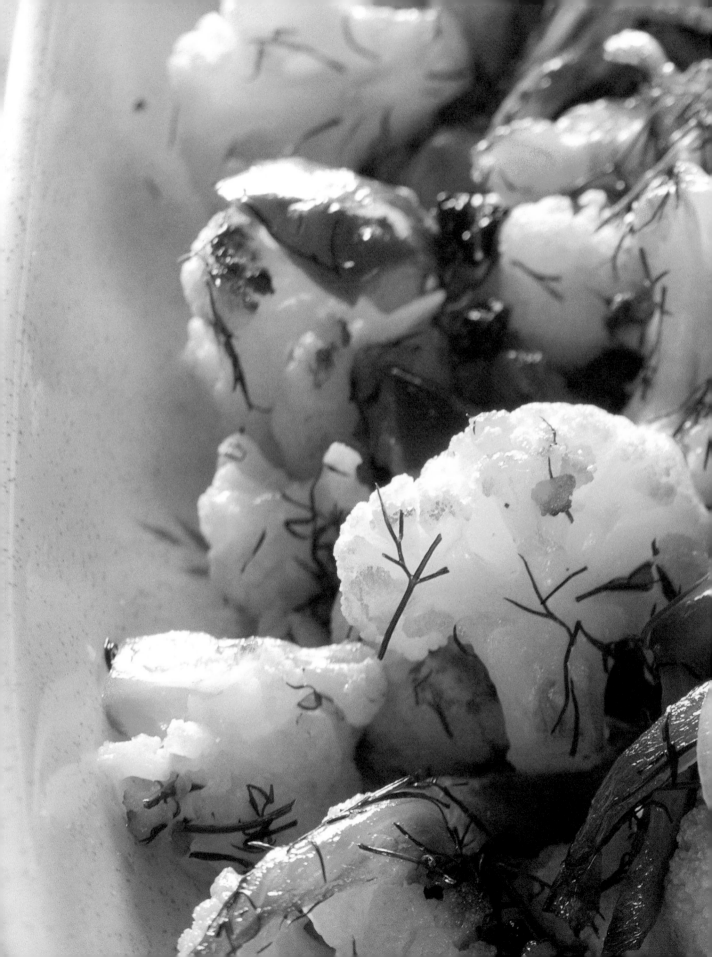

GARDEN BUDDIES: vegetables with herbs

ASPARAGUS WITH HOLLANDAISE IS SO GOOD, but it's so rich, prompting me to invent this tangy spin-off that requires far less butter. It's just as tempting, but more of a dish for everyday, and you'll find it much less tricky to make. While I was messing with a classic I naturally added a fresh herb.

ASPARAGUS in frothy tarragon sauce

6 SERVINGS

2 pounds fresh asparagus, preferably fat stalks

4 large egg yolks

¼ cup fresh lemon juice

½ cup water

¾ teaspoon kosher salt

Freshly ground black pepper

2 tablespoons unsalted butter

2 tablespoons chopped tarragon

Bring a large pot of salted water to a boil and choose a stainless steel mixing bowl that will sit on top of the pot without touching the water.

Cut off the bottom of the asparagus spears where they turn light colored and tough. If the asparagus is thick (which is how I prefer it), peel the bottom two-thirds of each spear with a sharp vegetable peeler. Whisk the egg yolks in the mixing bowl with the lemon juice, water, salt, and a few grindings of black pepper and set it aside.

Boil the asparagus until it's tender but still has some snap, 4 to 6 minutes. Test it by holding a spear by the bottom with tongs held horizontally; it should be limp and bend like a bow toward the floor. When cooked, use the tongs to remove the asparagus from the water and arrange it on a warm platter.

Put the bowl of sauce ingredients on top of the rapidly boiling water and whisk vigorously until it is very thick and foamy. This will only take 2 to 3 minutes and you will easily be able to sense the point when the sauce becomes custardy and fully cooked. Whisk in the butter and, when it's incorporated, add the tarragon.

Pour the sauce over the asparagus, or pass it separately in a serving bowl, and serve right away.

herbal improvisations
In place of the tarragon, add 2 tablespoons dill, ¼ cup chervil, or 1 tablespoon lemon thyme.

IF YOU HAVE A FEW ZUCCHINI PLANTS and basil in your garden, you'll make this all summer. It's easy, you can prepare it ahead, it goes with all kinds of other foods, and it brings out the best in this prolific vegetable.

ZUCCHINI BASIL gratin

6 SERVINGS

2 pounds zucchini (about 3 medium)

2 teaspoons kosher salt

3 tablespoons olive oil

½ cup chopped basil

¼ cup plus 1 tablespoon dry bread crumbs

¼ cup freshly grated Parmigiano-Reggiano

Shred the zucchini on a box grater or with the shredding disk of a food processor. Put it in a large colander, mix in the salt using your hands, and let the zucchini sit and drain for at least 30 minutes.

Preheat the oven to 400°F. Spread ½ tablespoon of the oil over the inside of a 10-inch-round gratin dish or glass pie plate. Sprinkle with 1 tablespoon of the bread crumbs and shake to coat the bottom and sides evenly.

Squeeze the zucchini dry by picking up baseball-sized handfuls and firmly pressing out the moisture. Put it in a mixing bowl and incorporate 1½ tablespoons of the olive oil and the basil (it's easiest to use your hands again for this). Loosely pat the zucchini into the gratin dish.

In the same mixing bowl, stir together the remaining ¼ cup bread crumbs, the cheese, and the remaining tablespoon of oil. Sprinkle the crumbs over the gratin (you can cover and refrigerate it at this point) and bake it for 30 to 35 minutes, or until the crumbs are deeply browned.

SPINACH AND LOVAGE ARE AS PERFECT A PAIR as basil and tomato. Enriched with a simple white sauce, they star in this gratin that's a fitting complement to any sort of simply cooked meat or fish.

SPINACH LOVAGE gratin

6 SERVINGS

3 tablespoons unsalted butter

1 large shallot, finely chopped

12 ounces baby spinach, or 12 ounces coarsely chopped stemmed spinach (about 2 bunches), washed and spun dry

Kosher salt

2 tablespoons all-purpose flour

1 cup milk, whole or low fat

3 tablespoons chopped lovage (young leaves)

Freshly ground black pepper

1½ tablespoons melted butter

¼ cup plus 2 tablespoons dry bread crumbs

¼ cup freshly grated Parmigiano-Reggiano

Preheat the oven to 375°F.

Melt 1 tablespoon of the butter in a large saucepan over medium heat. Add the shallot and stir it around for a minute, then add as much spinach as will comfortably fit in the pan and ¾ teaspoon salt. Toss the spinach with tongs until it wilts down, and then keep adding more spinach until it is all wilted. Tip the spinach into a bowl and return the pan to the heat.

Melt the remaining 2 tablespoons butter in the same saucepan and whisk in the flour. When the roux bubbles, pour in the milk all at once and whisk until the sauce boils and thickens. Stir in the spinach, lovage, another ¾ teaspoon salt, and a good grinding of black pepper.

Use ½ tablespoon of the melted butter to coat the inside of a baking dish about 6 × 10 inches. Sprinkle it with 2 tablespoons of the bread crumbs and shake the pan to distribute them evenly. Pour in the sauced spinach. Mix the remaining ¼ cup bread crumbs with the cheese and the remaining tablespoon of melted butter and sprinkle it over the top. The gratin can wait at this point. When ready, bake it for 25 to 30 minutes or until bubbly and browned.

herbal improvisations
In place of the lovage, add ¼ cup coarsely chopped dill or spearmint, or 1 cup coarsely chopped stemmed sorrel.

umbel JUMBLE

The mint family, or Labiatae, claims the largest number of culinary herbs, but second is the parsley family, or Umbelliferae. All Umbelliferas share several characteristics: They have umbrella-shaped flower heads, their hollow stems radiate from the center of the plant at ground level, and they have long taproots.

Perennial Umbels

Fennel and lovage are there for the long haul. Plant them once, and if they're happy with where they are, they'll stay there for many years, dying back each fall and coming up in a larger clump each spring.

FENNEL

The herb fennel is related to the vegetable fennel, but instead of forming bulbs at the ground level it grows into tall clumps of feathery stalks that bloom in midsummer. Fennel grows wild all over the West Coast, and there are two types grown in gardens: green and bronze; the bronze have reddish brown leaves and smaller flowers. All parts of the plant have flavor.

AS THE SWEET FEATHERY LEAVES EMERGE in spring you can tear them into salads or chop and stir them into sauces or soups.

WHEN THE PLANTS BLOOM, they produce umbels of tiny yellow flowers. Snip or pull them off the flower head and sprinkle the yellow dust over all kinds of foods, from summer vegetables and pastas to seafood and grilled meats. To make your own fennel pollen, harvest the yellow umbels and allow them to dry, then pull off the flowers and shake them through a medium-fine sieve.

AFTER THE FLOWERS FADE, the umbels are covered in strongly flavored soft green seeds. Chop them and add to foods you might flavor with dry fennel seed, but remember the flavor is much more intense.

THE STALKS CAN BE USED AS A BED for cooking whole fish or roasts. Cut them in even lengths and line them up in your roasting pan or on your grill. Leave some seed heads on for extra flavor.

LOVAGE

An herb that deserves to be better known, and one of the easiest to grow, lovage has a delightful, but powerful, celerylike flavor. It's among the first to wake up in the early spring garden and soon after forms a soaring clump of hollow stalks, topped with foliage that looks like celery leaves. In late spring it sends up enormous flowering stalks. Lovage is lovage; you don't have to be concerned about finding a good cultivar. Once you plant it you'll always have it.

THE YOUNGER THE LOVAGE LEAVES, the better their flavor. They are ideal when just emerging and still light green and glossy. As they mature they become stronger tasting and then bitter.

LOVAGE CAN BE ADDED TO A DISH in the beginning of the cooking process, or at the end. The flavor will be subtler if added near the beginning.

TO ENCOURAGE NEW GROWTH, which will yield the young leaves you need for the kitchen, keep cutting the flower stalks and older leaf stalks back at ground level and keep the plant well watered.

THE HOLLOW STEMS MAKE THE ULTIMATE STRAWS for bloody marys or virgin marys; they flavor the drink as it passes through.

Biennial Umbels

Biennials generally live two years, producing leaves the first year and flowering the second, though sometimes they will bloom their first season.

PARSLEY

There are three types of parsley, curly, flat-leaf, and Hamburg, which is grown for the edible roots. For the leaf, I always choose flat-leaf, which has the best texture for rough chopping.

TO WASH PARSLEY, dunk the bunch several times upside down in a large bowl of cold water. Shake or spin it dry.

IT'S RARELY NECESSARY TO INDIVIDUALLY PICK the leaves off the stems. Just whack off the stems at the bottom of the bunch, then quickly go through the leafy parts and pull out the really thick stems. When you chop it, the small soft stems will not be noticed.

I HARDLY EVER GIVE PARSLEY A FINE CHOP. A rough chop will offer more flavor, color, and character.

ANGELICA

This is not an herb you are likely to cook with often, but it is an interesting one to grow. When it blooms it soars into a huge dramatic plant, covered with fireworks-like umbels. If you plant it, make sure you grow *Angelica archangelica*; there are other garden-worthy species that are not culinary.

THE MOST TYPICAL THING TO DO with angelica is candy the stems. Young tender stems that emerge in the spring are best for this. Home-candied stems are far more flavorful than the commercially made product.

YOU CAN FLAVOR DESSERTS with angelica by steeping the stems and leaves in milk or cream (it's nice to add slices of ginger also), then use the infused milk to make custards or ice creams.

ANGELICA IS A CLASSIC PARTNER to rhubarb. Add the chopped young stems to pies or cobblers.

Annual Umbels

Annuals in this family share a common trait: their taproots are sensitive and transplanting them usually triggers them to bolt (send up flower stems), which means leaf production halts. In general, it's best to sow the seed for these herbs directly in the ground instead of buying little plants as starts. Grow them like a vegetable crop: Sow them in a row or scatter the seeds in a small plot. Every three or four weeks in the growing season plant another row, so that you always have some at its peak (this is called succession planting). To harvest these herbs, cut the stems down to the ground, a small section at a time.

DILL

If you're buying seed, Fernleaf and Bouquet are the most common varieties. Flavor varies little from one to another.

DILL LEAVES ARE OFTEN CALLED DILL WEED to differentiate it from the flowering dill stalks used for flavoring pickles.

DILL IS BEST USED RAW OR ADDED at the very end of the cooking process.

DON'T FUSS WITH REMOVING the small stems. Pick out the really thick ones, then chop the rest of them with the leaves.

DON'T GROW DILL NEAR YOUR FENNEL. They'll cross-pollinate, and next season you'll have oceans of an herb that is inferior to both.

CILANTRO

CILANTRO IS EASY TO GROW FROM SEED, but short-lived. It's best to sow a new crop every 3 to 4 weeks.

WHEN CILANTRO GETS READY TO FLOWER, it sends up leaves that are lacier and smaller. These can be used interchangeably, but they have a flavor that tastes a bit more like coriander seeds.

THERE'S NO NEED TO REMOVE THE STEMS when you chop cilantro; they're soft and flavorful. Just wash the bunch, shake or spin it dry, and chop it coarsely from the top down, stopping where it becomes more stem than leaf.

ALWAYS ADD CILANTRO at the end of cooking.

CHERVIL

This is a low-growing herb, like delicate-leaved parsley with soft anise flavor. The most commonly grown variety is *Crispum*, or curled chervil.

CHERVIL IS ONE OF THE FUSSIEST HERBS to grow. If it likes its spot it might self-seed for you and grow there happily ever after. More often, it will be a struggle to grow a good crop. Start off with very fresh seed and choose a partially shaded spot with rich, evenly moist soil. If the crop fails, keep trying new places in the garden until you find one it likes. It often does well under the canopy of a lacy tree.

NEVER COOK CHERVIL; always stir it in at the end, or sprinkle the roughly chopped leaves over a dish to finish it.

LIKE CILANTRO, there's no need to remove the thin stems. Just chop them with the leaves.

YOU'LL THINK YOU'VE DISCOVERED NEW VEGETABLES when you prepare this dish, so different are they from roots that are boiled or roasted. Shaving roots into long ribbons is a cinch if you have the right kind of vegetable peeler. I like the Swiss-made ones that have a sharp blade held horizontally in a colorful plastic handle.

ROOT RIBBONS with sage

6 SERVINGS

2 pounds medium root vegetables, such as carrots, parsnips, burdock, rutabagas, yams, parsley root, or salsify (avoid beets)

3 tablespoons unsalted butter

¼ cup coarsely chopped sage

1¼ teaspoons kosher salt

Freshly ground black pepper

1 tablespoon maple syrup

2 teaspoons fresh lemon juice

Peel the roots and discard the peelings. Continue to peel the vegetables from their tops to the root tips to produce ribbons, rotating the roots on their axis a quarter turn after each strip is peeled, until you're left with cores that are too small to work with.

Melt the butter with the sage in a large skillet over medium heat. Stir for a minute to partially cook the sage. Add the root ribbons and toss them with tongs until they begin to wilt. Add the salt, a good grinding of black pepper, the maple syrup, lemon juice, and about ¾ cup water. Continue to cook the vegetables over medium heat, turning them with tongs every minute or so, until all the liquid boils away and the ribbons are glazed and tender, about 10 minutes total. Serve right away, or cool and reheat in the skillet when ready to serve.

I WAS PLAYING AROUND, trying to come up with some sort of gratin to make use of a good crop of ripe tomatoes. I lined the bottom of an oiled heavy baking dish with slices of crustless bread, drizzled it with olive oil, sprinkled it with herbs and garlic, and topped it with juicy tomato slices, then more oil and herbs. What emerged from the oven surprised me: The bread was perfectly toasted on the bottom while moistened by the tomato, which was roasted and concentrated. And the flavor was huge, reminding me of the tomato bread I had in Barcelona, but in a much different form (the Catalonian version is toasted bread that is smeared with a ripe tomato). This dish is so simple and delicious I can't imagine I was the first to invent it. There are probably thousands of grandmothers who have been making it all their lives, but I don't recall ever hearing about it. Serve it as an accompaniment to a salad, a soup, or with grilled chicken or steak. Or have it for lunch or a snack all by itself.

TOMATO bread

4 SERVINGS

¼ cup plus 1 tablespoon extra virgin olive oil

About ½ loaf of chewy (not fluffy) Italian-style bread, fresh or day old, sliced ½ inch thick

3 cloves garlic, finely chopped

Small bunch fresh basil

3 ripe juicy tomatoes (1 to 1¼ pounds), sliced ⅜ inch thick

¾ teaspoon kosher salt

1 teaspoon thyme leaves

Preheat the oven to 400°F.

Spread 1 tablespoon of the olive oil on the bottom of a gratin dish about 8 × 10 inches in size. Cut the crusts off the bread and slice it into rough pieces about 2 × 2 inches. Fit the bread into a tight mosaic in the bottom of the dish to create a single layer of bread with no spaces. Drizzle with another 2 tablespoons of the oil and sprinkle with the garlic. Tear the basil leaves over the bread. Arrange the tomatoes in rows, overlapping them so they all fit. Drizzle with the remaining 2 tablespoons oil and sprinkle with the salt and thyme. Bake the dish for 25 to 30 minutes. It's done when the underside of the bread is lightly toasted when you lift a corner to peek. Allow it to cool for about 10 minutes and serve it warm, scooped from the dish with a large spoon.

herbal improvisation In place of the thyme, sprinkle the top with 1 tablespoon chopped marjoram or oregano.

NO OTHER HERB COMPLEMENTS cauliflower as well as dill. Rather than steaming or boiling the cauliflower, I roast it in a very hot oven, which brings out its nuttiness and minimizes its cabbagelike characteristics. This is a stunning side dish that you can pop in the oven and pay very little attention to while you prepare the rest of your dinner.

ROASTED CAULIFLOWER
with apple and dill

4 SERVINGS

1 cauliflower, about 1½ pounds, core removed and separated into florets

½ large red onion, cut into ¼-inch-thick slices from root to tip

1 large unpeeled apple, cored and coarsely diced

3 tablespoons extra virgin olive oil

¾ teaspoon kosher salt

3 tablespoons dried currants

¼ cup plus 2 tablespoons coarsely chopped dill weed

Preheat the oven to 450°F. Toss together the cauliflower, onion, apple, olive oil, and salt in a large shallow baking dish and spread the ingredients out into a single layer. Bake for 20 to 30 minutes, stirring once or twice along the way, until some of the edges of the cauliflower begin to brown. Stir in the currants and continue to bake for about 10 more minutes, stirring another time or two, or until most of the edges of the cauliflower are browned. Sprinkle with the dill, stir again, and scoop it into a serving dish.

IN MY RESTAURANT KITCHEN this squash preparation is used as ravioli filling. At home it's my favorite squash side dish, as is. The simple addition of browned butter, infused with the flavor of fresh bay leaves, gives the squash a gentle butterscotch richness. Use varieties of squash that retain a firm texture when cooked. Butternut squash is not one of those; it will end up like baby food.

MASHED WINTER SQUASH
with bay butter

6 SERVINGS

3 pounds winter squash, such as delicata, carnival, or acorn

8 tablespoons (4 ounces) unsalted butter

8 fresh bay laurel leaves, lightly crushed (see page 79)

Kosher salt

1 to 4 tablespoons pure maple syrup, to taste (optional)

Preheat the oven to 400°F. Split the squash in half, scoop out the seeds, and put it cut side up in a small baking dish. Dot with 1 tablespoon of the butter and bake until the squash is very soft, 45 minutes to an hour.

Melt the remaining butter in a small skillet with the bay leaves. Cook slowly over low heat until the solids at the bottom of the skillet turn chestnut brown, about 10 minutes. The bay leaves may pop and sputter a bit along the way.

Scoop the squash out into a mixing bowl and strain the butter over it. Mash it all together with an old-fashioned potato masher or a large fork. If the squash seems stringy, you can break it up with an immersion blender or pulse it in a food processor. Add ½ to 1 teaspoon salt (I like the larger amount to contrast the natural sweetness of the squash, like salted toffee). Stir in the maple syrup, if desired, depending on your taste and the sweetness of the particular squash.

herbal improvisation If fresh bay laurel is not available, cook the butter with ½ cup coarsely chopped sage leaves. There's no need to strain them out before adding the butter to the squash.

CERTAIN TYPES OF WILD MUSHROOMS that we prepare in the restaurant—like lobster mushrooms and blue chanterelles—require very long cooking because of their chewy texture. We put them in large covered pans with wine and herbs and bake them in our bread oven for an hour or two. It's an utterly simple way of cooking them that I've found works just as well in my home kitchen with all types of more common mushrooms, even ordinary button mushrooms. You put everything in a covered casserole in the oven and come back an hour later to a sumptuous mushroom stew.

If you wish, you can bundle the herb sprigs with string and pull them out before serving, but I like to leave them loose. The cooked sprigs look beautiful lying among the mushrooms and are easy to push aside if they leap onto your plate.

oven-braised forest
MUSHROOMS

8 SERVINGS

2 pounds assorted mushrooms, wild or cultivated, cleaned and cut into bite-sized pieces

Small bunch thyme sprigs (½ ounce)

5 fresh or dried bay laurel leaves

2 large sprigs sage

¼ cup finely chopped shallots

3 tablespoons butter or olive oil

2 teaspoons kosher salt

½ cup dry vermouth or white wine

Preheat the oven to 375°F. Layer the mushrooms, herbs, and shallots in a lidded covered casserole that's just large enough to hold them. Dot with the butter or drizzle with the olive oil, sprinkle with the salt, and pour the vermouth over the top. Cover tightly and bake for 1 hour, stirring halfway through the cooking. Serve the mushrooms hot from the casserole.

LIKE A CROSS BETWEEN A GLORIOUS Thanksgiving stuffing and a savory mushroom custard, this bread pudding is appropriate in any season. It is perfect if you're looking for an out-of-the-ordinary side dish to serve on a buffet or to pass at a large dinner. To make it ahead, bake the casserole when you first mix the ingredients together and reheat it before serving.

mushroom marjoram
BREAD PUDDING

10 SERVINGS

1 ounce dried porcini mushrooms

One (20 to 24-ounce) loaf rustic white bread, crust removed

6 tablespoons unsalted butter, softened

1 large onion, chopped

1 pound button or cremini mushrooms, rinsed and sliced

¼ cup chopped marjoram

6 large eggs

3 cups milk, whole or low fat

1 tablespoon kosher salt and ¼ teaspoon black pepper

Preheat the oven to 375°F. Put the mushrooms in a 2 cup liquid measuring cup and fill it with hot water. Dice the bread into rough 1-inch cubes. Smear the interior of a large shallow baking dish (at least 9 × 13 inches) with 2 tablespoons of the butter.

Lift the dried mushrooms out of their soaking liquid so that any grit they have released stays at the bottom of the cup. Chop them finely. Pour the mushroom soaking liquid through a fine strainer, agitating it as little as possible and keeping the last ½ cup or so of liquid behind.

Melt the remaining butter in a large skillet over medium heat and cook the onion in it until it softens, about 5 minutes. Add the sliced button mushrooms and the chopped porcini and cook them for another 5 minutes. Pour in the strained liquid and simmer for another 5 minutes. Stir in the marjoram and turn off the heat.

Whisk the eggs, milk, salt, and pepper together in a very large mixing bowl. Stir in the cooked mushrooms and onion. Add the bread cubes and gently toss them with a rubber spatula. Pour the pudding into the buttered baking dish. Bake for 50 to 55 minutes, or until browned on the top and firm to the touch in the center.

two SAVORIES

Savory is not as widely known as other robustly flavored herbs, but it should be. The two species, summer savory and winter savory, have similar flavors but different ways of growing. Summer savory is a fast-growing annual with a lacy upright habit; winter savory is a semi-evergreen perennial with leathery leaves and a dense habit that can be upright or trailing. Both taste something like a cross between thyme, sage, and oregano, the winter being a bit stronger and heavier in flavor than the summer species.

BEANS ARE THE CLASSIC PARTNER for both summer and winter varieties of this herb. Any kind of beans—from dried navy beans, to fresh shell beans, to tender green beans—tastes good with it. Savory is also good with potatoes and with deeply flavored roasts and stews.

WINTER SAVORY IS BEST WHEN COOKED in a dish to mellow its flavor. Summer savory can go in at the beginning or the end of cooking.

GROW SAVORY IN LOOSE SOIL WITH FULL SUN. Summer savory is short-lived and always wants to bloom, even if you are diligent about cutting it back. Winter savory will grow fuller if you keep it trimmed. Cut it back hard in late summer to encourage new growth that you can harvest in the colder months.

A GOOD POTATO GRATIN IS ALWAYS A HIT, whether for a family supper or a holiday feast. I find they always turn out better if you slice the potatoes quite thinly, which is most easily accomplished with a mandoline. A French version of this gadget will work beautifully, but I'm partial to Japanese mandolines, which are lightweight, inexpensive, and well worth having. Savory is not an herb I cook with as often as others in my garden, but its muscular flavor is my first choice for this dish.

savory POTATO GRATIN

6 SERVINGS

2 pounds Yukon gold or russet potatoes

2 tablespoons unsalted butter, softened

1½ teaspoons kosher salt

¼ cup finely chopped shallots

¼ cup coarsely chopped summer savory, or 2 tablespoons chopped winter savory

1 cup (3 ounces) shredded Gruyère

¾ cup whole milk

Preheat the oven to 400°F. Peel and rinse the potatoes and slice them about $\frac{1}{16}$-inch thick, as if for potato chips. It's easiest to do this on a mandoline, but if you don't have one, use the slicing blade of a food processor. It's possible to cut them thinly and evenly with a chef's knife, but quite challenging.

Smear the butter on the bottom and sides of a 10-inch-round shallow baking dish or glass pie plate. Arrange about one-third of the potato slices in concentric circles over the bottom of the dish. Sprinkle with ½ teaspoon salt, 2 tablespoons of the shallots, one-third of the savory, and one-third of the cheese. Repeat the process with another third of the potatoes and the same toppings, then finish with a layer of potatoes and sprinkle with the remaining teaspoon salt, the savory, and cheese. Pour the milk over the top.

Bake the gratin for 40 to 45 minutes, or until deeply browned all over. Serve in wedges from the baking dish, or let the gratin cool slightly and slide it out onto a platter.

herbal improvisations Instead of savory, add ¼ cup chopped marjoram or 2 tablespoons chopped thyme.

WHEN YOU UNEARTH THESE LITTLE POTATOES from their salty bed they are perfectly intact and dry to the touch, while soft and moist inside, and subtly flavored with ghosts of the toasty herb sprigs with which they were roasted.

salt-roasted POTATOES

4 SERVINGS

2 pounds rock salt

1 bunch thyme (about 1 ounce)

6 bay laurel leaves, fresh or dried

1½ pounds small potatoes, such as fingerlings or small Yukon gold potatoes, rinsed and dried

Preheat the oven to 425°F. Pour half of the salt into a deep baking dish, large enough to hold the potatoes in a single layer. Strew half of the thyme sprigs and the bay leaves over the salt and arrange the potatoes on top of the herbs. Cover the potatoes with the rest of the thyme, and then bury them with the rest of the salt. Bake for 45 minutes, or until the tip of a paring knife easily slides into a potato. If you are not ready to serve the potatoes, you can leave them in the salt for up to 30 minutes. There are two ways to dig the potatoes from the salt: either scoop them out with a slotted spoon, or turn the baking dish upside down over a large baking sheet, break the salt apart, and extract the potatoes (my preferred method). Use a soft brush to sweep the excess salt off each potato and pile them in a serving dish.

a few BREADS

SAGE LEAVES, ARRANGED IN THE BUTTERED PAN before the batter is poured in, form a beautiful pattern on the crust of this bread and distinctly flavor it throughout. Crumbled feta contributes moistness and a salty bite.

sage-feta CORNBREAD

ONE 9-INCH BREAD; ABOUT 8 SLICES

1 tablespoon unsalted butter, softened, for the pan

18 to 24 large sage leaves

¾ cup stone-ground cornmeal

1 cup all-purpose flour

2 teaspoons baking powder

2 teaspoons sugar

½ teaspoon fine salt

2 large eggs

1 cup buttermilk

¼ cup olive oil

4 ounces (1 cup) crumbled Greek feta

Preheat the oven to 400°F. Smear the butter on the inside of a 9-inch glass pie plate. Press the sage leaves into the butter in a circular daisy pattern, saving about 6 to press into the side of the pie plate horizontally.

Stir the cornmeal, flour, baking powder, sugar, and salt together with a wire whisk in a medium mixing bowl. Whisk together the eggs, buttermilk, and olive oil in a second bowl. Stir the liquid into the dry ingredients until the lumps smooth out. Stir in the cheese.

Pour the batter into the pie plate over the sage leaves. Bake for about 25 minutes, or until the crust is browned and the bread springs back in the middle when you press on it. Let cool for about 10 minutes in the pan. Loosen the sides with a paring knife, then flip the cornbread out onto a plate or board with the sage leaves on top, and serve while still warm.

I'VE BORROWED THE TECHNIQUE for these breads from Chinese scallion breads, which I've been making ever since I read about them twenty years ago in Barbara Tropp's groundbreaking *The Modern Art of Chinese Cooking*. To make the Chinese breads, a simple dough is rolled thin, coiled with scallions and sesame oil, rolled again into a flat pancake, then pan-fried. I love their particular texture, at once hearty and delicate, with thin chewy layers of dough and a bubbly browned, slightly crisped exterior. These have garlic oil in place of sesame and various herbs instead of scallions. Warm and cut into wedges, they make a fine snack, cocktail nibble, or accompaniment to soup or salad. They're fun to make, especially if you put a different herb in each one, but allow yourself some unhurried time for their preparation.

herbed SKILLET BREADS

6 BREADS

2½ cups all-purpose flour, plus extra for dusting

1 cup boiling water

Extra virgin olive oil

4 cloves garlic, finely chopped

For each bread, one of the following: 2 tablespoons chopped basil, 1 tablespoon chopped chives, dill, marjoram, or sage, or 2 teaspoons chopped rosemary or Greek oregano

Kosher salt

Put the flour in a food processor and, with the motor running, pour in the boiling water. Process for about 15 seconds to knead the ball of dough that will form. Put the dough in a lightly oiled bowl, cover tightly with plastic wrap, and let it rest and cool for 30 minutes.

Heat ¼ cup olive oil with the garlic in a small skillet over medium-low heat until the garlic cooks but does not brown. Pour the oil into a small bowl and wipe out the skillet.

Turn the dough out onto a floured board and cut it in 6 equal pieces. Roll one of the pieces into a thin 9-inch circle, rotating it a quarter turn between rolls and using as much flour as needed to keep it from sticking. Brush the dough with some of the garlic oil and sprinkle it with your choice of one of the herbs and about ¼ teaspoon salt. Roll up the circle from one end so that you end up with a tube shape and pinch the loose end to secure it. Coil the tube into a spiral, like a snail, and fasten the loose end again. Roll the spiral into a flat cake about 7 inches in diameter. Don't worry if a few of the herb pieces poke through the dough. Roll and fill the remaining pieces of dough in the same way. If you are not going to cook the breads right away, layer them between squares of parchment paper that have been lightly oiled or coated with pan spray.

Heat 1 tablespoon olive oil in a medium skillet. Slip in one of the breads, turn the heat to medium-low, and cook until the underside is dappled with a deep golden brown color and the top puffs a little, about 1½ minutes. Flip the bread and brown the other side. Drain the bread on paper towels, wipe out the pan, add more oil, and cook the remaining breads in the same way. Sprinkle the breads with a little more salt and cut each into 8 wedges. Serve warm.

CHIVE talkin'

Since they are alliums, chives are essentially like onion leaves, only thinner, milder, and more tender. With the tubular leaves growing up to 18 inches tall, and balls of pink flowers in spring, common chives don't vary much from plant to plant, even though you might see particular strains listed in catalogs. Garlic chives are different; they have flat leaves, a much stronger flavor, and white flowers. Don't substitute one for the other.

TO CHOP CHIVES, LINE THEM ALL UP in the same direction on the cutting board and slice in lengths with a sharp knife—less than ⅛ inch for finely chopped to 1 inch for very coarsely chopped.

ALWAYS ADD CHIVES AT THE END OF COOKING or sprinkle them on before serving. They lose their flavor and color with heat.

CHIVE LEAVES ARE FAIRLY MILD, but the flowers have a strong onion flavor. Tear the individual florets apart and cook them in scrambled eggs or omelets, or sprinkle them over salads or pastas.

TO HARVEST CHIVES, CUT BUNCHES OF THE LEAVES all the way at the base, less than an inch above the soil. If you have several plants, alternate between which you cut, harvesting one completely before you go to another. That way the first will grow back by the time you cut back the last.

IF YOU HARVEST YOUR CHIVES while they are blooming, be sure to pick out all the hard, unpalatable flower stems from the leaves.

AFTER THE BLOOMS START TO FADE IN SPRING, cut all your chives down completely, or they will become sparse and the leaves will yellow. They'll grow back full and healthy in no time.

I THINK I WAS WEANED ON NEW YORK ONION BAGELS and onion board (onion pletzel), so naturally I go in a big way for any kind of bread with onions. This focaccia, topped with a tangle of onion dappled with rosemary, is a favorite. With an electric mixer, it's one of the easiest yeast breads you can make; you just need to give it time to rise.

onion rosemary FOCACCIA

1 BREAD; 8 SLICES

1½ teaspoons dry yeast (two-thirds of a package)

1½ cups warm (110°F) water

1 teaspoon fine salt

6 tablespoons extra virgin olive oil

3½ cups unbleached all-purpose flour

1 large onion, halved and sliced ¼ inch thick from root to top

3 tablespoons coarsely chopped rosemary

¾ teaspoon kosher salt

Sprinkle the yeast into the water in the bowl of an electric mixer that has a dough hook. After several minutes, stir to dissolve it. Add the fine salt, 1 tablespoon of the olive oil, and the flour. Mix on low speed until the flour is incorporated, then knead on medium speed for 5 minutes. The dough will be very soft and sticky. Remove the bowl from the mixer and the dough hook from the bowl, cover the bowl with plastic wrap, and let the dough rise at room temperature until it more than doubles in size, about 1 hour.

Heat 3 tablespoons of the oil in a medium skillet. Add the onion, rosemary, and kosher salt and cook over medium heat until the onion wilts, but is still slightly undercooked, 3 to 4 minutes. Cool.

Preheat the oven to 400°F. Spread 1½ tablespoons of the oil over the bottom and sides of a baking sheet lined with silpat or parchment paper. Use a rubber spatula to deflate the dough and scrape it out onto the pan. Coat your hands with the last ½ tablespoon of oil and press and poke the dough to spread it evenly out to the edges. If it is very elastic and wants to spring back, let it rest for 10 minutes and then try again. Distribute the onion over the top of the dough. Let the bread rise until it looks puffy around the edges, about 30 minutes.

Bake the focaccia for 30 to 35 minutes, or until the crust is browned and the onion begins to brown at the edges. Slide it off the Silpat or parchment paper onto a rack or board. Serve warm or at room temperature within a few hours of baking.

OUR SHIBA DOGS, Ruggles and Lulu, eat pretty well. They get homemade beef and chicken stew every evening, and over the years have tasted everything from foie gras to Saint Marcellin cheese (okay, and they once had a few grains of caviar). They love these biscuits, probably more for the peanut butter and garlic than for the parsley, but that's in there because I think it's healthy for them. Both of them are very good dogs; Ruggles was just "acting" bad for the photo.

good dog, bad dog BISCUITS

2 TO 4 DOZEN FOR A GOOD DOG, OR
ONE "HELPING" FOR A BIG BAD DOG

1½ cups rolled oats

2 cups whole wheat flour

¼ cup dry nutritional yeast

1½ tablespoons garlic powder

1 cup parsley sprigs, gently packed

½ cup peanut butter, preferably unsalted

1 egg

1 cup water

Preheat the oven to 275°F.

Whirl the oats, flour, yeast, garlic powder, and parsley in a food processor until finely ground. Add the peanut butter and process until combined. Add the egg and water and process until the dough forms a firm ball that spins around the blade.

Turn the dough out onto a board and knead briefly. Pinch off a piece of dough (a size corresponding to the size of your dog), and roll it into a cylinder. Use your fingers to form it into a bone shape, pressing a fingertip into both ends to create sockets (kids will have fun making these). Arrange the biscuits on a parchment-lined baking sheet. Bake the biscuits for about 2 hours, or until lightly browned and quite dry. Cool and store in an airtight container, out of paw's reach.

HERB GARDEN
endings

TARRAGON ICE WITH
MELON BALLS

GREEN APPLE AND
SHISO ICE

RASPBERRIES IN LEMON
VERBENA GEL

BLUEBERRIES AND WATERMELON
IN CINNAMON BASIL SYRUP

STRAWBERRY ROSE
GERANIUM ICE CREAM

RHUBARB MINT COBBLER

ROASTED PEACHES FILLED
WITH ALMOND AND TARRAGON

ORANGE THYME FIGS WITH
MUSCAT SABAYON

WARM MAPLE ROSEMARY
BANANA SPLITS

HERBED WINTER FRUIT
COMPOTE

PEAR ROSEMARY
UPSIDE-DOWN CAKE

WARM LAVENDER
ALMOND CAKES

LAVENDER POUND CAKE

CHOCOLATE JASMINE
POT DE CRÈME

CHOCOLATE PEPPERMINT TART

HERE'S A STRIKING WARM-WEATHER DESSERT that's intensely flavored yet light and refreshing. Don't skimp on the quantity of tarragon leaves; it really does take a cup and a half to produce the full flavor and color. If you buy your tarragon at a market you'll need two or three bunches to yield enough leaves for the recipe.

TARRAGON ICE with melon balls

8 SERVINGS

1½ cups tarragon leaves, gently packed

⅔ cup sugar

¼ cup freshly squeezed lemon juice

2 cups cold water

4 cups melon balls, scooped from perfectly ripe melons, such as cantaloupe, honeydew, or galia

Puree the tarragon, sugar, lemon juice, and cold water in a blender on high speed for about 20 seconds. Pour the syrup into a fine sieve set over a bowl, and press the liquid through with the back of a ladle or a rubber spatula, squeezing the pulp to extract as much liquid as possible. Freeze the syrup in an ice cream maker until slushy-firm. Transfer the ice to a container and store it in the freezer until firm enough to scoop.

When ready to serve, fill small dishes or martini glasses with about ½ cup melon balls each, then top with several very small scoops of the ice or 1 larger scoop.

SHISO HAS ELEMENTS OF CINNAMON in its fragrance and flavor, so it's a natural partner to tart green apples in this intriguing ice that's ideal as an ending for an Asian-inspired menu. Be sure to freeze the ice as soon as you prepare the liquid to retain the green hue of the apple skins and the vibrant flavor of the herb.

GREEN APPLE and shiso ice

6 SERVINGS

2 Granny Smith apples, about 1 pound, unpeeled, cored and diced, plus another half for garnish

1½ cups water

¾ cup sugar

2 tablespoons fresh lemon juice

6 large green shiso leaves, plus one cut in thin strands for garnish

Puree all the ingredients except the garnishes in a blender (not a food processor) on high speed until they are liquefied. Pour the puree into a fine sieve set over a bowl, and press the liquid through with the back of a ladle or a rubber spatula, squeezing the pulp to extract as much liquid as possible. Immediately freeze the liquid in an ice cream maker. When slushy-firm, scoop it into a container and store it in the freezer until serving time.

Scoop into glasses and top with thin strips of raw crisp apple and a few strands of shiso.

NO, IT'S NOT JELL-O; this is a very sensual dessert. As you scoop up a mouthful, the raspberries float in a rose-colored gel just firm enough to embrace the fruit but yield softly to the spoon. And the flavor is startling and intoxicating: The gel melts on your tongue like a flood of lemon drops bathing the sweet berries.

RASPBERRIES in lemon verbena gel

6 SERVINGS

2½ cups water

½ cup sugar

1 cup lemon verbena sprigs, lightly packed

2 teaspoons unflavored gelatin (1 package minus ½ teaspoon)

¼ cup fresh lemon juice

1 pint fresh raspberries

Heat 2¼ cups of the water with the sugar in a small saucepan. As soon as it comes to a full boil, stir in the lemon verbena, cover, and remove it from the heat. Let it steep at least 10 minutes.

Meanwhile, sprinkle the gelatin over the remaining ¼ cup water and let it swell in the liquid for several minutes. Strain the verbena syrup and stir the gelatin into the hot liquid until it dissolves. Cool to room temperature (stir it over ice if you want to speed it up). Stir in the lemon juice.

Arrange the berries in six dessert glasses. Pour the gelatin over them and chill for several hours until set. The raspberries will color the liquid as it gels.

FOR EACH FRUIT OR BERRY OF SUMMER I have a favorite herb, and for blueberries it's cinnamon basil. There are few desserts that are simpler to prepare than this, but the result is as delicious as it is dazzling, especially if you can find yellow watermelon. Serve it in stemmed glasses or small glass bowls with plain sweet wafers or cookies.

BLUEBERRIES AND WATERMELON in cinnamon basil syrup

6 SERVINGS

¾ cup sugar

½ cup water

Two 3-inch cinnamon sticks

½ cup cinnamon basil or sweet basil leaves

1 tablespoon fresh lemon juice

4 cups seedless or seeded watermelon cubes, chilled

2 cups blueberries

2 tablespoons small cinnamon basil leaves or sweet basil, cut into thin strips

Bring the sugar, water, and cinnamon to a boil in a small saucepan. Reduce the heat and simmer the syrup for 3 minutes. Stir in the basil leaves and remove from the heat. Let the syrup cool to room temperature. Strain, and stir in the lemon juice.

Toss the watermelon and blueberries together in a large bowl. Pour in the syrup and sprinkle with the small leaves or strips of basil. Toss again and chill for at least 1 hour.

The melon will release juice and thin the syrup. Spoon the fruit and syrup into glasses or bowls and serve cold.

THIS ICE CREAM IS ASTOUNDING in its simplicity and fullness of flavor. The cream is first steeped with rose geranium, which wondrously amplifies the intensity of the berry, and the ice cream has no egg, which would mute the flavor. For the ultimate strawberry ice cream experience, serve it slightly soft, preferably an hour or so after it comes out of the ice cream maker. It's fantastic with Lavender Pound Cake (page 242).

strawberry rose geranium
ICE CREAM

1 QUART: 8 SERVINGS

2 cups half-and-half

1½ cups sugar

8 medium rose geranium leaves

1½ pints very ripe strawberries

Bring the half-and-half and sugar to a boil in a small saucepan. Stir in the rose geranium leaves, cover, and remove from the heat. After about 10 minutes, strain the cream and let it cool.

Wash and hull the strawberries. Puree them in a blender or food processor until fairly smooth. You should have 2 cups.

Stir the strawberries and infused cream together and chill in the refrigerator or over ice until cold to the touch. Freeze in an ice cream maker. Scoop the ice cream out into a lidded container and store it in the freezer until serving time.

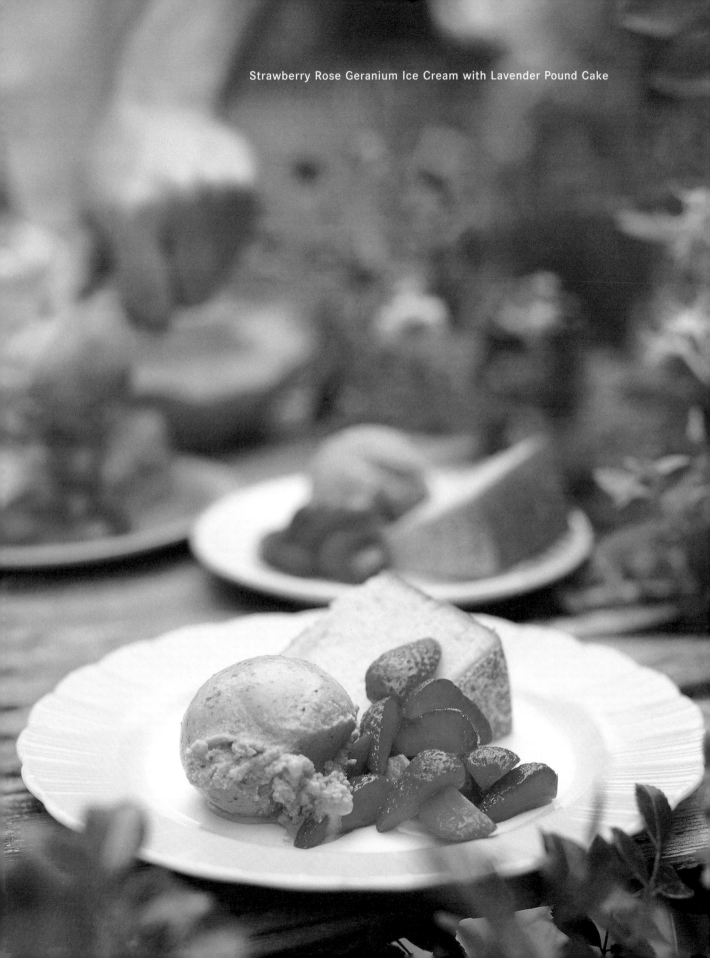

Strawberry Rose Geranium Ice Cream with Lavender Pound Cake

IF YOU COOK STRICTLY WITH THE SEASONS in a temperate climate, there is nothing but rhubarb for desserts between the last apples and pears of winter to the first strawberries of spring. But that's fine with me. I love rhubarb's bracing tartness and the way it tastes warm topped with something cold and creamy. I'm fond of flavoring rhubarb with angelica, which bursts from the soil at the same time of year, but spearmint also makes a good partner and is more likely to be in your garden. Both herbs complement rhubarb's vegetable essence while helping it achieve its fruity aspirations.

rhubarb mint COBBLER

8 SERVINGS

2 pounds rhubarb stalks

¾ cup sugar

½ cup chopped spearmint

2 tablespoons unsalted butter

BISCUITS

1 cup all-purpose flour

2 teaspoons baking powder

¼ teaspoon fine salt

5 tablespoons sugar

4 tablespoons unsalted butter

½ cup minus 1 tablespoon heavy cream

Preheat the oven to 400°F.

Wash the rhubarb and trim the tops and bottoms. Slice it into ½-inch pieces. Put it in a 9 × 13-inch baking dish and mix in the sugar and mint. Dot with the butter. Bake the rhubarb for 20 minutes or until it softens and bubbles around the edges, take it out of the oven, and stir it gently with a rubber spatula.

While the rhubarb is baking, make the biscuits. Put the flour, baking powder, salt, and 3 tablespoons of the sugar in a food processor and turn it on just long enough to mix the ingredients. Add the butter and pulse until the largest pieces of butter are smaller than grains of rice. Pour in the cream and pulse just until the dough gathers in clumps. Turn the dough out onto a piece of parchment paper and divide it into 8 equal pieces. Lightly form each piece into a shaggy disk the size of a sausage patty, about 2½ inches in diameter.

Arrange the biscuits on top of the hot rhubarb and sprinkle them with the remaining 2 table-spoons sugar. Put the dish back in the oven and bake another 20 minutes, or until the biscuits are nicely browned. Serve the cobbler warm with vanilla or strawberry ice cream or sweetened crème fraîche.

IF YOU GROW ANGELICA, replace the spearmint with ¾ cup finely chopped young angelica stems.

A ROSE IS NOT A rose

Looks like a geranium, smells like a rose. This plant is actually a pelargonium, just like a window-box geranium, as opposed to a true geranium, which is not edible. There are dozens and dozens of different "flavors" of scented geraniums, rose being just one, and many named varieties of rose geranium, such as attar of roses and lemon rose. As long as it smells like a rose, it's a good one.

ROSE GERANIUM HAS THICK FELTY LEAVES, so the best way to cook with it is to steep the leaves in hot liquid and strain them out.

I CAN'T THINK OF ANYTHING SAVORY that I would want to flavor with rose geranium. Save it for desserts and beverages. It almost magically intensifies the flavor of berries and is flattering to apple, pear, cherry, and apricot.

ROSE GERANIUM IS ONE of only a handful of herbs that tastes good with dark chocolate and, used with restraint, it makes a lovely flavoring for vanilla custards, ice creams, or butter cakes. Steep it in the milk or cream (heated to a boil) called for in the recipe before you begin, then strain it out.

ROSE GERANIUMS DO WELL IN POTS. Keep them outdoors in summer and park them indoors on your windowsill when the weather turns cold.

THESE PLANTS WILL FLOWER, especially in spring, but not as much as an ordinary geranium. The petals make a colorful garnish for anything you have flavored with its leaves.

AS THESE PEACH HALVES BAKE, their almond filling spreads over the tops, forming a crunchy nutty cap infused with the anise flavor of tarragon. They also taste beautiful with anise hyssop, which gives the dessert a sweeter, minty-anise flavor. Whichever herb you choose, you can have this dessert ready to put in the oven in about ten minutes.

ROASTED PEACHES filled with almond and tarragon

8 SERVINGS

6 tablespoons unsalted butter, softened

¼ cup sugar

¼ cup dark brown sugar, packed

1 large egg

¼ cup plus 2 tablespoons all-purpose flour

1 tablespoon coarsely chopped tarragon

¾ cup sliced almonds

4 large ripe freestone peaches

Preheat the oven to 400°F. Beat together the butter and both sugars in a mixing bowl with a wooden spoon, or in an electric mixer, until there are no lumps. Beat in the egg and then the flour. Stir in the tarragon and almonds.

Split the peaches in half and remove the pits. Arrange the peaches cut side up in a shallow baking dish just large enough to hold them. Divide the almond filling into 8 equal portions and mound each in the cavity of a peach half. Bake for 30 to 40 minutes, or until the filling spreads over the top of the peaches and becomes well browned and crisp. Cool the peaches slightly. Serve them warm in shallow bowls with whipped cream or vanilla ice cream.

herbal improvisations In place of the tarragon, add ¼ cup chopped anise hyssop leaves. Fresh green fennel seed is also good in this dessert; use 2 teaspoons of the chopped soft seed.

I ALWAYS HAVE ORANGE BALSAM THYME in my garden. The sturdy, easy-to-grow little herb has a brash but tantalizing scent of dried orange peel mixed with wild thyme. In most dishes its potent flavor can be too much of a good thing, but it fits deliciously in many fruit desserts, especially those with fresh figs. If you don't grow it (you're not likely to find it in the produce section) you can produce a very similar flavor with ordinary English thyme and orange zest.

The figs in this recipe can be cooked ahead of time but the sabayon should be cooked at the last minute. Don't let that put you off, because it takes only minutes to prepare. Be sure the figs you choose are really ripe. That means they'll be soft and squishy, almost oozing, and when you cut them in half the seeds will be held in a glistening pulp.

ORANGE THYME FIGS with muscat sabayon

8 SERVINGS

2 tablespoons unsalted butter, softened

2 pints ripe fresh figs

1 medium orange

4 teaspoons thyme leaves (English or orange balsam)

¾ cup light brown sugar, packed

Muscat Sabayon (recipe follows)

Preheat your broiler to 425°F (or medium, depending on your oven) with the rack set in the middle of the oven. Smear the butter over the bottom and sides of a large shallow baking dish. Cut the stems off the figs and then cut them in half. Arrange them, cut side up and close together, in the buttered dish. Grate the zest of the orange over the figs (use a microplane if you have one). Sprinkle them with the thyme and then the brown sugar.

Broil the figs until they are bubbling all over, juice collects in the bottom of the pan, and the sugar on top caramelizes to a deep brown color. Let them cool while you prepare the sabayon, or make them ahead and serve them at room temperature with the hot sabayon.

muscat SABAYON

8 large egg yolks

¼ cup plus 2 tablespoons sugar

1 cup sweet Muscat wine or other dessert wine, such as a late-harvest Riesling

Choose a large stainless steel mixing bowl and a large saucepan that it will sit on top of. Fill the saucepan with about 2 inches of water and bring it to a boil.

Whisk the yolks with the sugar until they are well combined, then whisk in the wine. Set the bowl over the boiling water and whisk constantly and rapidly until the mixture is very thick and fluffy and no sign of liquid is visible in the bottom of the bowl. This will take only 2 to 3 minutes, and you will easily be able to sense the point when the sabayon becomes custardy and fully cooked.

Spoon the sabayon into serving glasses or small bowls and top with the figs and their sauce. Serve right away with plain cookies or slices of pound cake or gingerbread.

NOTHING IS COZIER than a warm banana dessert in winter. This one is perfect for a spur-of-the-moment treat because you can make it in a flash with ingredients that are often on hand.

warm maple rosemary
BANANA SPLITS

4 SERVINGS

3 ripe but firm bananas, peeled and halved crosswise and lengthwise

½ cup maple syrup

Three 4-inch sprigs rosemary

Vanilla ice cream

2 tablespoons unsalted butter

⅓ cup coarsely chopped toasted walnuts

Put the banana pieces in a large skillet, pour the maple syrup over them, and tuck the rosemary sprigs in between. Bring the mixture to a low boil over medium heat and cook for about 1 minute. Turn the bananas over with two forks and cook for 30 more seconds. Scoop the ice cream into shallow dishes. Lift the bananas from the syrup with the forks and lay 3 pieces around each scoop of ice cream. Boil the syrup left in the pan for a minute or two until it thickens slightly, then swirl in the butter until it melts and incorporates. Use a fork to hold back the rosemary sprigs as you pour the sauce from the skillet over the bananas and ice cream. Sprinkle with the walnuts.

KEEP THIS SPARKLING PRESERVE IN THE REFRIGERATOR during the holiday season and you'll always have an elegant dessert on hand. Spoon it onto vanilla ice cream, serve it alongside Warm Lavender Almond Cakes (page 240), or fill the cavity of a baked apple with it. The winter herbs and vanilla give it a comforting yet beguiling flavor.

Quince, a relative of apples, lends a velvety texture to the compote, and its natural pectin helps thicken the syrup. If you can't find a quince, substitute a good cooking apple, like a Jonagold.

herbed winter
FRUIT COMPOTE

10 SERVINGS

1 ripe quince, unpeeled, cored and chopped into ½-inch pieces

1 ripe Bosc pear, unpeeled, cored and chopped into ½-inch pieces

1 cup dried tart cherries

1 cup pitted prunes

1 cup dried apricots

1 bottle Riesling

½ cup mild honey

1 cup sugar

1 vanilla bean, split

5 fresh bay laurel leaves or 3 dried

Two 4-inch sprigs rosemary

Two 3-inch sprigs sage

¼ cup Calvados, pear brandy, cognac, or Armagnac

Combine all the ingredients except the brandy in a large saucepan. Simmer over medium-low heat, uncovered without stirring, for 30 minutes. Gently stir in the brandy and allow the compote to cool in the pan. Store it in a sealed container in the refrigerator, where it will keep for several weeks, and bring it to room temperature before serving.

THIS IS MY KIND OF CAKE—comforting, gooey, and loaded with flavor. First you cook the pears and rosemary in brown sugar, creating a considerable amount of syrup in the bottom of the pan. When you pour the rich cornmeal batter over the top you'll think the cake will drown. Don't be concerned; as it bakes it will absorb the syrup to become uncommonly moist and saturated with the rosemary-pear flavor.

pear rosemary
UPSIDE-DOWN CAKE

8 TO 10 SERVINGS

¾ cup dark brown sugar, packed

4 tablespoons unsalted butter, melted

1½ tablespoons coarsely chopped rosemary

3 medium ripe pears, Bartlett or Anjou, peeled, quartered, and cored

BATTER

5 tablespoons unsalted butter, softened

¾ cup sugar

1 teaspoon vanilla extract

1 tablespoon chopped rosemary

2 large eggs

1 cup all-purpose flour

½ cup stone-ground cornmeal

¾ teaspoon baking powder

¼ teaspoon baking soda

¼ teaspoon fine salt

⅔ cup buttermilk

Preheat the oven to 350°F.

Stir the brown sugar, melted butter, and ½ tablespoon chopped rosemary together in a 10-inch pie pan or cast-iron skillet. Arrange the pear quarters in a circular pattern, rounded side down and stem end in, on top of the sugar, and use the last pear quarter to fill the center. Bake the pears for 15 minutes. They should be half-submerged in a bubbling syrup and very soft. If the pears were not ripe, continue to bake them, turning them from time to time in the syrup, until the tip of a paring knife slides in with little resistance.

While the pears are baking, prepare the cake batter. Beat the butter and sugar together in an electric mixer until fluffy and smooth. Beat in the vanilla, 1 tablespoon rosemary, and the eggs, one at a time. Whisk or sift together the flour, cornmeal, baking powder, baking soda, and salt in a separate mixing bowl, then add this dry mixture to the batter and mix until it's incorporated. Pour in the buttermilk and beat the batter on medium speed for about a minute.

Pour the batter over the hot pears and their syrup. Return the cake to the oven and bake for 35 to 40 minutes, or until it is golden brown and it springs back when you push on the center. Let the cake cool for 5 minutes, and then invert it onto a large flat platter. Serve the cake slightly warm or at room temperature with lightly sweetened whipped cream. It's best eaten the same day it's baked.

THESE CAKES ARE MIRACULOUS. You whiz everything up in a food processor, pop the batter into the refrigerator overnight, and then scoop it into ramekins or muffin tins to bake. You'll be amazed. The warm, slightly chewy cakes have a light crisp crust and a dense, moist interior suffused with the deep flavors of nuts, lavender, and honey, almost like a cross between a cake and a macaroon. Serve them in summer with lightly sweetened, softly whipped cream and fresh berries, or end a winter meal with the same cream and the Herbed Winter Fruit Compote on page 237. Or simply cut them in quarters and serve them with coffee, tea, or a glass of sherry in any season.

warm lavender
ALMOND CAKES

10 INDIVIDUAL CAKES

4 ounces raw sliced almonds (1 cup)

4 teaspoons lavender buds, fresh or dried

2 cups (8 ounces) powdered sugar

½ cup all-purpose flour

¼ teaspoon fine salt

¾ cup egg whites (about 6 large)

¼ cup honey

8 tablespoons (4 ounces) unsalted butter, melted and cooled

2 tablespoons softened butter, for preparing the molds

Begin preparation at least 1 day before serving.

Put the almonds and lavender buds in a food processor and pulse until they are finely chopped. Add the powdered sugar and continue to process for 30 seconds. Add the flour and salt and process briefly. Pour in the egg whites and honey and process until combined. Add the melted butter and process for an additional 15 seconds. Scrape the batter into a plastic storage container, cover, and refrigerate for at least 12 hours, or as much as a week.

Preheat the oven to 350°F. Generously butter ten (4- or 6-ounce) ovenproof ramekins or custard cups and place them on a baking sheet, or use a standard muffin tin. Divide the batter evenly among the ramekins or muffin cups. Bake until the cakes are evenly puffed and the tops crack and turn a deep walnut brown color, 30 to 40 minutes, depending on the molds and the temperature of the batter. Cool slightly and tip the cakes out of their molds. Serve them while still warm, whole or cut into quarters.

If you want to bake the cakes ahead, cool them completely and wrap in plastic wrap. They'll hold for several days. When ready to serve, unwrap, place them on a cookie sheet, and reheat in a 350°F oven for about 5 minutes.

herbal improvisation In place of the lavender, add the same quantity of rosemary leaves.

WHEN YOU ADD JUST ENOUGH LAVENDER to a plain buttery cake or cookie, it acts in the way vanilla does, as a background flavor that adds depth and fullness to the flavor but doesn't announce itself too boldly. Pound cake is particularly heavenly with lavender, and this one has such a fine, dense, and springy texture you could curl up on it. Like traditional pound cake, it has no baking powder and is leavened solely by the air beaten into the batter, so it's vital to cream the butter and sugar thoroughly. That makes it an easy cake to prepare if you have a stand mixer, but best to pass if you don't.

lavender POUND CAKE

ONE 10-INCH TUBE CAKE; 16 TO 20 SLICES

Softened butter and flour for preparing the pan

2 tablespoons lavender buds, fresh or dried

2½ cups sugar, preferably fine (baker's sugar)

3 sticks (12 ounces) unsalted butter, softened

1 teaspoon vanilla extract

½ teaspoon fine salt

5 large eggs, at room temperature

3 cups all-purpose flour, sifted

¾ cup sour cream

Preheat the oven to 325°F. Heavily butter a 10-inch tube pan, coat it with flour, and knock out the excess. Whirl the lavender and ¼ cup of the sugar in a spice grinder (rotary coffee mill), mini food processor, or blender until very finely ground.

Put the butter, the remaining 2¼ cups sugar, the lavender sugar, vanilla, and salt in the bowl of a stand mixer fitted with a paddle. Turn to medium high, set a timer for 4 minutes, and let the mixer do its work until the timer goes off. Scrape down the sides of the bowl with a rubber spatula and beat another minute. It will be very fluffy and nearly white. Add the eggs, one at a time, beating the batter well before adding another (crack the eggs into a cup first, for insurance against adding eggshells). Alternately add the flour and sour cream (⅓ of the flour, ½ the sour cream, another ⅓ of the flour, the rest of the sour cream, and finally the remaining flour), beating each addition into the batter completely before you add the next. Scrape down the sides of the bowl a couple of times during the whole process.

Scoop the batter into the prepared pan as evenly as you can and gently whack the pan on the counter a couple of times to expel air pockets. Bake the cake for 1 hour 20 minutes to 1 hour 35 minutes, or until it is golden brown and springs back when pressed, and a wooden skewer emerges dry after being inserted into the center. Let the cake cool in the pan on a rack for about 15 minutes, then turn it out onto the rack. Once it's completely cool, wrap it tightly in plastic wrap. It will be best the second day and still moist after about 4 days.

I CAN USUALLY TAKE OR LEAVE CHOCOLATE DESSERTS, but mercy, these custards do it for me. They're subtly flavored with jasmine pearls, a very high-quality tea made from the young leaf tips of the tea plant, hand-rolled into little balls, and infused with the exotic scent of jasmine flowers. The table-spoonful steeped into the cream in this recipe lends an intriguing floral hint on top of the complex flavor of the chocolate. For a more obvious flavor, add two.

chocolate jasmine
POT DE CRÈME

8 SERVINGS

1 cup whole milk

1½ cups heavy cream

1 tablespoon jasmine pearl tea (see page 251)

6 ounces high-quality bittersweet chocolate, such as Scharffen Berger, Callebaut, or Valrhona, broken up or chopped

6 large egg yolks

¼ cup plus 2 tablespoons sugar

Preheat the oven to 325°F. Gather 8 ramekins or custard cups that hold about 4 ounces each and put them in a large lidded baking dish (a braising pan or lidded deep sauté pan will work as well, and you can divide them into two different pans if they don't fit in one).

Bring the milk and cream to a full boil in a small saucepan. Remove the pan from the heat and stir in the tea. Cover and steep for 10 minutes.

Put the chocolate in a medium mixing bowl and place it on top of a pot of simmering water. Stir until melted. Remove the bowl from the heat and gently whisk in the egg yolks and sugar.

Strain the milk into a large liquid measuring cup and incrementally pour it into the chocolate mixture, about ½ cup at a time, gently whisking until incorporated before pouring in more.

If you have a gravy separator, pour the custard into it, then fill the cups, leaving the froth that floats to the top behind. If you don't have a separator, use a ladle to skim the froth from the top of the custard, then carefully ladle the custard into the cups. Put the dish holding the custards in the oven, pour about 1 inch of hot water into it, and cover. Bake until the custards are just set, 20 to 30 minutes. They should still jiggle like very loose Jell-O when you move them, but they will not be liquid in the center. Once they are out of the oven, let the custards rest

uncovered in the water bath for 10 minutes, then remove them from the bath and refrigerate until cold. Take them out of the refrigerator about an hour before serving; the texture is smoother when they warm up a little. If you wish, top with a small dollop of whipped cream.

herbal improvisations In place of the jasmine pearls, steep the cream with four 3-inch peppermint sprigs, 6 rose geranium leaves, or 1 tablespoon lavender buds, fresh or dried.

LOOKING LIKE IT CAME FROM A TONY BAKERY, this is one of the easiest tarts you can make. The buttery press-in crust is baked blind without the hassle of filling the shell with beans or pie weights; the silky, oh-so-chocolaty filling, like a giant soft truffle infused with fresh mint, takes only minutes to prepare. It's adapted from a recipe I received from my friend Conor, a chef in Ireland, who makes it with lavender.

chocolate peppermint TART

ONE 10-INCH TART; 16 SLICES

CRUST

1½ cups all-purpose flour

¼ cup plus 2 tablespoons powdered sugar

10 tablespoons (5 ounces) unsalted butter, chilled

2 large egg yolks

2 tablespoons ice water

¾ cup whole milk

¾ cup cream

Six 3-inch sprigs peppermint or chocolate mint

7 ounces high-quality bittersweet chocolate, such as Scharffen Berger, Callebaut, or Valrhona, in small pieces or chopped

4 large egg yolks

¼ cup plus 2 tablespoons fine (baker's) sugar

For the crust, pulse the flour, powdered sugar, and butter in a food processor until the largest pieces of butter are the size of grains of rice. Whisk the egg yolks with the ice water and pour them over the crumbs. Pulse again, just until the dough forms into a ball. If the dough seems too dry and crumbly, add more ice water, 1 teaspoon at a time. Spread the dough roughly across the bottom of a 10-inch tart pan with a removable bottom. Work the dough up the sides of the pan with your fingertips. Focus on making the sides of the tart the same thickness on the top and bottom (hold the forefinger of one hand horizontally across the upper edge as you press the dough against the side with your other hand), then even out the bottom of the crust so it is the same thickness throughout. Work quickly, but if you feel the dough is getting too soft and sticky, let the shell rest in the refrigerator for 5 or 10 minutes before going on. When the dough is evenly pressed, chill the shell for at least an hour before baking.

Preheat the oven to 350°F. Using the tines of a fork, poke holes evenly across the bottom of the crust to keep it from puffing in the oven. Put the tart pan on a baking sheet and bake the shell for 30 to 35 minutes, or until it is light golden brown all over and it shrinks away from the sides of the pan. Cool the shell in the pan.

Bring the milk and cream to a boil in a small saucepan. Stir in the mint sprigs, cover, and remove the pan from the heat. In 10 minutes, strain the cream, return it to the saucepan, and add the chocolate. After 3 minutes, gently whisk until the chocolate is completely melted and smooth.

Gently whisk the egg yolks with the fine sugar in a mixing bowl (don't whisk vigorously or you'll incorporate air, which will form bubbles on the surface of the tart), then pour in the chocolate, slowly whisking until incorporated. Pour the filling into the shell; there should be just enough to come to the top, but if there is too much, hold the last back before it spills over the edge. Chill the tart until the filling sets, at least an hour. Remove it from the refrigerator, and from the pan, about an hour before serving. Slice with a sharp knife dipped in hot water and wiped between each cut.

herbal improvisations In place of the peppermint, use six 3-inch sprigs spearmint, 8 medium rose geranium leaves, or 1½ tablespoons lavender buds, fresh or dried.

many MINTS

The package in the supermarket might just be labeled as mint, but to be correct it should read spearmint, as opposed to peppermint, apple mint, curly mint, chocolate mint, Moroccan mint, lavender mint, or a hundred others. Spearmint has a heady fruity fragrance, not the cool menthol quality of peppermint, and it complements all kinds of other flavors, both sweet and savory. Its leaf shape and color can vary quite a bit, from narrow and pointy to a bit wider and more rounded, and from light green to deep green, but you can always identify it by smell. Spearmint is the one mint all cooks must have in their garden. If you want a second type, choose peppermint or chocolate mint. Both are good in teas and in chocolate desserts.

FRESHLY CUT SPEARMINT from your garden will smell much stronger and fruitier than what you buy packed in a little plastic container.

MINT IS NOTORIOUS for taking over a garden by running with underground stems and popping up where it's not supposed to. Plant it in an isolated spot or in a large container.

WILD MINTS, OR NEGLECTED MINTS that escape to corners of gardens, often have inferior flavor. If they're in your garden, get rid of them and plant mints with good flavor.

TYPICALLY, YOU CAN HARVEST MINT by cutting halfway down the stems. If the plants are looking tired and spindly, cut the whole patch back all the way to the ground, feed and water it, and wait for it to grow again. Always cut mint back when it flowers. Hang the cut stems in bunches to dry, as this is when its flavor is strongest and best for tea.

MINT MIGHT GROW LIKE A WEED wherever you plant it, but it does best with at least half a day's sun and plenty of water.

Spearmint

Chocolate Peppermint

Sources

herb SEEDS

FEDCO SEEDS
PO Box 520
Waterville, ME 04903
(207) 873-7333
www.fedcoseeds.com

JOHNNY'S SELECTED SEEDS
955 Benton Avenue
Winslow, ME 04901
(800) 870-2258
www.johnnyseeds.com

KITAZAWA SEED COMPANY
(green shiso seed)
PO Box 13220
Oakland, CA 94661
(510) 595-1188
www.kitazawaseed.com

NICHOLS GARDEN NURSERY
1190 Old Salem Road NE
Albany, OR 97321
(800) 422-3985
www.nicholsgardennursery.com

RICHTER'S HERB SPECIALISTS
357 Highway 47
Goodwood, ON
L0C 1A0 Canada
(905) 640-6677
www.richters.com

SEEDS OF CHANGE
(888) 762-7333
www.seedsofchange.com

THE TERRITORIAL SEED COMPANY
PO Box 158
Cottage Grove, OR 97424
(541) 942-9547
www.territorial-seed.com

herb PLANTS

GOODWIN CREEK
Goodwin Creek Gardens
PO Box 83
Williams, OR 97544
(800) 846-7359
www.goodwincreekgardens.com

LINGLE'S HERBS
2055 N. Lomina Avenue
Long Beach, CA 90815
(562) 598-4372
www.linglesherbs.com

PURPLE HAZE LAVENDER
180 Bell Bottom Road
Sequim, WA 98382
(888) 852-6560
www.purplehazelavender.com

WELL-SWEEP HERB FARM
205 Mount Bethel Road
Port Murray, NJ 07865
(908) 852-5390
www.wellsweep.com

ingredients and EQUIPMENT

FRESH AND DRIED COLOSSAL CHESTNUTS
Allen Creek Farms
PO Box 841
Ridgefield, WA 98642
(360) 887-3669
www.chestnutsonline.com

HANDMADE KITCHEN KNIVES
Kramer Knives
5881 Storr Road
Ferndale, WA 98248
(360) 312-8244
www.bladesmiths.com

PEARL JASMINE TEA
Perennial Tea Room
1910 Post Alley
Seattle, WA 98101
(888) 448-4054
www.perennialtearoom.com

PAELLA PANS, PIQUILLO PEPPERS,
SMOKED PAPRIKA
The Spanish Table
1427 Western Avenue
Seattle, WA 98101
(206) 682-2827

PEARL JASMINE TEA, DRIED LAVENDER,
TRUE CINNAMON
World Merchants
1509 Western Avenue
Seattle, WA 98101
(206) 682-7274
www.worldspice.com

DRIED FENNEL POLLEN
Sugar Ranch
(800) 821-5989
www.fennelpollen.com

CORN CUTTERS, BENRINER JAPANESE
MANDOLINES
Sur La Table
(800) 243-0852
www.surlatable.com

Index

eggs:

 in asparagus in frothy tarragon sauce, 180

 in chervil avgolemono, 55

 in crab and lemon thyme flan with shaved
 mushrooms, 165-66

 in herbed skillet soufflé, 95

 smoked salmon stuffed, 28

English lavender, 173

English thyme, 15, 167

 see also thyme

essence of corn soup, 56-57

F

farfalle pasta, in herbed bow ties and tuna, 99

fennel, 185

 in black olive roast chicken, 124-25

 blossom soup, 59

 in lavender-rubbed duck breast with apri-
 cots and sweet onions, 171-72

 roasted peaches filled with almond and, 231

 in verdant seafood paella, 137-38

feta:

 in green bean, basil, and radish salad, 74

 -sage cornbread, 207

fettuccine fines herbes, 96

figs:

 orange thyme, with muscat sabayon, 232-33

 warm, filled with goat cheese and bacon, 22

fines herbes, fettuccine, 96

fish:

 halibut in carrot-cilantro broth, 159

 side of salmon slow-roasted in dill, 141

 slow-roasted salmon with spring herb
 sauce, 155-56

 smoked salmon stuffed eggs, 28

 smoked trout toasts, 27

 sole with wilted herbs, 109

 tuna rice bowls, 110-11

 in verdant seafood paella, 137-38

flan, crab and lemon thyme, with shaved mush-
 rooms, 165-66

focaccia, onion rosemary, 211

Fontina, in jump-in-the-mouths, 17

French lavender, 173

French-style lentils, 25

French tarragon, 114

French thyme, 167

fruit compote, herbed winter, 237

fruit sage, 146

G

garden sorrel, 32

garden thyme, 167

garlic chives, 210

garlic-sage butter, shrimp in, 160

Genovese basil, 122

geranium, scented, 229

 see also rose geranium; lemon geranium

gin:

 in sage rush, 48

 tonic, rosemary, 41

ginger:

 in cinnamon basil chicken, 120-21

 in halibut in carrot-cilantro broth, 159

 -lavender syrup, 51

 in spicy verbena meatballs, 36-37

 in tarragon oyster stew, 168

goat cheese:

 in green bean, basil, and radish salad, 74

 handkerchiefs with tart cherries and sage,
 153-54

 and minted lentil strudel, 25-26

 warm figs filled with bacon and, 22

golden marjoram, 102

golden sage, 146

good dog, bad dog biscuits, 212

Granny Smith apples, in green apple and shiso
 ice, 219

grapefruit juice, in sage rush, 48

gratin:

 savory potato, 201

 spinach lovage, 184

 zucchini basil, 183

Greek oregano, 102

green apple and shiso ice, 219

green bean(s):

basil, and radish salad, 74

in sea scallops on summer succotash, 162-63

green onion, in grilled lemon-rosemary hanger steak, 128

greens, winter, with sage-poached cherries, 84

green sauce, pork loin roasted in, 144-45

green shiso, 88

greeting tea, 40

grilled chicken with before and after marinades, 135-36

grilled lemon-rosemary hanger steak, 128

Grosso lavender, 173

Gruyère:

in herbed skillet soufflé, 95

in jump-in-the-mouths, 17

in rye-thyme cheese straws, 15

in savory potato gratin, 201

H

halibut in carrot-cilantro broth, 159

hanger steak, grilled lemon-rosemary, 128

hazelnut:

dilled celery, and Asian pear salad, 83

parsley, and mint soup, 60

herb(s):

garden lasagna, 132-33

leaves, torn vs. chopped, 9

preparation of, 7-8

sauce, spring, slow-roasted salmon with, 155-56

wilted, sole with, 109

see also specific herbs

herbed:

bow ties and tuna, 99

fresh vegetable pickle, 80

skillet breads, 208-9

skillet soufflé, 95

winter fruit compote, 237

herb gardens, starting, 4-5

Hidcote lavender, 173

holy basil, 122

honey:

in goat cheese handkerchiefs with tart cherries and sage, 153-54

in greeting tea, 40

in herbed winter fruit compote, 237

warm lavender almond cakes, 240-41

Hungarian paprika, 69

I

iceberg lettuce, in simpler summer rolls, 18

ice cream:

strawberry rose geranium, 224

in warm maple rosemary banana splits, 234

Italian oregano, 102

J

Japanese shiso, vs. Korean perilla, 88

jasmine chocolate pot de crème, 244-45

jump-in-the-mouths, 17

K

kale, orecchiette with pancetta, oregano and, 100

Korean perilla, Japanese shiso vs., 88

L

lamb:

chops with parsley, mint, and olive sauté, 176-77

shoulder chops, messy, with four herbs, 127

lasagna, herb garden, 132-33

lavender, 173

chocolate pot de crème, 244-45

-ginger syrup, 51

mai tai, 50

pound cake, 242-43

in provençal herb marinade, 135

-rubbed duck breast with apricots and sweet onions, 171-72

warm, almond cakes, 240-41

lavender mint, 249

leeks:

in asparagus and lemon thyme soup, 65

buttered, tarragon chicken breasts with, 113

pasta:

>fettuccine fines herbes, 96

>goat cheese handkerchiefs with tart cherries and sage, 153-54

>herb garden lasagna, 132-33

>herbed bow ties and tuna, 99

>orecchiette with kale, pancetta, and oregano, 100

>penne with walnut pesto and eggplant, 103

pasta squares, in goat cheese handkerchiefs with tart cherries and sage, 153-54

peaches, roasted, filled with almond and tarragon, 231

peanut butter, in good dog, bad dog biscuits, 212

peanuts, in simpler summer rolls, 18

pear(s):

>Asian, dilled celery, and hazelnut salad, 83

>braised pork shoulder with thyme and, 147-48

>brandy, in herbed winter fruit compote, 237

>rosemary upside-down cake, 238-39

pelargonium, 229

penne with walnut pesto and eggplant, 103

peppermint, 249

>chocolate tart, 247-48

perennials, 5

perennial umbels, 185-86

perilla, *see* shiso

pesto-stuffed chicken breasts with cherry tomatoes, 115-16

phyllo dough, in minted lentil and goat cheese strudel, 25-26

Piccolo basil, 122

pickle, herbed fresh vegetable, 80

pineapple sage, 146

pine nuts, in pesto-stuffed chicken breasts with cherry tomatoes, 115-16

piquillo pepper and squid salad with oregano, 90

popcorn chickpeas, 12

porcini mushrooms:

>in mushroom marjoram bread pudding, 199

>*see also* Boletus edulis

pork:

>butt, in spicy verbena meatballs, 36-37

>loin roasted in green sauce, 144-45

>shoulder, braised, with pears and thyme, 147-48

potato(es):

>in black olive roast chicken, 124-25

>gratin, savory, 201

>salt-roasted, 203

pound cake, lavender, 242-43

prosciutto:

>in jump-in-the-mouths, 17

>melon with lime and cilantro, 20

provençal herb marinade, 135

Provence lavender, 173

prunes, in herbed winter fruit compote, 237

Purple Ruffles basil, 122

purple sage, 146

Q

quince, in herbed winter fruit compote, 237

R

radish, green bean, and basil salad, 74

raspberries:

>in berry rose sangría, 42

>in lemon verbena gel, 220

red bell peppers:

>in corn, orzo, and basil salad, 76

>in sea scallops on summer succotash, 162-63

>in spicy cilantro slaw, 77

>in verdant seafood paella, 137-38

Red Rubin basil, 122

red shiso, 88

rémoulade sauce, 142

>for side of salmon slow-roasted in dill, 141

rhubarb mint cobbler, 226-27

rice:

>bowls, tuna, 110-11

>in chervil avgolemono, 55

>in verdant seafood paella, 137-38

rice paper rounds, for simpler summer rolls, 18

ricotta:

 in fettuccine fines herbes, 96

 in goat cheese handkerchiefs with tart cherries and sage, 153-54

 in herb garden lasagna, 132-33

roasted cauliflower with apple and dill, 192

roasted oysters with sorrel sauce, 31

roasted peaches filled with almond and tarragon, 231

rolls, simpler summer, 18

root ribbons with sage, 189

rose geranium, 229

 in berry rose sangría, 42

 strawberry ice cream, 224

rosemary, 14

 in black olive roast chicken, 124-25

 gin tonic, 41

 in herbed winter fruit compote, 237

 lemon chicken, 119

 -lemon hanger steak, grilled, 128

 mussel skewers, 33

 onion focaccia, 211

 pear upside-down cake, 238-39

 in popcorn chickpeas, 13

 in smoked paprika marinade, 136

 warm, almond cakes, 240-41

 in warm figs filled with goat cheese and bacon, 22

 warm maple, banana splits, 234

rosemary branches, 14

 for rosemary mussel skewers, 33

 for spicy verbena meatballs, 36-37

rosé wine, in berry rose sangría, 42

rum, white, in lavender mai tai, 50

Russian tarragon, 114

rye-thyme cheese straws, 15

S

saffron, in verdant seafood paella, 137-38

sage, 146

 -chestnut soup, 64

 in Cuban adobo marinade, 135

 -feta cornbread, 207

 -garlic butter, shrimp in, 160

 goat cheese handkerchiefs with tart cherries and, 153-54

 in herbed bow ties and tuna, 99

 in herbed winter fruit compote, 237

 in jump-in-the-mouths, 17

 in mashed winter squash with bay butter, 195

 in oven-braised forest mushrooms, 196

 -poached cherries, winter greens with, 84

 in pork loin roasted in green sauce, 144-45

 root ribbons with, 189

 rush, 48

 in smoky tomato-bean soup, 69

salad:

 cherry tomato, melon, and mint, 73

 corn, orzo, and basil, 76

 dilled celery, Asian pear, and hazelnut, 83

 green bean, basil, and radish, 74

 spicy cilantro slaw, 77

 squid and piquillo pepper, with oregano, 90

 winter greens with sage-poached cherries, 84

salmon:

 side of, slow-roasted in dill, 141

 slow-roasted, with spring herb sauce, 155-56

 stuffed eggs, smoked, 28

salt, types of, 13

saltimbocca, 17

salt-roasted potatoes, 203

savory, 200

 potato gratin, 201

 in provençal herb marinade, 135

sea scallops on summer succotash, 162-63

shiso, 88

 crab cocktail, 87

 in essence of corn soup, 57

 and green apple ice, 219

 in tuna rice bowls, 110-11

shrimp:

 in garlic-sage butter, 160

 in verdant seafood paella, 137-38